Richard Haughton

ABOUT THE AUTHOR

PHILIP BALL is a consulting editor for *Nature* magazine and a regular commentator on science in Great Britain. His book *Bright Earth* was a finalist for the National Book Critics Circle Award, and he won Great Britain's prestigious Aventis Prize for Science Books for *Critical Mass*. He lives in London.

Universe of Stone

Chartres Cathedral and

the Invention of the Gothic

PHILIP BALL

HARPER PERENNIAL

NEW YORK • LONDON • TORONTO • SYDNEY • NEW DELHI • AUCKLAND

HARPER ● PERENNIAL

First published in Great Britain in 2008 by The Bodley Head,
an imprint of Random House, Inc.

A hardcover edition of this book was published in 2008 by
Harper, an imprint of HarperCollins Publishers.

HarperCollins books may be purchased for educational, business,
or sales promotional use. For information please e-mail
the Special Markets Department at SPsales@harpercollins.com.

FIRST HARPER PERENNIAL EDITION PUBLISHED 2009.

Library of Congress Cataloging-in-Publication Data
is available upon request.

ISBN 978-0-06-115430-0 (pbk.)

HB 05.22.2023

Contents

Acknowledgements

It is always salutary to be reminded why writers need good editors, and both the shape and the fine print of this book have benefited immensely from the advice and experience of Will Sulkin and Terry Karten, whose enthusiasm has been a sustaining force. My agent Clare Alexander has also provided plenty of the latter, as has my wife Julia, with whom I discovered the delights of Chartres at first hand. Caroline Jackson generously read the section on medieval glass, and Donald Royce-Roll supplied some valuable papers on that topic. Alex Rowbotham has provided splendid images of the cathedral that I might not otherwise have had the means to obtain.

Introduction

In 1204 some of the finest churches in Christendom were ransacked and the precious icons and relics were divided up among the plunderers. They snatched reliquaries from altars, forced open chests filled with holy treasures, stripped gold and silver metalwork from church fixtures. In their haste they spilled the sacramental wine over the marble floor, where it might mingle with the blood of any priest who stood in their way.

But these marauders were not infidels. They were Christian knights of the West, the flower of Europe's chivalry, bearing the sign of the cross that identified them as Crusaders. For this expedition, the Fourth Crusade, went not to the Holy Land and Jerusalem but to Constantinople, the capital of the eastern Holy Roman Empire, where the schismatic Greek rulers refused to recognize the authority of Pope Innocent III.

This was not the only crusade underway at that time. There was another afoot in Europe itself, and it was concerned not with sacking churches but with building them. Just as the knights of France, England and Germany were despoiling the gilded splendour of the Hagia Sophia, builders in their homelands were inventing a new architectural style that would rival the glories of Byzantium. Over some three hundred years, the Europeans engaged on a 'cathedrals crusade', building churches on a scale never again equalled either in size or in quantity. In France alone, eighty cathedrals, five hundred large churches and several thousand small churches were constructed between 1050 and 1350. At the end of this period there was, on average, a church for every two hundred inhabitants of France and England.

And these were not squat and gloomy edifices in the style we now know as Romanesque, but towering monuments of stone and glass,

filled with light and seeming to ascend weightlessly towards heaven. They were the Gothic cathedrals. Now considered the finest works of medieval art, these churches are even more than that. They represent a shift in the way the western world thought about God, the universe and humankind's place within it.

The Gothic Myth

Our contemporary view of that transformation is obscured by a lot of rubble. Much of it was deposited in the nineteenth century, whose historians, artists and architects, in the course of rescuing the Gothic style from ill repute, laid down a mythology about what it represents. When we think of a cathedral today, it is a Gothic building that comes to mind, not the heavy Romanesque precursors. And for many of us this vision is embodied in a specific edifice, standing in what has been rightly called 'splendid isolation' on the Île-de-la-Cité: Notre-Dame de Paris, immortalized by Victor Hugo in his eponymous novel of 1831.

Hugo's book wasn't simply a work of fiction – it was a meditation on architecture in general, and on the architecture of the Gothic age in particular, and it defined a vision of these things in the same way that Dickens described a version of London that has now become inseparable from that city's stones. For Hugo, the Gothic cathedral was a social construction, a temple made for and by the people rather than decreed by an ecclesiastical elite. That image chimed very much with the tenor of post-Revolutionary France, and it gave rise to a myth of the cathedral that is still pervasive today. 'The greatest works of architecture', said Hugo,

> are not so much individual as social creations; they are better seen as
> the giving birth of peoples in labour than as the gushing stream of
> genius. Such works should be regarded as the deposit left by a nation,
> as the accumulations of the centuries, as the residue of successive evap-
> orations of human society, briefly, as a kind of geological formation.

It's not just Hugo's exquisite prose that makes the idea seductive. We can feel a little less overwhelmed by the stupendous scale and structure of the cathedrals of Notre-Dame de Paris, Strasbourg and

Chartres, if we can indeed regard these buildings as something geological, created by the immensity of time and the energy of countless generations, rather than as objects that were conceived in the minds of a handful of men and constructed by labourers stone by stone. And we need not feel oppressed by their colossal size if, like Hugo, we believe that in the Gothic era 'the book of architecture no longer belonged to the priesthood, to religion or to Rome, but to the imagination, to poetry and to the people'.

Hugo was not the first to voice these views, but no one had previously found words so compelling, and he made them so familiar that a whole generation of French intellectuals, historians and artists fell under their spell. For Eugène Viollet-le-Duc, the great nineteenth-century restorer of French Gothic buildings, Hugo's reading of the Gothic cathedrals meant that they became national monuments and 'a symbol of French unity'. If this belief helped Viollet-le-Duc return some of France's great churches to a state approaching their former glory, we have reason to be grateful for it. But that does not make it any less a facet of the romantic myth of the cathedral.

It is hardly surprising that historians of 150 years ago needed to have some story to weave around the Gothic cathedrals. These monuments seem to sit in defiance of the traditional narrative we have spun about western history, in which the Middle Ages separate the wonders of Greece and Rome from the genius of the Renaissance with an era of muddle-headed buffoonery. We are even now apt to forget that it was the Renaissance historians themselves who constructed this framework. Today, however, there is no shortage of alternative stories to replace that created by Hugo and his contemporaries – and each tells us something about our own times, regardless of how much light they shed on the High Middle Ages. And so the cathedrals become cryptograms of ancient, sacred knowledge; or they are symbols of church oppression; or they are testaments to the skills of the medieval engineers. Many of these stories have some truth in them; none gives us the full picture. That, after all, is what all great works of art are like: they are never unlocked by a secret code, but they may be enriched by repeated viewing, first from this angle, then from that. Knowing 'how' and 'why' they were created does not allow us to understand them fully, but it may inspire us to love them more ardently.

Why Chartres?

It feels like heresy to say so, but there is something not quite Christian about Chartres Cathedral. Or perhaps one should say that it is somehow super-Christian, a place that connects the central spiritual tradition of the western world to a more ancient, strange and mysterious narrative. People have always seemed to sense this; it is not only in modern times that Chartres has become a nexus of theories about mystical symbolism, hidden codes and vanished wisdom. You will understand why this is so when you go there. There are few buildings in the world that exude such a sense of meaning, intention, signification – that tell you so clearly and so forcefully that these stones were put in place according to a philosophy of awesome proportions, appropriate to the lithic immensity of the church itself. This is partly a happy accident: unlike most medieval churches, Chartres is no palimpsest but nearly a pristine document, miraculously preserved from a distant world, bearing a message that is barely diluted by other times and tastes and fashions. But the power of Chartres does not stem simply from its fortunate state of preservation, for even in its own time Chartres made a statement of unprecedented clarity and force.

No wonder people have argued for hundreds of years about what Chartres Cathedral 'means' (and still show no sign of reaching an agreement). From the moment you see the spires rise up on the horizon across the plains of Beauce, you can't avoid the question. It is all too easy to get carried away – to imagine, say, that there are supernormal forces whirling around those pale towers or slumbering in the ancient well, or that there is some occult cipher that will unveil the secrets locked into the shapes of the stones. The cathedral and its history have been repeatedly romanticized, as though there was ever a time when workmen did not grumble while they toiled and when priests were no less fallibly human than they are today. The incomparable windows and the astonishing labyrinth tempt us towards interpretations both fanciful and naïve, and the temptation has frequently proved too great. We have to come to Chartres prepared to admit that there are many things we do not and may never know, and that such answers as we have are not always simple or secure.

It may come as a disappointment that we must relinquish notions of 'sacred geometry' and hidden codes (I don't anticipate that everyone will readily do so), but it should take only a little sober reflection to realize that the past is not profitably understood through such simplistic formulas. What is perhaps more alarming is the number of apparently respectable and frequently recycled ideas about both Chartres in particular, and the whole Gothic enterprise in general, that turn out on close inspection to be built on sand. This debunking is the work of several careful scholars, and none of the credit belongs to me. But it is often in the nature of such efforts that they must focus on the demolition and forget about reconstruction, and sometimes they demolish more than is truly needed. I want to make it clear at the outset that the definition, meaning and chronology of Gothic are subjects that have spurred some bloody conflicts – parts of this literature are hardly for the faint-hearted. There are few points of view that have not suffered the withering dismissals of eminent and formidable critics.

Arguably, then, it is a foolhardy endeavour to say anything about 'why' Chartres Cathedral was built, which is in the end what this book attempts to do. But to my mind, it is only by confronting that question that we can fully experience what this most extraordinary, most inspiring building has to offer. Guidebook chronologies and ground plans will not help you with that, and there seems to be little point in knowing that you are standing in the south transept or looking at St Lubin in the stained glass or gazing at a vault boss a hundred feet above your head unless you have some conception of what was in the minds of the people who created all of this.

The answer is not easily boiled down. It is only by embedding the church in the culture of the twelfth century – its philosophies, its schools and its politics, its trades and technologies, its religious debates – that we can begin to make sense of what we see (and what we feel) when we pass through the Royal Portal of the west front. Within the space of a hundred years, this culture was transformed from inside and out; and that transition, which prepared the soil of the modern age, is given its most monumental expression in Chartres Cathedral.

This transformation was fundamentally intellectual. It was not until the start of the second millennium after the crucifixion of Christ that the western world dared to revive the ancient idea that the universe

was imbued with a comprehensible order. That notion flourished in the twelfth century, fed by an influx of texts from the classical world, preserved by the Islamic scholars and now becoming available in Latin translation. But not all the learning of the High Middle Ages was second-hand; among those who read the works of Plato, Aristotle, Euclid, Ptolemy and Archimedes were some men with ideas of their own, who posed questions that could only have been framed within a strongly monotheistic culture and yet which presented new challenges to old ideas about God's nature and purpose. From this ferment issued a strand of rationalism that sat uneasily with any insistence on gaining knowledge through faith alone.

This shift of inner worlds cannot be divorced from events in the sphere of human affairs. Wealth and commerce fostered new ideas, not only because they lightened the burden of terror that had previously made Christians little more than supplicants to a grave and unfathomable God, but also because trade opens doors for cultural exchange. And churches could not be built without money. We should not forget also that cathedrals were expressions of prestige, reflecting glory onto kings, nobles and bishops. This is why it is not enough to say that the Gothic cathedrals offer a vision of a coherent universe – they did not erect themselves, and bookish monks were in no position to dictate their design. Yet equally, it makes no sense to look for explanations of these greatest of the medieval works of art that do not encompass something of the conceptual and philosophical matrix in which they appeared. The programme of this book, then, is to show how these elements – the spiritual, the rational, the social and the technological – came together in twelfth-century Europe to produce a series of buildings that are unparalleled in the West, and to which frankly we are now quite unable to offer any rivals.

While I shall begin this journey among smouldering timbers in late-twelfth-century Chartres – a disputed territory on the fringes of the land that the French kings could realistically consider to be under their authority – we will need to take some substantial steps backwards in order to appreciate what it meant to undertake a cathedral-building project in the 1190s. First we will follow the emergence of the characteristic features of the Gothic architectural style, for it is as well to have our subject clearly in sight from the outset. Then we shall see what a many-faceted creation a medieval church was, at the same time

thoroughly mundane and deeply symbolic. This latter 'representational' aspect of the cathedral requires that we examine the philosophical and theological currents of the twelfth century, noting what these took from antiquity and early Christian thought, and discovering that this was an age when old certainties were being uprooted and new ways of thinking were provoking furious disputes about the nature and the boundaries of intellectual enquiry. In many ways these changes culminate at Chartres in the middle of that extraordinary century, at the height of this first renaissance and at the dawn of the Gothic era.

From the abstract notions of the philosophers and scholastics, I shall turn to the practical business of building, looking at the issue of how the cathedrals were erected and who designed them. Here we enter disputed territory of a more contemporary kind, when we are forced to ask how far and in what ways the worlds of the theologian, philosopher, architect and mason overlapped. Let me say now that there is no consensus on this question, although a great deal of the weight of interpretation rests on it. Moreover, it seems certain that the answer for the twelfth century would not be the right one for the fourteenth. In much of the literature dealing with these issues, one can say with some confidence that the more definitively a view is expressed, the more likely it is that it represents wishful thinking. That doesn't mean we have to surrender to ignorance, for we can re-create a picture of these interactions between different professions and authorities that is rich and varied, even if it cannot yet, and may never, throw into sharp relief what transpired on (and behind the scenes of) the building site at Chartres.

I will also examine a rather different facet of the intellectual trade between scholar and craftsman, manifested in the most glorious features of this jewel of Gothic building: the spellbinding windows of Chartres. And then finally we shall see the cathedral completed amid civic discord that undermines popular myths about the communal nature of the project.

Along the way, we will pass through the cathedral itself. Each chapter begins with an examination of some aspect of the church, looking at its history, its significance and perhaps its mythology. But of course words are a poor substitute for the train ride that, in less than an hour, takes you from Paris to the threshold of a marvel.

I

The Isle Rises

Chartres in the Kingdom of France

Then they took the holy tunic
From the mother of God, who departed . . .
The Lady who wore it
When she bore the Son of God
Thought it would be put
At Chartres, in her main church,
And that it would be preserved
In the place of which she is called the Lady.

Jean le Marchand, 1262

The Sacred Tunic

Like countless other churches in France, the cathedral of Notre-Dame de Chartres is a temple to the Marian cult of the Middle Ages, dedicated to the mother of Christ. In 876 Charlemagne's grandson Charles the Bald, king of the Carolingians, gave to the bishop of Chartres the cathedral's most holy relic: the tunic or *camisa* said to have been worn by Mary at the time of the birth of Jesus (or some say, the Annunciation). This *Sancta Camisa* had been given to Charlemagne himself by the Byzantine emperor Nicephoras and his wife Irene when the first Holy Roman Emperor passed through Constantinople on his way back from Jerusalem. It is not exactly a chemise, but more of a robe or wrap: a length of faded cloth about 5 metres (16½ feet) long, frayed at the ends, which is now preserved in a reliquary in the north-eastern chapel of the apse.

According to the seventeenth-century French historian Vincent Sablon, Nicephoras claimed that the Virgin, shortly before her death, asked the apostles to give her clothes to 'an honest widow who had always served her from the time her Son had returned to His Father'. Miracles were associated with the *camisa* while it was in Palestine, but 'with the passing of time, the clothes went through many hands'. Then two brothers from Constantinople, while on a pilgrimage to Jerusalem, stole the garment in its reliquary from a Jewess who was its guardian and carried it back home. Although there they tried to hide away their precious booty, 'the tunic made itself known by several miracles', drawing the attention of the emperor, who took it from the thieves and placed it in a temple specially built to house it.

The crypt of Chartres also houses a wooden statue of the Virgin, Our Lady of the Crypt – not a precious ancient relic but a modern copy of a copy, for the ancient statue, probably dating from the twelfth century but copied from one older still, was burned by Revolutionaries in 1793.

The sacred relics of a medieval church were at the same time a measure and a determinant of its status, not only to its priests and congregation but also, they suspected, in the eyes of God. And so the clergy were keen to advertise them, mindful that this would draw donations from pilgrims, from nobles and from princes and kings who hoped to secure divine favour. From the ninth century, Chartres became linked with a cult of the Virgin that extended throughout Europe, and it seems likely that the clergy were keen to exploit this association. There is evidence in the design and the iconography of the church that they sought to manipulate the character of the Marian cult at Chartres so as to establish it as something unique and not just one pilgrim destination among many.

That was a delicate game. The local cult of the Virgin may have owed more to folklore than to Christian piety: it appeared to be centred on a sacred well beneath the cathedral, and on the wooden statue, probably one of the black madonnas of pre-Christian origin. People in this rural community fondly believed that the Virgin could intercede directly on their behalf, an idea that tended to bypass the

authority of the bishop and priests. And so the churchmen aimed at the same time to use and to undermine this cult: to promote the status of Mary, but only in so far as it was controlled and sanctioned by the Church. In 1259 they ordered a new reliquary to be made for the *camisa*, concerned that it should be presented to maximum effect. And as the Marian cult gained pace in the early thirteenth century, the manipulations of the Chartrain clerics can be discerned in the imagery of the building. In the façade of the south transept, dating from the 1210s, she is shown alongside Christ during the Last Judgement, implying (without biblical justification) that she would be there to offer a good word on behalf of those who had venerated her on earth.

The town adapted to the idea that Chartres was the essential destination for the discerning Marian pilgrim. It had its souvenir vendors like any tourist centre today: pilgrims could buy items based on the Sacred Tunic, such as shirts blessed by a priest, which were thought to confer protection in battle. On several occasions (so the records insisted) the *camisa* gave such protection to the town itself, and some believed that the fortunes of Chartres were bound up with this swathe of holy fabric.

It is often said that the eleventh and twelfth centuries were a time of great change for the kingdoms of Europe; but the fact is that no century had resembled the preceding one ever since the Christian world began (and for long before that). The difference was that, after the turn of the millennium, change was often for the better.

The Carolingian Empire, racked by internecine conflict after Charlemagne's death, foundered in the ninth century before the onslaught of Viking freebooters, who plundered Flanders and Bordeaux, sacked Paris, and forced the Franks to cede the region later known as Normandy. Meanwhile, Magyar bands from the east roved murderously through Saxony, Bavaria, Aragon and Aquitaine. These barbarian raids left much of Christendom cowering in fear, preventing any real intellectual or spiritual progress until the Ottonian kings revived the aspirations of the Carolingians in Saxony in the mid-tenth century.

It wasn't just the threat of invasion that spread terror through early Christian Europe. Famine was equally lethal, more common and harder to flee. The prevailing agricultural methods were poor and yielded a harvest that barely fed the population, small though it was. But the eleventh century brought increasing social stability and economic growth, thanks in part to agricultural innovations. The introduction of improved harnessing of draft animals meant that ploughs could be drawn by horses rather than oxen. Three-field crop rotation methods, the asymmetric plough and the scythe also played their parts in raising yields, in some cases doubling or even tripling them.

At the end of the tenth century, sovereigns were nominal and had little real power. The feudal manor, with its more or less self-sufficient community of peasant serfs, formed the basis of this agrarian society. Yet kings were no longer content to be tribal chieftains or warrior-lords; they considered themselves the successors of the Roman emperors, and wished to be seen as wise and erudite. And so they learnt Latin and studied the liberal arts under the greatest scholars. (Charlemagne, for all his approval of scholarship, remained illiterate.) They patronized the best artists and craftsmen, and in the royal courts of the western world there arose the romantic ideals of chivalry, celebrated in poetry and song.

Ecclesiastical power structures were changing too. Formerly, the rustic communities of the monasteries had represented the spiritual and scholarly centres of the Christian Church. But increasingly the bishops, not the abbots, held most influence, and so the cathedrals, located in larger towns, came to provide the focus of religious life. While Romanesque was primarily the style of the monasteries, situated in rural regions, Gothic was an urban style: less mystical and inwardly focused, more rational and worldly.

From the beginning of the twelfth century the towns were the vital organs of a kingdom. That had arguably been the case in antiquity too, but one of the symptoms of the dissolution of the Roman Empire was the decline of the great towns. Previously administrative centres, these walled settlements were left with no role as centralized government dissolved and working the land became the only way to fill your belly. Within the civic perimeter of tenth-century Beauvais, one estimate suggests that there dwelt a population (excluding clerics and knights) of barely three hundred people.

Economic growth changed all that. Formerly the seats of regional government, towns became self-sustaining centres of wealth: they were their own *raison d'être*. These were the places where money changed hands, where deals were done, and where life was (for some at least) not the relentless hard grind of the peasant but the convivial existence of the merchant. Money began to replace land as the basis of prosperity. Between the eleventh and the early fourteenth centuries the population of France is estimated to have roughly doubled, and much of this growth was concentrated in the towns and cities, where the increases were greater still. Construction on the scale of the cathedrals crusade would have been inconceivable without this new confidence and prosperity.

Feudalism was a system suited to the countryside; the towns challenged it. When they were depopulated, some towns retained no figure of authority except the bishop, who took advantage of that situation to build a power base and wrest control from the lords and nobles. At Noyon the bishop even styled himself a count. The citizens too found the opportunity to free themselves from feudal ties – towns began to declare themselves communes, unfettered by allegiance to a lord. Some historians now believe that these changes in Europe's social structures were more profound than anything that occurred during the barbarian invasions of the fifth century, which were in truth more of a transfer of power and spirituality to a new set of rulers within a culture that was merely degraded rather than transformed. In that sense, the transition from the ancient to the modern European world took place not via some fictitious 'dark age' but as a result of the social and economic upheavals of the tenth and eleventh centuries.

The New Kings of France

The cathedrals crusade, like several of the military ones, began in France: at the very heart of the French kingdom, in the region within about a 50-mile (80-km) radius of Paris known as the Île-de-France. This was the domain of the House of France, the line of Capetian kings begun by Hugh Capet ('the caped'; *c.*938–*c.*996), who inherited the Frankish kingdom of the Carolingians.

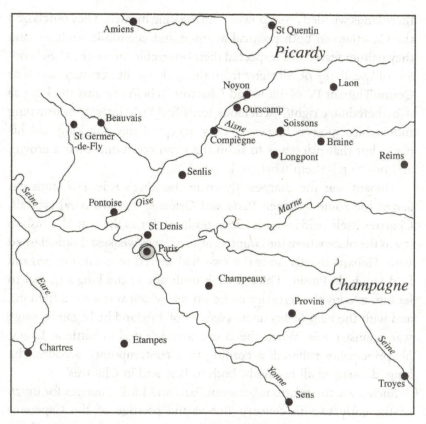

The Île-de-France and its environs in the twelfth century.

The Capetians had lofty ambitions, inspired by dreams of Christian chivalry that turned to grim and bloody reality during the Crusades. The Holy Roman Emperor was a German, true enough; but to Louis VI of France (who ruled from 1108 to 1137) it was the French king who was the real heir of Charlemagne. Was it not Charlemagne's father Pepin, king of the Franks, who had been designated 'protector of the Romans' in the mid-eighth century, when he defeated the barbarous Lombards? Was it not Pepin's son who was crowned first Holy Roman Emperor on Christmas Day of 800 by Pope Leo III?

Yet it was a very modest empire that the French kings now ruled. Nominally it extended from Toulouse to the Low Countries, but the royal authority was effectively ignored in the duchies of Normandy, Brittany and Aquitaine and the principalities of Champagne, Flanders, Poitou, Anjou and Blois-Chartres. Some of the princes and dukes of

these lands wielded more power than the king himself. They outclassed the Capetians in both political acumen and economic strength, and they neither feared nor respected their ostensible monarch. The chronicle of the abbey of Morigny from the early twelfth century says that Count Thibaut IV of Blois and Chartres 'rebel[s] against the king as if by hereditary right'. Rebellious lords had little interest in usurping monarchical power, however. They accepted that the king had his place; but that place was to sit in the royal court and wear a crown, and not to tell them what to do.

Thibaut was the sharpest thorn in the king's side. His lands cut across the route between Paris and Orléans, the two royal capitals. Chartres itself held an ambiguous position, for as the seat of a bishop it was the place where the count's authority was weakest. Louis clashed with Thibaut shortly after the two had united to crush the brigand lord Hugh de Puiset. Thibaut took umbrage at the king's refusal to let him occupy the territory of Le Puiset, which was a royal fiefdom, and with the help of his uncle Henry I of England he began to wage war against Louis. When the count was defeated in battle at Lagny, his principality suffered: according to a contemporary account, the king 'devastated all his lands, both in Brie and in Chartres'.

Such were the relations between Paris and Blois-Chartres for much of the early twelfth century. But as the prestige of the Capetians waxed, their troubles with the Thibautiens came to an end. Abbot Bernard of Clairvaux, the mastermind of the Cistercians, initiated a reconciliation at the consecration of the new church of Saint-Denis in 1144, and in 1160 that alliance was sealed by the marriage of Louis VI's son Louis VII to the sister of Thibaut IV's successor Thibaut V. The count in turn wedded the king's daughter Alix and became royal seneschal; he become known subsequently as 'the Good', a reminder of how history is written by the victors. Meanwhile, in 1165 his brother, known by the picturesque title of William of the White Hands, was made bishop of Chartres.

The new church-building style that started to crystallize in and around the Île-de-France at this time reflected the fresh confidence of the French monarchy, which was echoed in the intellectual and economic vitality of the region. This was the ideal launching ground for a radical departure from tradition, and it hosted all three of the great High Gothic cathedrals: at Reims and Amiens, and, before them, at Chartres.

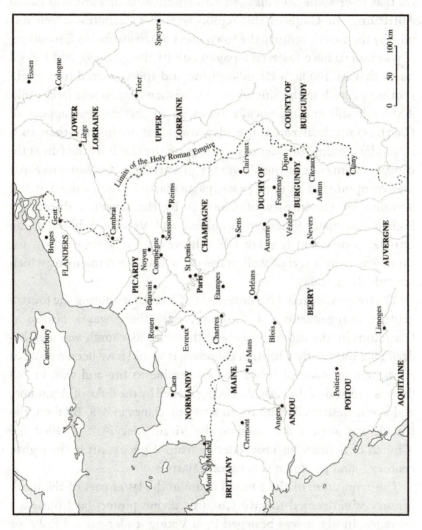

The kingdom of France in the twelfth century.

Carnotum

The Romans knew the river Eure as Autura, and the town situated on that river some 50 miles (80 km) south-west of Paris was called Autricum. The Gauls of this region were the Carnutes, which was why by the fourth century the town was known instead as Carnotum. It was said to have fostered a pagan cult of the goddess, and legend has it that by 100 BC a Druidic shrine and spring sacred to a virgin mother existed on the site where a Christian church was later built. Although still enthusiastically repeated to this day in support of Chartres' mystical roots, the idea owes less to history than to a misunderstanding of Caesar's writings on the Gauls by the fifteenth-century chancellor of the University of Paris, Jean Gerson. His error was compounded in later years, particularly in the rather fanciful accounts of the history of Chartres by the seventeenth-century French historians Sébastien Rouillard and Vincent Sablon. If the Druidic connection is mere fable, however, the spring is not, for there was truly a sacred well in the cathedral, the remains of which are still there today.

The town was probably converted to Christianity during the fourth-century evangelization of Gaul; certainly there was a bishop at Carnotum by the fifth century, and therefore its church was a cathedral. Like most early Christian churches, it would have been a protean construction, made of wood and vulnerable to fire and war. In 743 there is a record of the cathedral being sacked by the duke of Aquitaine, and it was destroyed again by an army of Danes in 858. By then, the church was already dedicated to the Virgin Mary – it is called the 'Church of St Mary' in a royal decree from Pepin's court in the eighth century – and the town was called Chartres.

The acquisition of the *Sancta Camisa* in the latter part of the ninth century was deemed to give Chartres divine protection from such outrages. In 911 it was besieged by a Viking leader named Rollo or Rollon. When the bishop, Gantelme, ordered that the relic be brought up onto the city ramparts and shown to the attackers, they fell into disarray and fled. Rollo himself converted to Christianity and in that same year he was made the first duke of Normandy, the province of the Norsemen, by Charles III of France. The *camisa* saved Chartres

again in 1119 when Louis VI prepared to besiege his foe Thibaut IV, who was encamped in the town. A procession led by the clergy, flaunting the precious relic at its head, persuaded the king to relent. (The trick did not work again fifteen years later, when the king again found cause to besiege Chartres and its lower quarters were badly damaged by fire.)

Whether by God's providence or not, Chartres prospered from the tenth century. The towns of the Île-de-France benefited from the burgeoning trade in wool from England and Flanders, which was turned into textiles and sold to merchants from the south of France and the Mediterranean. And the intellectual reputation of Chartres, which remained unequalled in France until the end of the twelfth century, was established when the talented Italian scholar Fulbert came from Reims in the 980s to lead the cathedral school. Fulbert turned it into one of the greatest centres of learning in Europe, and in 1006 he was made bishop of Chartres.

In 1020 the cathedral was once again consumed by fire on the eve of the Festival of the Nativity of the Virgin, and this gave Fulbert the opportunity to commission a much grander building. 'The church was not simply burned, but actually totally destroyed', says a contemporary document called the *St-Aignan Chronicle*. 'The bishop Fulbert, through his diligence, efforts, and material contributions, rebuilt it from the ground up and, once raised, practically saw it through to a state of wondrous greatness and beauty.'

To finance his ambitious scheme, Fulbert requested funds from King Robert II 'the Pious', the second of the Capetian monarchs. As the chronicle records, the bishop also swore to give over his personal income to the reconstruction of the church. 'Since I do not have the wherewithal to restore it in a fitting manner', he told the king, 'I refuse to allow myself even necessary funds. I am giving much thought to the possibility of obtaining at my effort, no matter how strenuous, help in restoring the church.' Fulbert obtained further contributions from the dukes of Aquitaine and Normandy and the count of Chartres-Blois; even King Canute of England donated gifts. Fulbert made sure to show his sponsors that their money was being well used – as the building work proceeded, he wrote to William of Aquitaine, saying, 'By the grace of God along with your aid, we have completed our crypt and have taken pains to cover it over before the rigours of winter damage it.'

The architect, a man named Beranger, retained the small crypt of the old Carolingian church but extended it into a much larger space, vaulted in the Romanesque manner. Beranger's crypt is the only part of Fulbert's church that still survives today. But because the Gothic church was built over it, the Gothic plan was to some extent dictated by this early Romanesque structure. This must be borne in mind when seeking to interpret the Gothic design in terms of late-twelfth-century architectural practices, for the Gothic builders at Chartres were unusually constrained in what they might do.

Fulbert died in 1028, just before his new church was completed. An eleventh-century miniature painted by a monk named André de Mici soon after Fulbert's death shows him conducting a service with the new church over his head, complete with western towers, aisles flanking the nave, and a characteristically Romanesque eastern end with its radiating chapels. The north-west tower was destroyed by fire just a year later, but nonetheless the church was ready to be consecrated in 1037 by Fulbert's successor, Bishop Thierry.

Out of Ashes

Early medieval bishops might set their sights on eternity, yet they had little cause to trust that their wooden churches would outlast a generation. Even a preponderance of stone was no guarantee of permanence: plenty of monumental Gothic buildings have been neglected and have descended into ruin, and others have been shattered by the violence of war and revolution. But when the clergy of Chartres undertook once again, at the end of the twelfth century, to repair the terrible damage to their church, it was the last time they would have to do so. Chartres Cathedral has not emerged unscathed from the intervening centuries; like any other church of the Gothic age it has suffered insults both planned and accidental. Yet its fabric, pieced together from dense limestone in the twelfth and thirteenth centuries, remains substantially intact as the best surviving example of High Gothic architecture, seeming in its vastness to assert imperviousness to time and flame. If that appears miraculous, perhaps it is because the cathedral itself was born from miracles.

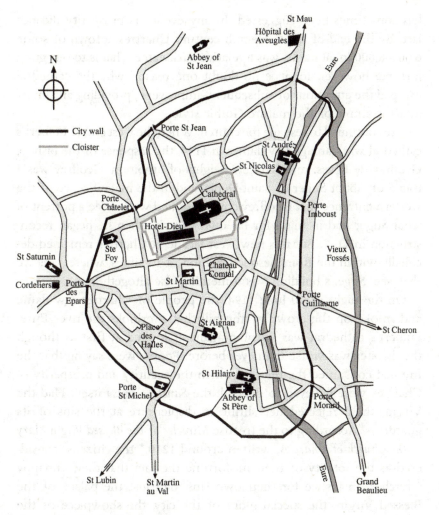

The city of Chartres around 1250.

By the start of the twelfth century Chartres was strong commercially, intellectually and spiritually. The city hosted four great fairs each year on the feast days of the Virgin: the Purification (2 February), Annunciation (25 March), Assumption (15 August) and Nativity (8 September). The Chartrain merchants grew wealthy on the proceeds, such that around 1160 the French poet Wace described Chartres as having an 'opulent citizenry' – although such claims should be kept in proportion, for the city was never large, grew very little during the twelfth century, and was probably not the economic powerhouse that

has sometimes been suggested. In any event, its prosperity did not last. By the end of the thirteenth century Chartres, a town of some 6,000–8,000 inhabitants, was a relative backwater. That is to our good fortune, however, for it is no doubt one reason why the cathedral escaped the attentions of subsequent 'improvers', providing an almost intact example of the mature Gothic style.

Fire continued to reshape the church. When the west end of Fulbert's cathedral was damaged by flames in 1134, the response of the bishop, Geoffrey de Lèves, revealed new heights of ambition. Geoffrey was a friend of Abbot Suger of Saint-Denis, and in the magnificence of the western entrance that Geoffrey commissioned we can see a portent of what Suger had in mind for his own church when he began recon- struction in 1137. But this new west façade at Chartres remained de- cidedly within the Romanesque tradition of its times, whereas, as we shall see, Suger's building was something else altogether.

On the night of 10 June 1194, the people of Chartres saw flame and smoke on the crown of the hill that overlooks the river Eure. Fulbert's cathedral was burning again. It looked at first as though the disaster was worse than ever before. People were saying that the fire had consumed the relic on which the security and prosperity of Chartres were believed to depend: the *Sancta Camisa* itself. Had the Virgin, then, rejected her shrine in displeasure at the sins of its guardians? According to the treatise *Miracles of the Blessed Virgin Mary in the Church of Chartres*, written around 1210,* the citizens 'consid- ered as the totality of their misfortune the fact that they, unhappy wretches, in justice for their own sins, had lost the palace of the Blessed Virgin, the special glory of the city, the showpiece of the entire region, the incomparable house of prayer'.

If this was truly a sign of divine displeasure, what point was there in rebuilding the church? In the days that followed, according to the *Miracles*, all were 'seized with incredible anguish and grief, concluding that it was unworthy to restore the structures of the city or of the church, if it had lost such a precious treasure, indeed the glory of the whole city'.

It is often suggested that the conflagration was so utterly devas-

* This was, as we shall see, no objective account of the fire of 1194, but was commis- sioned and written as propaganda to raise funds for the reconstruction.

tating that only the crypt and the western towers escaped destruction. Maybe so – certainly, the fire seems also to have destroyed much of the town itself. But contemporary accounts may have exaggerated the damage, for they would hardly have been content to impute to the Virgin some half-hearted gesture. Some now think that only the nave was truly obliterated, and that the choir may have been largely spared. The clerics would not, however, have been content to patch up stonework that the Virgin had apparently condemned.

Yet with the loss of the *camisa*, the canons of Chartres might have succumbed to total despair and never begun reconstruction at all, if the papal legate to France, Cardinal Melior of Pisa, had not been in the city. He assured them that the church must be rebuilt even if that meant the cathedral canons had to tighten their belts for the next several years to pay for the work. They eventually agreed; but as the burden would fall on the shoulders of the townspeople too, the cardinal needed to win them over to his cause.

The third day after the blaze was a feast day, which provided an opportunity to gather the citizens of Chartres into the square. Here Melior stirred the people with rousing words, entreating them to take heart and not to abandon their church. And as if stage-managed (perish the thought), it was at that moment that the bishop, Renaud of Mouçon, appeared at the head of a procession of monks, who carried with them the Sacred Tunic. It had been saved after all, they explained, by two quick-thinking priests who rushed into the burning building and took the relic down into the crypt. There they remained trapped while the fire raged above, but they were 'so preserved from mortal danger under the protection of the Blessed Mary that neither did the rain of burning timbers falling from above shatter the iron door covering the face of the crypt, nor did the drops of melted lead penetrate it, nor the heap of burning coals overhead injure it'. The woe of the townspeople turned to joy, and they celebrated the prospect of creating a new home for the precious *camisa*.

For what could this signify but the wish of the Virgin herself that an even more wonderful church be built in her honour? As the chronicler William the Breton wrote in his early thirteenth-century poem honouring the French king Philippe Augustus, 'the Virgin and Mother of God, who is called and indeed shown to be the Lady of Chartres,

wanted the sanctuary that is so specially hers to be more worthy of her. She therefore permitted the old and inadequate church to become the victim of the flames, thus making room for the present basilica, which has no equal throughout the entire world.' The fire itself thus became a holy miracle, and the survival of the *camisa* was compared with the deliverance of Noah from the Flood (celebrated in a window in the north aisle of Chartres) and Jonah from the belly of the whale.

So Chartres was to get a new cathedral. And clearly it had to be even more magnificent than the last. The canons were determined that it would outshine every other church in Christendom. By the 1190s, those who commissioned churches and those who built them had new ideas and new techniques, and at Chartres these practices came together in perfect harmony for the first time, establishing a new template for cathedrals throughout northern Europe.

2

A Change of Style

The Invention of Gothic

We resolved to hasten, with all our soul and the affection of
our mind, to the enlargement of the aforesaid place – we who
would never have presumed to set our hand to it, nor even to
think of it, had not so great, so necessary, so useful and
honourable an occasion demanded it.

Abbot Suger, *De consecratione*, 1140

Chartres was often treated as though it had no antecedents but
was the result of a superhuman feat of imagination (the myth in
its art-historical form); in fact, it emerged almost inevitably out
of developments taking place in the regions of Laon and Soissons.

Peter Kidson, 'Chartres', *Grove Dictionary of Art*, 1996

The Nave

As you enter Chartres Cathedral from the west, what strikes you first
is the sheer scale. Your eye is drawn in two directions: forward to the
sacred altar and up into the lofty shadows – towards the cross of Jesus
and to God in heaven. And you realize that the worship of God can
move men to conquer stone and transform it into something without
apparent weight or bulk. 'At first', said Rodin on stepping inside the
cathedral, 'I was completely dazzled, so that I could only dimly see a
luminous purple. Then, little by little, I began to make out an immense
arcade – like a Gothic rainbow, appearing at the springing of the vaults.
Slowly the mystery fades; slowly the architecture begins to emerge.

And my admiration is compelled irresistibly.' Beneath the vaults of Chartres, Napoleon Bonaparte said, the atheist would feel uneasy.

Chartres quotes from earlier examples of Gothic church-building – from Saint-Denis, from Notre-Dame de Paris, and from its near contemporaries, the cathedral at Soissons and the abbey church of Saint-Yved at Braine in Aisnes. But it was the largest and most awesome cathedral begun in the twelfth century, filled with touches of striking originality, and it set a standard that subsequent Gothic buildings struggled to surpass. There would be longer and wider naves (that at Chartres is about 110 m long [360 feet] and the central aisle 16.5 m [54 feet] wide), and higher vaults (those at Chartres rise to a height of 35.5 m [116½ feet]), but there is no church that can surpass the sense of clarity and harmony evoked in the nave of Chartres – especially if you are lucky enough to visit at a time when there are no chairs set out for a service, and you can see the space almost as it would have appeared to worshippers in the thirteenth century. 'Both Bourges and Chartres were thought through completely, down to the last detail', says the French art historian Jean Bony. Nothing is superfluous: the six (almost) identical bays are clearly delineated from the floor to the boss that crowns the vaults. Clarity is the key, and we should treasure it at Chartres all the more because it was so soon squandered. As the German art historian Hans Jantzen points out, elsewhere (in England especially) it became common for a preponderance of detail and an insistence on variety to obscure the 'transparent logic of French cathedral Gothic'.

The nave is illuminated by two tiers of windows on either side and by the rose window of the western façade; if the sun is in the right place, these throw patches of gorgeously coloured light onto the stone floor. But the light is dim at the best of times, because the glass is coloured so deeply: as Rodin says, the predominant blues and reds combine with the natural hue of the stone to create a purple-tinted aura.

The floor itself slopes down by about 80 cm (31 inches) from east to west, apparently an intentional feature that made it easier for the limestone flagstones to be washed down to clear it of the debris

that would accumulate from the many worldly purposes to which
it was put in the Middle Ages: a reminder that this most holy of
places also had functions very much rooted in the quotidian life of
the city.

Nothing good can come out of northern Europe: that was how Giorgio
Vasari saw things in the sixteenth century. The nationalistic Florentine
artist wrote with horror of the destruction of the 'fine arts of Italy'
by the barbaric plunderers who arrived from the murky extremities
of the Roman Empire: the Visigoths, the Ostrogoths, the Vandals. You
can sense him shudder as he relates how, even in more recent times,
the crude manners of the north imposed themselves on the refine-
ment of the Italian peninsula. After Rome's demise, he said, 'those
who practised architecture produced buildings which were totally
lacking in grace, design, and judgement as far as style and proportion
were concerned. And then new architects came along who built for
the barbarians of that time in the kind of style which we nowadays
know as German; they put up various buildings which amuse us
moderns far more than they could have pleased the people of those
days.' Of this 'German' style, Vasari explained that:

> Nowadays it is no longer used by men of ability, but is eschewed because
> it is monstrous and barbaric. It was invented by the Goths after they
> had destroyed the old Classical buildings and the last Classical archi-
> tects had perished in the wars of the *Völkerwanderung*. God preserve
> all countries from this accursed type of building.

Vasari was echoing the prejudice of earlier generations, for in the early
fifteenth century the Florentine architect and sculptor Filarete said of the
Gothic style, 'Cursed be the man who introduced "modern" architec-
ture . . . I believe that it can only have been the barbarians who brought
it to Italy' – by which he meant the *transmontani*, the Germans and French.

The irony is that when Vasari was writing, the Gothic period had
in any case more or less burnt itself out: it had metamorphosed into
an ornate, florid and decadent form that presaged the triumph of style

over substance in late Renaissance mannerism. Yet what Vasari saw as
crude and ugly, we now regard as elegant in its simplicity and honesty.
His xenophobic snobbery is, however, a stark reminder that it is point-
less to shout too loud about what is praiseworthy and beautiful in art,
for in making such evaluations we are always slaves of fashion. Who
can tell whether the seemingly tasteless excesses of Baroque will not
one day come again to be seen as preferable to Chartres' clean and
monumental lines?

Yet Vasari's bad history (and, we might be tempted to add, his poor
judgement) persisted for several hundred years, during which Gothic
became more or less a term of abuse. Its first documented use is in
the mid-fifteenth century by the humanist philosopher Lorenzo Valla;
two hundred years later John Evelyn called it 'a fantastical and licen-
tious manner of building' which produced 'heavy, dark, melancholy,
monkish piles'. Not until the nineteenth century was the Gothic style
seen as having any aesthetic virtue. By then it was too late to throw
away the historical misnomer that awarded the innovations of the
Franks to their German rivals.

Vasari disapproved of just about any building erected between the
fall of Rome and the rise of Florence. How horrified he might have
been, then, to discover that we now link the stolid, gloomy churches
of the early Middle Ages with the glories of Italian antiquity by calling
them Romanesque. This was the predominant building style
throughout Europe until the twelfth century, and the challenge for
architectural historians (who still do not entirely agree about how it
should be met) is to explain how and why Romanesque was trans-
formed into Gothic.

A change of this magnitude could not have happened simply because
of the human urge to innovate. The design of a church was too import-
ant a matter to have been decided by mere artistic experimentation.
But before we explore the possible reasons for this transformation,
we need to see what it entailed: how is the change in style actually
manifested in bricks and mortar? What distinguishes a Romanesque
church from a Gothic one? What are the characteristic features of the
Gothic style? What, in a building like Chartres Cathedral, should we
look for as signifiers of this new architectural thinking?

The Old Manner

One thing is certain: the stunning architectural invention of Chartres did not spring up unheralded. When the Cistercian abbot Bernard of Clairvaux complained in 1124 about 'the measureless height of the houses of prayer, their exaggerated length, their useless width, the amount of stonemasons' work they involve, their paintings which stimulate curiosity and disturb prayer', he was not talking about anything Gothic, but about the improprieties (as he perceived them) of the Romanesque churches of the Cluniac Order, the dominant monastic organization during the previous hundred years. The new choir of the abbey church at Cluny, begun in 1088,* soared to a height of 100 feet (30.5m). By the twelfth century there was nothing new in the idea that an abbey or a cathedral might be made on a monumental scale.

In the first half of the eleventh century, churches tended to have timber ceilings and roofs. But the Cluniacs began to give their buildings stone vaults, constructed on a skeleton of arches. The oldest fully vaulted church still standing is at the Cluniac monastery of Saint-Etienne at Nevers in Burgundy, begun in 1083; but the use of stone vaulting predates that by at least half a century. The introduction of the vault created the concept of a bay: a coherent, repeated and self-contained unit of the building defined by its segmentation with windows and arches. The practice of construction by repetition of bays is apparent in Cistercian churches too. Later we will see how developments in vaulting shaped and modified this 'modular' principle.

The architects of Normandy, a region regarded in Paris as a backwater, were particularly inventive in their interpretations of what we regard as Romanesque, and some of the key features of Gothic were prefigured there. Norman churches have rib vaults dating back at least to 1100, while the pointed arches of both Normandy and Burgundy (the latter evident, for example, in the Romanesque church at Autun) are widely cited as precursors to those of the great cathedrals of the Île-de-France.

* This is the building known as Cluny III. The church went through several incarnations; Cluny III was the most monumental French building of its time, but was destroyed almost completely in the French Revolution.

But to the extent that Romanesque churches look different from Gothic ones, the fundamental reason may be plainly stated. In the former, the stones are there simply to hold the building up. The architecture expresses nothing in itself: it is merely functional. That is how men had always built since antiquity. For all its elegance of proportion and its refined ornamentation, Greek architecture leaves you in no doubt that those massive pillars support immense loads. Gravity dictates the form. That is what the Gothic style changed.

It is in this liberation from gravity, this apparent transformation of stone into something light and airy, that we find the essence of Gothic – and we should let no one obscure that fact with talk of rib vaults, pointed arches and flying buttresses. The distinction is at root one of architectural philosophy. You could say that the task of the Romanesque builders was easy by comparison: their job was merely to erect a building that would not fall down. That is why their walls are thick and their windows – potential weak points in the masonry fabric – are small. The consequent gloom might indeed have encouraged an attitude of veneration and contemplation, but the fact is that the builder's life was simply made easier if he did not carve out great holes in the walls.

That is not to say, of course, that Romanesque builders were unconcerned about artistry, show or elegance. Step inside Vézelay or Durham and you will immediately see otherwise. Indeed, many builders of the Romanesque period gave free rein to their love of ornamentation, as Bernard was to lament. The bare appearance of many of these churches today is due simply to the chastening effect of time, which has stripped away the murals that were painted to instruct and awe the congregation. These literally superficial embellishments made the builder's task less onerous, since there was little need for beautifully jointed stonework when it was only going to be hidden by a layer of painted plaster.

In some ways the Gothic style may be seen not so much as an exaggeration and elaboration of Romanesque features as a simplification of them. St Bernard may have exhibited the killjoy tendencies of a man who cannot hold art and God simultaneously in his heart, but he had a point. For by the early twelfth century the artistic style in sculpture, painting and metalwork had become rather overheated,

unhinged by wild, exuberant flourishes. From 1130, Bernard's austere regimen helped to bring a return to simplicity: the forms became less fanciful, the lines straighter and calmer. It has been suggested that the banishment of ornamentation, and indeed of much representational art, from Cistercian buildings paved the way for the clarity and purity of the constructional principles that characterize early Gothic in general and Chartres in particular.

A Brief Tour of the Medieval Cathedral

Like any other technical discipline, church architecture has its own specialized terminology. But don't be deterred; much of it is familiar from everyday use.

Many (but by no means all) Gothic churches have the cruciform plan established in the Romanesque period, with the long axis running from west to east. According to the twelfth-century theologian and philosopher Honorius of Autun, 'churches made in the form of a cross show how the people of the Church are crucified by this world'. Honorius also explained that 'churches are directed to the East, where the sun rises, because in them the Sun of justice is worshipped and it is foretold that it is in the East that Paradise our home is set'.

The central, wide avenue leading from the west entrance to the crossing point of the arms is called the *nave*, after the Latin *navis*, suggesting the image of the church as a ship. This is flanked by one or two sets of narrower passageways called the *aisles*. Double aisles are separated by rows of columns; at Antwerp Cathedral, there are no fewer than three aisles on either side. The row of arched columns along either side of the nave is called an *arcade*, and it divides the aisles and nave into a series of segments called *bays*. At the western end of the nave there is often an entrance vestibule or interior porch called the *narthex*.

The short arms of the cross, running to the north and south, are called *transepts*, and their intersection with the nave is simply called the *crossing*. Here the four pillars at the corners have the task of anchoring the entire assembly, and they are generally the most

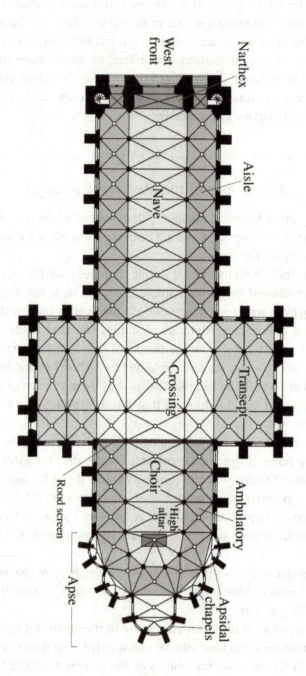

The typical Gothic church plan.

massive uprights in the building, their complex surfaces recalling the ridges and grooves of the trunks of ancient, colossal trees. In some Gothic cathedrals, such as those at Laon and Ely, there is a glazed tower built over the crossing, called a *lantern*, which floods this intersection with light.

Despite the cross symbolism, transepts were not considered an essential component of the church plan; their occasional abandonment was one of the innovations of the Gothic architects. At Sens, often considered the earliest true Gothic cathedral (built in the mid-twelfth century), the present transepts were added only in the fifteenth century. Notre-Dame de Paris has no transepts visible from the outside, where its walls extend unbroken from west to east. And the cathedral of Saint-Étienne at Bourges, built more or less contemporaneously with Chartres (begun c.1195), lacks any hint of transepts; as a result there are few more striking evocations of the cathedral as holy ship. In some cathedrals the transepts seem to have been reserved for the church officials (canons); in others they provided an alternative entry point for the congregation, which might be preferred to the west end if (as at Bordeaux, for instance) that fitted more comfortably with the layout of the town outside.

The region east of the crossing (when there *is* a crossing) is the most sacred part of the building, and was normally out of bounds to lay worshippers: it was often separated from the nave by an arcade called the *rood screen* or *jubé*. This was a robust structure with a platform where a priest could act as an intermediary between the bishop celebrating Mass at the high altar and the congregation in the nave. He might sometimes offer a sermon or read an epistle, or recount the bishop's blessing, the *Jube domine benedicere*, from which the screen gets its name. The jubé was decorated with sculptures, often showing the life of Christ or the Passion, and there would be an altar for the congregation at the foot of the western face. Most rood screens were demolished or removed in the eighteenth and nineteenth centuries. That at Chartres, installed around 1230 by the donation of King Louis IX, was destroyed in 1763; and if the central passage is as a result somewhat less authentic,

it is nevertheless more unified. An unhappy liturgical necessity, screens were common elsewhere in the church, especially around the choir. Made of stone, wood or metal, they were generally decorated with great care and skill, but they tended to clutter the articulation of space that the master builder worked so hard to achieve.

Beyond the dividing line of the jubé (which might be placed either at the eastern or the western edge of the crossing) is the *choir*, the centre of worship. It was here that the high altar stood; the space in front of it is the *sanctuary*. There was sometimes a second screen separating the choir stalls, where the canons worshipped, from the sanctuary itself, where the bishop conducted Mass. The eastward extension, beyond the crossing, of the aisles of the nave is called the *ambulatory*, a passageway that circulates around the choir and is separated from it by columns, and often also by the *choir screen* erected between the pillars. Many of these choir screens were removed from churches in the eighteenth century and replaced with rather plain iron grilles.

At the very eastern end of the church, in the semicircular tip called the *apse*, several small enclosures (*radiating* or *apsidal chapels*) may bud out from the ambulatory. These may be little more than semicircular alcoves, or they may be small chambers in their own right. Often each was dedicated to a particular saint or martyr, and pilgrims were sometimes allowed access to the tombs that the chapels housed. The ambulatory and chapels became common in Romanesque churches around the beginning of the twelfth century, partly because of the increased prevalence of processions around the building. Cistercian churches, rejecting such ceremonies, terminated the eastern end of the building with an uncompromising blank wall against which the altar stood. (English Gothic churches too commonly end with a flat rather than curved eastern end.) Many Gothic churches have a substantial chamber in the apse called the Lady Chapel, which may be an entirely separate building connected to the ambulatory by a passage or a doorway. The apse and chapels are alternatively known as the *chevet*.

Those are the elements of a cathedral plan. Let's now look at the vertical components, called the *elevation*. The columns on which

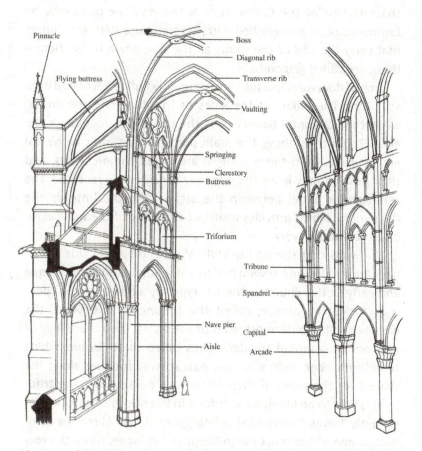

Pinnacle

Flying buttress

Boss

Diagonal rib

Transverse rib

Vaulting

Springing

Clerestory
Buttress

Triforium

Tribune

Spandrel

Nave pier

Capital

Aisle

Arcade

Elements of the Gothic elevation, both with (*right*) and without (*left*) a tribune.

arches and vaults rest are called *piers*; the ceilings that cover the nave, aisles, choir and ambulatory in a complex web of arches are the *vaulting*. The base of each pier is typically a massive, decorated pedestal, while the block at the top, often ornately carved, that receives the vault arches is called a *capital*. The point at which the arches of the vaults alight onto the pier tops is called the *springing*. Gothic vaults are distinguished by their skeletal framework, defined by raised *ribs*; at the central crossing point of the ribs there is generally a round, carved element called the *boss*. A

characteristic of the Gothic style is the way the piers may be composed of, or embellished with, several more slender columns that carry the ribs of the vaults all the way down to the floor – these are called *responds*.

Arched doorways (*portals*) are commonly highly decorated with sculpture. The pillars at the sides of the doors are the *jambs*, while the horizontal beam across the top of the doorway is the *lintel*. The arches above the main portals in a Gothic cathedral are typically multi-tiered – these are called the *archivolts*, and their nesting may leave the doorway considerably recessed. The semicircular panel between the arches and the lintel is the *tympanum*, which provides a surface for some of the most elaborate sculptural work.

The walls that rise up like cliffs of glass on either side of the nave are divided into several horizontal segments. In Romanesque and early Gothic churches there is typically a lower row of openings above the arcade, called the *tribune*, that exposes the windows in the outermost walls of the aisles. Then there may or may not be a row of smaller arches called the *triforium*, which sometimes open onto a narrow passageway running along the space over the aisles. If there is no such passageway, the triforium is said to be blind; some triforia in later Gothic churches (for example, Troyes, Tours and Strasbourg) are glazed. Above the triforium is one of the most magnificent of Gothic features: the row of huge windows called the *clerestory*. Tall, thin windows with arched tops are called *lancets*, while the round windows that sometimes sit above the lancet points are called *roses*. Magnificent, immense rose windows are often situated at the western end of the nave and in the transepts.

The four-storey elevation – main arcade, tribune, triforium and clerestory – was used in several Romanesque churches from the early twelfth century, such as Tournai (begun around 1135) and Saint-Donatien at Bruges (begun around 1130, and now destroyed). It was given its first Gothic incarnation at Cambrai around 1150, and is seen also at Laon (around 1165–75) and Noyon (around 1160–85). The technical innovations introduced at the

end of the century allowed the builders of Chartres to do away with the tribune altogether, and the resulting three-tiered elevation became the standard design for the later great Gothic cathedrals.

Outside the church, ribs of stone jut out from the walls to strengthen them – these are the buttresses, or more precisely the *pier buttresses*. In Gothic buildings some of these pier buttresses stand separate from the walls but are connected to them at the top via arches, called *flying buttresses*. We will look in Chapter 8 at the function of buttressing in supporting the building. While it would be wrong to suggest that architects did not worry about the appearance of all this external scaffolding, it is true that a church was designed to be experienced from the inside: the primary concern was the organization and articulation of the enclosed space. On the outside, according to John Ruskin, you are on 'the wrong side of the stuff, in which you find out how the threads go that produce the inside, or right side, pattern'.

This profusion of features seems confusing at first. But they are not arbitrary. While we will see that they are nearly all anticipated in the churches that predate the Gothic era, the Gothic architects did not simply accumulate them as a way of filling space (although there was a lot of it to fill). The key feature of Gothic is the way that these elements are woven together to create a space that is unified and intelligible. It is, indeed, the principal achievement of the Gothic builders that they were able to incorporate elements from diverse sources, with many different architectural functions, into a single scheme that comes closer than any other in the history of Christian churches to convincing us that heaven has been embodied on earth.

The Transformation of Saint-Denis

The Île-de-France never had a particularly strong Romanesque tradition, which is one of the reasons why the Gothic style was able to

establish itself there: people did not have strong preconceptions about how a church ought to look. So when the Benedictine monk Suger became abbot of the church of Saint-Denis in 1122, just a few miles north of Paris (today it is a down-at-heel suburb), and saw that it was in urgent need of repair and reconstruction, he was not obliged to heed any template.

The abbey church of Saint-Denis was to the kingdom of France what Westminster Abbey is to England and the basilica of St Peter's to Rome. It had been the royal abbey since Charlemagne's grandson Charles the Bald became lay abbot in 867, and as such it was the spiritual heart of the state. It marked the burial site of St Denis, the apostle of France, who was believed to be one of seven bishops sent to evangelize in Gaul by St Peter himself. The fifth-century basilica received generous donations from the Merovingian king Dagobert I (628–38), who became the first of many Frankish kings to be buried there. The ties with the throne of France were secured by the Capetians in the tenth century; today the church and its crypt are filled with the tombs and effigies of the French monarchs.

And yet the church that Suger came to regard as his own was in a sorry state – a symbol of the condition of the monastic order that was supposed to maintain it. There were cracks in the walls, and the towers were damaged. The treasures and relics that Saint-Denis had accumulated – including those of the saint himself, the holy protector of the nation – were either lost or, as Suger himself said, 'mouldering away'. Around the church itself, outbuildings stood empty and crumbling. And it was plain to Suger that the monks had grown lax and had lost sight of their holy mission. The famous French scholar Peter Abelard, who took his holy vows at Saint-Denis in the early 1120s, called the abbey 'completely worldly and depraved', and condemned the previous abbot, Adam, as 'evil-living' while his monks indulged in a 'disgraceful way of life and scandalous practices'. Abelard was prone to exaggeration, but he was not alone in his low opinion of Saint-Denis; Bernard of Clairvaux complained that the abbey cloister was always filled with knights, tradesmen, prostitutes and rabble of all kinds.

In the 1120s Suger set out to reform the Benedictine Order at Saint-Denis, and he was so successful that he won praise even from Bernard,

whose standards were high indeed.* The two men would remain cordial throughout their lives – one might almost call it a friendship, albeit one that was frequently tested. But some strain in the relationship is hardly surprising, for Suger was a very different man from Bernard, and they had rather divergent beliefs about what a church should be.

While Bernard appears to be a model of the cold, austere medieval ascetic, Suger is too human to be contained by any stereotype. He has tended to emerge as one of the most vivid and personable figures of the Middle Ages, a man who one feels would have left his mark on any age, who combined vivacity with wry political sensibility, who possessed both the desire and the ability to achieve greatness. This appealing portrait, which owes much to the historian Erwin Panofsky, has been blurred by more recent scrutiny, but there seems little question that Suger was an adept and energetic statesman in a time when princes, kings and popes often owed their positions more to heredity or wiliness than to any qualities of leadership. When Suger is vain, his pride is so ingenuous that we forgive it. When he is expedient, we see that he is motivated by good intentions. When he grasps power, we understand that he does so not for his own sake (even if he is nevertheless quite prepared to enjoy it). Abbot Suger was precisely the sort of man who could spark a revolution in the way churches looked. He was, according to his secretary and first biographer, the abbey librarian Willelmus, 'capable of governing the universe'.

Suger has been presented as the classic self-made man, although it seems likely that hagiography and calculated distortion have contributed to this image. Calling himself a 'beggar, whom the strong hand of the Lord has lifted up from the dunghill', he was actually from a family of minor knights. Not rich and powerful, but hardly of lowly stock either, they owned land in the Oise valley at Chennevières-les-Louvres. Willelmus was keen to play up the rags-

* A letter of 1127 from Bernard to Suger is stern and congratulatory at the same time, implying that Suger's earlier conduct had been widely deplored: 'It was at your errors, not at those of your monks, that the zeal of the saintly aimed its criticism. It was by your excesses, not by theirs, that they were incensed.' The rumours that had been circulating about Suger's lax standards were in fact quite possibly instigated by Bernard himself. The laudatory tone of his later correspondence may have been motivated partly by pragmatism, owing something to Bernard's wish to make Suger an ally in his campaign against the royal adviser Stephen de Garlande (see below).

to-riches tale in his biography, adding for good measure that his former master was physically unremarkable too: 'allotted a short and spare body', a 'weak little frame'. Simon Chièvre d'Or, canon regular of Saint-Victor, built on the romantic image: 'small of body and family, constrained by twofold smallness, he refused, in his smallness, to be a small man'.

'He excelled', Panofsky claimed, 'at being human' – and one suspects that Suger's humanity sometimes compromised his piety: he was too enamoured of this world to be preoccupied with the next. Debates about scholarly theology, like those that Abelard provoked at Saint-Denis, weren't terribly interesting to him. He was more concerned simply that men should not argue or condemn one another too stridently. Not for Suger the hair shirt and flagellant's cell; he saw no reason why men and women could not follow their faith in a little comfort. Moderation was preferable to self-denial: his food, it was said, was 'neither very exquisite nor very coarse'.

Another component of the Suger myth is the story of the prince and the pauper. As a boy of ten, in 1090 he was given by his family to the monastery of Saint-Denis as an oblate – a person whose life is dedicated to the institution. It seems a harsh fate, but Suger felt nurtured at Saint-Denis, which he often called his 'mother'. It has long been believed that at the abbey school at l'Estrée he befriended a lad who turned out to be the future king of France, Louis VI. This, as the story goes, accounts for his later influence at the royal court. But in fact Louis left the tuition of the abbey school just two years after Suger began his life there; and during that time Louis would probably have had a private tutor rather than mingle with the other boys.

Suger did indeed become the king's closest adviser, but that did not happen until around 1130, after Louis VI's former chief minister Stephen de Garlande fell out of favour. Suger was more careful than his predecessor – he kept his position as royal adviser until his death in 1151, maintaining it under the king's successor Louis VII. To call Louis VI his friend is probably going too far; but if Suger's biography of the king is not entirely flattering (the title, *The Life of Louis the Fat*, gives some indication of that), it does betray a certain affection for this somewhat indolent monarch. He seems still less impressed with Louis VII, and their relationship, while respectful, was rather cool.

Suger held tremendous power and influence over the French

monarchy. He was generally a voice of moderation and reason, his instinct always being to seek conciliation and negotiation before recourse to arms. This was not just a sign of an irenic nature. Intensely patriotic, Suger was determined that the House of France should play a dominant role in the affairs of Christendom, and he felt this was more likely to happen by talking to people than by conquering them.

That is why Suger worked hard to reconcile the French kings with the papacy, whose expectation of obeisance often rankled with the northern Europeans. An alliance with Rome put the French in a stronger position against their mutual rival in Europe, the German Holy Roman Emperor Henry V, who came to the brink of invading France in 1124 until Louis VI mustered a force that faced him down. Suger urged the king to make peace with Henry I, king of England and duke of Normandy,* and also with the troublesome Thibaut IV, prince of Blois and Chartres, Henry's nephew. He recognized the political expediency of Louis VII's marriage to Eleanor of Aquitaine, and persuaded the king not to pursue the divorce that he desired. (Louis went ahead with it the year after Suger died.)

The trust that the French kings placed in Suger was not just on account of the soundness of his advice. During the 1110s he proved himself to be a strong military leader in the conflict with Thibaut. Indeed, Louis VI's fury on hearing of Suger's election as abbot of Saint-Denis was probably not just because the king had not been consulted over the decision but also because he was unhappy about losing such a valued commander. That a cleric could also be a man of war was one of the curious paradoxes of the time.† This man of action was the natural choice as regent of France while Louis VII was absent on the Second Crusade in 1147.

* All the same, Suger had preconceptions about the natural hierarchy, among them the conviction that the English were 'destined by moral and natural law to be subjected to the French, and not contrariwise'. The Norman duchy, he reasoned, was a mere fief from the kings of France, so the duke and his subjects owed allegiance to the Capetians.
† Even then its propriety was questioned, however. One reason why Bernard objected to Stephen de Garlande's position at the royal court was that Stephen, a cleric, was also royal seneschal, the nominal head of the French army. It is ironic, then, that Bernard sought to enlist Suger's help in opposing this arrangement.

Suger's plans for Saint-Denis were part of his vision for the glorification of France. Its state church, he felt, should be a building more splendid than any other, a jewelled casket fit to receive the French kings as well as to celebrate and honour God. And if this marvellous edifice also happened to earn some credit for its abbot, well, so be it.

What Suger achieved with the abbey church is a testament to his boundless creativity and energy, which led him to manage the project with all the dedication, persistence and indeed obsession (if none of the psychoses) of Dean Jocelyn, the protagonist in William Golding's novel *The Spire*. We can imagine him mingling with the masons and carpenters, diverting them from their business by asking the names of their contraptions and devices. Suger went himself to supervise the preparation and transport of stone from a quarry near Pontoise, where he heard the ox-drivers complain that, because bad weather had driven the quarrymen away, they had nothing to do. No labourer could afford to be complacent while Suger was around. On asking for some very long wooden beams for the new west roof of the church, he was told that there were no trees big enough in the forests nearby, and that he'd have to go all the way to Auxerre, at considerable cost and inconvenience, to find them. One can easily imagine the builders shaking their heads behind the abbot's back, despairing (in the way that builders have always made their speciality) at how he would insist on intervening in matters about which he knew nothing. But Suger would not relent:

On a certain night, when I had returned from celebrating Matins, I began to think in bed that I myself should go through all the forests in these parts . . . Quickly disposing of other duties and hurrying up in the early morning, we hastened with our carpenters, and with the measurements of the beams, to the forest called Iveline. When we traversed our possession in the Valley of Chevreuse we summoned through our servants the keepers of our own forests as well as those who knew about the other woods, and questioned them under oath whether we could find there, no matter with how much trouble, any timbers of that measure. At this they smiled, or rather would have laughed at us if they dared; they wondered whether we were quite ignorant of the fact that nothing of the kind could be found in the entire region . . . We, however – scorning whatever they might say – began, with the courage of our faith as it were, to search through the woods; and toward the

first hour we had found one timber adequate to the measure. Why say more? By the ninth hour or sooner we had, through the thickets, the depths of the forests and the dense, thorny tangles, marked down twelve timbers (for so many were necessary) to the astonishment of all.

Panofsky was surely right in this respect: it is Suger's humanity that prompted him not only to hitch up his abbot's robe and tread through the thorns but to record the event with a freshness that evokes the scene so compellingly. And it is this readiness to engage with the most mundane, material aspects of the construction, at the same time as he plots the political ramifications and charts the spiritual philosophy of the project, that marks out Suger as a truly remarkable man. When he stipulates that the inscription made on the consecration of the new church in 1144 should end with the boast 'I, who was Suger, being the leader while it was being accomplished', we can hardly deny him that touch of self-aggrandizement.

Quick Work

Although we can still delight today in the spaciousness and luminosity of Suger's (or rather, his architect's) vision, we can experience only a part of the impact his new abbey church must have made in the mid-twelfth century. The church is now a mere skeleton, swept and scraped clean of its rich textures and fabrics: gone are the painted and gilded statues, the bejewelled golden altar, the wall hangings that made Saint-Denis an Aladdin's cave of gaudy colour and opulence. Ever a man of the world, Suger recognized that such spectacle and display would captivate the common people, leaving them suitably awestruck by God's palace.

This was architecture with an agenda, as much political as spiritual. Even the apparently straightforward representation of Old Testament kings, queens and prophets as column statues flanking the main entrance*

* The statues are no longer there – they were removed in 1771, and only a few fragments survive. But drawings of them in Dom Bernard de Montfaucon's *Monuments of the French Monarchy* (1729) show us what the visitor to Saint-Denis saw on the threshold of the abbey in the Middle Ages.

(which prefigure and provide the prototypes for those at Chartres) were intended to imply a link between these biblical rulers and the monarchs of Suger's contemporary France, legitimizing the idea that it was France, not Germany, that was the true spiritual home of Christianity in the West. To emphasize the point, one new window of the abbey depicted Charlemagne, a Frank (even if his court was at Aachen).

Suger wanted the church to be reconstructed from floor to spire. But the abbey officials baulked at his grand plans, and all he was able to build in his lifetime was a new west end, narthex and choir. The nave was not remade until the thirteenth century, which is why it is unambiguously Gothic. Suger argued that not only was the old building in bad repair but its importance to the kingdom meant that it was now too small to serve the function required of it. 'Often on feast days,' he said, 'completely filled, it disgorged through all its doors the excess of the crowds as they moved in opposite directions, and the outward pressure of the foremost ones not only prevented those attempting to enter from entering but also expelled those who had already entered.' One suspects a little exaggeration, however, when he claims that 'the narrowness of the place forced the women to run to the altar upon the heads of the men as upon a pavement with much anguish and noisy confusion'.

The initial reconstruction of Saint-Denis proceeded at an extraordinary pace, for which again Suger must no doubt take much of the credit. 'For three years we pressed the completion of the work at great expense', he says, 'with a numerous crowd of workmen, summer and winter, lest God have just cause to complain of us: Thine eyes did see my substance yet being imperfect.' In fact the work spanned the years from 1137 to 1144, which was still extremely fast for such a monumental undertaking. Initially focused on the western façade, the rebuilding became more innovative with the reconstruction of the choir after 1140. In the ambulatory there is hardly any wall to be seen; the vaults are supported by surprisingly slim columns, while the windows reach almost to the floor, creating what Suger called a 'crown of light'. The ambulatory is double, having two walkways separated by pillars; this was made possible simply by removing the walls between the apsidal chapels, and it facilitated the circulation of pilgrims who came to see the relics.

That Suger's architect is unknown is a rather shameful thing. The

abbot wrote three commentaries on the building work, and yet, while he was involved in practical matters to an unusual degree, it did not seem to occur to him to mention the man who was responsible for designing the new church. This, says the English historian Peter Kidson, 'betrays the complacency of the great patron who knows exactly what he wants and does not care how it is done'. It is tempting to wonder whether Suger did not wish to share the credit for the work. His silence on the matter has served him well in posterity, for some have spoken implausibly of Suger himself as the inventor of the Gothic style. Kidson puts that notion firmly in its place: the rebuilding of Saint-Denis, he says, shows 'a powerful mind at work, thinking imaginatively about architectural problems and working out subtle and effective solutions. That mind was not Suger's.' Perhaps Suger really did not view the architect's job as significant – he would not have been alone among patrons or clerics in that regard, as we shall see. But 'whether he knew it or not', says Kidson, 'Suger employed an architect of genius'.

This forgotten man was eclectic in his composition. He took rib vaulting from Normandy and pointed arches from Burgundy (Suger himself knew both places well). The cylindrical columns speak of ancient Rome, as does the triple portal of the west front, which echoes the triumphal arch of Constantine (Suger claimed that these three doors symbolized the Trinity). One of the most striking innovations was the west rose window that opens up the wall between the twin towers.

Suger may have actually envisaged something far more conventional and conservative – his aim was after all to reassert the glory of France, not to reinvent it. And yet in what may have been a happy confluence of ideas, the integration of these elements achieved by Suger's architect seems wholly consonant with the classical rhetorical skills of *variatio* – the use of variety – and *aemulatio*, the adaptation of an old model for the purpose of fashioning something new, which would have resonated with Suger's desire to express a link between the French kings and those of ancient times. And, while allowing that the true originality of Saint-Denis is hard to gauge when so many of the other churches built in Capetian France in the first half of the twelfth century have been destroyed or rebuilt (or are simply less well dated), it is hard now to contemplate how Notre-Dame de Paris or

Chartres might have come into being were it not for the breakthroughs achieved at the royal abbey.

The new style evident* (particularly in the lambent choir) at Saint-Denis must have exerted a strong influence, for Suger surely employed many of the most skilled craftsmen of northern Europe, who would have taken the fresh ideas away with them. What is more, the abbot of course made sure that everyone knew about his new church. The ceremony of consecration on 11 June 1144 was as characteristically lavish as the building it celebrated: Louis VII came with his queen Eleanor, along with the queen mother and archbishops from far and wide – Reims, Rouen, Bordeaux, Canterbury, Chartres (where Geoffrey of Lèves was bishop), Orléans and Senlis, among others. Even Thibaut of Blois and Chartres took up Suger's invitation. All of them had their eyes opened to what a church might be. 'Of the diverse counts and nobles from many regions and dominions, of the ordinary troops of knights and soldiers there is no count', Suger boasted. The common people flocked to see this imposing retinue, and so great was the crush that when a chorus of pontiffs sprinkled the holy water onto the outside walls, 'the King himself and his officials with canes and sticks kept back the tumultuous impact and protected those returning to the doors'.

Saint-Denis was not to everyone's taste; some saw Suger's love of precious materials and gorgeous display as vulgar. For Bernard of Clairvaux it must have bordered on the profane, a throwback to the excesses that he condemned in the abbeys of the Cluniacs. As he explained apropos of the Cistercians in his *Apologia* of 1124, addressed to William of St Thierry, 'We who have turned aside from society, relinquishing for Christ's sake all the precious and beautiful things in the world, its wondrous light and colour, its sweet sounds and odours,

* Appreciating the design of Suger's architect is complicated for us today, however, by the later remodelling of the other parts of the building. The upper parts of the choir were rebuilt by Pierre de Montreuil in the thirteenth century, and he also began the transepts and eastern nave, now joined awkwardly to the narrower choir. The nave was completed in 1281, but further tampering inside and outside the building continued throughout the centuries, culminating in a disastrous renovation in the nineteenth century which so destabilized the north tower of the west façade that it had to be taken down. The accretion of mismatched tombs, columns, windows and chapels serves as a reminder of how much we have to be thankful for at Chartres.

the pleasures of taste and touch, for us all bodily delights are nothing but dung.' He objected to such splendours for the same reason that Thomas Aquinas advised against instrumental music during the liturgy: it 'moves the soul rather to delight than to a good interior disposition'. In churches attended by the laity, Bernard admitted, such finery might be justified to appeal to their baser instincts: 'since the devotion of the carnal populace cannot be incited by spiritual ornaments it is necessary to employ material ones'. But an abbey or monastic church should be devoid of such trinkets.

There is no record of any direct attack from Bernard on Saint-Denis, but it would surely have fallen within the remit of his earlier criticisms of church ostentation, such as that made in his *Apologia*:

> . . . what is the good, among poor people like yourselves – if, that is, you are truly poor – of all the gold that glitters in your churches? You display the status of a saint, male or female, and you think that the more overloaded with colours it is, the holier it is . . . Likewise in the churches, it is not crowns that are hung from the ceiling but wheels covered with pearls, surrounded by lamps, encrusted with precious stones which gleam more brightly than the lamps . . . Oh vanity! Vanity! And folly even greater than the vanity! The church sparkles and gleams on all sides, while its poor huddle in need; its stones are gilded, while its children go unclad; in it the art lovers find enough to satisfy their curiosity, while the poor there find nothing to relieve their misery.

Suger's little book on the consecration of his church can be read in part as a pre-emptive response to such charges. Yet that text is also an expression of immense pride in his creation. There was no question in his mind that the church was indeed 'his', and he added many reminders to that effect: the building houses four likenesses of Suger, along with thirteen inscriptions in his honour. The abbot of Saint-Denis would press visitors to admit that it was the most wonderful church in the world. If they declined to agree, he would merrily quote St Paul – 'Let every man abound in his own sense' – which was no doubt less an acceptance of 'each to his own' than a polite way of implying that not everyone had the clear sense of Abbot Suger.

Parallel Lines

At the same time that Saint-Denis was being reinvented, a similar
process was underway at the cathedral of Saint-Étienne at Sens in
Burgundy. The original building was damaged by fire in 1128, but
the reconstruction did not begin in earnest before at least 1140, and
perhaps not before Saint-Denis was consecrated. So the claim some-
times made that Suger borrowed ideas from Sens does not really
stand up, although it is possible that both works informed one another.
It is curious that Sens, although generally regarded as the first of the
true Gothic cathedrals, has never been awarded a status comparable
to that of Saint-Denis in establishing the new style. Perhaps that has
something to do with the fact that there is no personality attached
to it, no lively record or enchanting stories of the sort that Suger left,
no hint of an attendant philosophy. But the evidence at Sens and else-
where shows that Gothic did not crystallize in a single building, but
was already by the 1140s starting to percolate through the kingdom
of France.

At a glance Sens looks Gothic, but it is revealing to compare it with
the cathedral of St Julien at Le Mans, where the clerestory of the nave
was rebuilt, and the old flat roof replaced by stone vaults, after a fire
in 1137. Le Mans is clearly still Romanesque* – the round-arched nave
windows are small and those of the new clerestory still modest; but it
is not hard to see it as the precursor of Sens, for all that the height of
the latter has grown, the windows have lengthened and the arches
become pointed. The architecture of Sens is plain (St Bernard would
have found little to object to), and light is not at the forefront of the
builders' considerations, but the trend is clear enough – for there is still
a solidity to Le Mans, while at Sens the walls are thinner and one has
the impression that the massiness of the stone is starting to disappear.
Here begins the Gothic builders' 'incessant war against weight', as
Jantzen puts it, a campaign that progressed at Noyons (begun in the
late 1150s), Laon (started 1160) and Soissons (c.1177) before culminating
at Chartres.

* The unambiguously Gothic choir is thirteenth-century.

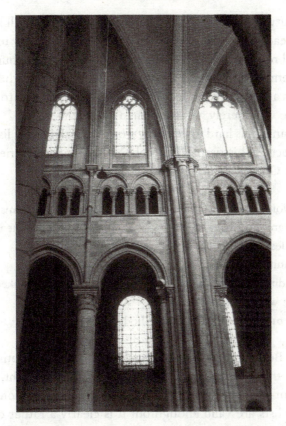

The nave elevation of Sens cathedral, the construction of which began in the 1140s. (Note that the clerestory was remodelled in the thirteenth century.)

So What is Gothic?

Inevitably, the nascent Gothic style produced a cluster of mid-twelfth-century buildings that have an ambiguous, transitional status, still constrained by Romanesque ideas – the cathedral of Saint-Maurice at Angers is one such. Others, being partially reconstructed, became mixtures of old and new, with varying degrees of success. But more contentious than the inevitably arbitrary game of putting these buildings into boxes marked 'Gothic' or 'Romanesque' is the question of what, precisely, identifies a church as Gothic.

The architectural engineer focuses on elements such as the pointed arch, the use of rib vaulting in ceiling structures, and the external flying buttresses that push against the walls and stop them from

bursting outwards under the pressure of the vaults. I shall look more closely at each of these elements later, in particular to reveal their mechanical roles in aiding construction and holding the buildings up. The problem in using them as labelling devices is that they all have pre-Gothic antecedents; it seems a little unsatisfactory to conclude that Gothic was merely an assemblage of older forms.

All the same, it is hard to get away from some degree of list-making. The architectural historian Christopher Wilson offers a series of 'basic features of Gothic', which include:

- a cruciform plan, with the nave longer than the other arms
- a nave and possibly other arms built to the basilican scheme, with side aisles
- arch vaulting
- longitudinal divisions of the arms into bays defined by linked arches
- an apse with radiating chapels
- one or more towers in the main body of the church.

To Jean Bony, meanwhile, the 'technical bases' of Gothic are the rib vault, the pointed arch, the insistence on height, and the thinning-out and 'skeletonization' of the structural masonry. Again, both these lists are valid enough but it is clearly a rather depressing exercise to tick off the boxes like a roster of entry requirements. And where do you stop? It seems fair to say that, along with the pointed arch and rib vaulting, the soaring Gothic style would not have been mechanically possible without, say, the compound pier (a column composed of a bundle of shafts, each of which serves a different architectural role at the top) and the external flying buttress. But these are enabling devices, not principles of design: as historian Otto von Simson insists, such things are merely constructive entities and not artistic ones.

So the art historian tends instead to pose questions of intention and interpretation. When we look at a Gothic building, what are we seeing? Is it a style based on elevation and upward motion? Is it a skeletal form in which the walls are reduced to transparent membranes? Or is light itself the central concept of Gothic architecture?

Certainly, one can argue that there is a distinct urge towards *unity*: that the Gothic cathedral is a place to be experienced all at once. This

is reflected in the way that, relative to earlier designs, the ambulatory of Gothic churches seems to be an extension of the aisles of the nave, barely interrupted by the transepts. But Hans Jantzen argues that the central concept is not in the *plan* but in the *elevation*:

> In the Gothic nave wall there is no hint of load bearing. All its characteristics are essentially vertical. The vault is not felt as something heavy, hardly indeed as a cover, but simply as the place towards which the lines of upward thrust converge.

Gothic is then a kind of flight – indeed, at Beauvais Cathedral, which collapsed twice, it has been called an 'Icarus flight'. Wilhelm Worringer coined a suitably Dionysian phrase for this upward tendency: vertical ecstasy.

But Jantzen has no time for the idea that the opening-up of space has some underpinning in a metaphysics of light, which he dismisses as purely 'of the mind' and thus not something to conjure from stone and glass. For him the underlying principle of Gothic is the 'diaphanous structure' of the walls – a very felicitous coining. They are not really walls at all, Jantzen argues, in that they 'reject the characteristic of continuous mass' and are instead a kind of projection of space:

> The entire expanse of wall is set against a background of space, which is either in darkness or consists of coloured light, so that the nave of the Gothic cathedral appears to be enclosed in an envelope of space . . . The nave wall looks like a latticework placed in front of an envelope of space.

In other words, the wall is not even merely 'porous', as von Simson claims – rather, it is not actually a wall at all, but a fence of struts that hold membranes of coloured light. Curving around the ambulatory of Saint-Denis, this fence becomes a tenuous shell, a kind of holy cockpit.

To the influential German art historian Paul Frankl, Gothic began with the rib vault, from which, he asserts, every other innovation followed inevitably. According to Frankl, ribs on the diagonals of vaults impose a 'diagonality' elsewhere – in particular, they force piers of square cross-section to be aligned with their diagonals rather than

their faces along the compass directions. The rib vault, he says, 'proposed a general sense of direction, leading to a goal which could not be foretold, but could only be realized through a strict adherence to this direction'. This is a deterministic view that regards the Gothic style as something immanent in its earliest stages, but which could be realized only as the builders worked through 'a chain of creations' to find out where it led. The architects needed to experiment with a range of forms and structures, each proceeding from the previous one, until they discovered for themselves what the Gothic style dictated.

This view of history as somehow preordained is rather old-fashioned, harking back to Hegel (some critics felt that Frankl's tome *Gothic Architecture*, published in the 1960s, read as though written four decades earlier). And Frankl's theory illustrates one of the great dangers of art-historical interpretation: his was the perspective of the critic who enjoys his own good taste too much to be concerned about what the builders themselves actually thought and did. Indeed, Frankl felt justified in judging their achievements according to his own concept of an 'ideal' Gothic, as though marking an exam paper. For him the question is simply how close each building comes to manifesting this ideal, which apparently exists in some abstract aesthetic space. Thus he speaks of cathedrals as 'corrections' of other cathedrals: 'Reims was a correction of Chartres: Le Mans is a correction of Bourges.' Somewhat disturbingly, this Hegelian perspective leads Frankl to speak about a 'final solution' – which was to be found, moreover, not in France but in Germany. If you are (like him) sensitive enough to form, Frankl says, you can understand church architecture without any knowledge of its historical context: a visitor to a Cistercian church 'who understands the language of stone' will be aware of Cistercian culture 'without literary proof'. It is the artistic snobbery of Michelangelo all over again – either you've got it or you haven't. Considerations of masonry techniques or ecclesiastical economics would have been not merely uninteresting to Frankl, but unbearable.

But Frankl is an extreme case, and such cases have a value in establishing poles of opinion. If nothing else, Frankl (who cannot be bettered for his first-hand knowledge of Gothic buildings) demonstrates how dogmatic the debate about the 'meaning of Gothic' has been inclined to become. In some art-historical discussion one senses

a near-desperation to grasp that meaning, the elusiveness of which only hardens the resolve and the certainty of the commentator.

Needless to say, Gothic in any event 'means' different things in different places. Spanish Gothic churches seem hardly to be of the same species as those in Poland, while Venice claims a brand of 'Venetian Gothic' in its canal façades that nowhere but the lagoon city could have produced. Bony asserts that Gothic building was not a homogeneous or even an incrementally changing enterprise, but has two main eras: from the beginning of the construction of Saint-Denis until the late thirteenth century it was primarily a French movement, whereas after that the rest of Europe responded with its own interpretations.

There is of course no more reason to expect to find a definitive interpretation of the Gothic style than of any other artistic movement or great work of art. We needn't be too concerned about that. The defining frameworks that have been proposed should, like all art criticism, simply be used to assist us in seeing what is there, in identifying connections and characters and perspectives. This is especially true of medieval architecture, which emerged from the work of many individuals, often anonymously, and for which it is hard to make attributions for the creative impulse. The real point is that, as Frankl says, 'in the regions where the Gothic style was born and developed, "building in the Gothic style" was simply called building'.

3

Heaven on Earth

What is a Cathedral?

To understand the meaning of a Gothic church, one must understand both the meaning of religion and, more especially, the meaning of the Christian religion during the age of Gothic architecture.

Paul Frankl, *Gothic Architecture*, 2000

Architecture has always had something significant to say about the time and place in which it originated.

Hans Jantzen, *High Gothic*, 1984

The Elevation

The nave walls at Laon, Notre-Dame de Paris, Chartres, Reims and Amiens do not, at a glance, look so very different from one another. Each is divided into bays by massive piers; in each of them, pointed wall arches lead into side aisles; and they all feature relatively large, luminous clerestories in place of the small, mean, high windows of the Romanesque churches. But look closely, and the differences appear. Over the arcades of Laon and Paris (which predate the other three) there are tribune galleries which admit additional light into the nave from windows set behind their arches. And at Laon a fourth tier is interposed between the tribune and the clerestory: the triforium. At Chartres and its successors, the tribune is no longer there. Between the arcade arches and the clerestory there is only a triforium opening onto a narrow passageway. Yet illumination is not sacrificed, for the lancets of the clerestory reach down almost to the level of the aisles.

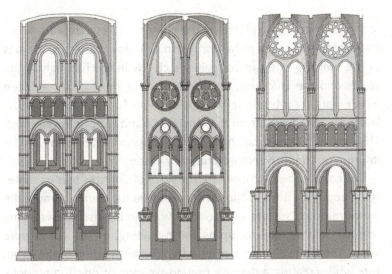

The elevation of bays in the nave walls of Laon (*left*), Notre-Dame de Paris (*centre*) and Chartres (*right*) shows the evolution of the Gothic façade. Laon and Notre Dame both contain a tribune level, and Laon has a four-tiered structure that includes a triforium. But by the time Chartres was built, it was possible to dispense with the tribune and to make the windows of the clerestory even bigger.

It was at Laon and Noyon in the mid-twelfth century that the triforium was formalized as a continuous series of small arches that filled the 'dead' space between the tribune and the clerestory, giving the classic four-storey elevation of early Gothic. But by the end of the century, new means of supporting the nave walls meant that the tribune was no longer needed. It was abandoned at much the same time at Soissons and Chartres, making the clerestory almost as high as the arcade. One can argue about whether Chartres quotes Soissons in this respect or vice versa; either way, the three-storey elevation became the standard design for Gothic churches. It was, like everything else about Chartres, both a simplification and a unification, making each bay of the elevation a coherent structural element that echoed the logic of the whole building.

This unity was emphasized in striking fashion by the way the walls were painted. For the interior stonework of many medieval churches was covered from top to bottom in a layer of paint, applied

to a fresh coat of thin plaster in the manner of fresco murals. A few traces of this so-called polychromy remain today at Chartres in parts of the building one can scarcely see clearly in the half-light – the vaults and the triforium, for example – but most of it has been either worn (or intentionally stripped) away to bare stone or over-laid with paint layers from the nineteenth and twentieth centuries. This means that we can have only an approximate notion of the impression the architecture originally made.

The colour scheme chosen for the walls of Chartres tells us some-thing about the aims of those who designed the church. Almost the entire masonry surface was covered with an intense yellow ochre, relieved only by some columns and mouldings picked out in pure white. The white elements emphasized the articulation of the struc-ture while creating a delicate pseudo-skeleton of ribs, too tenuous in itself to carry the weight of the stones around it. There is no doubt, then, that this paintwork is not mere decoration but is deliberately 'architectural', both reinforcing and sensitively elaborating the order and logic of the masonry. And to make this even more clear, the smooth coat of yellow ochre was laced with a web of 'false joints' picked out in white lines nearly an inch (25 mm) thick, pretending to be the outlines of stone blocks but in fact bearing no relation to the real ones beneath the plaster. This faux-joinery was incredibly detailed and intricate – for example, tracing fake voussoirs (stones shaped for arches) in window frames and in the high vaults – and it follows a rigorous logic by decreasing in scale from floor to ceiling, as though to reassure the congregation that the lower building was anchored by the most massive blocks. Indeed, the largest blocks of all are intimated in the nave piers, insisting on their monumental strength and stability. It is staggering to contemplate the patient labour required to trace out this network of joinery, and it shows just how insistent the church builders were on preserving the archi-tectural quality of the space: the paintwork was not allowed to obscure the impression of stones laid in place.

At the same time, the simplicity of the colour scheme ensures that it does not dominate, but only accentuates, the forms of the stonework, and that it does not distract from the play of coloured

light in the gorgeous windows. Other schemes were tried out in other Gothic churches: Reims had joints picked out in vivid red, while at Amiens the aim was more naturalistic, with white joints on a painted surface of stone-grey. Chartres was given some red false joints during 'restoration' work in the nineteenth century, but conservators soon thought better of it and covered the lower church with light grey paint before the First World War, imitating bare stone and creating the popular impression that the Gothic stones were originally unadorned.

When Christians enter a church today, they come into a place of worship and reverence, sacred to God. But crossing that threshold in the Middle Ages took you into many places at once: a town hall, a social club, even a marketplace, and yet also a temple, a place of authority, and indeed nothing less than a kind of heaven itself.

The notion of a medieval church as a representation of heaven is easy to misunderstand. For medieval intellectuals, the world was defined by relationships and schemata. The significance of objects and events was determined not by those things in themselves but by what they represented. This is clear in medieval art, the non-naturalism of which says less about any deficiencies in the technical abilities of the artists than about the way they conceptualized their experiences. They could see of course that skies were not made of burnished gold, that babies were not proportioned like adults, that people's faces were not all identical. But it did not matter what they saw. They aimed to depict the underlying nature and structure of a universe that, in the here and now, was transient and imperfect.

Thus, while later artists presented real events as allegories, medieval art does not generally concern itself with 'real events' at all, because what is truly real is not the particular event but the concept it embodies. It would not be stretching the point too far to say that this art was performing a function that science aims to fulfil today: to simplify the world, to strip away what is contingent from what is essential, to reveal the framework. Art existed to reveal the deep design of God's creation.

That was equally true of the art we call architecture. So when we

say that the church was conceived as an image of heaven, we should not regard it as a kind of theatrical set intended to depict God's realm. Such a simulacrum would have been verging on the blasphemous. Rather, the structure of a church encoded a set of symbols and relationships that mapped out the universe itself.

This is why it can be misleading to call medieval churches 'works of art' at all. That is supposed to be a way of venerating them – a way that even the secular observer can appreciate – but in fact it merely encourages us to think about a church in the same way that we think about an Epstein sculpture or a Matisse canvas. While we might rightly praise the expressiveness of the statuary at Chartres or the elegant, soaring lines of the columns and arches, we should not imagine that the medieval worshippers did the same, or that they possessed anything comparable to our aesthetic sense of what to 'look for' in art. 'Contemporary man', says the German archaeologist and historian Ernst Curtius, 'places an exaggerated value on art because he has lost the feeling for intelligible beauty which the neo-Platonists and the Medievals possessed.' This intelligible beauty that the builders of the cathedrals sought to convey was not an aesthetic but a moral reality.

The medieval church was a representation – more precisely, an evocation – of the celestial Jerusalem, the heavenly city in which the saved would abide after the Last Judgement: 'The nations will walk by its light, and the kings of the earth will bring their splendour into it. On no day will its gates ever be shut, for there will be no night there. The glory and honour of the nations will be brought into it.' But there was no point in taking the biblical description literally, for there it is stated that the New Jerusalem is 12,000 stadia (about 1,400 miles or 2,250 km) in length, breadth and height, with walls made of jasper that are 144 cubits (about 200 feet or 65 m) thick. The city itself is of pure gold ('as pure as glass'), and its foundations are decorated with 'every kind of precious stone'. While one can find some of that imagery echoed in the Gothic churches, these gargantuan proportions could scarcely be regarded as a blueprint. The Temple of Solomon described in detail in the First Book of Kings (see page 125) was also considered to prefigure the Christian church in a more tangible way; but again, its form was not seen as a precise architectural prescription.

In any event, to re-create a scaled replica of the Celestial City or the Temple of Solomon would have been to make a mere *thing*. And

the Middle Ages, according to the historian Johan Huizinga, 'never forgot that all things would be absurd, if their meaning were exhausted in their function and their place in the phenomenal world, if by their existence they did not reach into a world beyond this'. To the extent that we can talk at all of artistic creativity in the Middle Ages, this found expression not in literal depiction but through what we might call allusion and analogy (although those words are really too weak). Visual representation was a way of drawing the mind towards something beyond appearances, something that could not be revealed with earthly matter. Churches were infused with symbolism not so that the faithful might consciously note how, say, the twelve columns lining the nave represented the twelve apostles (as Suger tells us of Saint-Denis), but with the aim of focusing the attention subliminally on the divine. Such symbolism was a kind of invocation, a way of summoning heavenly truths into the world of humankind. This is why the Gothic cathedrals are almost terrifying in their beauty: they encode a renunciation of our poor, drab and degenerate world and an exhortation to seek only knowledge of God.

So the church builders of the Middle Ages strove to represent an abstract notion, one that the mythic biblical edifices also embodied: the logic of God's creation. The world was, according to Umberto Eco, 'God's discourse to man', and the cathedrals sought to reiterate this discourse: they 'actualized a synthetic vision of man, of his history, of his relation to the universe . . . The cathedrals, the highest artistic achievement of medieval civilization, became a surrogate for nature.' They can be considered embodiments of the medieval universe, and thereby allow us a glimpse of how their creators understood their world.

A World Apart

Undertaking the construction of such a 'model' demanded an intellectual and theological confidence that did not exist in Christendom until the twelfth century. Before that time, it would have seemed absurd to suppose that anyone could perceive the world clearly enough to symbolize it in stone. 'The eleventh-century Christians', says the historian Georges Duby, 'still felt utterly crushed by mystery, overwhelmed

by the unknown world their eyes could not see ... Man felt as if surrounded by thick bushes; somewhere in them God was concealed.'

Monasteries were havens in this confused and frightening world – but only because they renounced it. The mission of the monasteries was not exactly to understand God but to revere him in what was commonly a mixture of blind adoration and terrified propitiation. Society at large tolerated the monkish withdrawal from the struggle and toil of daily life because the doctrine of original sin created a social need for monasteries. Once it was accepted that salvation could be attained by prayer and sacraments, divine grace became something that could be stockpiled like grain. But few could afford to spend all their days in prayer and worship, and so monks took on this responsibility for the entire community. It was a simple division of labour: the monks' self-sacrifice and piety bought redemption for all, while peasants made sure there was daily bread. Rich families would send their youngest sons into monastic life not to get them out of the way but so that, as monks, they might pray for everyone's salvation (family members first).* Some monasteries were ordered to offer prayers for the salvation of the emperor and his family. They prayed also for the dead, now languishing in purgatory. With so much saving to be done, monks were obliged to undertake charitable deeds for the poor only in so far as they could find the opportunity. Thus, the community considered monasteries to be engaged in a vital task, perhaps the most vital of all.

The ninth and tenth centuries brought serious disruption to these institutions. Some monasteries were harassed by the Norsemen and the Danes; others suffered oppression from local feudal lords, who might regard religious communities as their personal property. In the ensuing disorder, the state of monastic education and morality was so debased that by the start of the tenth century monks were widely considered incapable of any longer fulfilling their duty to earn universal salvation. In response came a wave of reform, as religious leaders sought to restore the original monastic ideals of purity and devotion laid down by St Benedict (c.480–543), founder of the first Christian monastery at Monte Cassino. A council of church leaders in 909

* Daughters of the aristocracy might also serve this function, although many of those in nunneries had simply not been found suitable marriages.

attempted to define principles that would bring back discipline to the monasteries. This in turn led to the establishment of congregations of like-minded, ascetic brotherhoods; one of the earliest and ultimately the most notable of this period was the Order set up by William the Pious, duke of Aquitaine, in 910 at the abbey of Cluny.

St Odilo (c.962–1048), fifth abbot of Cluny, developed the Order into a monastic empire. He became an adviser to the German Holy Roman Emperor Otto III, and the Cluniac influence spread through England and France with such efficiency that Adalbero, bishop of Laon, complained that the Cluniacs were not so much monks (monachi) as soldiers (milites) under Odilo's command. Close in spirit to the Benedictines, the Cluniac Order was in some degree anti-humanist: while the monks of the cathedral schools studied the liberal arts, many monasteries turned their backs on the learning of the classical world, worrying that it would pollute their sanctuary. The Order was an austere bastion against the encroachment of profane scholarship: austere, that is, in spiritual terms, for materially the Cluniac abbeys were rich indeed, and their workshops turned out opulent offerings to God. Until the twelfth century monasteries housed the best artists in Europe, and the high standard of craftsmanship in the early Gothic churches was partly a consequence of skills fostered and honed in the cloisters. Under Peter the Venerable, abbot of Cluny in the first half of the twelfth century, Romanesque art reached its zenith. But it was an ecstatic art, more or less devoid of intellectualism, lacking reason and method. While we can enjoy the uninhibited vigour of the sculpture in the Cluniac abbeys of Vézelay and Moissac, we must acknowledge that behind it lies a renunciation of the material world.

The evolution of the Cluniac abbeys followed a common trajectory for religious reform movements in the Middle Ages, which time and again would arise with the goal of restoring the original Benedictine ideals only to decline rapidly into decadence (or so their opponents claimed). And so it was, near the end of the eleventh century, that another reforming order was initiated by Abbot Robert of Molesme, near Langres in Burgundy. In 1098 Robert, despairing of the laxity of his monks, led twenty loyal followers to a remote region in the diocese of Chalon-sur-Saône, near Dijon, named after the coarse grasses that grew there: Cistercium, or, in French, Cîteaux. Here he

founded the Order of the Cistercians, who wore habits made of undyed cloth (later bleached a more emphatic white). The Cistercians did not observe penitence for society as a whole; they sought their own salvation through imitation of the humility and poverty of Christ.

The white monks were, like the Cluniacs, wary of classical learning. The library at Cîteaux was filled with books on liturgy and patristic texts, but one would search in vain for law, medicine or philosophy. It is true that the Englishman Stephen Harding, who became third abbot of Cîteaux in 1110, wrote that 'By reason the Supreme Author of things has made all things; by reason he rules all things'; but reason here meant something quite different from the logic and rationalism of the French schools.

In 1113 a devout and energetic young nobleman of Burgundy named Bernard arrived at the abbey of Cîteaux with a group of companions. Seeing promise in this initiate, Harding sent Bernard two years later to establish a new Cistercian centre at Clairvaux. By the 1120s, Bernard of Clairvaux had become the central figure of the Cistercian Order, and he grew to be a man powerful and respected enough to dictate to popes and kings. St Bernard, as he later became, was a complex and difficult man, and his extreme asceticism provides a counterpoint to the fresh spirit of intellectual enquiry that emerged in the dawn of the Gothic era.

By 1145, thanks in large part to the efforts of Bernard of Clairvaux, there were 350 Cistercian monasteries in Europe, and a Cistercian pope sat in Rome. But by the end of the twelfth century the Cistercian abbeys too had turned into little manors, as grand and as profane as the Cluniac abbeys they had sought to replace. The White Order was itself challenged by the appearance of mendicant ('begging') orders such as the gentle Franciscans and the militant Dominicans. The latter, extreme ascetics whose mission was not so much to pray as to preach, helped to establish the Inquisition in the 1230s. The anti-heresy procedures instituted by Pope Innocent III in the fourth Lateran Council of 1215 resulted in an Inquisitorial tribunal that under Pope Gregory IX was granted the power to impose the death penalty. It was during this severe age – a kind of Counter-Reformation to follow the twelfth-century Renaissance, when Christendom stiffened its crusading zeal and the Neo-Manichaean sect of the Albigensians was brutally suppressed in Languedoc – that the vaults of Chartres were closed.

Already, it seemed, men were starting to forget what the stones represented.

Style and Symbol

In contrast to monastic abbots, whose task was to guide their holy community of monks (*ab* means 'father' in Syriac Hebrew), bishops were church officials who played a broader role in the world. The system of bishops – the episcopate – is an ancient Christian institution with obscure origins that date back at least to the second century. The bishops are considered the successors of the Apostles; some believe that these 'overseers' of the faith (that is the meaning of the Greek word *episkopos*) stem from the organizational structures of Jewish or even Greek religions. Bishops were charged with the responsibility to preach against heresy, paganism and schism in their diocese, and also to administer church property and to wield judicial powers in both the church and the *civitas*. The bishops' churches – the cathedrals, from the Latin word for the bishop's throne, *cathedra*, which was placed at the end of the church's apse – admitted and even celebrated the secular world. They contained images of peasants, craftsmen and tradesmen at work, the cycles of the seasons, and the forms of the natural world, reminding us that these buildings were social as well as religious institutions.

By the late eleventh century the trappings and symbols of the Church reflected the emergence of a hierarchical feudalism in secular life. Like lords and dukes, the Church owned large tracts of land and could claim tithes from the serfs who lived on it. And like those nobles, the priests and abbots began to drape themselves in gold and precious stones. Some of them even behaved like knights, going hunting and living with spouses. The pious showed their piety with ceremonial gestures and donations rather than through prayer and humility. Even God and Jesus were envisaged in lordly fashion: not poor and humble like the Christ of the Gospels, but crowned and robed, surrounded by a court of saints as they sit on royal thrones and dispense judgements. This martial vision of Christianity is clearly evident in the art of the Romanesque churches. On the central tympanum of the Royal Portal at Chartres, Christ is seated in majesty; in other such images

he is often shown wielding a sword as a symbol of justice. Both Romanesque and early Gothic churches are dominated not, like later Christian art, by the life and teachings of Christ, but by his judicial and genealogical aspects.

But a different attitude is already evident in a late-twelfth-century window at Chartres that shows the Passion and the Resurrection. Here we see the characteristic medieval image of the Crucifixion, where Christ is no longer an awesome king but instead a fragile, mortal man, dressed in rags and twisting in agony on the cross. This is not the judge of humankind but its saviour. Depictions of the Passion with this sort of humanist immediacy were encouraged by the capture of Constantinople in 1204, which brought to the West relics from the Crucifixion – pieces of the cross, nails, the Roman lancehead that pierced Christ's side, his tunic and crown of thorns.

During the early Gothic period, images of the Virgin began to proliferate as the Marian cult burgeoned. Chartres contains the first known stone statue of the Mother of God, and both this church and that of Notre-Dame in Paris were dedicated to the Virgin. She appears enthroned with the Christ child on the tympanum of the south door of the Royal Portal, and this image recurs in the Chartrain stained glass of the twelfth and thirteenth centuries: in the centre of the rose and the central lancet of the north transept, for example, and in the stunning Blue Virgin window of the south ambulatory. The life of Mary is recounted in gorgeous blues in a nearby lancet from around 1212. 'If you are to get the full enjoyment out of Chartres', Henry Adams wrote, 'you must for the time believe in Mary, and feel her presence as the architects did in every stone they placed and in every touch they chiselled.'

Whether the more recondite and abstract symbolism that seems to be evident in Gothic architecture was already inherent in its Romanesque predecessor is controversial. There was certainly a degree of symbolism in the form of Romanesque churches, most obviously in the cross-shaped plan. But some historians assert that no over-arching conceptual scheme gave shape to the entire building: the walls were there simply to hold up the vaults, the roof to give cover, and the windows to let in a little light. The architecture does not, in this sense, express anything beyond itself – spiritual messages were instead conveyed primarily by murals.

Others claim that the numerical and geometric symbolism in the designs of Gothic cathedrals is plain to see in Romanesque churches too. Simple numerical coincidences are so easy to find that they are hard to assess: anyone can find theological correlates for the numbers of towers, pillars, steps, portals, windows of a certain type, and so on. The number two, we are told, symbolizes the spiritual and mundane worlds, three represents the Trinity, seven the days of the week (and the number of planets), nine the Virgin ('The Blessed Virgin is nine, for she is the root of the Trinity', said Dante, based on questionable mathematics), twelve the number of Apostles. It has been asserted meanwhile that the use of square forms symbolized the earth, while circles represent the perfect geometry of heaven. The octagon supposedly mediates between the two, a symbol of eternity. But simple geometrical forms were the natural language of builders, particularly (as we shall see) in an age when the very means of construction was based on geometry. So while it does seem that the clergy sometimes planned aspects of their churches with such symbolism in mind, we should not be too ready to ascribe every feature to an interpretation of this kind. There is still less reason to suppose that there was anything specifically Gothic in such modes of representation.

I shall explore these questions of geometrical symbolism in Chapter 5. They are central to the matter of who planned the cathedrals, and with what aims in mind. But we must not let the broader picture become obscured by debates about whether a cathedral can be contained in a square or a hexagon, or whether this or that proportion can be traced to Euclid. For Gothic churches display, in a way that Romanesque does not, an overarching vision: a sense of wholeness and coherence. Jean Bony claims that the Gothic style expresses what was believed by the architects to be the theoretical framework of the building. What was the philosophy that supplied this framework? If we think about the ecclesiastical notion of what a church represents, it seems reasonable to suppose that these buildings are physical expressions of a particular theology. This view has a lot to recommend it, but it is too simplistic on its own. If, on the other hand, we regard the architects first and foremost as technicians and engineers, we must try to interpret the 'theoretical framework' in mechanical terms. This was the perspective adopted in a tradition of Gothic interpretation initiated by the influential restorer of French Gothic architecture Eugène

Emmanuel Viollet-le-Duc in the nineteenth century. In seeking to reclaim Gothic buildings from the depredations of time and revolution, Viollet-le-Duc took an attitude later encapsulated in the modernist phrase 'form follows function'. It would surely be foolish to ignore this aspect of the architects' objectives – for their first concern was that the building would stay up. What I hope to show is that both perspectives have their virtues, and that they need not be mutually exclusive. It might be fairest to say that the 'theoretical framework' encoded in a building like Chartres is in fact that of a new way of thinking that developed in France in the twelfth century. It is a pattern of thought that influenced practical men as well as scholars and theologians, and it laid the foundations for the modern age.

The Church in Practice

Although the cathedral was named as a bishop's seat, it generally belonged to the chapter, a communal organization of priests (canons) and dignitaries who advised the bishop and helped him to govern the diocese. Individuals were either elected as canons by the existing chapter or appointed by the bishop. Because many of the Church's revenues accrued to the chapter, the position of canon could be lucrative, and was sought after. From the end of the twelfth century, many canons were of noble birth.

The chapter was headed by the dean, and its secretary was the chancellor. Since the ninth century, the bishop of a diocese was in theory elected by the chapter (of which he was nominally a member); but in practice the appointment was often determined by the pope, so that the chapter might have an unwelcome outsider imposed on them. Although the canons were supposed to assist the bishop, they could sometimes enforce their own wishes over his, and it was usually they who were in charge of building projects.

Relations between the canons and the bishop could be rather frosty, even hostile. This was apparently the case at Chartres in the late twelfth century, as the cathedral records (the cartulary) make plain: the many oaths and decrees spelling out the rights and responsibilities of the canons and the bishop are a sign that these were disputed territory, which occasionally required the intervention of the pope. A papal

decree of 1195, for example, prohibited the bishop of Chartres from curtailing the privileges of the dean and chapter. The chapter's customs (statutes) of the year 1200 contain an attempt to assert this independence, insisting that 'even the least canon of our church is completely free and immune from the jurisdiction of the bishop'. And a charter of 1259 records the intervention of the archdeacon in a quarrel between the chapter and the bishop over who should pay for the gold- and silverwork on the reliquaries, the vessels in which relics were kept. In short, piety was no guarantee of harmony. At Langres in 1320 the bishop even had to hire men to storm his cathedral, smashing down the doors with axes, to wrest control back from the canons who had barricaded themselves inside.

Disputes might also arise within the chapter itself. A charter of the Chartrain canons in 1224 stipulates that the moneychangers, who had previously been permitted to set up their stalls in the south porch of the church, were to move to the cloister to the south. This meant that all the dues the church could collect from the business would go directly to the chapter as a whole, and that 'whoever should be elected to the deanship might not lay claim to them'.

Whether this organizational framework was concordant, disputatious or merely officious, the cathedral was thus administered by a sizeable community – at Chartres, the chapter counted seventy-two members at one point. The canons and the bishop occupied quarters around the church itself. Strictly speaking, the 'cathedral' was thus in fact a complex of buildings, a 'holy town', which might command a considerable plot within the city walls. As well as the episcopal palace, there were the canons' dwellings and administrative buildings, a hospital and hostelry called the Hôtel-Dieu, and a school and library. The school was run by a canon called the *scolasticus* or, in France, the *écolatre*. Contrary to the impression given today of a cathedral as an isolated entity, these buildings could be physically attached to the church, either by walkways or adjoining walls. Indeed, it was common practice until the eleventh century for a cathedral to be composed of *two* distinct churches, running east–west in parallel; the north church would be used in summer, the south church in winter. And in front of the west entrance to the church(es) there would be an open square called a *parvis* in France, derived from the word meaning paradise. All this space was typically enclosed by a wall that emphasized the

separation, both physical and social, from the town itself. Thus we should be wary of the romantic idea that the cathedral 'belonged' to the citizens. They probably had little sense of that, and it was not a notion the clerics had any wish to encourage.

All the same, the cathedral was the focus of the spirituality that permeated the social fabric of the age. Yet it was precisely because religion was so central to all aspects of medieval life that townspeople did not necessarily adopt a disposition of hushed awe when they passed inside its walls. The choir and sanctuary, in the eastern end of the building, was a holy place, hidden from the laity by the rood screen. But elsewhere in the church, the ordinary people made themselves at home. When a service was not in progress, they would meet their friends here, bring in their dogs and their hawks, arrange trysts, eat snacks. The poor might even bed down for the night in the gloomy recesses. Stalls clung like limpets to the walls of the building. At Strasbourg, the mayor held office in his pew in the cathedral, meeting burghers there to conduct business.

Wine merchants, probably employed by the chapter itself, even sold their wares from the nave of Chartres – by selling inside the church, they were exempted from the taxes imposed by the count of Blois and Chartres. Whenever the wine-sellers broke open a new barrel, the 'criers' they employed would yell out the virtues of its contents. Jehan Bodel's play *Le Jeu de Saint-Nicholas*, written around 1200, gives us an indication of the colourful calls that would have resounded inside the cathedral:

> New wine, just freshly broached,
> Wine in gallons, wine in barrels,
> Smooth and tasty, pure full-bodied
> Leaps to the head like a squirrel up a tree
> No tang of must in it, or mould –
> Fresh and strong, full, rich-flavoured
> As limpid as a sinner's tears
> It lingers on a gourmet's tongue –
> Other folks ought not to touch it.

These calls eventually became such a nuisance that the canons of Chartres excluded the wine-sellers from the nave in 1327, forcing them to relocate to the crypt. But it is not only for commercial reasons that

they should have welcomed wine into the building; the patron saint of wine-makers, St Lubin (Leobinus), was bishop of Chartres in the mid-sixth century, and was reputed to be the founder of the cathedral chapter and school. In the thirteenth century he was a cult figure at the church, and two feasts were held annually in his honour, at which there was surely no lack of fine Chartrain wine. One of the windows tells the story of St Lubin, embellished with images of wine-making and -selling, and he appears in several others too.

Church services could be hardly less riotous than the busy trading inside and outside its walls. The clergy were happy to popularize their message so that it would be accessible to the common person, and to that end a ceremony might be instilled with an element of theatre. Animals were brought in to re-enact the Flight into Egypt or the Adoration of the Magi. Liturgical stage props abounded: sculptures of angels or the Virgin were wheeled down the aisles or lowered from the ceiling. On Palm Sunday a procession ended outside the west door, where the congregation heard the singing of angels, supplied by a choir in a gallery up on the west front, perhaps, as at Salisbury Cathedral, conveyed through holes in the wall. The consecration of a church was highly stage-managed: a cleric played the role of the evil spirit that the ceremony exorcized. He would wait inside the church as the procession approached from the outside, from where the bishop called out: 'Lift up your heads, O ye gates, and be ye lifted up, ye everlasting doors, and the King of Glory shall come in.' 'Who is the King of Glory?' asked the 'demon', to which the crowd responded, 'The Lord of Hosts, He is the King of Glory.' That was the sign for the doors to be pulled open and the evil spirit to dash out into the assembled throng. Yet the element of farce in all of this was as nothing compared with the clownish and lewd goings-on during the wintertime Feast of Fools, an echo of the Roman Saturnalia. And on 6 December, the Feast of St Nicholas, the choir boys were permitted to drive the canons from their seats, which they then proceeded to occupy for the rest of the service while attended by their masters. Afterwards they went carousing in the town, and the wine flowed freely. The canons were themselves not averse to a fortifying draught: on the first day of the Advent fast, the bishop traditionally gave the chapter around 750 litres (165 gallons) of wine, and the dean, treasurer and archdeacons made comparable donations for several days thereafter. It was a lot to get through on an empty stomach.

The sculptures of Chartres reveal how religious observance heeded the routines of daily existence. A zodiacal calendar in the porch of the north transept contains exquisite depictions of the toils and hardships of ordinary people. Women prepare cloth by stripping and carding flax, while peasant farmers cut their vines in March and head out to the fields with a scythe in June. In February, the canny peasant sits by the fire warming his hands and feet.

It is entirely characteristic of medieval theology that such prosaic concerns should coexist with the idea that the church is a representation of heaven. That may, in fact, stand as a metaphor for the very paradox that these buildings present to modern times. They are surely the most profound expressions of the Christian faith, and with it the ontological framework, of the Middle Ages. And yet they remain resolutely material: stone and glass, wood and iron, shaped by the hands of unlettered men, who sometimes enjoyed a great deal of latitude for injecting their own preoccupations and ideas into the fabric. They are prodigious collaborations between the tangible and the spiritual, the mundane and the transcendental, the public and the personal. They embody a kind of union that art has long forgotten how to make.

4

Seek Not to Know High Things

Faith and Reason in the Middle Ages

Western religious art is an accurate reflection of mankind's changing attitude to the spiritual world.

Hans Jantzen, *High Gothic*, 1984

One of the most singular phenomena of the literary history of the Middle Ages is the vigour of the intellectual commerce, and the rapidity with which books were spread from one end of Europe to the other.

Ernest Renan, *c.*1852

The Crypt and Plan

The eleventh-century crypt of Chartres, built by Bishop Fulbert's architect Beranger, was nothing less than a second church situated beneath the main edifice. Beranger constructed two long passageways that ran from the west end under the nave aisles, so that pilgrims could gain access to the relics without trailing through the church above. He built a semicircular passage around the central sanctuary – in essence an early ambulatory, a structure that eventually became a standard feature of Romanesque churches. The first ambulatory may have been constructed in the Carolingian abbey church of Saint-Denis around the mid-eighth century, with the aim of easing the flow of pilgrims wishing to see the shrine of St Denis. The visitors could enter on one side, walk around the sanctuary to view the reliquaries, and exit down the other passage.

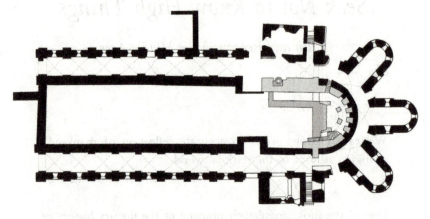

The plan of the eleventh-century crypt at Chartres.

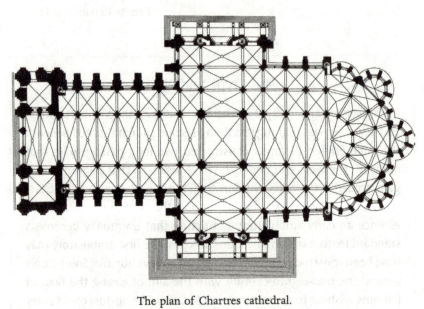

The plan of Chartres cathedral.

The Chartres legend has it that this kind of arrangement was necessary to accommodate the hordes of pilgrims who came to the cathedral to see the relics, especially the *camisa*, and who would have disrupted church services if they had to pass through the main building to reach the crypt below the apse. But legend may be all it is. According to historian Nicola Coldstream, Chartres was not a major site of pilgrimage either in the twelfth or early thirteenth centuries, and there is no reason to believe things were any different in Fulbert's time. Rather, the design of the crypt may have been more an expression of intent – evidence of a concerted effort to swell the number of visitors, rather than a response to it. Thus it is possible that the attempts to manipulate the Marian cult of Chartres began with Fulbert. In any event, when Pope Alexander IV referred in 1260 to the 'innumerable multitudes of the faithful' that the town attracted, he may have been simply accepting what the Chartrains asserted about the situation.

Beranger constructed three deep chapels at the eastern end of the apse. Such chambers, emanating like incipient branches from the ambulatory, had previously been included in the apse of Rouen Cathedral in the 990s, and were built at Auxerre at much the same time as Chartres.

The lower church at Chartres was more than a walk-through display of relics. Pilgrims could lodge under the vaults – it has been suggested that the carelessness of those sleeping within the church on the eve of the Festival of the Nativity might have been responsible for the fire of 1020. There was even a hospital attached to the northern aisle of the crypt to treat the sick. The legendary sacred well was still maintained on the north side of the apse: it was known as Saints-Forts, since several martyred saints had been thrown into it by Viking raiders. That, at least, was what was alleged by monks in the early twelfth century, and no doubt the idea encouraged belief in the healing powers of the well waters – another attraction for pilgrims. Next to the well is an inner sanctuary, the *confessio*, probably dating from the ninth century and dedicated to St Lubin. The original wooden statue of the Virgin was placed here in the eleventh century, perhaps by Fulbert himself. In this way, the crypt contained the focal elements of the local

folk cult of the Virgin, emphasizing that these belonged to and oper-
ated through the church alone.

The architect of the Gothic church was constrained by the fact
that he was building on top of Fulbert's crypt. Furthermore, the
mid-twelfth-century west end of the cathedral was still standing,
though it needed modifying considerably to blend with the new
construction and the Gothic style. So before we start to weave elab-
orate schemes that 'explain' the fundamental geometric concept of
the cathedral, we need to recognize just what the architect could
and could not do in the first place.

It is easy to forget this when we look at the plan of the existing
church, which appears so coherent and orderly that it is hard to
believe it was not imagined from scratch. The truth is that the archi-
tect wrought wonders under considerable constraints, integrating
the old and the new so seamlessly that we barely notice the joins
at first glance. Only on closer inspection do we see the compromises:
for example, the uneven west bays of the nave (see page 274), the
asymmetries of the remodelled west front (page 275), and the discrep-
ancy between a single-aisled nave and the double ambulatory (both
were double at Bourges Cathedral, begun at much the same time).
All the same, the plan is a good deal more regular and unified than
several of its near-contemporaries, such as Soissons, and it is easy
to see how it served as the prototype for Reims and Amiens.

Gothic churches are rightly celebrated for their use of proportion,
geometry and symmetry. But it is all too easy to overstate the case.
It seems likely that the careful plans of the architects may have
sometimes been undermined by limitations in the accuracy of laying-
out procedures on site, or by shifts in a building's fabric caused by
irregular settling of (often inadequate) foundations – not to mention
budgetary compromises or changes of heart by the church patrons.
There is probably no intention in the fact that the nave width at
Laon tapers by 3 per cent, or at Bourges by twice as much. Suger's
proto-Gothic choir at Saint-Denis is rather irregular, while the ground
plan of Notre-Dame de Paris is frankly something of a disaster from
a geometric point of view. When faced with claims like those of
Australian architect John James that an apparent twist in the key

axes of the plan of Chartres is purposefully intended to 'inject asymmetry' into the design, we have to wonder whether the building practices of the Middle Ages really allowed for that kind of finesse. Isn't it more likely that this simply reveals their technical limitations?

In 1834 the twenty-year-old Eugène Viollet-le-Duc, a budding architect and artist without any social position to speak of, went travelling with his friend Léon Gaucherel to look at France's ancient buildings. They stopped at Chartres, where they passed their days inside the cathedral making sketches and water-colours. 'I have never seen anything as beautiful in my life', Viollet-le-Duc wrote to his wife. 'We live in the cathedral and we only leave when night has fallen . . . I am continually torn between the joy of reproducing such beautiful things for myself and the sadness of never being able to produce anything associating such great beauty.'

He speaks for countless visitors who pass through the Royal Portal every day. But as should now be clear, we cannot assume that what the beauty of Chartres means to us, and what it meant to Viollet-le-Duc, is the same as what it meant for worshippers in the thirteenth century. If historians are right to regard medieval art as an attempt to reveal the 'intelligible beauty' of creation, then we cannot hope to understand Gothic buildings unless we appreciate something about what this notion of beauty means and where it came from. In what sense was God's Creation beautiful? And what, in a world still emerging from centuries of turmoil and barbarism, could have given rise to the idea that God's work was pervaded by such magnificence?

Stirring Rome's Embers

For western intellectuals at the dawn of the past millennium, understanding the world meant looking to the past. They were acutely aware that the ancients had attained a philosophical sophistication of which only pitiful remnants had survived through the harrowing times that followed Rome's collapse. So the mission of the 'sciences', such

as they were, was not to explore the universe but to scour the meagre works of the philosophers of antiquity in the hope of recovering what they had known.

If this seems an oddly defeatist attitude today, it is because the Enlightenment idea of progress – technological, intellectual, spiritual and moral – has become second nature to us. We may not believe that things always get better – the current fashion is to imagine quite the contrary – but we have come to accept that change is inevitable and that our store of knowledge (if not wisdom) is forever growing. But the Middle Ages shared none of our hubris. People then did not believe that the questions they faced were any different from those that confronted their dimly perceived forebears, who were considered to have been far better equipped to find answers. What remained of that learning in the tenth and eleventh centuries was to be trusted precisely because it had stood the test of time. Scholars lived in hope of scavenging more, and then recording it for posterity: truth was timeless. 'The twelfth century schools', says the English historian Richard Southern, 'were engines designed for [the] single purpose of discovering a clear and unambiguous body of truth that could be handed on from generation to generation.'

This reverence for the classical heritage pervaded political and institutional structures. If Charlemagne's coronation as Holy Roman Emperor gave western Christendom fresh pretensions of grandeur, they were of a decidedly derivative nature – the emperor's very title said as much. Pope Leo III crowned him 'Augustus', and it was understood that he was successor to the Caesars. Nobles were starting to learn to read and write so that they could study not only the Bible but also the books of the classical scholars. At the start of the eleventh century, the duke of Aquitaine was said to be devoted to learning: 'He keeps in his palace a great number of books, and if war chances to leave him some leisure time, he devotes it to reading them himself, and spends long nights among his books until sleep overcomes him.'

In the court of Charlemagne, workshops were established to translate and copy the classical Roman authors, a project that secured the precarious survival of many works. An educational programme in the liberal arts was advocated by the English scholar Alcuin of Northumbria, whom the Frankish king made master of the palace school at Aachen around 781. Alcuin helped to establish schools at

the major cathedrals of the Holy Roman Empire: Paris, Orléans, Toledo, Chartres and Cologne.

To Alcuin, the liberal arts were the columns that propped up the temple of Christian wisdom. Before joining Charlemagne's court, he commended the library of the monastery at York warmly for its stock of texts from the scholars of antiquity:

> There shalt thou find the volumes that contain
> All of the ancient fathers who remain;
> There all the Latin writers make their home
> With those that glorious Greece transferred to Rome,
> The Hebrews draw from their colossal stream,
> And Africa is bright with learning's beam.

This educational programme was supported by the Neo-Platonist John Scotus (c.810-c.877), known as Eriugena because he was an Irishman (in those times, a 'Scot' was as likely to be Irish as Scottish). An important interpreter of St Augustine and Boethius, he has been called the only truly significant thinker in the western world between the seventh and the tenth centuries. He came to the Frankish court at the invitation of Charles the Bald around 847, only to find it devoid of scholars as learned as himself. In contemplating the spiritual realm, said Eriugena, one has a duty to employ the worldly faculties of sensation and reason.

The Carolingian Empire of the ninth century is often said to have hosted a modest renaissance, although this is rather generous to a culture that tended to regard books not so much as receptacles of wisdom but as expensive luxuries for princes to display ostentatiously. Yet if these books had few readers able to understand them, nonetheless their very existence helped to foster the belief that, just as questions about religion were answered by careful study of the Scriptures, so issues about philosophy and science were decided by appeal to ancient, pagan authorities – men who, unlike the fearful and bewildered Carolingian schoolmen, had been at home in their universe.

But when intelligent people devote themselves to learning, they can scarcely help but contribute to it. Despite the absence of any clearly defined sense of mission to elucidate the nature of the world, scholars in the early Middle Ages began to have new ideas. One of the curious things about this time, says Bertrand Russell, is that it was

original and creative without knowing it. Originality was not neces-
sarily seen as praiseworthy – it exposed one to accusations of exces-
sive pride – yet it happened all the same.

The Fathers of the Western World

In the twelfth century, learned clerics were guided in their studies of
the Scriptures by the commentaries of the early Christian writers known
as the Fathers: men like Clement of Alexandria (died c.215), Origen
(died 254), Basil of Caesarea (died 379), St Augustine (354–430), Boethius
(c.480–c.525), Cassiodorus (died c.580) and the Venerable Bede (died
c.735). These 'Patristic' interpretations of the Bible, known as glosses,
gave men hope of negotiating a path through some of the recondite
aspects of Christian thought, such as the precise meaning of the doctrine
of the Trinity.

But many medieval scholars found instruction and inspiration also
in the pre-Christian writers of Rome and Greece. They learnt about
the Greek myths from Ovid, and about the poetry and humanities
of the ancient world from Virgil, Horace and Livy. And for under-
standing the fundamental basis of the natural world, there were no
more eminent authorities than Plato and his pupil Aristotle. One can
chart the course of natural philosophy in the West until the seven-
teenth century more or less in terms of the waxing and waning of
the reputations of these two philosophers.

To characterize Plato and Aristotle by contrasting them is inevitably
simplistic; but doing so highlights two seemingly universal responses
to the world. Crudely put, Aristotle was concerned with things as they
seem, and Plato with the truth that lies behind appearances. Aristotle
discusses the world as we experience it through our senses. Plato
distrusts sensory information, which is susceptible to irrationality, and
he insists that genuine insight arises only when we can penetrate
beyond appearance to the fundamental, universal properties of things.
Aristotle's world is that of *physis*, or what we might call nature. For
Plato, the cosmos comes into being as a kind of creative expression
or interpretation of transcendental, archetypal forms, and thus it is
more a matter of *techne*, of art.

Both men recognized that we struggle to make sense of the world,

and that there is much in it that is confusing or seemingly inexplicable. For Aristotle this was because our sensory organs are imperfect: there is an objective world out there, but in interpreting it we are hampered by bad data. So we are forced to work hard at the task, reducing error by investigating and observing with great diligence. In the view of most intellectuals from the Middle Ages onwards, this required the scholar to specialize. Plato, on the other hand, felt that ignorance is inevitable, because it reflects the diminished reality of the material world in comparison to the transcendental.

The invitation, then, is to see Aristotle as the proto-scientist and Plato as the mystic. But that is to go too far. For one thing, Aristotle exhibits little interest in the careful experimentation that is the hallmark of today's science. He focuses on particulars, to be sure, but typically interprets them on the basis of rather arbitrary preconceptions that observation need confirm only schematically. And the most fundamental aspects of modern physical theory refer to entities, ideas and forces that are certainly inaccessible to our everyday sensory experience, drawing on forms of mathematical abstraction (especially symmetry) with which Plato would have felt comfortable. In the end it is somewhat futile to try to reconcile the philosophies of either man with modern science.

Many philosophers of the Middle Ages were more concerned with what some historians have described as an equally futile quest: to reconcile Plato and Aristotle with one another. Both were regarded as having privileged insight into the natural world, and so it flew in the face of all reason that they should not agree with one another. How, though, to make them consistent? There is, according to Southern, 'no scholarly ambition more ancient than this'.

In the twelfth century Aristotle's oeuvre was only just being rediscovered by Christian scholars translating his texts from Arabic transcriptions. The century that followed saw the triumph of Aristotelian 'naturalism', notwithstanding papal attempts to ban Aristotle's *Physics*. Albertus Magnus, a Dominican cleric from Swabia, and his Neapolitan pupil Thomas Aquinas presented the case for congruence of Aristotle's views with Christian belief, while the Aristotelian emphasis on sensory data was expounded in the experimental work of the Englishmen Robert Grosseteste and Roger Bacon at Oxford.

But during the springtime of the Gothic revolution, Plato was the dominant authority in natural philosophy. The mighty edifice of medieval

Platonism rested on thin foundations, however, for many of his original writings were lost, and all that was really known in the early twelfth century were fragments of his *Timaeus*.* Yet despite this paucity of sources, Platonism was, in the view of the historian Raymond Klibansky, a force 'continuously stimulating scientific thought, aesthetic feeling and religious consciousness', from antiquity until the High Middle Ages. Because of the endorsement of Platonic philosophy in the Patristic texts, the *Timaeus* came to be seen as the most profound description of the physical universe. The book was widely available to scholars, the number of transcribed copies peaking around 1150.

For medieval Christian thinkers, the Fathers represented a link between this golden age of antiquity and their own tradition. These men, living through the waning of the Roman Empire, had enjoyed access to a wealth of classical thought that was now largely lost, while being able to contemplate it in a Christian context. The Platonism of early Christian thought tended to promote the view that nature is a projection of God, so that the aim of philosophy is not so much to discover how the world is constituted as to decode it. Yet that was in itself an important step forward, reflecting a new-found confidence in the intelligibility of the universe.

The Dilemmas of Augustine

The most authoritative and influential of these church patriarchs was Augustine. There are few more contradictory figures in early Christian thought than this North African bishop: he was progressive and reactionary, a liberal scholar and an austere zealot, a subtle philosopher who laid the basis of a sledgehammer morality. Augustine illustrates the problem that we face in understanding any philosopher of times past: he did not materialize with a doctrine that was fixed and polished, but spent his life struggling towards some kind of personal truth. As a result, he said conflicting things at different times, so that what later thinkers took away from Augustine was very much dependent on their own times and character.

* Two of Plato's other works, *Phaedo* and *Meno*, were translated around 1155, but they were never quoted in twelfth-century texts, and no copies now remain.

Augustine was born in 354 in the town of Thagaste in the east of modern-day Algeria. Here he inherited the Latin Roman culture of North Africa: his was a basically Christian society stimulated by the learning of classical Rome and Greece and by the influences of the Middle East. As a young man, Augustine was drawn into the Persian cult of Manichaeism, based on the beliefs of the third-century sage Manes or Mani – a strange blend of Babylonian folklore and cosmogony welded opportunistically to elements of Christianity. The Manichees maintained that our world is a battleground between the rival forces of good and evil; they considered that our dutiful attempts to direct thoughts and actions towards the good are constantly undermined by the snares that evil forces have set everywhere.

Augustine's initial enthusiasm for Manichaeism later cooled, and although it seems he did not reject it fully until around 383, he subsequently became a vociferous critic. During that period he earned a living as a teacher of rhetoric, first in Thagaste and then in the major city of Carthage in modern-day Tunisia. In 383 he went to Rome, and in the following year he took a prestigious teaching position at the court in Milan, where he came under the influence of Bishop Ambrose of Milan. His mother, a devout Christian, joined him there, and she and Ambrose between them persuaded Augustine to convert to Christianity. Ambrose baptized him in 387.

In Milan, Augustine discovered Platonic philosophy, which came to shape his thinking to such an extent that some have suggested his Christianity was simply a convenient peg on which to hang it. Like Manichaeism, Platonism is dualistic; but whereas the realms of good and evil are both material, Plato's later interpreters, such as the third-century Hellenic Neo-Platonists Plotinus and Porphyry, asserted that the physical world accessible to sense perceptions is a mere shadow of an immaterial realm of true reality, where all things are intelligible and perfect. For Augustine this transcendental world of Plato seems to have been a pagan version of the kingdom of God, which was unchanging, flawless and infinitely reasonable. Christian doctrine taught how God's love could render this world perceptible to us like a light shining in darkness.

In its insistence that all things are created by the emanation of God's goodness, Platonism sounded similar to Christianity. But Plato's transcendentalism was not moralistic; it was simply a description of how

things are. This optimistic, pantheistic vision was modified in import-
ant ways by Augustine in order to bring it in line with a more expli-
citly Christian outlook. By fixing its gaze beyond the mundane world,
Platonism renders this world an illusion of little interest. Augustine's
Neo-Platonic Christianity did not merely remain aloof, however; it was
apt instead to condemn and vilify the physical world, which is seen as
inferior not just ontologically but morally. Knowledge of the transcen-
dental realm of God is thus the only real knowledge worth having. 'I
desire to have knowledge of God and the soul', he wrote in his *Soliloquies*.
'Of nothing else? No, of nothing else whatsoever.' If the world is just
an illusion invoked by our unreliable senses, and if an understanding
of true reality can be revealed only to the soul illuminated by God,
there is no point in making too close a study of observable things,
because they cannot in themselves bring us any closer to the Deity.
Their existence, moreover, is arbitrary: they are contingent things, the
fruits of the seeds of causation that God sowed in the world.

The Role of Reason

Augustine concluded that one must seek God by withdrawing from
the world and becoming an ascetic. It sounds like a prescription for
ignorance, for weaving barren theological webs; and that is what it
sometimes became in the monasteries of the Middle Ages. But total
indifference to the world was not quite what Augustine had in mind.
Allied to his trust in divine illumination was a faith in human ration-
ality. God has placed in the human mind a capacity for reason that
can and indeed should be used to deepen our understanding of him.
Reason is a tool that may be honed and wielded by means of the
intellectual disciplines cultivated by the ancient scholars, which became
enshrined in the tidy conceit of the liberal arts.

These disciplines were regarded by the classical writers as the essen-
tial components of a sound education. According to the sixth-century
Roman monk Cassiodorus, 'liberal' has its roots not as we might
expect in the Latin *liber*, 'free' – that is, being the topics suitable for
the training of a free man in the ancient world – but in *liber*, 'book':
they were subjects to be learnt by reading. Cicero listed them as geom-
etry, literature, poetry, natural science, ethics and politics. The Roman

scholar Marcus Terentius Varro (116–27 BC) included medicine and architecture in the roster. But by Augustine's time the syllabus of the liberal arts was generally deemed to be composed of seven topics: the *trivium* of grammar, dialectic and rhetoric, and the *quadrivium* of arithmetic, geometry, astronomy and music.

Augustine believed that, as God's reason has rendered the world intelligible, this order can be discovered by the use of mathematics, geometry and astronomy, as well as through literature, poetry and music. These subjects may be pursued, then, not for the sake of mere learning or art but as a route to divine truth – as a way of enabling men to appreciate the rational basis of their faith. Augustine's advocacy of the liberal arts can be seen as a call for a research programme that is no open-ended inquiry but whose aims and conclusions are preordained. Mathematics, for example, can be deployed to help us understand the significance of numbers that appear in biblical allegories. The purpose of studying nature was not to discover what it was like and how it was constituted but to uncover new demonstrations of the moral order and divine wisdom inherent in all creation.

Augustine thus initiated the discourse between faith and reason that continues even now to characterize the interactions of science and religion. On the one hand, he argued that it was essential to cultivate understanding of the world, because without that there could be no true belief. On the other hand, there was only one way this understanding was permitted to turn out: it had to be congruent with Christian doctrine, and so could hardly be a matter of genuine inquiry at all. Yet even in Augustine's time it was recognized that some of the descriptions of the world that appeared in the Scriptures did not match what was generally known to be true. Augustine accepted this as evidence that even the Bible's authors didn't know everything, showing that even his austere theology found no place for the credulous literalism of some of today's Christian fundamentalists:

> In points obscure and remote from our sight, if we come to read anything in Holy Scripture that is, in keeping with the faith in which we are steeped, capable of several meanings, we must not, by obstinately rushing in, so commit ourselves to any one of them that, when perhaps the truth is more thoroughly investigated, it rightly falls to the ground and we with it.

True, this passage artfully protects Christianity from being under-mined by advances in our understanding of the world; but if dogma-tists then and subsequently had heeded it, they would not have needed to deny the evidence of their senses. Galileo cited the remark in his defence against Rome.

Augustine's support of the liberal arts – the 'sciences' of antiquity – as tools for extracting religious knowledge informed a vigorous debate among early Christians. Some of the Greek Christians expressed a deep distrust of this ancient learning. The fifth-century Syrian theologian Theodoret, bishop of Cyprus, argued that because science could always be improved or disproved, it could not offer the kind of robust truths that religion provided – he likened it to writing on water. (Here perhaps is the patron saint of today's creationism.) Others shared Augustine's notion of pagan philosophy as a 'handmaiden to theology' – this was the position espoused in the second and third centuries by Clement of Alexandria and his disciple Origen. The idea was systematized in the fourth century by Basil of Caesarea, whose book *On How to Make Good Use of the Study of Greek Literature* was regarded by some as granting permission to read the classics. Basil noted that one could hardly under-stand the description of the Creation in Genesis if one was wholly ig-norant of the natural world. Moreover, studying nature brought to light fresh examples of God's providence, foresight and wisdom; for example, in the way that he has provided creatures with the physical features they need to survive: an early example of what would later be regarded as the argument from design for the existence of God.

Sin and Recantation

But times change, and people are changed with them. In 410 the Visigoth leader Alaric conquered and sacked Rome; and if that event was not exactly perceived at the time as the end of western civilization that subse-quent historians have made of it, nonetheless it was a stark reminder of the fragility of tradition for those living in the twilight of the Roman Empire. Refugees from Rome reached the seaport of Hippo on the North African coast (now Annaba in Algeria), where Augustine had become bishop fifteen years earlier. The news of Rome's demise may have hardened the conservatism of this increasingly reactionary man.

It is a likely, if not necessarily logical, consequence of Neo-Platonic philosophy that the world we live in should come to seem tawdry, flawed, and of little value. Augustine eventually went further by effectively pronouncing the world of humankind to be intrinsically wicked, and all of humanity likewise. How was that possible, if God created it? But God did not create evil itself, for that was unthinkable; he merely gave man free will, which Adam squandered. According to Augustine, this original sin tainted and damned us all. This was the argument he expounded in *The City of God*, written between 412 and 427, over which looms the gloomy spectre of the sack of Rome. It provides a prescription for the harshest and most disheartening aspects of subsequent Christian theology, burdening it beneath a crushing weight from which only the humanism of the twelfth and the fifteenth centuries offered some respite. Not only are we damned, and deservedly so (for Adam's transgression is ours too), but we can do nothing about it. Certainly, a man may lead a pious life in the hope of salvation – but that is conferred only by God's grace, bestowed on an elect for reasons of which we can know nothing. This grace, Augustine argues, is evidence of God's essential goodness.

Until they are baptized, then, infants belong to Satan. (There is a trace of residual Manichaeism in the way that Augustine, and others after him, began to elevate Satan from a fallen angel to the source of all evil who threatens and even dominates humankind.) The concept of original sin – a doctrine of despair, which is nowhere afforded clear support in the Bible – is surely Augustine's most insidious legacy, a reminder of where we are prone to end up once we avert our eyes from this world and seek perfection in a higher one. There was some meagre consolation in the eleventh-century idea that priests, rather than divine providence alone, could save men's souls from hell (albeit not before the discomforts of purgatory). Even this was of questionable benefit, however, for while it seemed to make redemption a little more attainable, it also strengthened the Church's power over the laity.

Pelagius, a Welsh cleric known by the Latinization of his native name of Morgan, objected to original sin on the grounds that if all we can do is hope that God selects us, for reasons unknown, to join the elect, there is no motivation even to seek salvation. Either it will come or it will not, regardless of our efforts. Pelagius considered that Augustine's theology undermined free will, and, as a consequence,

any sense of moral responsibility. Surely, he argued, humankind may be virtuous only if we have the power to redeem ourselves?

But Augustine was not moved, and because of his opposition the Pelagian position was denounced as heretical. As his views became ever more fixated on the contrast between the worthlessness of this world and the perfection of the next (that is, if you were among God's elect), he even withdrew his support for the liberal arts, writing in his *Retractions* of 426 that the theoretical sciences and mechanical arts held no value for the devout Christian. He read Cicero and Aristotle, he confessed, but 'what did it profit me? . . . For I had my back to the light.' Among other complaints, Augustine said of the liberal arts that 'many holy people have not studied them at all, and many who have studied them are not holy'. (One might even then have said much the same of the Bible.)

It has been argued that Augustine might never have looked very favourably on the liberal arts in the first place – his *De doctrina Christiana*, for example, which has been interpreted as a manual for their use, arguably presents a rather sceptical assessment of their value. He warns there of the dangers of intellectual pride, of 'a passion for wrangling and a kind of childish parade of getting the better of one's opponents'. The purpose of these skills, he says, is to help us sift through pagan philosophies for tools that might illuminate the Scriptures. Knowledge 'can give us swollen heads and stiff necks, unless we submit them to the Lord's yoke'. It is the Bible, after all, that warns how 'knowledge puffs up; love [of God] builds up'.

These attacks on secular learning were especially severe in Augustine's 'intellectual autobiography', the *Confessions*, in which he portrays himself and his scholarly peers as 'selling talkative skills' like intellectual prostitutes. Curiosity, he wrote, is a 'lust of the eyes'. What we dignify by the names of learning and science is merely 'empty longing and curiosity'. This inquisitiveness is a form of pride, and as such is deeply sinful: 'The proud cannot find you', said Augustine, addressing himself to God, 'however deep and curious their knowledge, not even if they could count the stars and the grains of sand, or measure the constellations in the sky and track down the paths of the stars.' The conflation of curiosity and pride was reflected in the Middle Ages in a common mistranslation of a passage from St Paul's letter to the Romans: where the Latin Vulgate Bible read *noli altum sapere*, the meaning was interpreted not as 'be not high-minded' – or

as modern versions might have it, don't be arrogant – but rather, 'seek not to know high things': don't ask questions.

And there was, after all, no escaping the fact that the ancient exemplars of the liberal arts – Plato, Aristotle, Horace and the rest – were pagans. Not only were their words consequently incomplete but they could be misleading, because they contained no awareness of the Lord. The mission of humankind, churchmen insisted, was to cultivate one's reverence for God, and ancient philosophy and literature might be no more than a dangerous distraction from that. So in the early Middle Ages a man could know more than was good for him. Theologians gave warnings about the futility and the perils of knowledge. 'For with much wisdom comes much sorrow; the more knowledge, the more grief': in the end, the supposedly wise man faces the same fate as the fool, and not all the learning of Solomon (whom some have considered to be the author of those words) would save him from that. The love of God is his only redemption. We find Bernard of Clairvaux issuing a reminder of that to a young man whom he deems to be spending too long studying the liberal arts in the French schools:

> I grieve to think of that subtle intelligence of yours and your erudite accomplishments being worked out in vain and futile studies, of you with your great gifts not serving Christ, their author, but things that are transitory. O what if unexpected death should strike and snatch them from you? Alas, what would you take with you from all your toil? He will come, he will come and he will not delay, to demand what is his with interest. What will you answer at that dread tribunal for having received your soul in vain?

Having sown the seeds of Platonism in the Christian West, Augustine ended his days bolstering those who would condemn the enquiring spirit of its rationalistic supporters. This leads to the strange spectacle, in the twelfth century, of Platonic rationalists engaged in a war of words with Platonic mystics. Like Christianity itself, Plato's influence became so pervasive that it could be adapted to more or less any philosophical position (and by the same token you could usually invoke Augustine in your support too). We must bear this in mind before falling too deeply in thrall to the notion that Gothic

churches are a kind of Platonism wrought in stone – for so, it seems, are Romanesque buildings to some extent, whether Cluniac, Cistercian or otherwise. Gothic might never have happened without the Platonism of Augustine and the other Church Fathers; but that did not in itself make the style inevitable.

Consolation for the Arts

Although Plato was not strictly a monotheist, his concept of a supreme deity who created the world lent itself readily to a Christian interpretation. Aristotle's ideas, on the other hand, were widely deemed incompatible with the doctrines of the Creation, divine providence and the immortality of the soul, and they were often resisted and suppressed. This antipathy hardened in the fifth century when Aristotle's teachings were embraced by the heretical Christian sect of the Nestorians in Syria. Nestorius, a patriarch of Constantinople, was condemned by the Council of Ephesus in 431 for his suggestion that Christ was born of Mary as a human rather than as a divine being. The Nestorians, persecuted by the Church, fled east to Persia, where their enthusiasm for the rational, 'scientific' works of Aristotle, Euclid, Hippocrates, Galen and Archimedes enabled these texts to pass to the Muslim world. There they were preserved as Byzantium foundered.

But Aristotle had a Patristic champion in the person of the Roman statesman Boethius. Boethius was responsible for some of the earliest Latin translations of Aristotle's works, and this, along with his knowledge of Euclid and Ptolemy, made him something of an authority on the liberal arts, particularly mathematics and logic. He declared his bold intention to 'translate into Latin every book of Aristotle that comes into my hands'. Even more boldly, he strove to bring rational analysis to bear on the theology of the Christian schools, and entreated Pope John I 'as far as you are able, [to] join faith to reason'.

But as one would expect from a pupil of the Platonic Academy in Athens, there is much Platonism in Boethius's vision too, particularly in his concept of God – Plato's 'One' – as pure form. Indeed, if Boethius is seen as a champion of Aristotle, that is a product of historical circumstance, for he meant also to provide exhaustive Latin translations of Plato's works, many of which might never have been lost if

only Boethius had managed to do so before being put to death. His untimely execution for alleged treason against the Ostrogoth king Theodoric, says Raymond Klibansky, 'deprived the medieval world of an opportunity of access to the whole heritage of Plato'. Boethius was one of those who hoped to unite the two great philosophers of Greece, and his most famous work, the *Consolation of Philosophy*, written while Boethius languished in Theodoric's jail, is profoundly Platonic. Both here and in his book *On Arithmetic*, Boethius proposes the Pythagorean idea that the universe is based on numbers:

> God the Creator of the massive structure of the world considered this first discipline as the exemplar of his own thought and established all things in accord with it; through numbers of an assigned order all things exhibiting the logic of their maker found concord.

At the twelfth-century cathedral school of Chartres there was no mathematical authority who surpassed Boethius, and his writings on number and proportion were at the core of the canon. Some have ranked Boethius's influence on medieval thought alongside that of Plato himself.

Augustine and Boethius stand at the border between the ancient and medieval worlds, and by bridging the two they played a vital role for the philosophers of the Middle Ages. Theirs was, however, a world that seemed to be collapsing and shutting down: Rome was eclipsed during their lifetimes, and the Athenian Platonic Academy was closed four years after Boethius's death. It is not surprising, then, that these two men found solace in Plato, whose philosophy emphasizes the abstract over the material and thus seemed to promise unassailable certainties in an increasingly precarious age. On the one hand, this led both men to develop an aesthetic philosophy based on geometry and order that found its greatest expression at Chartres. On the other hand, it prompted Augustine to devalue the physical world of human experience in preference to an imagined 'higher' reality: the prescription for a corrosive, anti-humanistic theology that condemned worthless humanity to shudder in the dark as it prayed blindly for salvation. These two outlooks – the rational and the anti-rational – were destined to clash furiously in the century during which the building of Chartres Cathedral began.

Exchange of Words

Traders are pragmatic types, rarely deterred by war, religion or politics. Even as Arab armies harried the borders of the Christian West and the knights of Christendom rode in a muddle of piety, bellicosity and plunder-lust to the Holy Land, the twelfth-century merchants of Venice, Naples and Genoa were happy to conduct brisk business with the infidels around the fringes of the Mediterranean. Inevitably it wasn't only goods that got exchanged, but ideas too.

Some of this intellectual trade – which flowed almost entirely from east to west – came about as a direct consequence of commerce. It was on a business trip to North Africa that the Italian Leonardo of Pisa (later known as Fibonacci) learnt Arabic mathematics at the beginning of the thirteenth century, in particular the system of Arabic numerals whose virtues Leonardo expounded in his *Liber abaci* (1202). Other Europeans had advertised the benefits of this system during the previous century; the Arabs, who themselves acquired the numeral scheme through trade with India, already recognized how well suited it was to the everyday needs of merchants and engineers. For them, mathematics was a practical science. The great Arabic mathematician Al-Khwarizmi, whose writings on algebra were translated into Latin by Adelard of Bath in the twelfth century, explained that he had focused his attention on 'what is easiest and most useful in arithmetic, such as men constantly require in cases of inheritance, legacies, partition, lawsuits, and trade, and in all their dealings with one another, or where the measuring of lands, the digging of canals, geometrical computation, and other objects of various sorts and kinds are concerned'.

Much of the knowledge that came to the West from the Arabs was of a similarly applied character – medicine, craft recipes, mechanics, chemistry. But the Islamic scholars also wrote extensively on more abstract and philosophical matters, and it was abundantly clear to Christian scholars that the heathens knew plenty that they did not. A great deal of that information was second-hand, derived in particular from the works of the ancient Greeks; but some, like Al-Khwarizmi's algebra, was original. The Nestorians, fleeing from Byzantium to Persia in the sixth and seventh centuries, helped to

export Greek scholarship to the Islamic world, but the Muslims also had a great deal of direct contact with the remnants of Hellenic culture in Byzantium itself. By the ninth century, Baghdad had become a major centre for the translation of Greek texts into Arabic. From these books – mostly scientific texts by writers such as Euclid, Aristotle, Archimedes and Ptolemy – sprang much of the subsequent learning of the western world. A handful of scholars, versed in Arabic, travelled from all over Europe to the volatile yet fertile boundary between the Christian and Islamic worlds, seeking the wisdom of the ancients. After the Europeans seized Constantinople in 1204, an increasing number of manuscripts became available in the original Greek, and scholars were able to make direct translations into Latin rather than working from intermediate Arabic sources.

It is tempting to regard these translators as little more than diligent scribes, fluent in languages but mechanical in transcribing them. That is by no means so; many were original thinkers. Constantine of Africa was an influential teacher at the great Italian medical school of Salerno, while Adelard of Bath studied at Chartres and provided perhaps the most elegant and dignified defence of science ever uttered: 'If we turned our backs on the amazing rational beauty of the universe we live in, we should indeed deserve to be driven therefrom, like a guest unappreciative of the house into which he has been received.' He makes it clear that, contrary to what Bertrand Russell claims, some medieval thinkers were fully aware of their capacity for original thought. But they found it expedient to disguise their creativity, to hide their new wine in old flasks, so that others would take them seriously. 'Our generation', Adelard wrote ruefully,

has this deep-rooted defect: it refuses to accept anything that seems to come from the moderns. Thus when I have a new idea, if I wish to publish it I attribute it to someone else and I declare: 'It is so-and-so who said it, not I.' And so that I will be completely believed, I say of all my opinions: 'It is so-and-so who invented it, not I.' To avoid the disadvantage of people perhaps thinking that I myself, a poor, ignorant man, derived my ideas from out of my own depths, I make sure they are believed to have come from my Arab studies . . . I know what the fate of original thinkers is among the vulgar; thus it is not my case I am presenting, but that of the Arabs.

This explains why so many of the supposed works of philosophers and savants from antiquity to the Renaissance are apocryphal: attributing a book to Pliny or Avicenna greatly increased its chances of being read.

Adelard's complaint was no doubt justified, but the appearance in western Europe of classical texts and the interpretations and additions of the Islamic authors was surely a major impetus behind the emergence, in the eleventh and twelfth centuries, of thoughtful, probing men like him. This period was marked by a revival of learning and enquiry that was more profound than the institutional bibliomania of the 'Carolingian renaissance'. Now there was an alternative to the rote-learning of texts at the ecclesiastical schools or the blind faith of the abbeys: the path of reason, scepticism and questioning opened up before men such as Adelard more clearly than ever it did for Augustine. Out of the subsequent clash of ideologies came the age of the cathedrals.

Against Reason

There is no better illustration of this struggle, and of what was at stake, than the dispute which took place in the early part of the twelfth century at the same time as a new way of looking at the world was being formulated at the Chartres cathedral school. Its protagonists were, in their different ways, two of the most influential men of their age – both of them difficult, contradictory and extreme personalities, who might well stand as the two prototypes of the French intellectual during the twelfth-century renaissance.

Ever since Augustine, there was opposition to the notion of trying to understand the world. Leading that attack in the early twelfth century was one of the most powerful men in Europe: Abbot Bernard of Clairvaux. Bernard was, as we have seen, responsible almost single-handedly for the flourishing of the Cistercian Order, but there are few historians today (if they do not wear a white robe) who will offer unqualified praise for his achievements. A generous assessment is that St Bernard was simply a man of his time – revered and admired (not to mention feared) all over Europe in the twelfth century, he seems to us now to have been possessed of an ascetic severity that borders on misanthropy. Certainly, it is hard to warm to this 'violent, emaciated

man' who crushed his enemies mercilessly and campaigned vigorously for the fruitless Second Crusade of 1146.

In Bernard the austerity of the Benedictine ideals became almost pathological. There seems to be no space for joy in his world; rather, he believed that life must be lived in fear, for our fate in the afterlife depends on the ineffable grace of God. 'Be fearful when grace smiles on you,' he wrote, 'be fearful when it departs; be fearful when it returns.' Like Augustine, Bernard believed that no man may be certain of his salvation. And from Augustine too he inherited a bitter view of the contemptible nature of humankind, brimming with self-loathing:

> Born of sin, of sinners, we give birth to sinners; born of debtors, we give birth to debtors; born corrupt, we give birth to the corrupt; born slaves, we give birth to slaves. We are wounded as soon as we come into this world, while we live in it, and when we leave it; from the soles of our feet to the top of our heads, nothing is healthy in us.

His disgust at the decorative excesses of the Cluniac churches seems to stem not just from a belief that piety demands simplicity but also from an almost philistine attitude to the arts: he called representational art 'monstrous', and banned it from all Cistercian churches and works. (This proscriptive injunction was not always observed.) His tirade against gargoyles speaks of his impatience with anything frivolous or exuberant in humankind:

> What purpose is there in these ridiculous monsters, in this deformed comeliness, and comely deformity . . . in these unclean apes . . . monstrous centaurs . . . this creature with many heads united to a single body . . . this four-footed beast with a serpent's tail? . . . For God's sake, if men are not ashamed of these follies, why at least do they not shrink from the expense?

Yes, it is hard to feel much sympathy for this cold, sometimes vicious and vindictive man. But we should hesitate before making him into a cartoon villain. He did much to stem the persecution of the French Jews, arguing that one should rather convert than condemn them. There seems nothing Machiavellian in his political manoeuvres: his convictions may seem harsh and barren, but they were genuine. And

it appears that even he was baffled by the intensity of his own censor-
ial urges: 'All my works frighten me, and what I do is incomprehen-
sible to me', he confessed.

Erwin Panofsky accuses Bernard of being 'blind to the visible world
and its beauty', pointing out that he is said to have ridden for a whole
day on the shores of Lake Geneva without casting a single glance at
the scenery. He complained how fine sculptures in the cloisters would
distract monks, leading them 'to spend the whole day in admiring
these things, piece by piece, rather than meditating on the Law Divine'.
But this denial of beauty does not necessarily imply indifference
towards it; in fact, Bernard writes almost with yearning, and certainly
with perspicacity: 'his analysis of what he rejects is extraordinarily
fine', says Umberto Eco. 'Don't allow yourself to be ignorant of beauty
if you do not want to be confounded by the ugly', Bernard said,
making clear that he was neither blind to beauty nor unconcerned by
ugliness. It is possible that his assault on the allures of artistry and
beauty was all the more severe because he felt them so strongly himself,
just as Augustine declared bodily pleasures sinful because he had
yielded to them so wholeheartedly in his youth. Thus, Bernard's renun-
ciation of art may have come at considerable personal cost.

Where he appears at his most conservative, however, is in his
views on what we might call the science of his age. He believed
that God is ineffable and cannot be understood through reason –
in which case it was presumptuous to try to do so. Had not the
Church Fathers, St Augustine in particular, inveighed against
curiosity? The African writer Lactantius in the early fourth century
claimed that it was God's intention that humankind should not
know about the secrets of creation, wherefore he made Adam only
at the end of his labours. It was Adam's pride and curiosity, said
Bernard, that led him to seek 'forbidden knowledge by forbidden
means', and thus to 'the beginning of all sin'.

Such a forceful critique of reason was bound to come into conflict
with the rise of science stimulated in the twelfth century by the influx
of ancient treatises on natural philosophy. Nowhere was this battle
waged more fiercely than in the heart of France, where a man every
bit as argumentative and contrary as Bernard of Clairvaux achieved
fame and notoriety from his defence of the merits of rationality. His
name was Peter Abelard.

The Calamities of Abelard

Peter Abelard (c.1079–1142) was the son of a minor lord of Le Pallet, near Nantes in Brittany, then a duchy more or less independent from the French king. He was the kind of person who, delighting in his own brilliance, could not imagine how it might be improved by listening to others. Rather, the young Abelard was determined to make of himself an intellectual warrior who would ride forth and challenge all the great knights of the French schools to a duel.

Abelard argued that truth must be discovered not by poring over old books or contemplating God in a monastic cell, but by asking questions and looking for answers – as fair a description of the future programme of science as you could wish for. He quoted Virgil approvingly: 'Happy the man who has been able to discern the cause of things.' It was not primarily in natural philosophy that Abelard exerted his undoubtedly prodigious talents, however, but in logic and dialectics. He agreed with the great dialectician of the late eleventh century, Berengar of Tours (who studied under Fulbert of Chartres), that reason itself 'is worth more than any man' and does not need to be backed up by the words of dead authorities.

To prove himself in battle Abelard was naturally drawn to Paris, the intellectual centre of France since the early eleventh century. That fact alone made the city a treacherous Babylon of false learning in the eyes of Bernard: 'You will find much more in forests than in books,' he admonished those who flocked to the Parisian schools, 'the woods and rocks will teach you much more than any master.' But to a scholar such as the Englishman John of Salisbury, an alumnus of the Chartres school in the 1130s, it was paradise. As he said in 1164 in a letter to Thomas Becket,

> I . . . turned my face towards Paris . . . the thrill of this happy pilgrimage compelled me to confess: 'Truly the Lord is in this place, and I knew it not.' It came to my mind how the poet said: 'A happy thing is exile in such a place as this.'*

* John's 'exile' from his home country was necessitated by his support for Becket, who by 1164 was so alienated from the English king Henry II that he was himself forced to flee to France.

In Paris, Abelard's first great bout was fought against William of Champeaux, a philosopher and theologian who became a close friend of Bernard of Clairvaux. William taught at the cathedral school of Notre-Dame, and although Abelard arrived as a pupil, he confesses that 'I became most burdensome, for I sought to refute his teachings, frequently attacked him by reasoning against him, and sometimes seemed to be superior to him in disputation'. Their argument was over the vexed issue of universals: the question of whether general classes or categories of objects, such as 'man' or 'horse', have a real metaphysical existence. For the so-called Realists, to whom William of Champeaux was sympathetic, these categories are concrete entities. This was an attractive notion to a Platonist like Bernard. But the Nominalists, whose position was essentially defined by Abelard's one-time tutor Roscelin of Compiègne in the late eleventh century, maintained that such classes are merely conventions and mental constructs, and that only the particular, tangible examples of them are real things. This seems an abstract, even an obtuse, issue today, yet to these men the whole of philosophy rested on the rights or wrongs of Nominalism. Indeed, the debate was in a sense a restatement of the conflict between Platonic transcendentalism and Aristotelian concreteness. 'In the Paris of the twelfth century', says Abelard's biographer Roger Lloyd, 'all academic discussions led sooner or later to the problem of problems, the question of Nominalism and Realism.'

Abelard adopted a Nominalist position, but he did not merely echo Roscelin. Whereas the debate had been conducted previously in isolation from other philosophical issues, Abelard was searching for an entire system of logic, an integrated framework within which a Nominalist standpoint could be seen as consistent with the other elements. This need for consistency in a philosophical scheme may seem obvious today, but it was not strongly felt in the early Middle Ages. Yet to Abelard there was no value in winning a debate by clever rhetoric or scriptural evidence unless one's argument dovetailed with the rest of one's ideas. In this sense it was not the materials he had at his disposal that made Abelard an intellectual innovator, but the way in which he constructed philosophical propositions with them.

But Abelard was not merely argumentative – he was a polemical point-scorer who could see no motive other than jealousy in his opponents and who used every opportunity to ridicule them. With some

justification he has been accused of being 'possessed with an inordinate impulsion to undo his rivals'. It is not hard, in reading Abelard's account of his youth, to understand Bernard's fear that dialectic would lead to vanity and empty posturing: that's not all there was to Peter Abelard, but there was plenty of it in the mix.

Abelard pursued his battle against William with martial rigour and determination, even comparing it to the struggle between Ajax and Hector. His attitude precipitated his expulsion from the Paris school, but he took a band of followers with him and set up his own school at Melun on the Seine. His attacks were eventually so damaging to William of Champeaux's reputation that William left the Paris school himself and set up a new theological academy at a Parisian hermitage called Saint-Victor.

Realizing that skill in dialectic alone would not advance his career in the Church, Abelard went to study theology at Laon with William's own teacher, Anselm, who was by then an old man. Characteristically, Abelard was unimpressed. 'He had a miraculous command of words', he wrote, 'but was contemptible in sense and empty of reason.' Abelard decided that there was nothing to be gained by sitting at the feet of such teachers, and that in any case the Scriptures were easy enough to comprehend without devoting long hours to studying the Patristic glosses. So he began, without any prior training, to teach them himself. Anselm was outraged and forbade it, and so Abelard returned to Paris, where he thrived as a teacher at the cathedral school.

It was here that he seduced Heloise. That, according to Abelard himself, is entirely the right word to use. Devotees of the romantic fable will be disappointed by his account of how, at almost forty years of age, he calculatedly selected the young niece of a canon named Fulbert as the target of amorous conquest. The many sentimental retellings of this tale have more to say about the times in which they were written than about Abelard and Heloise. After all, we know virtually nothing about Abelard's lover that does not come from Abelard himself, and he is not a reliable source. What he wrote about his personal life was, like so much medieval 'documentary' literature, intended not as history but as moral rhetoric that we would be foolish to take at face value. He recounts his story in the *History of My Calamities*, the first of the famous *Letters of Abelard and Heloise*; but the *History* is no more an autobiography than the *Letters* are genuine messages between the former

lovers. The *Letters* seem to have been written as an instruction manual for the nunnery that Heloise later led. They were intended to be bound and kept in the library; to read them as one might the correspondence of nineteenth-century lovers is an anachronistic exercise that destroys their real meaning. For while it seems likely that Abelard was indeed as arrogant in his youth as he portrays himself to be, the person in the *History* is merely a symbol of vanity. And the 'continuing passion' that Heloise at first confesses for Abelard* simply establishes her need for spiritual succour, which she eventually finds (and which the nuns would be expected to find) by binding herself to the nunnery.

At any rate, Heloise fell pregnant from their affair and gave birth to a son named Astrolabe. But she resisted the role of wife for fear that such domestic banality would impair Abelard's reputation and abilities, it being a common belief at the time that sexual continence and chastity were good for a man's powers of reason. Fulbert, infuriated by the refusal of the 'lovers' to adopt a conventional husband-and-wife relationship, incited his friends to an act of terrible violence. One night they burst in on Abelard and castrated him. Shamed as much by the loss of his reputation as of his manhood, Abelard fled to the abbey of Saint-Denis.

But his experiences had not instilled much contrition in Peter Abelard. His controversial ideas about the Trinity, whom he seemed to portray as three separate deities, led to a summons before a church council at Soissons in 1121, at which his work was condemned. He then had the temerity to suggest that the patron saint of Saint-Denis (and of the entire kingdom of France) was not the man they thought he was: he had become historically confused with a Greek named Dionysius who was converted by St Paul in Athens (see page 241). One could not make such accusations with impunity, and Abbot Adam of Saint-Denis decided that the troublemaker should be handed over to the king for judgement. He fled; but after Adam died in 1122, his conciliatory successor Suger persuaded the Royal Council to let Abelard be. He set up a hermitage

* It is not at all clear that any of Heloise's letters were actually written by her. Some historians consider the correspondence too contrived and ornate to be genuine, or else too similar in style to be the work of two different hands. Others have claimed that Abelard's entire *History* is a forgery, or at least that it was not written by Abelard himself.

near Troyes, which he named the Paraclete.* Soon students were drawn there to hear this reputedly brilliant master, and the place grew into a school.

Abelard's unorthodoxy and his passion for cross-examining the Scriptures under the spotlight of reason were bound to draw condemnation from Bernard of Clairvaux. To escape his powerful persecutors, he took on the abbacy at Saint-Gildas-de-Rhuis in Brittany, and for ten years from 1125 he wrestled with the 'wicked and unmanageable habits' of the Breton monks, who refused to be reformed and even tried to rid themselves of his meddling by poisoning his food. During this time, Abelard proposed that the Paraclete, which had become a moribund institution, should be made a nunnery, with Heloise at its head.

Abelard left Saint-Gildas (in little better condition than he found it) in 1135 and returned to Paris, where John of Salisbury saw him teach at the school of Mont-Sainte-Geneviève. Like many churchmen, he was aware that the writings of the Church Fathers were not always consistent with one another, and in his book *Sic et non* he suggested that these inconsistencies should be reconciled not by pedantic scholasticism but by using the criteria of reason. *Sic et non* is something of a sceptic's manual (the historian Constant Mews calls it an 'invitation to thought', which is perhaps the same thing). It collates extracts from authoritative texts that offer opposed views on many propositions of the Christian faith, implying how difficult it is to really know the truth.

Naturally, there was much that was provocative in this position. Abelard was persistently criticized by William of St Thierry, abbot of the Cistercian monastery of Signy-l'Abbaye in the Ardennes, who, apparently lacking the intellectual confidence to engage in dispute himself, wrote to his former master Bernard of Clairvaux imploring him to expose what this wretch was up to. Bernard had little appetite for academic theological debate; for him, study was about devotion, not learning. 'My masters are not Plato and Aristotle, but Christ and the Apostles', he said. But bookishness was worse than useless when it produced ideas as unorthodox as those he discovered in Abelard's

* This word, from the Greek *Parakletos*, 'one who consoles', is used in the Gospel of St John, and was considered by early Christians to refer to the Holy Spirit. John says that another comforter or 'paraclete' will follow Jesus and console his disciples.

work. Take, for instance, Abelard's views on sin, which could hardly be further from his own harsh position. 'Sin has no reality', said Abelard, pointing rightly to the way that men like Bernard turned it into a denial of humanity: 'It exists rather in *not being* than in *being*. Similarly, we could define shadows by saying: The absence of light where light usually is.' Abelard did not deny that people could be sinful, but he did not consider this to be the fundamental human condition, and he felt it should be remedied not with punishment but with sincere contrition: 'Sin does not persist along with this heartfelt contrition which we call true penitence.'

This was vexing enough to Bernard; but Abelard truly overstepped the mark when he suggested that those who do evil without intending it do not sin. Even the men who crucified Christ, he said, were blameless in so far as they were just doing their duty. 'The crime lies in the intending', Abelard claimed, 'not in the doing.'

Castigated by William and Bernard, Abelard requested an opportunity to defend himself against his detractors, and he was summoned to a debate at Sens in 1140. Here Bernard presented his prosecution in a work unambiguously titled *Treatise Concerning the Errors of Peter Abelard*, in which he did not hesitate to exaggerate his opponent's views so as to present him in the worst possible light. He called Abelard a heretic who 'is trying to make void the merit of Christian faith, when he deems himself able by human reason to comprehend God altogether'. It was gross impiety, Bernard charged, to shine the spotlight of reason into every corner of God's creation: 'he goes farther than is meet for him . . . Of all that exists in heaven and earth, he maintains, nothing is unknown to him unless it be himself . . . This man is content to see nothing in a glass darkly, but must behold all face to face.'

At Sens, Abelard's nimble rhetoric and logic proved no match for Bernard's political acumen. His works were denounced, and Bernard pressed the matter with Pope Innocent II, who duly issued a condemnation in 1141. Humiliated for a second time, Abelard decided to take his appeal directly to Rome. But by now he was a sick man, wearied by his tribulations. He got only as far as the abbey of Cluny before his health prevented him from continuing. The abbot was Peter the Venerable, a tolerant and sensitive man who did much to re-establish the good reputation of the Cluniacs in the mid-twelfth century. Not

only did Peter welcome Abelard warmly but he even brokered a recon-
ciliation of sorts with Bernard. In 1142 Peter sent the ailing Abelard
to the monastery of Saint-Marcellus near Chalon-sur-Saône, where he
died. Peter's final act of kindness was to send a letter to Heloise at
the Paraclete that was a model of delicacy, informing her that her
former lover had passed away.

We should resist the idea that Peter Abelard was a lone martyr to
logic and reason in an anti-rational age. Aptly called a 'prince of egoists'
by the historian Christopher Brooke, much of what he said seems to
have been motivated by ambition and by a desire to impress with
dazzling intellectual displays. It was at the cathedral school of Chartres,
as we shall see in the next chapter, that reason and science found more
sober and systematic champions. But Abelard undoubtedly contributed
to a climate in which an inquiry into nature could take root. His
staunch defence of Nominalism, which earned him the vividly apt
nickname of *Rhinocerus indomitus*, helped to encourage people to study
the particular and thus to anchor the abstract tendencies of Platonism.
And he refused to be cowed into capitulating all knowledge to an
unknowable God. It was Abelard who (controversially as ever) coined
the very word 'theology' for the study of the Scriptures, calling one
of his works *Christian Theology* – before that, the term was used only
for the study of pagan beliefs. Here as elsewhere he argued for debate
and for a healthy scepticism rather than for the stock answers of the
theologians: 'We seek through doubt, and by seeking we perceive the
truth.'

5

Building by Numbers

Science and Geometry at the School of Chartres

We are amazed at certain things because they fit together in a clever and harmonious way, so that the very planning of this work seems to a certain extent to indicate the particular attention and care of the founder.

Hugh of St Victor, twelfth century

A considered arrangement of symmetries and repetitions, a law of numbers, a kind of music of symbols silently coordinate these vast encyclopedias of stone.

Henri Focillon, *Art of the West*, 1963

The West Front and the Royal Portal

One of the joys of Chartres is that the square or *parvis* in front of the west end of the church has been kept free and uncluttered, so that you can appreciate this main entrance from a distance. As we have seen, this western mass escaped the great fire of 1194: it dates from the 1140s, when the Gothic style was still barely imagined, its earliest experiments being conducted at that moment at Saint-Denis. The west porch is flanked by two towers, built at more or less the same time but rather different in design. They are square in cross-section, but the uppermost tier of the south tower modulates cunningly into an octagonal form in preparation for its spire. Two great bells, weighing 13 and 10 tonnes, once hung up here; but they were melted down in 1793 to make cannons for the

Revolutionaries. The north tower, which was begun immediately after the fire of 1134, was given a wooden steeple that was set ablaze by lightning in the fifteenth century. The stone spire that crowns the tower today was built at the end of the Gothic period, between 1507 and 1513, by Jean Texier, known as Jehan de Beauce, and in consequence it is encrusted with elaborate flourishes, crockets and curlicues that are quite out of keeping with the simplicity of the twelfth-century church. Jehan also added the little clock pavilion at the foot of the north tower around 1520.

The north tower has windows on all sides, even that facing east into the church, indicating that it was initially free-standing to the west of the entrance to Fulbert's church. It seems the plan was to link the western mass to the main church via a covered courtyard or portico. The fine sculptural work that now adorns the western entrance (the Royal Portal) was originally intended for a new entrance into Fulbert's church from the east side of this portico. But Geoffrey of Lèves seems to have altered this plan while the south-west tower was still being built, deciding instead to extend Fulbert's nave to meet the new towers. Work was in progress on both towers by 1145. Just the lower section of the wall that bridges them, with its three lancet windows, dates from this mid-twelfth-century rebuilding; the west rose window was added when the Gothic church was constructed. In fact this west front was initially set back between the two towers – only in 1150 was it advanced to become flush with the western faces of the towers.

While in most cathedrals with a triple west portal the flanking doors open *through* the towers onto the aisles of the nave (they do so at Notre-Dame de Paris, for instance), the initial lack of connection between the west towers and the old church of Chartres means that its three portals are squeezed *between* the towers so that they all open onto the nave. This curious history is also revealed by the fact that the builders did not quite get the towers aligned properly with the centre-line of the nave – when they were joined up, it was found that this line passed slightly to the south of the midpoint between the towers. As a result, the southernmost portal, which was designated to take some of the sculptures already

prepared for the more easterly entrance that was originally planned, had to be made slightly narrower than intended. On the lintel above this door, the lying figure of the Virgin was clearly intended to be central, but is displaced slightly to the right, while one of the three shepherds has suffered the indignity of being sawn in half. It is worth noting too, lest we be inclined to enter into raptures about the perfect proportions of Chartres, that the difference in size between the two towers has created a difference in the proportions of the first bay of each aisle. Even with the best of intentions, sometimes the builder's job had to be a little makeshift.

A visitor to Chartres could easily stand arrested on this threshold for an hour or more, browsing through the library of warm, tawny stone that is the Royal Portal. This grand entrance represents many points of transition: from the sunlight of Beauce to the mysterious gloom of the great church, of course, and thus from the secular to the divine world; but also from the Romanesque to the Gothic, and from the age when God was feared to a time when it was believed that his works could be understood.

Although the three portals have pointed arches, their form is rooted in the Romanesque tradition, as are the statues that grace them in such profusion. But the wild vitality of the sculpture at Vézelay and Autun is replaced here by something calmer, less fantastic and more ordered and majestic.

There is almost too much to take in. Figures crowd across the frieze below the capitals of the jambs, and they fill the archivolts arrayed three deep over the central portal. But let's focus our attention on the southernmost door, and in particular on the figures around its two archivolts. Nearly all of the images shown on the portals are biblical, but the characters depicted here do not appear in any books of the Scriptures. These men are, for the most part, pagans: philosophers and writers from ancient Greece and Rome, and here they represent the seven liberal arts that constituted the intellectual syllabus of the Middle Ages. Each of these scholars is accompanied by a female figure personifying the respective academic discipline.

Geometry is denoted by Euclid, rhetoric by the Roman writer

Cicero, while Aristotle stands for dialectics. Boethius represents arithmetic, and Ptolemy astronomy. Bent over a writing desk on his knees, Pythagoras is accompanied by a woman playing an array of bells, depicting music, while grammar is embodied by a figure who is either Donatus or Priscian, both renowned Roman grammarians.

These savants were, where necessary, welcomed as honorary Christians because of the light that their learning had shed on the world. Erected while the cathedral school was led by the progressive humanist Thierry of Chartres, the Royal Portal reveals how the Chartrain scholars were intent on mining the ancient world for new, rational understanding of the physical world. Their blend of Platonic philosophy and logical inquiry created an intellectual tradition that led to the growth of early science in the following century, and to the notion of a universe governed by order.

There are around 1,800 images and scenes carved into the stones of Chartres. But most of them are out of view – or would have been to a worshipper of the twelfth century, lacking powerful binoculars to spy out high nooks and remote, shadowy galleries. They were chiselled with great care and sensitivity by a skilled mason, and then carried to some location where the artist could not expect them to be seen again by human eyes.

This apparent perversity tells us everything about the philosophy with which Chartres was constructed, and it could hardly be more different from 'modern' ideas about the uses and functions of art. When Titian painted an altarpiece three hundred years later, he would have thought as much about his wish to impress the onlooker as about the picture's function as an offering to God. But for many of the sculptors of Chartres, God was the only audience they thought they would ever have, and he was the only one they needed. It really did not matter to these men whether any mere mortals saw, appreciated or understood what they had done. The building was a sacred symbol, and every part had the primary function of expressing piety and encoding a belief in divine order.

We no longer know how to read this code. It unites the physical

with the metaphysical: according to Abbot Suger, building a church involved the transposition of the material into the spiritual. Artists of later ages, even until the present, have tried to achieve something analogous, but they have had no rules to guide them. Their attempts to forge materials into an expression of the ineffable therefore become highly personal visions, reflections of one individual's spiritual world.

The theoretical principles governing the construction of the Gothic cathedrals were geometry and clarity. The structure of these buildings is dictated by proportion, by simple numerical relationships between the key dimensions. These mathematical relations were deemed to be expressions of perfection, a belief that stemmed from ancient Greek thought and for which some found endorsement in the Bible. So when we experience unity and order in Chartres Cathedral, it is the result of careful and rational planning, motivated not by aesthetics but by morality. The building expresses a conviction that the glory of God's universe is expressed as a system of eternal order. This was a belief fostered in the early twelfth century at the cathedral school of Chartres itself.

The School of Thought

The cathedral schools were not merely centres of religious education but academies where students acquired a general education in the arts, literature, sciences and philosophies, both Christian and pagan. As at the monasteries, one learnt of course to be devout, to study the Scriptures, and to love God; but the schools were also places where one could learn about the world.

This isn't to say that their academic programmes were necessarily either rigorous or liberal: they could be patchy, dogmatic, and highly dependent on the quality of the masters. In the tenth century Gerbert of Aurillac had to travel to Reims to get decent tuition in dialectics, while Abbo of Fleury could find satisfactory instruction in music only at Orléans, and in astronomy only at Reims. But in principle at least, students at the cathedral schools were given a rounded education in the academic disciplines that comprised the *trivium* and *quadrivium*. The conservative scholastic tradition, which flourished at the schools of Paris, Orléans and Laon, favoured the *trivium* of rhetoric, logic and dialectics, often applied in pedantic detail to fine points of scriptural

analysis. At the Chartres school, on the other hand, the emphasis was on the *quadrivium* of arithmetic, music, geometry and astronomy, considered at that time to represent the four mathematical 'sciences'.

Students went where the best masters were, while masters might rove with skills for hire or, like Abelard, set up their own academies. Thus both teachers and pupils could find themselves in a city far from the one where they were born. In an age in which cities tended to function as self-contained mini-states, this meant that their rights as 'foreigners' were curtailed considerably, and they recognized the benefits of cementing their academic community into something akin to a trade guild. These trade organizations were sometimes called *universitas*, meaning totality, and this term became transferred during the twelfth century onto associations of masters and students. At first, a 'university' might comprise just a particular faculty, such as that of medicine or theology; but by the thirteenth century it had come to denote the *studium generale*, the collective organization of a school. By 1200 there was a 'university' in Bologna, in Paris and in Oxford.

The cathedral school at Chartres never became a university in this sense. But it was unquestionably one of the major centres of learning in France – aside from the school of Paris, it had no peer. This was due to a succession of extraordinary chancellors during the twelfth century, all of them fundamentally like-minded men who seem to have combined administrative ability and dynamism with prodigious intellect and that most controversial of endowments, curiosity. It is no exaggeration to say that the impulse to understand the world, which found a voice in thirteenth-century Oxford and flourished in the great universities of Renaissance Italy, found its first medieval expression in the chilly chambers that clustered around the imposing Romanesque church of Chartres. When that church had to be rebuilt at the end of the twelfth century, it was inevitable that the progressive spirit of the cathedral school's golden age should have infused and literally shaped the stones themselves.

The eminence of the Chartres school was kindled by the man whose effigy now stands in front of the cathedral's twin spires. The Italian Fulbert of Chartres (born *c.*960–70) was a pupil of the great tenth-century scholar Gerbert of Aurillac, a man so learned in mathematics and the sciences that, despite becoming the first French pope (Sylvester II) in 999, he was rumoured to be a magician in league with the devil.

Gerbert was not content to take his learning from the simplistic glosses and summaries of ancient works in common currency at the cathedral schools; he studied at first hand the logic of Porphyry and Aristotle. It is said, apocryphally, that he invented the pendulum clock (an innovation more plausibly associated with Christiaan Huygens in the seventeenth century) and that he helped to spread the use of Arabic numerals and the abacus. Fulbert studied under Gerbert at Reims, where the cathedral school was at that time just about the only intellectual centre in France that could rival the German schools. Around 990 he arrived in Chartres, where he became chancellor of the chapter and head of the school. He was made bishop of Chartres in 1006, a position that he occupied until his death in 1028.

Characterized as the 'Venerable Socrates of the Chartres Academy', Fulbert established the cathedral school as a haven for rational and progressive debate. He seems to have been one of those people who, although not startlingly original, leaves his mark through an ability to inspire others. 'Without himself writing anything great, or starting any new line of thought,' says Richard Southern, 'he was able, by his sensitivity to what was going on around him, by his encouragement, and his genius for drawing men to him, to make the school of Chartres the most vigorous in Europe.' He combined a great breadth of interests with administrative skill and a moderation of temperament that won other men's confidence. Thanks to Fulbert, Chartres became for at least a hundred years one of the principal conduits of Arabic science and mathematics, and it was here that these discoveries became integrated into Christian thought. The Chartrain Socrates knew about the latest developments in astronomy and arithmetic; his pupils learnt the Arabic names for the stars, and he is credited with introducing the astrolabe (a device for predicting the positions of the stars) into Europe.

But Fulbert's principal interests were in logic and grammar rather than science. It would not do, he said, to rely on abuse, dogma and assertion in arguing one's case, as was the schoolmen's habit. If someone disagreed with your point of view, you did not call him a dunderhead and hunt down a text from the church patriarchs showing he was wrong. You listened to his position and cross-examined it systematically. Fulbert instilled that attitude in his most celebrated student, Berengar of Tours, who sharpened the analytical and dialectic tools needed to conduct debates in this manner. Berengar acknowledged that the holy texts and

Scriptures were indeed ambiguous, and he felt that their true meaning could be extracted only by careful examination of the words, based on the principles of logic. Nothing was too sacred to be exempt from this method. By applying dialectic thinking to the Eucharist, for example, Berengar felt compelled to deny the doctrine of transubstantiation (for which he was duly condemned by the Church). Anselm of Bec, author of the ontological proof of God's existence, was another product of this school of rationalistic grammarians.

Until the early eleventh century the main centres of learning were the monasteries; the monks tended to view cathedral schools as undisciplined and degenerate. But Fulbert's school was one of the institutions that reversed this conception. The library of Chartres accumulated new translations of the works of ancient writers and philosophers. Here pupils could hone their rhetorical and literary skills by studying Livy, Virgil, Ovid and Horace; for logic and science, they read Porphyry, Boethius and Aristotle's *De interpretatione*. Tragically, nearly all of this collection was destroyed in the Second World War.

On Giants' Shoulders

After Fulbert's death, the school did not see his equal until the early twelfth century. It was then the cathedral's good fortune to acquire several able chancellors who did for the school's reputation what the politically astute bishop, Geoffrey of Lèves, did for the standing of the Chartrain episcopate. A friend of Bishop Stephen of Paris, Geoffrey was intimate with the most powerful churchmen of the age: his integrity was praised even by Bernard of Clairvaux. Geoffrey was bishop of Chartres from 1116 to 1149 – throughout the school's golden age – and his appointment as papal legate in 1132 raised the status of the city. A man of honour, he showed by his defence of Peter Abelard before the Council of Soissons that he could stand up for rationalism without alienating its opponents.

Geoffrey's first appointment as head of the school was a Breton, Bernard of Chartres, who became chancellor around 1119. What little we know of Bernard is derived from the writings of John of Salisbury about half a century after his death; but if John is to be believed,

Bernard was a deeply learned and venerated man, 'the most perfect Platonist of his time'. John says that Bernard introduced his students to a range of philosophies, while taking care to adapt his teachings and his methods to the abilities of his audience:

> Such is the method that Bernard of Chartres followed, this well of learning, a man more well read than they are today. When he read and commentated on the great writers, he showed what was simple and conformed to rules . . . He highlighted the relationship of the passage studied to the other disciplines. He took care, however, not to teach everything about everything, but considered the capacity of his audience, giving them at the right time the amount that he knew they could manage.

Bernard's most abiding contribution to the intellectual world was to provide us with a vivid image of how knowledge progresses by building on its antecedents. 'We are dwarfs on the shoulders of giants,' he said, 'so we perceive more things than they do.' Isaac Newton claimed the phrase for science in the seventeenth century (while allegedly also using it as a barb to injure his short-statured enemy Robert Hooke). Bernard may have been merely paraphrasing a remark by Priscian; but if so, how memorably!

The grammarian Gilbert de la Porrée (c.1075–1154) became chancellor of the school after Bernard's death, and was succeeded in 1142 by the greatest of the 'scientific' chancellors, Thierry of Chartres, who was most probably Bernard's younger brother. For Thierry, the sciences of antiquity not only were consistent with Christian theology but were the essential tools for understanding God's creation. In *On the Seven Days and the Distinction of the Six Works* he explained how the story of Genesis can be understood in terms of the classical elements. Indeed, he said, one cannot truly comprehend God's creation without being familiar with mathematics and with the account of matter and its transformations expounded in Plato's *Timaeus*. Here the Greek philosopher explains that the four elements, earth, air, fire and water, are composed of fundamental particles – atoms, as Democritus called them in the fifth century BC – with geometric shapes that account for the way they can be interconverted. 'Let us begin with what we now call water', says Plato.

We see it, as we suppose, solidifying into stones and earth, and again dissolving and evaporating into wind and air; air by combustion becomes fire, and fire in turn when extinguished and condenses takes the form of air again; air contracts and condenses into cloud and mist, and these when still more closely compacted become running water, which again turns into earth and stones. There is in fact a process of cyclical transformation.

Thus, Plato says, 'The names fire, air, water, earth really indicate differences of quality, not of substance.' He goes on to explain that, since the atoms of these elements are composed of polyhedral bodies with geometric faces – triangles and squares – these bodies may fall apart when 'surrounded by [particles of] fire and cut up by the sharpness of its angles and edges', after which they may be reconstituted into atoms with different shapes.

This Platonic cosmology provided Thierry with a physical description of the material world that he forged into an explanation of the biblical Creation. The medieval Platonists found in the *Timaeus* a universe that was consistent with their own sense of a natural hierarchy, consisting of concentric spheres with earth (the mundane world) in the centre, surrounded by water, then air, and finally fire, which extends from the orbit of the moon to the firmament of the stars. Plato himself talks of how this universe was created by a supreme deity; as he says, 'God placed water and air between fire and earth, and made them so far as possible proportional to one another, so that air is to water as water is to earth; and in this way he bound the world into a visible and tangible whole'.

Thierry and his contemporaries at Chartres considered that this account must equate with that in Genesis. Fire, said Thierry, vaporized some of the water surrounding the earth and let it ascend to the firmament, dividing the waters so that dry land might appear. From the moisture in the mundane sphere, plants were formed. The water in the firmament condensed to form the stars, which then gave warmth that allowed birds and fishes to appear in the rivers and seas, and animals on the earth.

As we've seen, Platonism had profoundly influenced Christian thought at least since Augustine's time. But it was not until the flourishing of the Chartres cathedral school in the twelfth century that the 'scientific' passages of the *Timaeus* were given due consideration. These

were virtually unique in ancient literature in discussing how the universe was built up from the elements and in presenting thereby a fundamental theory of the physical universe and its cosmogeny. Moreover, the *Timaeus* supplied extraordinarily fertile soil in which a primitive physics could germinate. For instance, it implied that each element tends to collect together on its own, which explained the action of gravity: stones fall to earth because they are drawn to the primal earthy sphere at the centre of the universe. Likewise, fire tends to rise towards the fire of the firmament. These notions sometimes spawned surprisingly 'modern' ideas about gravity. John Scotus Eriugena, an avid Platonist himself, suggested that in effect the strength of gravity (that is, the heaviness of a body) varied according to its distance from the centre of the earth; Adelard of Bath asserted that a stone dropped into a hole passing through the earth would stop at the centre. The *Timaeus* also furnished the medieval Platonists with physical theories of sensations, colour, physiology, disease and mental health.

When Thierry's student, the philosopher Clarembaud of Arras, called him the most important philosopher in all of Europe, it was not simply the habitual genuflection of a medieval pupil towards his mentor. The renowned translator Hermann of Carinthia suggested that the heart of Plato was reincarnated in the famous master of Chartres, and in 1143 he dedicated his translation of Ptolemy's *Planisphere* to Thierry. Under Thierry Chartres drew students from all over Europe, who came to learn the liberal arts and to read what the ancient and Islamic writers had to say about them. Thierry admits that some of these pupils were of decidedly indifferent quality, so that in the end he became compelled to shut out of his classes 'the ignorant mob and the mish-mash of the schools . . . those who counterfeit genius, hating study, and those who claim to study at home, pretending to be teachers, and the clowns of scholastic disputation, armed with fistfuls of inane words'.

For Thierry, the world was systematic: what was true here must also hold there. It is this belief in pervasive principles that vindicates the words of historian Thomas Goldstein, who asserts that some day Thierry will probably be recognized as one of the true founders of western science.

The Possibility of Science

The programme that Thierry began was consolidated by an unruly Norman, William of Conches (*c*.1085–*c*.1154), and his sometime pupil, the sober Englishman John of Salisbury. William was just the sort of provocateur that an intellectual transformation needs; John was the kind of conscientious scholar required to sustain it.

William of Conches studied under Bernard of Chartres, and began teaching (most probably there at the cathedral school) around 1120. But it seems that this irascible philosopher fell out with the bishop, and was soon blaming bishops everywhere for a decline in teaching standards. He said that they engage men 'without learning, without distinction, mere shadows of clerics', who will never challenge or contradict them. In his dialogue *Dragmaticon*, he charged that

> Most of these prelates seek in the whole world of pork butchers and skilful meat carvers to make poivrades and other delicacies. As soon as they find them, they cling to them at all costs. As for we philosophers, they flee from us as if from lepers. But to disguise their true villainy, they accuse us of pride, scandal, and all other crimes.

He went to the court of Geoffrey le Bel, Plantagenet count of Anjou, where he became tutor to the count's heir Henry, later Henry II of England. He was more interested in the sciences than in theology, and his *Philosophia mundi* provided twelfth-century Europe with its first comprehensive treatise on the physical world. It was a thoroughly rationalistic tract that made ample use of the new translations of Greek and Roman natural philosophy. Like his colleague Thierry, he used the elemental theory of the *Timaeus* to concoct a picture of how the stars were formed and how life began. He argued that natural phenomena arise from forces that, while of course created by God, may now act under their own agency. This system of nature, William insisted, is coherent and consistent, and therefore accessible to human reason: if we ask questions of nature, we can expect to get answers, and to be able to understand them.

That is a necessary belief for one even to imagine conducting science. If everything is governed by the whims of God, there is no guarantee

that a phenomenon will unfold tomorrow in the same way as it does today, and there is then no point in seeking any lawlike consistency in nature. William of Conches had no time for a Creator who was constantly intervening in the world. Rather, he envisaged the universe as a divinely wrought mechanism: once God set the wheels in motion, they would run of their own accord. It was in the twelfth century that one can find the first references to the universe as *machina*.

Just as essential to the scientific model is the notion that these natural laws are sufficiently simple for the human mind to comprehend. Like modern scientists (although perhaps for different reasons), William trusted that God's natural laws are well ordered and harmonious – for that was, as Plato attested, the very hallmark of the divine. Why, after all, would God have given us reason if the universe were not fashioned on the same principle?

Some regarded this attempt to develop a Christian Platonic natural philosophy as misguided. For all that he shared Augustine's Neo-Platonic convictions, Bernard of Clairvaux denounced Peter Abelard's use of the pagan Greek philosopher, saying that 'By making Plato into a Christian you are only showing that you yourself are a heathen.' To such attacks, William of Conches responded, 'If anyone considers not only Plato's words, but his meaning, he will find not heresy, but the most profound truth hidden under the covering of words. It is this that we, who love Plato, will make clear.'

Yet, as we have seen already, to take too strong an interest in nature as a physical rather than a moral entity was to invite accusations of blasphemy. What wicked hubris this was, according to Absalom of St Victor, this study of 'the composition of the globe, the nature of the elements, the location of the stars, the nature of animals, the violence of the wind, the life-processes of plants and of roots'. Since everything was surely determined moment by moment by the will of God, it was not only futile but impious to seek anything akin to what we would now regard as physical law, since that would be like trying to second-guess God at his own business.

The quest for laws of nature was also deemed improper because it seemed to constrain the omnipotence of God. That was what led the eleventh-century Italian cleric Peter Damian to cast doubt on all knowledge, saying that since God could act however he willed, no one could be certain about anything. William of Conches had an answer to that.

'One will say that it conflicts with divine power to say that man is made thus. To this I respond: on the contrary, it magnifies it, since we attribute it to Him to have given things such a nature, and thanks to this nature, to have created thus the human body.' He was not so unwise as to suggest that God was indeed bound by the laws he created; but, displaying a pragmatism that philosophers have frequently forgotten, he cannily indicated that this was not the issue: 'Certainly God can do everything, but what is important is that he did such and such a thing. Certainly God could make a calf out of the trunk of a tree, as country bumpkins might say, but did he ever do so?'

Thus the rationalists did not deny that God was the first cause of everything; but if that was where everything began, they did not believe this was where it ended. In his *Quaestiones naturales*, Adelard of Bath recounts a discussion he supposedly had with his nephew, who serves as a foil through which the traditionalist's position can be challenged. Yes, says Adelard, it is God who decides that plants should grow in the ground – but the process is 'not without a natural reason too'. Shouldn't one attribute all natural processes to God alone, his nephew asks? To which Adelard replies:

> I do not detract from God. Everything that is, is from him, and because of him. But [nature] is not confused and without system, and so far as human knowledge has progressed it should be given a hearing. Only when it fails utterly should there be recourse to God.

It would be hard to improve on this as a description of the scientific attitude, or for that matter as a rebuttal to modern fundamentalism; and it serves as an epitome of the programme at Chartres.

But William of Conches was not a man to stand on scholarly argument alone. He was not above giving more salty responses to his accusers:

> Ignorant themselves of the forces of nature and wanting to have company in their ignorance, they don't want people to look into anything; they want us to believe like peasants and not to ask the reason behind things . . . But we say that the reason behind everything should be sought out . . . If they learn that anyone is so inquiring, they shout out that he is a heretic, placing more reliance on their monkish garb than on their wisdom.

He mocked the way these narrow-minded clerics would invoke God's mysterious powers to explain everything. Perceiving that attack is sometimes the best defence, William threw charges of impiety back at his assailants. Only by understanding the world can we appreciate how skilfully God has wrought it, and thus delight in his wisdom. Studying natural philosophy is thus not just a noble and worthy cause but an obligation, he said.

But there were powerful men among his enemies. That inveterate agitator William of St Thierry wrote to Bernard at Clairvaux, warning that the heretical Peter Abelard had a successor:

> [From] the stock of serpents has emerged a viper, an individual of obscure name and without authority, but who infects the air with a pestilential poison. After the *Theology* of Peter Abelard, William of Conches offers us his new *Philosophy*, confirming and amplifying all that the former has said, and adding still more impudence into the mix that the former hadn't said.

These natural philosophers, William of St Thierry complained, were trying to explain the creation 'not through God, but by nature, spirits, and stars'. That was, of course, a condemnation of the whole Chartrain enterprise. Bernard never challenged the Chartres school itself – perhaps he was too wily a politician for that, or perhaps his friendship with the bishop held him back – but William of Conches was ultimately denounced as a heretic and sorcerer, and was forced to return to Normandy.

William's Platonic cosmology was supported by his colleague at Chartres, the Spanish-born Bernard Silvestris. And his rationalism (if not so much his science) was echoed by John of Salisbury (c.1115–80), who, in contrast to William's bullishness, wrote in a calm, urbane and moderate fashion, spiced with wit in the manner of Erasmus. His erudition was put to good effect in the Church: returning to his native country after his years of study as a young man in Paris and Chartres, in 1147 he became secretary to Archbishop Theobald of Canterbury (to whom he was recommended by none other than Bernard of Clairvaux), and he was serving in the same capacity to Thomas Becket when the English archbishop was murdered in 1170. Six years later John went back to Chartres as the new bishop, where he remained until his death.

John's ideas were shaped by Peter Abelard, William of Conches and Gilbert de la Porrée. He was primarily a humanist, a literary rather than a scientific man. But as a natural philosopher he brought a measured, Aristotelian empiricism to temper any excesses of Platonic abstraction. Men need to confine their studies to practical and concrete matters, he said, since the human intellect is limited and *a priori* logic will not alone suffice to decipher the world.

In one sense the spirit of rationalistic, proto-scientific inquiry that was developed at Chartres by Thierry and pursued by his successors can be seen as a natural outcome of the emerging humanism of the times, a consequence of the fresh influx of classical texts in Latin translation. But this was more than a question of the western assimilation of 'new' knowledge. The whole idea of studying nature for its own sake, and of looking for rational causes for natural phenomena, was new to medieval Europe, and signalled a profound shift in thinking. Previously, the only reason to study the mundane world was to uncover symbols for moral instruction. Things were the way they were because God willed it so, and if there was logic or reason to be found, that was simply an illustration of the wisdom and foresight of the Creator.

The Platonism of Chartres was not the same as the Neo-Platonism of Renaissance philosophers such as Marsilio Ficino and Pico della Mirandola, which emphasized the Gnostic mysticism of Plato's interpreter Plotinus rather than the rationalism of his elemental physics. For the Chartrains, nature was a network of laws that reason could penetrate, and they believed in what we might now call the Baconian accumulation of knowledge through experience, rather than the Neo-Platonic 'Light of Nature' as a source of revelation. They praised the way that Alexander the Great, Aristotle's pupil, was said to have been lowered to the seabed in a glass barrel to study the fish and the flora of the deep. To that extent, it was genuine proto-science and not pseudo-science that was incubated at Chartres.

But one could hardly study Plato without embracing some of his mysticism. We shall see that the Neo-Platonic notion of divine light may have played a role in shaping the new cathedral. And it seems that the Chartrain scholars regarded the natural universe not so much as a machine but as a creative entity: a central belief of later Neo-Platonism, in which the universe is seen, in the words of the twelfth-century theolo-

gian Gerhoch of Reichersberg, as 'this great factory, this great work-shop'. William of Conches drew a parallel between the artisan and God: 'All work is the work of the Creator, the work of nature, or of man-the-artisan imitating nature.' The Chartrains exalted Solomon as an ancient sage of the 'occult' hermetic arts, and it seems likely that as a result they treated the manual crafts with an esteem that was lacking at the universities. Some contemporaries of Thierry and William of Conches, such as Hugh of St Victor in Paris and the German monk Honorius of Autun, even admitted mechanics as a liberal art – in Honorius's words, a discipline 'where the pilgrims learn the working of metals, wood, marble, painting, sculpture, and all the manual arts'.

It must be said that the whole notion of a 'school of Chartres' has been challenged. Richard Southern in particular has argued that it was far less of a coherent movement than has often been suggested, some of its leading members having spent only brief periods at Chartres itself. And Southern asserts that the programme at Chartres was concerned not with disentangling science from theology but with weaving them more tightly together – which, he says, was no different from what other schools throughout Europe were doing at the time. Historians 'have been dazzled by the great name of Chartres', says Southern, 'which required that the works associated with it should be more than just remarkable examples of a common tradition; they were required to have a special kind of distinction different from all others'. The 'school of Chartres', he concludes, is 'a door that must be left behind, forgotten even'. As with most extreme positions that historians have a tendency to adopt, this one is not to be taken liter-ally but should rather be seen as a warning not to overstate the case. 'It remains clear', says the historian Winthrop Wetherbee, 'that there are important and widely influential common elements in the thought of those masters whose names have been most frequently associated with Chartres.' It is hard to argue with that.

All Things in Proportion

A reverence for light and a belief in the creativity of the universe were not the only mystical aspects of Platonic philosophy that the Chartres school embraced. More significant perhaps than both of these was

the sacredness of number, a notion promoted not only by Plato but also by Pythagoras. The Pythagoreans, according to Aristotle, 'reduce all things to numbers . . . they construct the whole universe out of numbers'. Plato was profoundly influenced by this idea, since he was taught mathematics by the Pythagorean Archytas of Tarentum.*

The ancient philosophers knew that musical harmony is governed by principles of proportion. A plucked string clamped at its midway point produces a tone a perfect octave above the 'fundamental' that is sounded by the open string. Clamp it two-thirds of the way along (giving a length ratio of 2:3), and you get a note separated from the fundamental by an interval of one-fifth: a harmony most pleasing on the ear. Other harmonious tones come from other simple ratios of length: a fourth from a ratio of 3:4, a whole tone from 9:8. It was clear that harmony was linked to mathematics.

In the *Timaeus*, Plato explained that this same principle of construction from ratios extended to the structure of the universe. He said that the 'world soul' can be regarded as a strip, which God subdivided to produce the orbits of the planets:

> He began the division as follows. He first marked off a section of the whole, and then another twice the size of the first; next a third, half as much again as the second and three times the first, a fourth twice the size of the second, a fifth three times the third, a sixth eight times the first, a seventh twenty-seven times the first.† Next he filled in the double and treble intervals by cutting off further sections and inserting them in the gaps, so that there were two mean terms in each interval, one exceeding one extreme and being exceeded by the other by the same fraction of the extremes, the other exceeding and being exceeded by the same numerical amount. These links produced intervals of 3/2 and 4/3 and 9/8 within the previous intervals, and he went on to fill all the intervals of 4/3 with the interval 9/8; this left, as a remainder in each, an interval whose terms bore the numerical ratio of 256 to 243.

* Their relationship was complex, however, and they often disagreed over philosophical issues. It certainly seems simplistic to assume, as is sometimes done, that Plato was an uncritical disciple of Archytas.

† That is, the ratios of the strips here are 1:2:3:4 $[2^2]$:9 $[3^2]$:8 $[2^3]$:27 $[3^3]$.

Plato goes on to describe the construction of the heavens from these strips in a process of truly baffling complexity, sounding somewhat like the fabrication of an extremely complicated paper chain. The point, however, was not that one might follow exactly how this process unfolded, or how strips of the world soul should be mapped onto the observable universe. Rather, Plato's account showed that God was a builder, and that he built using the strict geometric, harmonious principles that can be discerned also in music. This was embodied explicitly in Plato's famous formulation, in his *Republic*, of the harmony of the spheres.

The geometric nature of the universe was also reflected in Plato's theory of the elements. As we have seen, he maintained that each of these is composed of atoms with geometric shapes, now known as the regular or Platonic solids, which are polyhedra for which every face is a regular polygon with all sides and angles equal. The properties of the elements derive from these shapes: tetrahedral fire is sharp and penetrating, cubic earth may be stacked into stable arrays. The fifth regular solid, the pseudo-spherical dodecahedron, represents the eternal cosmos. Thus, in Plato's cosmology the world is made from components and materials that are fashioned by the Master Builder into perfect geometric shapes and proportions, particularly those based on squares, cubes, triangles, and musical ratios.

Augustine and Boethius both wrote about the mathematical aspects of Platonism, and they were considered the greatest mathematical authorities at Chartres. 'Reason', said Augustine, 'is nothing else than number.' And since reason is a divine attribute, Augustine agreed with Plato that the geometry of nature reveals its intrinsic 'goodness' and thus provides an objective basis for aesthetic judgement. True beauty, in other words, came not from the hands and minds of artists but from order and proportion. These qualities, said Augustine in his book *On Order*, are to be found in the two supreme 'arts', music and architecture. Just as music can be derived only from harmonious proportions, the architect makes a 'good' building by observing simple mathematical relationships between its dimensions and by dividing space using geometric figures. This, then, is how one may build a temple or church that reflects the true, divinely beautiful structure of the universe.

This underlying order of the universe was considered to be a moral reality that transcended the purely sensual realm. While Augustine

does seem to have been sensitive to the delights of music, he would surely have baulked at the suggestion that its purpose was to give pleasure. In *De institutione musica*, Boethius approvingly quotes Pythagoras's injunction to regard music as an idealized thing that should be studied by 'setting aside the judgement of the ears'. Likewise, for Augustine harmonious intervals were 'good' not because they sounded pleasing; rather, their pleasing effect was an inevitable side-product of the metaphysical dignity that stemmed from their mathematical origin. Music made by people untutored in its mathematical foundations was merely 'art'; but music based on those laws was 'science'.

Thus, Platonists held that beauty was not at all in the eye of the beholder but was an objective and quantifiable property: it was present in a body to the extent that the body exhibited order. In other words, regularity did not supply beauty but actually defined it. 'In the body a certain symmetrical shape of the limbs . . . is described as beauty', said Cicero. The Greek sculptor Polyclitus went further in the fifth century BC, explaining that beauty derived from *symmetria* and that 'the beautiful comes about, little by little, through many numbers'. But it was Plato himself who made the most explicit statement of geometrical aesthetics. He distrusted the visual arts as deceitful, since they merely imitated superficial nature and did not attempt to reveal the underlying simplicity and order that lay beneath. 'I would not describe as beauty of form that which most would probably believe, namely the beauty of living bodies or certain paintings', he said in *Philebus*. 'What I would describe as beautiful is rather something straight or circular, and from these then the surfaces and volumes which are turned or defined through spirit levels or squares . . . for these are always in themselves beautiful and have a unique attraction.' By the twelfth century this Platonic view of beauty was the conventional one.

So profoundly did the Platonic reverence for numbers influence Thierry and his followers at Chartres that it has been said they attempted to turn theology into geometry. Thierry even tried to reduce the doctrine of the Holy Trinity to a mathematical formula, something that would strike us today as cold to the point of impiety. It was a puzzle to many Christian theologians how God could be 'three in one': was he truly threefold, and, if so, how did he nonetheless retain his unity? Thierry proposed that these were precisely the properties of the number one,

or unity: it could be multiplied by itself without changing its essential nature. Thus the Trinity could be represented as the equation $1 \times 1 = 1$, in which the first '1' represents God the Father, the second '1' is the Son (equal to God but distinct), and the multiplication sign is the Holy Spirit that connects them and restores them again to unity.

From School to Stone?

There can be no doubt that geometry and proportion provide the central organizing principles of Gothic architecture in general and of that at Chartres in particular. But was that a consequence of the geometrical theology devised by the school of Chartres? This question has divided historians of art and architecture ever since Erwin Panofsky proposed in the 1950s that Gothic building was an embodiment of the abstract principles explored in the progressive medieval schools. This idea, itself a kind of riposte to the popular nineteenth-century view that Gothic was foremost a manifestation of technical and engineering advances, reflects the art-historical enthusiasm for uniting art with its intellectual climate. It was a tremendously fertile suggestion, which has helped to sharpen discussions about the state of twelfth-century philosophy and the extent and mode of its dissemination. It forces us to examine the character and training of the patrons and architects of the Gothic churches, and the nature of the discourse between them.

Panofsky claimed that

> During the 'concentrated' phase of this astonishingly synchronous development, viz., in the period between about 1130–40 and about 1270, we can observe, it seems to me, a connection between Gothic art and Scholasticism which is more concrete than a mere 'parallelism' and yet more general than those individual (and very important) 'influences' which are inevitably exerted on painters, sculptors, or architects by erudite advisers. In contrast to a mere parallelism, the connection which I have in mind is a genuine cause-and-effect relation; but in contrast to an individual influence, this cause-and-effect relation comes about by diffusion rather than by direct impact. It comes about by the spreading of what may be called, for want of a better term, a mental habit.

What Panofsky had in mind was that all educated people in the 'tight little sphere' of the '100-mile zone around Paris' – the Île-de-France, which was the cradle of both Gothic architecture and French intellectual culture – acquired the habit of thinking in the way that the scholastic movement fostered. While admitting that 'it is not very probable that the builders of Gothic structures read Gilbert de la Porrée or Thomas Aquinas in the original' (the latter in any event would have prayed under Gothic arches already in place during his student years in Paris), Panofsky reasonably argued that they were exposed to the scholastic tradition in many other ways. By the latter half of the thirteenth century, he says, 'the architect himself had come to be looked upon as a kind of Scholastic'.

And what, then, did the cathedral builders learn from the scholastic movement? First and foremost, says Panofsky, 'the unity of truth', coupled to the 'elucidation of faith by reason' – the principle, in other words, that was nurtured at the school of Chartres. And beyond this, a technical method of organization through a scheme of division and subdivision, which the scholastics employed 'to make the orderliness and logic of their thought palpably explicit'. And this, Panofsky says, is precisely the scheme that is evident in the Gothic style, in which the principles of organization are transparent and the total effect is one that conveys comprehensible order. 'Pre-Scholasticism', he says, 'had insulated faith from reason by an impervious barrier much as Romanesque structure conveys the impression of a space determinate and impenetrable.' The Gothic church is constructed from units and motifs that recur identically and consistently, as opposed, for example, to the profusion of different vaulting forms that can be found in some Romanesque buildings. The Gothic wall has a hierarchical structure in which there is clear differentiation of elements and yet also consistency of forms.

This mode of organization by subdivision, says Panofsky, is evident in the west portals of the great Gothic churches, such as those of Chartres, Amiens and Notre-Dame de Paris. With their nested archivolts and their layered tympana, they speak of an orderly and systematic partitioning of space. This was a habit taught in all spheres of the liberal arts, from rhetoric (indeed, Thomas Aquinas was led ultimately to complain of the penchant for 'multiplication of useless questions, articles, and arguments') to geometry and music, where time itself was segmented into hierarchical sequences of notes.

At first glance, it might seem far-fetched to suppose that practical men, faced with the almost unimaginably daunting task of erecting a soaring temple of stone while coping with the grumbles and caprices of an itinerant workforce, the vicissitudes of funding and weather, and the demands and entreaties of clergymen, would have thought to import ideas half-assimilated from the traditions of bookish theologians. But we should never forget what it was they were building: a representation of heaven on earth. They knew that, and they believed it too. And they accepted the medieval notion that the physical world is no more than a symbol of an ultimate, immaterial reality – of which architecture was intended and experienced as a representation. Recall Jean Bony's remark that the physical form of the cathedrals expresses what was believed by the architects to be the theoretical framework of the building. Scholasticism supplied that framework, the guide to that ultimate reality.

Otto von Simson expanded on Panofsky's argument in the 1950s, making even stronger claims in the same direction: 'Gothic art', he said, 'would not have come into existence without the Platonic cosmology cultivated at Chartres.' While Panofsky wished to point out the general analogies between twelfth-century scholasticism and the Gothic style, von Simson looked more closely at the role that geometry and order had to play in this relationship. 'The Gothic builders', he says, '. . . are unanimous in paying tribute to *geometry* as the basis of their art.' He asserts that it was at the school of Chartres that this long-standing tradition became linked to beliefs about the way God had constructed the universe. Alain of Lille, one of the great humanists of the school, spoke of God as the *elegans architectus* who created the world using the harmonious rules evident in music. 'The first Gothic,' von Simson argues,

> in the aesthetic, technical and symbolic aspects of its design, is intimately connected with the metaphysics of 'measure and number and weight.' It seeks to embody the vision that the Platonists of Chartres had first unfolded, no longer content with the mere image of truth but insisting upon the realization of its laws. Seen in this light, the creation of Gothic marks and reflects an epoch in the history of Christian thought, the change from the mystical to the rational approach to truth, the dawn of Christian metaphysics.

For and against Panofsky

Erwin Panofsky was not the first to make the connection between scholasticism and architecture. In 1860 the German architect Gottfried Semper called Gothic 'the lapidary translation of scholastic philosophy', while seven years later the historian Ferdinand Piper saw a 'wonderful consummation in the parallel phenomena of scholastic systems and the Gothic cathedrals'. And Raymond Klibansky was developing the idea of a 'parallelism' between the scholarship of the Chartres school and the 'artistic symbolism of the building' in the 1930s.

But Panofsky's short treatise *Gothic Architecture and Scholasticism* argued for this connection with more force and clarity than anyone had done previously. As a result, says the British historian Peter Kidson, 'Gothic at last took its place as a major manifestation of the spiritual ferment which transformed twelfth-century Europe, and it could be seen to bear the imprint of much contemporary intellectual activity.'

That's the position I want to advance in this book. But I do not wish to advocate uncritical acceptance of Panofsky's idea. His analysis of the links between the schools and the builders of the Gothic era is too narrow and too assertive – as Kidson says, he succumbed somewhat to 'the temptation to rewrite history rather more emphatically than the evidence warranted'. It has rightly been pointed out, for example, that the great age of cathedral-building had to be supported on the solid bedrock of economic prosperity; theology alone wouldn't have sent those spires heavenward and filled those walls with light. But that pertains to the scale of the enterprise, not its style. It is also true that, as we have seen, the emergence of Gothic does not constitute an abrupt break with the Romanesque tradition. Let alone anything else, the 'architects' of the twelfth and thirteenth centuries did not have a sound enough theoretical knowledge of mechanics to introduce all the innovations at once.

In the absence of definitive evidence, however, historical debates of this sort are unfortunately apt to be advanced with ungenerous

and dogmatic certainties. As a result, Panofsky's thesis has some-
times been not so much critiqued as trashed. The acerbic art histor-
ian Jan van der Meulen dismissed his book as a 'facile little tract',
and claimed that 'the theological origins of every individual form
of the High Gothic cathedral of Chartres and of their overriding
relationships lie . . . long before that synthesis of reason and faith
during the advancing thirteenth century stressed by Panofsky'. He
has a point, although it rather leaves one wondering why it was
nevertheless precisely during the period of that 'synthesis' (rather
earlier than van der Meulen states) that the Gothic style appeared.
Van der Meulen also objects, with some justification, that Panofsky
displays the bad habit common among art historians of relying on
an analysis of styles rather than the scientific and archaeological
evidence of the methods and patterns of construction.

But Panofsky himself admitted that hard evidence for his thesis
is 'very slight' – he could adduce little more than the (disputed)
journal of a thirteenth-century architect (see Chapter 6) which
makes glancing reference to the rhetorical practices of scholasti-
cism. 'The gentle reader', Panofsky says, 'may feel about all of this
as Dr Watson felt about the phylogenetic theories of Sherlock
Holmes: "It is surely rather fanciful."'

Temples to Proportion

Was von Simson correct to equate the geometry of Chartrain (and
other Gothic) architecture with the Platonism of Chartrain thought?
It would be rather surprising if the two were not somehow connected.
But while some critics insist on the lack of hard evidence, others ques-
tion the significance of this link for the opposite reason that geom-
etry and architecture, and particularly sacred architecture, seem already
to have been firmly wedded centuries before the golden age of
Chartres.

'Thou hast ordered all things in measure and number and weight':
this thoroughly Platonic idea is voiced in the First Book of Kings by

Solomon himself, and Christian theologians had no doubt that it was embodied in the king of Israel's legendary temple. It was not out of sheer pedantry that the Bible specifies the proportions of this building in such detail, but because these dimensions had holy significance:

> The temple that King Solomon built for the Lord was sixty cubits long, twenty wide and thirty high. The portico at the front of the main hall of the temple extended the width of the temple, that is, twenty cubits, and projected ten cubits from the front of the temple ... The lowest floor was five cubits wide, the middle floor six cubits and the third floor seven ... And he built the side rooms along all the temple. The height of each was five cubits ... He partitioned off twenty cubits at the rear of the temple with cedar boards from floor to ceiling to form within the temple an inner sanctuary, the Most Holy Place. The main hall in front of this room was forty cubits long.

And so the description goes on, with sufficient detail that one can make an architectural drawing. All of the building's key proportions correspond to simple integer ratios: 1:2, 1:3 and so forth. 'Let no one be so foolish or so absurd', Augustine warned in *On the Trinity*, 'as to contend that [these numbers] have been put in the Scriptures for no purpose at all, and that there are no mystical reasons why these numbers have been mentioned.' Clement of Alexandria, one of the first Christian Platonists,* expresses this same belief with his injunction that a church should be 'constructed in the most regular proportions'.

This idea that a sacred building should embody numerological symbolism seems to have been manifested in western Christianity from at least the time of Charlemagne. His chapel at Aachen, which was planned around 790 when Alcuin was at the imperial court, bears the following inscription: 'As the living stones are bonded in a fabric of peace, and all come together in matching numbers, the work of the lord who has built the entire hall shines forth brightly.' This symbolism is even more explicit in the description given by a monk called Arnold, from the abbey of St Emmeram in Regensburg, sixty years after it was begun in 976:

* Origen, Clement's most famous pupil at his school, the Didascaleon, also studied under Ammonius Saccas, the Neo-Platonic teacher of Plotinus.

[Abbot] Ramwold . . . commanded the erection of a crypt at St
Emmeram. This building – very artfully ordered by the man of God
– exhibited in threefold and even fourfold notion what was intended.
And because the originator of this work [the abbot] loved the holy
Trinity and held fast in the faith of the four Gospels, he produced thus
a kind of credible evidence. The columns, indeed, which hold up this
underground church compose wonderfully the duality of his twofold
love, namely of God and the neighbour. Also the five altars – in
which . . . relics are arranged . . . keep in mind foremost respect for the
five Books of Moses, and they urge strongly ever to have fivefold
circumspection regarding the five bodily senses. The sixth altar,
however . . . announces the perfection of the 'sextuple', comprising
everything.*

There was arguably a more direct avenue for Pythagorean
symbolism and Platonic geometry to find their way into architecture
in the tenth century – the early Romanesque period – than the twelfth,
since clerics were much more involved in the building programme of
their churches before the professionalization of architecture in the
early Gothic era. In any event, there is nothing uniquely Gothic, let
alone Chartrain, about Platonic church geometry. Bernard of Clairvaux
shared Augustine's Platonic mysticism, so it is no surprise that many
of the key proportions at Chartres – simple ratios such as 1:2, 1:3, 2:3
(see p. 117) – can be found also in Cistercian churches.

But there is another reason, aside from Christian Platonism and
biblical symbolism, why number, proportion and geometry may have
taken root in medieval architecture, for these principles are also
evident in the secular traditions of building practice. The architects
of the cathedrals did not use geometry purely or even primarily for
theological or philosophical reasons, neither was this an aesthetic
choice of what 'looks right' (at Reims, for example, the ribs under
the vaulting are circumscribed by equilateral triangles, which is not
a feature any observer would have noticed). It has been asserted instead
that these practices merely provided the architect with convenient
rules of thumb, or even that they constitute nothing more than an
unquestioned tradition, being notions learnt by rote during a mason's

* Six was known to be a 'perfect' number, equal to the sum of its factors 1 + 2 + 3.

apprenticeship without any real understanding of where they came from.

In so far as this architectural tradition drew on the authority of classical authors, its equivalent of Euclid's *Elements* or Ptolemy's *Algamest* was *De architectura* by the Roman Marcus Vitruvius Pollio (born *c*.80–70 BC), who was more or less the only pre-Christian writer known to have discussed the topic. (Hero of Alexandria, born *c*. AD 10, whose followers built the vaults of the Hagia Sophia, was apparently a greater authority than Vitruvius, but his works were lost.) Vitruvius advised the architect to build according to rational, mathematical principles and argued that architecture should be considered a liberal art. He stressed that the architect needs a broad education, encompassing geometry, arithmetic and music, so that he might 'demonstrate and explain the proportions of completed works skilfully and systematically'.*

For Vitruvius, a sound and beautiful building is one that observes the tenets of symmetry and proportion: 'The composition of a temple is based on symmetry, whose principles architects should take the greatest care to master. Symmetry derives from proportion, which is called *analogia* in Greek.' Proportion itself, he says, is 'the appropriate harmony arising out of the details of the work itself; the correspondence of each given detail among the separate details to the form of the design as a whole'. It is the key to shapeliness, defined as 'an attractive appearance and a coherent aspect in the composition of the elements', which is achieved when 'the elements of the project are proportionate in height to width, length to breadth, and every element corresponds in its dimensions to the total measure of the whole'. In these prescriptions, Vitruvius can be seen to provide a blueprint for the 'modular', hierarchical coherence of Gothic to which Panofsky alludes: 'Proportion', Vitruvius wrote, 'consists in taking a fixed nodule, in each case, both for the parts of a building and for the whole.' Victor Hugo captures this spirit in his description of the medieval churches of Christendom: 'Everything is of a piece in this logical, well-proportioned art, which originated in itself. To measure the toe is to measure the giant.'

* Martial was not so sure: if your son is a little dull, he says, 'educate him as a page or an architect'.

Vitruvius is not obviously a profound thinker – some have presented him as a rather naïve dilettante, others as a boring engineer. In any event, he seems to have been rather conservative in his methods and views. Yet his geometric approach does contain a clear strand of Pythagoreanism. He notes that the height of a man is more or less equal to the span of his outstretched arms, so that the human figure can be inscribed in a square: the *homo quadratus*, as it became known in the twelfth century. The square is a fundamental building block for Vitruvius, reflecting the Platonic idea that it is a particularly stable shape.

In the writings of Vitruvius, the medieval builder may have found a vitally important conceptual tool:* geometry was shown to be a means by which the proper shape of a building might be deduced from simple, basic figures. Beginning with such figures, commonly the square or the equilateral triangle, the Gothic architect was able to calculate all the dimensions of both the ground plan and the eleva- tion by strictly geometrical means. This practical utility of geometry played an especially important role in a time when there were several different systems of measurement in use (see Chapter 7). The ques- tion of whether such figures were merely a matter of practical con- venience, or whether they reflected a desire to 'encode' geometry into the building, is obviously bound up with the matter of what the builders knew, and of how much say they had in matters of design. I shall explore these issues in the next chapter.

The use of geometry in the structure of Chartres Cathedral there- fore permits of several interwoven interpretations, and how much significance one attributes to each of them must remain for the time being a matter of personal preference. The builder appreciated geomet- rical means of construction as a practical tool, but he also inherited Vitruvius's notion that it was a way to achieve harmony of propor-

* That's to say, he *could* have found it, but we don't know if he really did. It isn't clear whether master builders took the trouble to read Vitruvius, nor whether those who read him used what he said. According to Lynn White, a historian of tech- nology, 'Vitruvius was not widely read in the Middle Ages, because the men who built Cluny and Beauvais did not need him.' *De architectura* was surely a part of the scholarly canon, but its message about proportion may have filtered through to prac- titioners at several removes. After all, anything Vitruvius could tell them was prob- ably already part of their standard practice.

tion. That in turn connects geometric ratios and angles to a more metaphysical perspective, in which geometry confers a kind of 'rightness' – in Platonic philosophy it has intrinsic virtue, and one can find biblical support for this idea.

To go any further than this – to understand how and why the master builders might have used geometric principles in practice – we need to take a closer look at the roles of these men in the construction of a cathedral. But we should not lose sight of the fact that, according to the natural philosophy that developed in twelfth-century Chartres, a church modelled on geometrical form would have in some sense reflected the structure of the universe. That, as we have seen, was one of the key functions of ecclesiastical architecture. The stones themselves encoded a belief in an ordered and thus a comprehensible cosmos; according to Georges Duby, in the twelfth century 'the universe ceased to be a code that the imagination strove to decipher. It became a matter of logic, and the cathedrals were to restore the pattern of it . . . Henceforth it was up to the geometers, using the deductive science of mathematics, to embody in stone the fantastic airiness of the celestial Jerusalem.'

Sacred Geometry or Numerology?

A great deal has been written about the 'sacred geometry' of Chartres and the mystical secrets it is supposed to encode, most of it wildly speculative, if not outright fantasy: we are told that one can read here the 'lost secrets' of the Druids, the Knights Templar or some such semi-legendary institution. Some have claimed that geometric construction was applied in the church to a degree that seems almost obsessive, such that there is not the smallest feature – the angle of a bevel in a window frame, say – that was not calculated using a geometrical scheme.

The problem in assessing these claims is that which dogs all numerology: if you look hard enough, you will almost always find a 'meaningful' ratio more or less close to your measurements. Thus, for example, one might look for simple integer ratios found in musical scales, such as 1:2 and 1:3, but also 2:3 (that is, proportions related by a factor of 1.5), 3:4 (1.333), 4:5 (1.25) or even 8:9 (1.125). Then one could also search for ratios of $1:\sqrt{2}$ (1.414) and $1:\sqrt{3}$ (1.732).

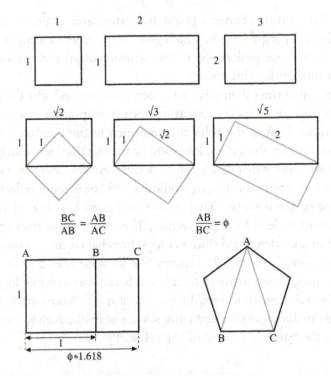

$$\frac{BC}{AB} = \frac{AB}{AC} \qquad\qquad \frac{AB}{BC} = \phi$$

Some common ratios in medieval church architecture, and how they are constructed. The lower two figures show the Golden Mean ϕ and how it is related to the proportions of a pentagon.

Allowing for only a small margin of error in measuring these figures, it is not hard to encompass most of the numerical space between 1 and 2 with 'significant' ratios.

We should bear in mind that it is not clear whether medieval masons had any concept of what a square root actually was; these ratios are simply those that appear in simple geometric figures, such as the diagonal of a square or the hypotenuse of a right-angled triangle with other sides in the ratio 1:√2. √2 and √3 are, and were even then, recognized by mathematicians as so-called irrational numbers, which cannot be represented by any ratio of integers. This was, to men trained to think in terms of simple proportions, an uncomfortable notion; but it seems that they were often content to use rational approximations in their measurements. √2, for instance, can be reasonably well represented by the fraction $^{17}/_{12}$

(equal to 1.417), or even ⅞ (1.4). It wasn't only masons who made such simplifications; two scholarly pupils of Bishop Fulbert of Chartres, himself a masterly mathematician, can be found discussing the relative merits of these two rational approximations.

A ratio that has aroused particularly enthusiastic commentary is 1:1.618, which corresponds to the *sectio aurea* or Golden Mean (1:(1+√5)/2), one of the most profound proportions in classical antiquity.* It has been asserted (and the notion is still popular today, though apparently unfounded) that a rectangle whose sides are related by this proportion is uniquely pleasing to the eye. Whole books have been written on how this number may be found in the forms of nature and in the human anatomy. The ratio is also distinguished as that to which the successive numbers of the Fibonnaci sequence converge. This sequence of integers, in which each is found by adding together the two previous numbers in the series, was popularized in the West by Leonardo of Pisa (Fibonacci), who discovered it in Arabic mathematics; it begins 1, 1, 2, 3, 5, 8, 13, 21 . . . As the numbers get larger, the ratio of two consecutive members of the series gets ever closer to 1:1.618. The Golden Mean was revered at the Chartres cathedral school, where it was known from Euclid's *Elements*. Ptolemy describes how to construct it geometrically in his *Algamest*, a translation of which, apparently made by Adelard of Bath around 1150, was dedicated to the chancellor of Chartres.

Vitruvius recommended the use of the 'early Fibonacci' ratios 2:3 and 3:5, which may have led to their adoption by architects even though Vitruvius did not justify the choices. It has been claimed that the ratio 5:8 is particularly prominent at Chartres, where it is said to represent an approximation to the Golden Mean.† Otto von Simson asserts that the proportions in the cathedral's columns seem to be based on the Golden Mean. From the top of the plinths to the springing of the nave

* The appearance of the square root of 5 in this number is apt to get the Golden Mean invoked by advocates of 'sacred geometry' whenever a proportion involving √5 seems to appear. But √5 is also simply the length of the diagonal of a rectangle of sides 1 and 2.

† That interpretation is sometimes also inferred for the use of the ratio 3:5. But it isn't clear that this has anything to do with approximations to the Golden Mean: the same ratio is found in Pythagoras's famous right-angled triangle with sides in the proportion 3:4:5.

is a distance of 8.61 m (28 feet 3 inches); the height of the shafts above this is 13.85 m (45 feet 5 inches); and the distance between the base of the shafts and the lowest string course (the narrow, horizontal raised ribs that punctuate the elevation) is 5.35 m (about 17 feet 6 inches). The ratios 5.35:8.61 and 8.61:13.85 are both equal to 1.609 – which is indeed rather close to 1.618. And the lower string course of the walls, level with the floor of the triforium, divides the shafts into lengths of 8.78 m (about 28 feet 10 inches) and 14.19 m (about 46 feet 6 inches) with a ratio of 1.616.

Moreover, the Golden Mean is related to the dimensions of the pentagon, a shape that von Simson claims was widely used by the designer of Chartres. For instance, the ratio of the width to the length of the crossing – 16.44:13.99, as measured in metres from the centres of the piers – is equal to the length of side of a pentagon to the radius of the circle in which it may be inscribed.

These numerical matches look impressive, and perhaps von Simson is justified in regarding them as intentional. Yet as we have seen, there are in fact rather few numbers between 1 and 2 for which a close correspondence with some 'meaningful' ratio cannot be found. How close do the numbers have to be to make a convincing match? And how do we measure dimensions in any case? If we are fitting a ratio or a geometrical figure to the ground plan, do we use the midpoints of walls or their internal or external faces? The same pertains to the positions of columns. The differences can be significant, yet the choice is arbitrary. That is why, the moment one hears an appeal to 'sacred geometry' in church architecture, it is wise to heed what one contemporary historian has said:

> The presence of proportions in a building can be asserted with confidence, but they are notoriously difficult to demonstrate, at least on the evidence of the building alone. Monuments of great age hardly ever survive intact or unchanged, and, even if they are well-enough preserved for their mathematical proportions to be detected, few were built to standards of exactitude high enough to resolve the problem beyond doubt.

Art historian Eric Fernie is more outspoken, calling the notion of sacred geometry 'pyramidiocy' that relies on coincidence. 'So much of what has been written on the subject is nonsense', he says, 'consisting of webs of literally unbelievable complexity and corresponding intellectual nullity which are clearly not worth the effort required to unravel them.'

One of the most controversial conjectures of this kind in regard to Chartres has been made by John James. He claims, for instance, that the ground plan is based on the figures of three adjacent squares and that the lengths of the building in feet can be construed astronomically: 365¼ (from the Royal Portal to the tip of the apse) is of course the number of days in a year, and 354 (from the Royal Portal to the centre of the easternmost apsidal chapel) corresponds to the number of days in a lunar year, which was important for determining the date of Easter. James identifies several proportions that are apparently related according to the squares and cubes of a basic dimension ($x:x^2:x^3$), and others that reflect the Golden Mean. He argues that even minor adaptations to the design to make features fit would be done using geometric construction rather than arbitrary shaping. 'There was not one decision that was not made through geometry', James claims. In some other dimensions of the cathedral, meanwhile, he identifies numbers allegedly encoded in sacred phrases, such as *Maria mater dei*, according to the cabbalistic system of gematria, which assigns numerical values to alphabetical letters. Again, it is hard to know how impressed one should be by such suggestions.*

Mindful of that danger, the British historian Nigel Hiscock has proposed schemes for the geometrical basis of medieval churches with some circumspection, admitting that his evidence comes from plausibility arguments rather than documentation. Hiscock argues that Platonic tendencies are equally if not more characteristic of Romanesque building than of Gothic, so he believes that we should search for geometric principles not in the current cathedral at Chartres but in Fulbert's earlier design.

* The fiercely sceptical van der Meulen can barely hide his glee when James shoots himself in the foot, suggesting in his book *The Contractors of Chartres* that if you 'doodle . . . yourself [with the plan of the church] you will effortlessly come up with geometric forms'.

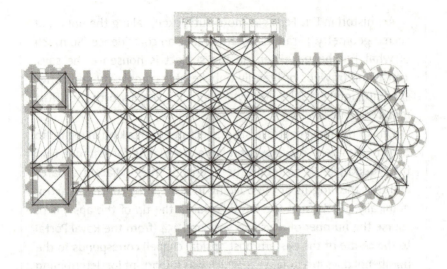

The geometrical scheme underlying the design of Chartres, as proposed by historian Nigel Hiscock.

Fulbert's plan can be reconstructed with a fair degree of reliability, not least because his crypt still survives. Hiscock shows that the positions of all the principal elements, such as the aisle and bay widths, narthex and radiating chapels, can be derived from a series of geometric constructions based in particular on the right-angled triangle with an internal angle of 60°. The resulting scheme looks highly complex – a web of lines that, one might imagine, can be tuned to fit anything. But the series of 'moves' that leads to this construction involves only a few steps. To the obvious charge that one could find such schemes that fit *any* building with a little ingenuity, Hiscock responds by demonstrating that geometric designs built up this way can be found for many medieval buildings but not for later ones that have no reason to be informed by Platonic thinking.

Is it convincing? You must decide for yourself. But Hiscock's suggestion that the Gothic plan at Chartres can be accounted for

by elaborating on the same scheme he evolves for Fulbert's church seems to demand either that a record of these design principles was preserved for more than a century and a half, or that the Gothic architects were remarkably attuned to the logic of their predecessors. And for this way of building to have been standard among Romanesque and Gothic architects but to have left no record demands either an impressive adherence to secrecy among these professionals, a remarkable loss of documents (which is by no means impossible), or such a casual familiarity with the approach that there was thought to be no need to write it down. Yet at the very least, Hiscock says reasonably, this theory 'shows there are alternative geometric proportions present in medieval architecture to those commonly advanced in the literature'. His proposal will surely not be the last.

In the end, there is one very serious objection to any notion of 'sacred geometry' that goes beyond the widespread use of simple ratios and geometric figures by the master builders: the buildings themselves contradict any suggestion of some universal geometrical key that unlocks their secrets, for the proportions of Gothic churches vary immensely and no two are identical in this regard.

6

Masters of Works

The Men Who Planned the Cathedrals

The early master [builder] had the tradition of generations behind
him, but when he departed from the magic circle of that tradition
his experiments were fraught with danger and were apt to be made
at the expense of his employers.

Louis Salzman, *Building in England Down to 1540*, 1979

An honourable work glorifies its master, if it stands up.

Lorenz Lechler, 1516

The Labyrinth

The labyrinth in the floor of the nave at Chartres is perhaps its most
captivating and enigmatic symbol. This sinuous trail of white stone,
40 feet (12 m) in diameter and composed of eleven concentric rings
that trace out a path 858 feet (26 m) long, has been given many inter-
pretations, most of them more or less fanciful. Is it an allegory on the
pilgrimage route to the Holy Land, or on humankind's passage through
life? Did the devout once crawl along the twisting path on their knees,
much as pilgrims walk it in meditative silence today? It seems deeply
unsatisfactory to have to admit that we simply do not know the
answers; but that is all we can honestly say.

The labyrinth of Chartres is not unique. Such motifs were laid at
several other great Gothic cathedrals – at Auxerre, Sens, Reims, Arras,
Amiens – but all of these were destroyed between the seventeenth
and the nineteenth centuries. A few survive in lesser buildings, such

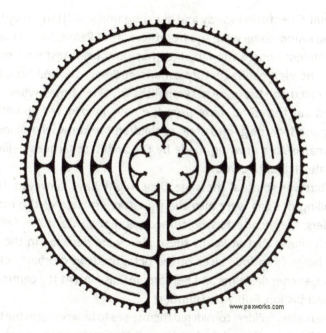

The labyrinth in the nave floor at Chartres.

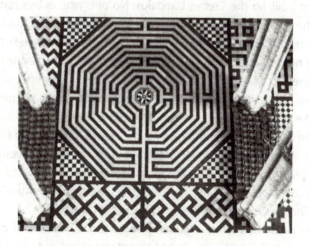

The restored labyrinth at Amiens cathedral.
(*Photo courtesy of Stephen Murray.*)

as Saint-Quentin in Picardy and at Guingamp in Brittany. They were not all round: some were square, others (as at Reims, Saint-Quentin and Amiens, where the labyrinth has now been restored) octagonal. The eighteenth-century canons of Reims showed how little they cared for the mystic symbolism of older times when they ripped out the stone maze from the nave in 1779, fed up with its being used for the games of noisy children. We know what it looked like thanks to a drawing made by the architect Jacques Cellier in the late sixteenth century.

Whatever spiritual message they might have conveyed, these spiralling designs were also the signatory emblem of the master builders, the architects who turned geometry into stone. Cellier's sketch shows that at Reims these men were depicted in the cells that bulge from four faces of the octagon: Jean d'Orbais, Jean le Loup, Gaucher de Reims and Bernard de Soissons. At the centre was the archbishop, Aubry de Humbert.

The master builders considered themselves to be working in the tradition of Daedalus, the architect and inventor in Greek legend, who created the marvellous maze of Minos in Crete. Carved on one of the entrance pillars in the thirteenth-century portico of Lucca Cathedral is a labyrinth identical to that of Chartres; beside it, an inscription reads: 'This is the labyrinth built by the Cretan Daedalus. No one who enters has ever found the exit, except Theseus, and he also would have failed, had Ariadne, from pure love, not helped him with her thread.' One can see that this claim is not to be taken too literally, for it is actually impossible to get lost in the Lucca labyrinth, just as it is at Chartres: a labyrinth, unlike a maze, has only a single path that has no branches. A copper plaque once sat in the centre at Chartres which depicted Theseus, Ariadne and the Minotaur: strikingly pagan images for the House of God. Now there is nothing at the heart of the labyrinth but stone pierced by rivet-holes, for the plaque was pulled up in 1792 and later melted down to make rifles for the Napoleonic wars. Thankfully, the seventeenth-century French writer Charles Challine has left us a description of it.

There is claimed to be a cunning logic to the placement of this cryptic mandala, which you might sense if you stand in its centre and look back and up to the west. The line to the centre of the west rose

slopes up at about 45°, which means that, if the west wall were to be folded down flat, the rose window would sit roughly over the labyrinth. The match is generally overstated, being far from exact, and we can only speculate about whether this is an intentional feature introduced with medieval imprecision, or just another example of the unwarranted retrospective insistence on design in every aspect of the cathedral's geometry.

In some of the great Gothic cathedrals, the names of the master builders responsible for these awesome projects are cut into the very stone. They wanted future generations to know who they were. 'He who was master of this work', read an inscription formerly in the nave at Amiens, 'Master Robert was his name and de Luzarches was his surname. Master Thomas de Cormont was after him, and after him his son Master Regnault, who when master made this inscription to this point; less than twelve years were wanting for the Year of our Lord to be 1300.' At Notre-Dame de Paris, an inscription in the south transept reads: 'Master Jean de Chelles commenced this work for the Glory of the Mother of Christ on the second of the Ides of the month of February, 1258.'

At Reims one of the architects of the city's great Gothic churches is given even more prominence: he is depicted on the slab of his tomb within the cathedral itself, and in his right hand he cradles a model of the church he helped to make. His other hand grasps a measuring rod, while at his feet are the builder's set-square and a pair of compasses. His name was Hugh Libergier, and his work on the church of Saint-Nicaise at Reims claimed thirty-four years of his life.* Pierre de Montreuil, who succeeded Jean de Chelles at Notre-Dame de Paris, was buried at the monastery of Saint-Germain-des-Prés (where he built the refectory and lady chapel) with an epitaph that conferred on him the pseudo-academic title of *Doctor Lathomorum*, Doctor of Masons: a remarkable accolade for a man associated with a manual trade.

* Libergier played no part in the building of Reims Cathedral itself, the principal architects of which were the four men mentioned above. But Libergier's tomb was moved there after the church of Saint-Nicaise was destroyed in the eighteenth century, another casualty of the Revolution.

The tomb of the master builder Hugh Libergier.

But of the masters who devised Chartres we know nothing, for the record books of the cathedral from that period have not survived. 'It would be difficult', says Otto von Simson, 'to name a monument of similar importance whose maker or makers have been so completely forgotten.' What, exactly, was their role? What were they masters of? Did they actually design the contours of the building, or were they merely foremen who ensured that the stone blocks were laid in their assigned places?

There can be no doubt that they were remarkable men. These versatile craftsmen learnt through long, demanding and probably itinerant apprenticeships how to cut and shape stone – not just into blocks for building, but into the most exquisite foliage and garlands, into lively animals and gnashing demons and the suffering faces of saints. They knew enough geometry to unfold an entire cathedral from inside a square. They knew not only where the immense stones should go but how to get them there. And they surely needed boundless energy and not a little guile to negotiate with contractors and workmen and suppliers, to reason with impatient and fretful abbots, canons and bishops, and to administer and keep an eye on an ever-uncertain budget. To call these men architects is almost to diminish them. Each was truly a *magister operis*, a master of works.

The astonishing thing is that the master builders in fact had so little tradition on which to draw in the twelfth century. The methods and principles of the ancient architects were barely known, available only as sparse hints in encyclopaedic works by Vitruvius and Pliny. Unlike the intellectuals in the cathedral schools, they had no giants' shoulders on which to stand. Yet they raised giants themselves.

The Great Artificers

The established hierarchy of today's architectural tradition leaves us with a sense that there seems to be a gap between the highest echelons of the medieval craftsmen employed on a project and the stratum of the church officials who commissioned the work. Today, labourers and clients are bridged by the architect. But the master builder who directed the construction of a large building in the Middle Ages was generally a master mason, whose title of *cementarius* in medieval records

makes him sound like nothing more than a better class of workman. There seems to be no record of any person giving him instructions about planning and design. Who was the source of technical knowledge about how high or how thick the walls should be, where to place the flying buttresses, how to lay out the windows? Where, in other words, was the architect?

Arkhi-tekton indeed means 'chief builder' in Greek, but we cannot be sure quite what the Latin form *architectus* meant to those who used it in the Middle Ages. The figure of a master builder who applies scientific principles in his work can be discerned in St Augustine's writings. To the scholars of Chartres, God himself was the great *architectus*, who used geometrical schemes to construct the universe – an image famously depicted in a French Bible commentary of about 1250. But it is not clear that the term implied any real proximity to bricks and mortar, nor whether the *architectus* of a building project had much say in matters of design. It seems to have been not until the mid-thirteenth century that the idea of an architect as we know it arose: before this, the *architectus* of a church was either the cleric responsible for overseeing the work, or (more rarely) the patron who paid for it. The implication in many monastic records is that the master builder is a mere labourer, skilled at his craft but himself little more than a tool used to put the bricks in place. It is only in the light of this disregard, by those who kept such records, for the manual aspects of the task that one can understand the seemingly bizarre comment of one eleventh-century chronicler that Queen Emma of England 'built' (*construxit*) the church of Saint-Hilaire-le-Grand at Poitiers. The monk admits only in passing that the queen did so 'by the hand of Walter Coorland', an English master builder. The English monk Gervaise, who recorded the rebuilding of Canterbury Cathedral after a devastating fire in 1174, refers to the masters who were summoned to advise on the repairs simply as 'French and English workmen' (*artificers*), when it seems clear that they must have been specialists with a great deal of technical knowledge.*

* Hans Jantzen inadvertently perpetuates this snobbish rejection of the manual when he attempts to redeem the master builder's reputation with the claim that 'Gothic architects were not engineers, but artists' – apparently it is inconceivable to Jantzen that the two could have been combined in a single person.

Although his clerical disdain for manual work led him to be frustratingly brief about how the new cathedral was planned and executed, Gervaise's account remains one of the most valuable sources of information we have about this process. The advice of the various 'workmen' consulted by the monks and the bishop left the clerics fearing that their church might have to be rebuilt from the ground up, which would mean that they would not see it towering towards heaven again within their lifetime. 'But one,' says Gervaise,

> William of Sens, was present with the other workmen – a man both physically strong and a skilful worker in wood and stone, and to him under the providence of God, the finishing of the work was committed, rather than to the others, on account of his experience and fame in such work. He proceeded to spend many days in careful investigations with the monks, both of the upper and lower walls, and the interior and exterior, so that the least damage might be sustained by the weaker portions. He went on preparing everything necessary for the work, either himself or deputing it to others, and when he saw that the monks were a little consoled he had to tell them that the pillars damaged by fire and the superstructure ought to be pulled down if they wished to have the work satisfactorily done. At last they were convinced and consented, which work he promised should be done, since they wanted to be secure.

So while William of Sens is presented here as merely a good craftsman, the monks were clearly utterly dependent on his expertise. To their good fortune, that was both sound and innovative: William is credited with introducing the characteristic features of the Gothic style to Canterbury. It is not surprising that this should have been the natural inclination of a master from Sens, where the first proto-Gothic cathedral had been constructed three decades earlier. But the fact that he seems to have been at liberty to make these stylistic alterations to the church says much about the freedom that at least some master builders enjoyed. William's case also illustrates how the Gothic style was spread partly by the movements of the master builders themselves, particularly once the building 'boom' in early thirteenth-century France subsided and the French masters began seeking work further afield.

The 'pillars damaged by fire' that Gervaise mentions were those in the cathedral's choir, and while William had the new ones built to the same width as the old, their height was greater, impressing Gervaise with the way the new choir soared despite the apparent slenderness of its supports. Even more strikingly, William replaced the previous painted wooden ceiling with stone vaults, and he had the decoration carved delicately with chisels rather than, as before, crudely hacked with axes. At the same time, he was dealing with complex logistical matters such as arranging for the transport of stone from Caen in Normandy. (Canterbury is partly French not only in appearance but in its fabric.) To this end, William 'constructed ingenious machines for loading and unloading ships'.

William's indispensability became apparent when in 1178 he fell from scaffolding 50 feet (15 m) high as the timbers broke under his feet. 'No one other than himself was in the least injured', Gervaise says. 'Against the master only was this vengeance of God or spite of the devil directed.' (It was always hard to tell which was which.) Although William's fall was not fatal, it left him bedridden and he never recovered his health. Some key tasks could be delegated – 'the master though still in bed gave directions as to what should be done first, and what next', writes Gervaise. But that was not sufficient, particularly as the approaching winter lent urgency to the process. In the end William was forced to resign and return to France and the work was taken over by an Englishman, also named William, who, although 'in workmanship of many kinds acute and honest', seems to have been less adventurous and indeed less competent. The English William may well have travelled to Paris to inspect the innovations made at the Gothic cathedral of Notre-Dame, but he did not really understand what he saw, and his flying buttresses at Canterbury are more or less decorative features that do not fulfil their intended structural function of supporting the walls.

The case of William of Sens shows that good master builders were in great demand. In 1110 Hildebert, bishop of Le Mans, secured the loan of a monk named Jean from Geoffroy, abbot of the Trinity at Vendôme – and Jean did such a good job that Hildebert kept him there, despite Geoffroy's entreaties for his return. In the end Jean confounded them both by leaving France to travel to Jerusalem. He

was apparently an anomaly in being a monk, for most master builders came from the laity.*

By the early thirteenth century, master builders were rising through the ranks of the hierarchical medieval society. Hugh Libergier's tombstone portrait shows a well-dressed burgher, and the prominence given to the burial places of such men says much about their status. By the fourteenth century architects might be regarded almost as family members by their patrons. Charles V of France was godfather to the son of his architect Raymond du Temple, to whom he gave 220 gold florins in 1376 as a token of his appreciation for 'all the good and pleasant services which our friend has done and is still doing for us daily and which we hope he will continue to do in future'. On the other hand, the expectations placed on these men could be tremendous, and the consequences of mistakes proportionately disastrous. In the contract drawn up for work on Fotheringhay Church in Northamptonshire, England, in 1453, the commissioners, acting on behalf of the duke of York, added a dire warning for the master builder William Horwood: 'And if it be that the said William Horwood makes not end of the said work within reasonable time, which shall be set clearly by my said lord, or by his counsel . . . then he shall yield his body to prison at my lord's will, and all his moveable goods and heritances at my said lord's disposition and order.' In those days, it seems, there were decisive ways to make sure that builders did not overrun the schedule.

The Making of a Master

How did one progress from being a mere cutter of stone to a person who planned the greatest artworks of the Middle Ages? Von Simson is content to regard this progression as simply a matter of steady advancement of the most capable individuals, whose career began like that of any other mason: in the mud, the rain, the dust and the arduous toil of the quarry. Skill at stonecutting might qualify the mason to

* It has been suggested that skilled masters were sometimes subsequently admitted into the church order; but if this happened, it was very rare. The example often cited is that of the Englishman William of Wykeham, who became a bishop – but it now seems unlikely he was ever truly an architect.

work on 'freestone', that is, fine-grained limestone or marble, which carried with it the title of 'freestone mason', or simply freemason. This superior work would still be conducted according to the instructions and designs of the master mason; but the best freemasons were given the prestigious job of carving sculptures for the façades (which permitted them some degree of individual expression), from which one might eventually progress to be a master of works.

That career trajectory seems plausible enough when one considers that these masters would commonly continue to shape some of the material for their buildings with their own hands. Several of the statues in Regensburg Cathedral were fashioned by the master builder Konrad Roriczer himself. In fact, by the mid-thirteenth century the Dominican friar Nicolas de Biard was moved to criticize those master masons who, while being paid more highly than anyone else, 'work with words only . . . rarely or never putting his hand to the task'.*

But a mason could not become a master builder simply by being exceptionally good at his job. For one thing, he would need extraordinary administrative skills: to negotiate with clerics, no doubt eager for the work to be finished with a minimum of time, cost and inconvenience; to arrange for the shipments of materials, sometimes from a great distance; to keep the labour force employed, sober and remunerated (and to prevent its disintegrating during the winter months when work might have to be postponed); and to co-ordinate the efforts of a whole team of men who were artists in their own right. There may have been as many as thirty sculptors (*imagiers*) alone working on the statuary of Chartres, and there is no reason to suppose that the artistic temperament was any less volatile in the twelfth century than it is today.

The master was responsible for the contracts specifying rates of payment. These were important enough to be written on expensive parchment in duplicate. The two copies would then be separated by cutting them in a sawtooth pattern that acted as an anti-fraud device: only the true copies could be precisely united again. The masters could

* It's not clear that Nicolas is in fact here lamenting a decline in the amount of masonry work a master mason did. It may have been rather common for these masters to devote themselves entirely to planning and supervision rather than to stonework; but Nicolas, seeing them with his cleric's eye as mere manual labourers, may have been disgusted that they did not seem to do any 'real' building work.

be well rewarded for their efforts: when he died in 1260, the English king's mason John of Gloucester owned an estate at Bletchingdon as well as houses in Bridport, Oxford and Westminster. James of Saint George, the architect of a series of castles in Wales in the late thirteenth century that included Caernarvon and Conway, is estimated to have received the immense sum of £80 per year. On the other hand, a contract was of little use if the money ran out, as it often did during major projects – unless, like Raymond, the master builder of Lugo Cathedral in 1129, you had stipulated that payment should in that event be made in kind: in lieu of cash, Raymond would receive cloth, wood, shoes, salt and candle wax.

During the thirteenth century the duties of the master builder may have been somewhat lightened by a finer division of labour, partly due to the development of masons' lodges and guilds governed by well-defined regulations. There was an increasing tendency to separate the administrative and financial responsibilities from the technical and artistic ones: the latter remained in the charge of the master builder, whom we can thus begin to regard as more of an architect in the modern sense, while the administrative duties fell to a kind of project manager called an *operarius*. But no such divisions were formally established when the walls of Chartres were rising, and it is likely that the master builders there would have had some part to play in all these aspects of the construction.

A skill at stonework and an aptitude for administration were by no means the full extent of the abilities that they needed. As the true architect of the building (whether or not that was what he was called), the master builder would need to have a sound knowledge of engineering, geometry and mathematics. If the roof fell down or the walls gave way, he was the one responsible.

As we shall see in Chapter 8, there are a number of engineering principles that govern the stability of the Gothic cathedrals. Even if the master builder did not comprehend the mechanics that underlie them, he had to be able to determine, say, how deep the foundations should be dug, how high the walls might be, or how much of them he could omit to make way for windows, how steeply the roof could be sloped. The masters by no means always got their calculations right, although failures as spectacular as the collapse of the crossing spire at Beauvais seem rare. Foundations were a common weak point,

since there was little understanding of the mechanics of soil or the processes of drainage. That was why, for example, the foundations of Chartres had to be reinforced in modern times.

Who Made the Decisions?

How much control did the master builder really have over the layout and design of a church? Was it he who decided how many arches to place along the triforium – or indeed whether to include a triforium at all, and whether it should be blind or should front a passageway in the wall? The decision at Chartres to create a double ambulatory was apparently taken by the clergy in 1199. But Hans Jantzen assumes that it was the master builder of Chartres, not the canons, who decided that the great piers of the nave should alternate with octagonal and circular cross-sections (see page 220). Jantzen wonders whether the master chose this 'lively rhythm' to avoid what might otherwise have been a monotonous row of pillars. (Actually the alternation is a rather old-fashioned feature initiated for technical reasons, as explained in Chapter 8.) This anonymous master, says Jantzen, ensured that 'everything is always completely thought out and in full understanding of the effects of the whole'. Yet would the master have been entrusted with so radical an innovation as the design of the clerestory windows, with the virtually unprecedented placement of roses above pairs of lancets? If so, would he have had to explain the reasons for the design to the chapter, and to secure their approval?

The historians Charles Radding and William Clark point out that one of the major weaknesses in the thesis of a connection between intellectual and architectural developments in the Gothic era was that scholars and clerics had very little input into the essential elements of a church that define both the Romanesque and the Gothic styles: 'the decisions to employ a particular set of constructional features were made by the builders seeking to fulfil the demands of their patrons, rather than by the patrons themselves'. If, as has been proposed, Abbot Suger was obsessed with the Neo-Platonic idea of filling his choir with light, he would have had no idea how to go about it; and the means of doing so, decided by the master builder, were not at all uniquely

defined. To credit a cleric like Suger with the invention of Gothic, as some have done, is absurd, as Peter Kidson has indicated:

> It ought to be obvious to art historians, if to no one else, that patrons, even the most enlightened and exigent of them, do not normally invent styles . . . So while it may be granted that any symbolism present in Gothic architecture was the contribution of the clergy rather than the craftsmen, at best it can have been no more than a partial and superficial factor in the design procedure . . . By its very nature medieval architecture involved mysterious operations that were excluded from the conspectus of the liberal arts and therefore beyond the understanding of even the most educated ecclesiastical patrons.

The master builders and their paymasters in the church were not the only parties who might have expected to have some say in matters of design. When money came from donors, there may have been strings attached – after all, a noble could command the construction of a private chapel even when it ate into the fabric of the church and disrupted its unity and poise. Disputes about the design of great cathedrals like those at Canterbury and Milan brought together many players, each with different ideas and preoccupations.

Some notion of how these decisions were apportioned can be gleaned from the contracts made between patrons and master builders. That for the castle of Mahaut, countess of Artois, at Bapaume in Flanders, where work began in 1311, is highly specific about the plan that the master mason Jehan de Lohes should follow. It indicates the dimensions of the main hall and the thickness of the walls, and goes on to say that

> On one side, there will be an arch adjoining the chapel as is suitable with an opening equal to the width of the chapel. The arch will be decorated with roll mouldings; there will be four large windows at the ends of this hall, and four on the two sides . . . And there will be six double windows and six ordinary ones with frames on the inside . . . At the ends of the hall, there will be two gable ends as high and as wide as is necessary for them to fit the roof structure as well. These gables will be crowned with French copings, as is suitable, and decorated on these copings with bosses, balls and fleurons in sufficient quantity . . .

Of course, we cannot know how much of this was decided in consultation with the master mason in advance, nor to what extent the patroness and her advisers intervened in the subsequent construction work. Bear in mind too that, while contracts became standard practice in the late twelfth century, they were initially much simpler affairs than this one.

What is also clear from the contract of Jehan de Lohes is the extent to which the master mason was expected to fund certain features at his own expense – that is, to find the money from his agreed salary:

> For the foundations, the said Jehan must go at his own expense 3 feet down below the ground . . . He is to provide labour to put up the fencing, and furnish the four columns at his own expense, as has been said, except for the transport, which will be charged to us. The said Jehan must take the cut stone that is already available to use for the said work, and at the price obtaining before the work commences; he is to deduct this price from his salary.

That salary was agreed with these costs in mind, but the master mason could increase his profit margin by corner-cutting and the use of inferior materials. No doubt that is one reason why masons' guilds instituted statutes to avoid their profession being discredited by poor workmanship; an article of the Strasbourg stonecutters in 1459 stipulates that 'If a master mason has agreed to build a work and has made a drawing of the work as it is to be executed, he must not change this original design. But he must carry out the work according to the plan that he has presented to the lords, towns or villages in such a way that the work will not be diminished or lessened in value.'

One of the main reasons why it is hard to know how design decisions were taken – and whether those decisions were modified by the builders during implementation – is that the drawings and plans for High Gothic churches such as Chartres, Amiens, Reims and Laon are non-existent. It is not necessarily that they are lost; they may never have been made at all. According to the historian Robert Branner, until the thirteenth century a master builder formulated the plan of a building 'in his head', and then laid out the design directly on the ground without the intermediation of a drawing. 'Although it may be difficult for us to imagine nowadays,' Branner

says, 'when sketchbook and pencil are the architect's vade mecum, the habit of thinking out the design, even down to the details, was perfectly normal when there was no strong tradition of drawing, and several texts from the early thirteenth century indicate that the mental procedure was still well known at that time.' If this was how things were done, the master's presence on site was surely indispensable, for without his instructions there was nothing to work from. No wonder, then, the injured William of Sens had to keep directing the reconstruction of Canterbury from his sick-bed.

As the image on Hugh Libergier's tomb shows us, the design for a building was often displayed in models of wood, plaster or stone. Yet if the Libergier inscription is depicted to scale, it suggests that such constructions were tiny and could not have included much detail. On the whole, these models were used only to give patrons a general idea of what the master had in mind, and not as guides for the masons, let alone as trial pieces for testing the mechanical principles involved in the building. That seems to be borne out by the rather sketchy model of a thirteenth-century church held in the hand of a tomb effigy now in the Germanisches Nationalmuseum at Nuremberg. In later centuries, however, these models could be major works in themselves. A surviving sixteenth-century wooden model of a church in Regensburg (now in the Museum der Stadt) is a quite beautiful artefact. And the model made by Filippo Brunelleschi for the competition to design the great dome of the cathedral of Santa Maria del Fiore in Florence in the fifteenth century was 12 feet (3.6 m) tall – big enough for the judges to inspect it from the inside – and was constructed from more than five thousand bricks. Brunelleschi even hired respected sculptors to decorate the façades, which were painted and gilded to create a work of art in its own right.

Architectural drawings of a sort *were* made at least from the thirteenth century onwards, however. But no one really knows how common these were, nor how extensive, detailed or accurate. In the High Gothic era, it is not clear that they were scale drawings of the sort made by architects today. A major reason why such plans have rarely survived is that the only medium for carrying robust yet portable drawings in the early Middle Ages was parchment, which was very expensive. So once a drawing had served its purpose, the parchment would have been scraped clean and reused. Alternatively, temporary

The architectural drawings for Strasbourg cathedral show how detailed and accurate such drawings were by the late thirteenth century. (*Photo: Ville et Communauté Urbaine, Strasbourg.*)

plans might have been drawn on boards or canvas, with no sense of their being documents worth preserving for posterity. The earliest signs of suchillustrations, scratched with a sharp point into the plaster or stone of the building's walls, appear around 1220. A few drawings on parchment still exist from the later part of that century, probably the best examples being those for the cathedrals at Strasbourg and Reims, both made between the 1250s and 1270s. These are extremely detailed, scaled and executed with high technical proficiency, and they would have given patrons a clear idea of the master's intentions. Drawings like this could have been important for spreading new styles and designs, for they could be passed between architects, masons and sculptors without the craftsmen having to travel to see the buildings *in situ*. But that kind of transmission was dependent on who owned the plans – if the patron paid for the expensive parchment, he or she was unlikely to let the master builder walk off with it. In 1460 the master builder Hattonchâtel was contractually bound to hand over the drawings of Toul Cathedral to the chapter.

Yet even drawings as proficient as those of Strasbourg and Reims were not blueprints for construction: they did not necessarily give unambiguous guidance to the masons. All the same, they offer a striking contrast with most medieval art and map- making, from which the notion of an 'accurate', scaled representation of the world in two-dimensional form seems absent. This latter sort of depiction was symbolic, showing codified relationships without any real attention to dimension. Given the significance accorded to geometry, mathematics and proportion among medieval philosophers, that might seem odd. But there is no contradiction; it was the Platonic world-view itself that militated against placing too much emphasis on the precise shapes and dimensions of the mundane world, which were regarded as no more than degraded and imperfect manifestations of a more orderly and regular, transcendent reality. Thus, early medieval figurative art is relational, not naturalistic.

The Gothic architects eventually managed to move beyond that manner of representation, but it isn't clear when and how this happened. An adherence to the symbolic tradition is certainly in an eleventh-century sketch of the monastery at Canterbury. This is intended as a plan for building work – in fact, apparently for the laying-out of drains – but it mixes plan and elevation in a way that denies

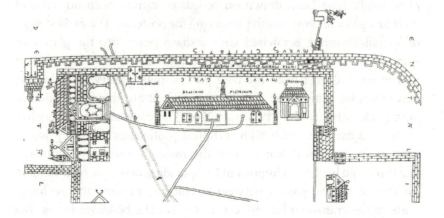

An eleventh-century sketch of building plans for the drainage system of Christ Church Priory in Canterbury shows how space was still conceptualized in a non-naturalistic way, based on the traditions of manuscript illumination rather than the formalized abstractions of later architectural plans.

any attempt to visualize the scene from a particular viewpoint. At the same time, the buildings are shown in far more detail than would be necessary simply to establish the courses of the drains, implying that there was no sense of the kind of abstraction typified in building plans today. The artists here were adhering to conventions that paid little heed to the real needs of the builders. A transition from this form of representation, in which technical instructions were cobbled together using the tropes of an entirely different tradition, to a genuinely diagrammatic mode of illustration is evident in the most famous of surviving 'architectural' drawings from the Gothic age: the sketch-books of the Picard craftsman Villard de Honnecourt. But this document, which I shall describe shortly, is perhaps better known for the disputes it has excited over the master masons' use of geometry.

Line and Stone

There is no doubt that geometry and proportion were central to the practices of the master builders. As the anonymous *Articles and Points of Masonry*, a kind of builder's handbook written around 1400, entreats:

Marvel you not that I said that all science lives all only by the science of geometry. For there is no artifice nor handicraft that is wrought by man's hand but it is wrought by geometry . . . geometry is said [to be] the measure of the earth, wherefore I may say that men live all by geometry.

This passage reminds us that geometry indeed means 'the measure of the earth', and not, as at school, lines drawn on paper. According to the author of the *Articles*, this is the way in which it was taught to Euclid in Egypt by none other than Abraham. Euclid then passed on this knowledge to the Egyptians, the master builders of the ancient world: 'And they took their sons to Euclid to govern them at his own will, and he taught them the craft [of] masonry and gave it the name of geometry.'

No one could become a master mason without becoming a master geometer. 'Does not geometry teach how to measure every dimension, through which carpenters and stoneworkers work?' asked Robert Kilwardby, archbishop of Canterbury, around 1250. But it is not clear what the sources of this knowledge were, or what the medieval architects intended to express through it. They probably knew at least some of what had been written on architecture and proportion by Vitruvius, and on geometry by Euclid and the Islamic authors. And while it is likely that the numerological symbolism of the iconography and proportions in the cathedrals relied on some degree of input from the clients, clerics would not have had the confidence or knowledge to instigate the kind of geometrically based designs described in Chapter 5. These expressions of Platonic principles must surely have come from the masters themselves.

But all of this could easily have been passed on through the traditions of an apprenticeship rather than being based on direct reading of the classical texts. The historian Lon Shelby argues that the geometry employed by medieval masons was 'constructive' – it required no formal mathematics or theoretical foundations, but was merely a collection of routines for creating geometrical figures. Such a facility with geometric manipulations became taken for granted in builders. According to the Spaniard Dominicus Gundissalinus in the mid-twelfth century, 'Each skilled person in the mechanical arts is involved in the practical application of geometry. Through its application he forms

lines and surfaces, creating square, round and all kinds of other shapes in the material subject to his skill.'

The distinction between the 'theoretical' geometry of the cathedral schools and universities, governed by mathematical proofs, and the 'practical' geometry that could be used mechanically for constructing regular forms was first emphasized by the French scholar Hugh of St Victor in the twelfth century. In his *Practica geometriae*, Hugh wrote:

> The entire discipline of geometry is either theoretical, that is, speculative, or practical, that is, active. The theoretical is that which investigates spaces and distances of rational dimensions only by speculative reasoning; the practical is that which is done by means of certain instruments, and which makes judgements by proportionally joining together one thing with another.

But as this distinction evolved in a climate of scholastic disdain for practical matters, later academic works on geometry ignored its craft aspects and wrote at a level that would have been incomprehensible to craftsmen.

The builders, meanwhile, had little need for mathematical understanding, for they could draw and interpret plans according to geometrical constructions encoded in sequences of operations that could be learnt by rote and passed on in oral tradition. (It is by no means clear that master masons were even universally literate.) The books on architectural geometry written by Matthew Roriczer (father of the aforementioned Conrad and his predecessor as the master builder of Regensburg Cathedral) in the 1480s bear evidence of this constructive approach. In his *Booklet on the Correct Design of Pinnacles* and *German Geometry*, the prescriptions for how to construct regular polygons, or to find the centre of a circle from an arc, are ones that can be managed with compass and ruler without the slightest intimation that Euclid would have accompanied such procedures with rigorous proofs. Do it like this, the booklets say.

The knowledge of determining architectural proportions by unfolding them from simple geometrical figures was maintained as a trade secret by the medieval masonic lodges until it was revealed

Quadrature: how to 'double the square'.

by Roriczer.* One of the most important of these was the way that the elevation of a structure – a vault, a tower, or an entire building – could be deduced from the plan by a process of projection based on elementary geometric forms. Roriczer showed how this was done for pinnacles. He also revealed common tricks such as constructing squares whose areas follow a geometrical progression in the ratio 1:2:4 . . . Vitruvius records how to do this, having learnt it from Plato. The construction, which involves inscribing around one square a second with precisely twice the area ('doubling the square'), produces a ratio of length of sides of $1:\sqrt{2} = 1:1.414$, explaining why this ratio (which at first glance doesn't look at all 'simple') is common in the proportions of Chartres and other Gothic cathedrals. According to Eric Fernie it 'appears to have been overwhelmingly more popular than any other in the designing of buildings'; for example, it often defines the ratio of the length of a nave to the total length of the church. Despite popular claims about the status of the Golden Section, it was the $1:\sqrt{2}$ rectangle that was the 'standard Gothic rectangle', the medieval 'true measure'. A small indication of how this ratio might be used for setting out proportions can be seen in a window of the fourteenth-century choir at York Minster, where the radius of the pointed arches is a factor of $\sqrt{2}$ greater than the window's width.

The forms traced on a stone that is now preserved in the chamber

* Peter Kidson suspects that this very secrecy prevented the masons' geometrical knowledge from ever becoming very sophisticated. 'So long as masons managed to keep themselves secluded in their lodges', he says, 'there was no one to tell them that their little rules of thumb were not mathematics at all.'

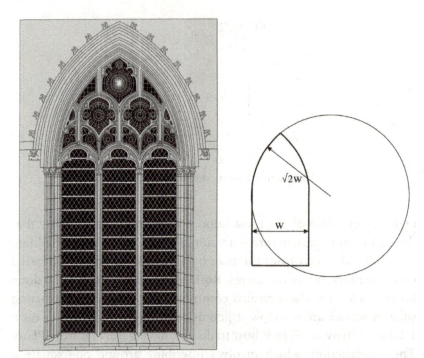

This window at York Minster has proportions governed by the ratio 1:√2.

of the south tower at Chartres demonstrate that we should be wary of placing symbolic or overtly Platonic interpretations on these uses of constructive geometry. This block originally served as a capital for one of the piers in the south transept porch, until it broke and was replaced. Its flat surface is engraved with lines, suggesting that it served as a temporary surface for tracing out designs and templates in the workshop before it was cut to shape (some of the lines run over the current edges of the block). There was no harm in using stone blocks this way while they awaited the final ministrations of the masons, for no one would see the markings once the stone was in place.

The tracings include several spiral figures that correspond more or less to the form known as an Archimedean spiral, first studied by Archimedes in the third century BC. They are constructed by drawing semicircles of increasing radius around a straight line, a procedure that would have been rather easy to implement. Since there is no such spiral in the architecture of the cathedral, what was its purpose?

Perhaps it was used as a geometric means of constructing ratios corresponding to the square roots of certain integers, such as √2 and √3 – which, being irrational numbers (not reducible to simple fractions), are hard to measure out in other ways.* These numbers crop up in the proportions of wedge-shaped stones used as the keystones of pointed arches – and indeed, the juxtaposition of an Archimedean spiral and keystone profiles on a page of Villard de Honnecourt's notebook implies that this was indeed the function of the geometric construction.

Yet at the same time we should not open too wide a chasm between the practical, constructive geometry of the Gothic master masons and the metaphysical connotations of geometry and proportion understood by those scholars who had read and studied Plato, Pythagoras and Euclid. They do, after all, have the same origins, as Hugh of St Victor made clear, even if both scholars and builders tended later to forget it. Plato's belief that certain geometric figures, especially the square and the equilateral triangle, were especially stable became embedded in architectural lore, so that a preference for these shapes may have seemed to the builders to be a practical one, whereas in fact it had philosophical origins.

That elision is evident in the deliberations of a council convened in 1392 to discuss the problems in stabilizing Milan Cathedral, begun six years earlier. The patron, Duke Gean Galeazzo, demanded a church in the French style, with which Italian builders had little experience. The Milanese lodge and canons could not agree on how it should be done, and so they sought external advice in a meeting of specialists,

An Archimedean spiral seems to be related to the shapes
of keystones on a page of Villard's notebook.

* Actually they are not *that* hard: as we've seen, the diagonal of a square gives √2, while the diagonal of the 'standard Gothic rectangle' is equal to √3, and that of a 1:2 rectangle is √5. But there might have been some value in having a single figure that allowed for construction of all of these.

A discarded capital from the lower bed of the south transept porch at Chartres is inscribed with several Archimedean spirals (*top*). Here the shaded area is the extant capital – lines outside of these regions are reconstructed. The lower frame shows two of the spirals reconstituted and complete. (After Branner.)

called an expertise. The issue hinged on the question of whether the proportions of base width to height based on the square (*ad quadratum*), as proposed in the original design, or on the triangle (*ad triangulum*), as proposed by a consultant mathematician named Stornaloco, were more sound. Stability was thought to stem from such geometrical relationships between the dimensions of the ground plan and of the elevation, rather than any knowledge of the actual stresses that a design would impose on the masonry.

Stornaloco's *ad triangulum* design implied that the ratio of the cathedral's height to its base should be an irrational number. How could a builder deal with that? The 'obvious' answer is simply to round off the numbers to a close approximation. In this case, the *ad triangulum* height measures about 83.1 *braccia*, where a *braccio* is the Milanese cubit, about 0.6 m (2 feet). But that was not what Stornaloco recommended. Instead, he suggested increasing the height to 84 *braccia* – not just a whole number, but one that gives a relatively simple base:height ratio of 8:7. In other words, he felt it best to sacrifice close adherence to the perfect triangular proportions in order to obtain a nice integer ratio. That is the problem with 'perfect' geometric figures: they can lead to ratios that don't look perfect at all.

In the end, the Milan committee opted for reducing the height still further to give an even simpler ratio of 8:6 – the proportions, in fact, of Pythagoras's right-angled triangle. That was not the end of the matter, however; the disputes continued as the building progressed, leading to another enquiry in 1399–1400. On this occasion the Milanese sought the advice of a French architect named Jean Mignot. He drew up a long list of problems with the work, to which the Italian builders responded with what in truth is often a fair point for a craftsperson to make: 'Theory is one thing, practice is another.' To this, Mignot retorted tartly that 'practice without theory is nothing'. Now, both the Milanese and Mignot used the words that would have been natural for their time: theory was *scientia*, practice *ars*. A crude translation of Mignot's remark therefore has it that 'art without science is nothing'. This has given rise to the idea that Mignot was somehow heralding the age of a 'rational art', in the sense of the Renaissance use of proportion, perspective, light and shadow and accurate anatomy. In this way Mignot has been made a precursor to Brunelleschi, Leonardo and the rest. But it isn't so. Mignot's *scientia* was probably no more than a book of rules handed down through generations of master builders, of which he possibly had only enough understanding to see where they were being broken. In any event, *scientia* did not carry the day; the Milanese committee rejected his recommendations, and the cathedral is still standing.

Yet theory was the foundation of much masonic practice, whether they were aware of it or not. According to Nigel Hiscock,

Rigid distinctions that continue to be made between practical, theoretical, and allegorical geometry are likely to be more modern than medieval . . . It is unlikely that a patron would have understood the lodge practice behind the mason's markings on a keystone any more than a mason would understand how the geometrical figures he was so used to constructing related to the cosmological speculations of Christian Platonist thought. Yet these were undoubtedly the ends of a single spectrum of understanding.

To illustrate this point, Hiscock adduces the sculptors' use of a lens-shaped figure called the *vesica piscis*, within which Christ is often seated in majesty. This design is found in the Royal Portal at Chartres, and also in the early eleventh-century cathedral at Aachen, in the twelfth-century Norman nave at Ely, and on the tympana of Autun (1130–40) and Vézelay (c.1125–30). It seems to have been a feature of Christian art since at least the tenth century. The shape comes directly from geometrical theory. It is found, for example, in Boethius's *Ars geometriae et arithmeticae*, where he explains that it is the region of overlap between two equal circles whose circumferences pass through one another's centres. Boethius explains that this construction, which can be made with a pair of compasses, may be used to construct an equilateral triangle, the most 'perfect' of triangles. So it would have been used to frame the figure of Christ not simply because it was a pleasing and convenient shape but because of its Platonic connotations. Of course, once this became a convention the masons need have known nothing about the symbolism – but the link was there.

The Enigmas of Villard

Geometrical design can be seen in abundance in the notebook of Villard de Honnecourt. Historians attempting to uncover the working practices of the Gothic cathedral architects have long celebrated and even venerated this thirteenth-century document, alleging that it supplies unique and compelling insights into the way these men thought and worked. Villard's 'book' comprises thirty-three pages of parchment that by some miracle passed down through the centuries

more or less intact to give us a window into the visual language of
the age of Chartres. When Villard was alive, all of the great cath-
edrals in the Île-de-France were either recently completed or in
progress.

What is often glossed over, however, is that his manuscript is our
only record of Villard's existence. In consequence, we know almost
nothing about him. While it has been almost universally asserted that
he was a working architect during the 1220s and 1230s, even that is
conjecture. It is not clear that a single building was ever raised under
Villard's instruction or guidance, nor does he ever claim as much. He
does not reveal whether he was a master builder, or a regular mason,
or indeed a craftsman of any sort. Some have suggested that he was
no more than a clerk of a masons' lodge who took it upon himself
to make drawings of the works he saw. Others wonder whether he
was a lay traveller with artistic pretensions who enjoyed making
sketches of buildings, animals and inventions.

Villard's book is a portfolio: the pages of parchment are stitched
between covers of brown pigskin. To call it a sketchbook is anachron-
istic, for it seems that the pages were loose while Villard owned them,
though they may have been kept together in the portfolio cover. They
are a little larger than today's standard A5 format, and while they are
numbered, the pagination is merely the composite result of several
later guesses at the correct sequence. In any case, at least eight and
perhaps as many as fifteen leaves were lost between the thirteenth
and eighteenth century, when the portfolio became part of the French
national collection at the Bibliothèque nationale. It was all but forgotten
until the middle of the nineteenth century, when its rediscovery and
publication during the peak of the Gothic revival in France aroused
considerable excitement and initiated the idea that Villard was a great
architect of the early Gothic era. According to one nineteenth-century
historian, his sketchbook contains all that a Gothic architect needed
to know.

It was said that Villard was educated at the Cistercian monastery
of Vaucelles and that he knew Latin, adding to the impression that
architects of his day received a thorough academic education. In fact,
neither of these things can be asserted with any certainty; the language
in which the sketchbook is annotated is mostly a Picard dialect of Old
French. It does seem likely that Villard travelled widely – his sketches

suggest that he visited Cambrai, Chartres, Laon, Meaux, Reims and indeed Vaucelles, as well as Lausanne in Switzerland. He also depicts the abbey of Pilis in Hungary, and says that he was 'sent into the land of Hungary' on unspecified business.

One thing of which we can be sure is that Villard had a voracious curiosity. He drew not only architectural designs and masonry but also examples of carpentry and furnishings, mechanical devices, humans and animals, and geometrical figures. His pages show boars, bears and insects, biblical figures, war machines, knights and dragons. All the pictures are executed in lead point, some with the aid of rulers and compasses. Villard then added a sepia ink wash and emphasized the relief with hatching or further inking. This all shows that, whatever his profession, he had a sound training in draughtsmanship. But there is no apparent plan or system to any of it; it is as if he drew whatever took his fancy, sometimes scraping the page clean to make fresh space. Into the text, which explains what the drawings depict, he weaves recipes for medicines and a description of lion-taming. He drew some architectural features not for edification but simply because, as he says, 'I liked it'. Thus, when Villard apparently decided, after completing his sketchbook to his satisfaction, that it should be used as an instruction manual in which 'will be found sound advice on the virtues of masonry and the uses of carpentry', one should not be tempted to interpret that as a systematic educational programme devised by a master craftsman.

Villard was especially fond of machinery, although it is not clear whether his illustrations depict devices of his own invention or just things he saw or heard described. Here, a water-wheel drives an automated saw; there he shows how to make a saw operate under water. A weight-driven clockwork machine powers an angel which revolves so that its finger is always pointing to the sun. A pivoted brazier in a brass shell acts as a hand-warming device for bishops celebrating Mass in winter. And a giant wheel ringed with hinged mallets filled with mercury will turn forever of its own accord – or so Villard claimed in this early depiction of a perpetual-motion machine.

In certain images Villard is said to have revealed some of the masons' most closely guarded 'secrets', such as how to 'double a square' and how to project elevations from the ground plan of a

building. This, it is argued, supports the idea that he was connected to the mason's trade. He explains how to transfer sketches from parchment onto stone, and how to scale them up. More prosaically, he gives a recipe for mortar ('lime and pagan brick and linseed oil'), which indicates that, if he was not a *cementarius* himself, he had an uncommonly deep interest in the trade. But it is not clear how much of these things Villard really understood – his visual formula for doubling a square may have just been copied in rote fashion, for example. Moreover, some of the practical instructions in the sketchbook were added in the thirteenth century by later editors who seem to have erased several of Villard's own drawings to make the space, suggesting that they did not consider them useful enough to be worth retaining. The historian Carl Barnes has suggested that Villard's rendition of drapery is characteristic of that employed by thirteenth-century metalworkers: this, not masonry, might have been his true profession.

Much has also been made of the way that Villard drew images of humans and animals onto geometric forms. Indeed, this has even prompted the rather absurd claim that he experimented with a primitive type of cubism. Is this an illustration of the principles of proportion described by Vitruvius? Or is it some kind of codification of Platonic ideal forms in organic objects? It seems more likely that the constructions were merely a technique for transferring drawings from one medium to another – as Villard himself hints when he explains that 'Here begins the method of drawing as taught by the art of geometry, to facilitate working'. Jantzen's suggestion that Villard's lion, which Villard says is 'drawn from life', has its 'natural appearance . . . subordinated . . . to the laws of geometry' (and is thus a 'Gothic lion') has to be weighed in that light. And even if Villard absorbed the classical Platonic literature sufficiently to have developed a 'geometric' drawing style, that doesn't in itself make him a Platonist.

Villard's knowledge of classical geometry and its application in the crafts is more apparent on two pages showing a series of constructions and procedures, such as 'How to measure the diameter of a column, only part of which is visible' and 'How to find the midpoint of a drawn circle'. (It is thought that some of these diagrams may have been added by one of the later thirteenth-century editors.) Again,

'Geometric' faces and animals in Villard's notebook.

this doesn't prove that Villard's source was a classical geometer like Euclid, for practical handbooks describing such geometric methods were widely available in the thirteenth century.

A hint that Villard may indeed have been familiar with the technical literature of antiquity, however, is found in his drawing of a so-called Tantalus cup, a playful gadget in which a bird perched on a tower in the cup's centre appears to drink wine as it is poured in. Villard explains how the cup works, but both this explanation and the drawing itself contain errors or omissions that show he never actually held such an object in his hands. He may have simply copied the description from a Latin translation of the *Pneumatics* of Hero of Alexandria.

The idea that Villard was an architect originates primarily with the drawings of church plans and elevations. These take up about a sixth of his book; many are rather fine, and they show that the basic schema of

the church plan used today, indicating the individual bays, the positions of piers, and the form of the vault ribs, was already established in Villard's time. This transparent schematization of space, with proportions accurately observed, would have been far more instructive to workmen than would the pictorial representations of two centuries earlier.

On the other hand, the drawings are not always accurate. The elevations that Villard sketched at Reims differ from the way the building actually looks in ways that are unlikely to be due to bad draughtsmanship. Rather, it has often been suggested that Villard transformed the designs, constructed in 1211, into ones that would have been more appropriate to the style of the time the drawings were made, around twenty years later. In other words, perhaps he tended to reproduce designs not as he saw them but as he'd have constructed them if he had done the job himself. He made significant alterations in his sketches of the cathedral tower at Laon – which, with its attempts at crude perspective, would have been more confusing than useful to a builder – and of the great rose window of Chartres. (Curiously, his drawing of the Chartrain labyrinth is a mirror-image reversal of the original.)

It is possible that, rather than revising and 'updating' buildings as he sketched them, Villard in fact copied them from architectural drawings – including some that were proposed and rejected for the projects in question. That might explain why his sketch of the rose window at Lausanne is nothing like the one actually built. And it seems to be the only way to account for the fact that Villard draws the elevation and the flying buttresses of Cambrai Cathedral (which was later destroyed) while indicating in his text that they hadn't been built yet. If this is so, it rather throws into question the idea that Villard went to all the places he depicted – maybe he simply got hold of the drawings. Branner argues, however, that at least in the case of Reims the inaccuracies in the drawings can be interpreted only by reference to the building itself.

It is perhaps the very lack of information about master builders in the twelfth and thirteenth centuries that has made art historians so willing to seize on the idea that Villard, this intriguing survivor from a largely silent chapter of building history, was one of them. It may be that this mysterious Picard can indeed tell us something about the work of the Gothic masters, but we have to resist the urge to generalize or extrapolate from his sketches. We simply don't know how

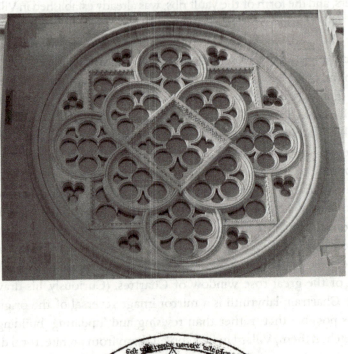

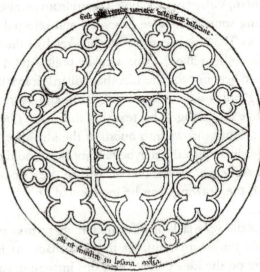

The rose window of Lausanne Cathedral (*top*) is very different from Villard's sketch of it (*bottom*). (*Photo: Daniela Salvatore.*)

Villard earned his keep on his supposed peregrinations around Europe. We don't know what his relationship really was with the cathedral builders. There is no telling whether or not drawings like Villard's were carried around by these masters and handed for instruction to the masons and carpenters. But at the very least they give us a glimpse of the practical, conceptual and intellectual resources that were available to the likes of Robert de Luzarches at Amiens, to Jean d'Orbais at Reims, to William of Sens at Canterbury, and to the forgotten masters of Chartres.

7
Hammer and Stone

Medieval Masons

With wonderful art he built the work that is the cathedral church.
For in its erection he not only granted means and the labour of
his own servants, but the aid of his own sweat. Many a time he
carried the hewn stones in a kind of hod, and the lime-mortar also.

The Metrical Life of St Hugh, c.1220

The Sculpture of the Portals

'Of all the experiments, all the innovations, all the surpassings of
limits that the growth of the West occasioned in the field of artistic
creativity', asks Georges Duby of the age of cathedrals, 'was any
more overwhelming than the deliberate return to monumental
sculpture?'

A return? Yes, because before 1100 it had scarcely been practised
for seven hundred years. In his determination to eliminate non-
Christian religions, the Roman emperor of the east, Theodosius II,
decreed in 408 that all statues should be removed from pagan
temples. This spread a fear that the depiction of the human form
in sculpture would be seen as heretical idolatry. Some statues did
remain in use, but these were portable, made from gold or ivory, and
kept near the altar where only the most learned and pious could
see them. When medieval sculptors began again to carve in stone,
the classical tradition was all but lost and the art had to be re-
invented. It took its lead from other visual forms, such as book illu-
minations, wall paintings and gold-working, which had developed

iconography quite different from the naturalistic statues of anti-
quity. The result was a sculpture of relief, a basically two-dimensional
form in which figures merged with the background. Romanesque
and early Gothic sculpture thus has no weight, no sense of rounded
solidity. At Chartres, that began to change.

Sculpture in a medieval church was, like its stained glass, a way of
telling stories and illustrating allegories and morals to the illiterate
worshippers. In Romanesque churches these messages were often
cautionary: the Romanesque Christ has a rather fearsome aspect and
the worshippers were given constant reminders that they would one
day be judged before God. The Last Judgement was a favourite scene
to place on the tympanum above the main portal, as a caution to
churchgoers that only by passing through this apocalyptic trial could
they enter the kingdom of Heaven. In that respect Chartres is no
different, for Christ sits in judgement over the Royal Portal.

But there *is* something different about the Royal Portal of
Chartres. On the colonnades flanking the doors (the jambs), the
figures – kings and queens of Judah, prophets and patriarchs of the
Old Testament – are starting to float free from their supports. They
are not quite free-standing, but neither are they part of the columns,
like the caryatids of classical tradition. With their feet on tiny plinths,
they seem in fact to be suspended, both part of the architecture
and separate from it.

These figures are still highly stylized: their bodies are elongated
and the folds of the robes fall in concentric waves or parallel pleats,
as regular as the scallops of a seashell. (The French writer Joris-Karl
Huysmans made the rather less elegant, although undeniably apt,
comparison with sticks of celery.) That is a typically Romanesque
trope, and echoes the style of manuscript illustrators and gold-
smiths. The same style was used for the statues at the cathedral
of Saint-Lazare at Autun, and also on the jambs at Saint-Denis just
a few years before the western porch of Chartres was constructed.
It has even been suggested, on stylistic grounds alone, that the
same sculptor (or craftsmen from the same workshop) worked at
both Saint-Denis and Chartres.

What is less evident to the casual glance is how exquisitely the

sculptors have rendered the proportions of these figures. Seen face on, the heads are rather too big for the narrow shoulders. But that is not how we do see them, for they are above head-height, and the artists have made allowance for it so that the proportions look about right from the ground. The same trick was applied to statues in the high galleries at Amiens and on the spires of Reims, where arms that are too short and shoulders that are too low become corrected from the perspective below. And notice too that although the figures are of different heights – taller the further out they are from the door – their heads are nevertheless at an identical distance from the ground.

There were once twenty-four statues on the columns of the Royal Portal: three at each extremity, four on the inner sides of the north and south doors, and five each side of the central door. Only nineteen of them still survive, and some of these are recent copies. It is clear that the sculptors were already moving away from the uniformity evident in older Romanesque statues: the figures are individualized, and one can even find clues about their intended age. This dramatic 'personalization' has sometimes got critics a little overexcited, as, for example, when Viollet-le-Duc claimed that he could detect in one of the figures 'frivolity and vanity, but also intelligence and coolness at moments of danger'.

The tympana of the two side portals in the west front show the Epiphany and the Ascension: a symmetry of themes in which Christ is incarnated on earth and returns to heaven. The archivolts speak of more secular symbolism: as we saw earlier, those of the south door show the liberal arts, while those of the north display the signs of the zodiac and the monthly labours of the year.

The sculpture of the Royal Portal must have been planned as a whole when the west façade was built around 1150. The art historian Wilhelm Vöge, analysing the styles of the work in 1894, claimed that it was crafted by several hands: one chief master, who made the central tympanum of Christ in majesty, four subordinate masters, and their assistants.

Not everyone finds a sense of freedom in the bulking-out of these figures from their supports. The German art historian Horst Bredekamp has nominated them as his 'most hated masterpiece',

claiming that earlier Romanesque sculpture displayed more energy and invention – at least until Bernard of Clairvaux began to denounce such 'excesses'. To him, the figures of the Royal Portal reveal a curbing of the imagination in response to Bernard's fierce criticisms; here, he says, we find sculpture that has 'changed its nature and become architecture'. Bredekamp claims that 'with the creation of the west portal, sculpture was taken from the realm of freedom into a domain narrowly constrained by theology'.

Whether or not that is so, it would be hard to level the same complaint at the sculpture of the north and south porches. This was created more than fifty years later, when the Gothic cathedral was built, and the changes in style and sensibility are very apparent. There is more movement in the jamb figures, they are less bound to their pillars, and they seem to have been conceived as coherent groups. It is hard to see how anyone could detect a constrictive theology in perhaps the most famous of the Chartres sculptures, the figure of John the Baptist in the central bay of the north porch, which is one of the most expressive and touching works of art in the entire Middle Ages. Faced with such peerless lapidary artistry, we might be anachronistically dismayed at the thought that these figures of plain and humble stone were originally bright with paint and gilt. If that is so, it is merely a reminder that our response to the work of those who made Chartres Cathedral is shaped by our aesthetic and not theirs.

'Stone age' is a synonym for the primitive only in the minds of those who have never worked with stone. It is a difficult art that requires immense skill, patience and strength, and for hundreds of years after the fall of Rome, men had forgotten it. They built their churches from wood, which meant that fire razed them with depressing regularity. It wasn't until the tenth century that stone became again the builder's principal material, allowing him to set his sights on eternity. 'I found an abbey of wood and I leave one of marble', boasted St Odilo, who commissioned the imposing new abbey church of Cluny, erected between 1088 and 1135.

During the cathedrals crusade of the twelfth and thirteenth centuries, men scoured the land for stone. With nothing but hand tools they excavated more hard rock than was ever mined in ancient Egypt: not 'marble', on the whole, but its geological precursor limestone, from which the bricks of their churches were hacked and chiselled.* The quarries in the Île-de-France, such as that at Berchères-les-Pierres in the Beauce which provided most of the purple-grey limestone for Chartres, were not discovered until the cathedrals created the demand. Without these lithic resources fortuitously to hand, church-building would have been even slower and more costly. During the Middle Ages, tens of thousands of open-air stone pits were dug throughout Europe, most of which have now vanished. Paris itself sits on a maze of around 300 km (about 185 miles) of tunnels burrowed into its foundations, many of which provided the fabric for monumental buildings such as Notre-Dame.

The stonecutters, masons and sculptors of the Gothic age redefined what could be done with stone. Some of the blocks at Chartres are on such an awesome scale that it makes your legs tremble just to look at them. From others, the craftsmen have brought forth figures of breathtaking sensitivity and invention. Even masonry components that seem purely functional, such as the blocks comprising the great arches of the vaulting, often have highly complex shapes that have been made with stunning precision. It's true that the masonry of Chartres is not known for the high quality of its finish (it has been charitably assumed that the masons expected some of their work to be obscured by the gloom). But there is plenty to admire nonetheless, especially among the smaller figures, and we should never forget how demanding this work was. Carving hard, brittle limestone is an arduous and precarious business; raising it over a hundred feet high and setting it in place, often in locations that were partly exposed to the elements, is laden with hazard. There is surely no other realm of artistic expression in which the artists, if we may call them that, have been pitted against so recalcitrant and unforgiving a medium, and have risen so memorably to the challenge that their materials present.

* Limestone (a form of calcium carbonate) was the hardest and strongest building material; but some medieval churches, such as the cathedral at Strasbourg, are made of sandstone, which is composed primarily of quartz and feldspar.

Work in Progress

The builders of the cathedrals could rarely expect to see their work finished, and neither could the people who paid them. If today we regret the scaffolding that might disfigure this or that part of a building during its seemingly interminable restoration, we should remember that for medieval worshippers these places tended to look like construction sites for generations. Indeed, many of them were *never* finished in the way they were originally planned: Chartres will for ever lack the nine spires that were apparently envisaged at the outset. And even when the vaults of a church were sealed and the roof put in place, tastes might have changed so much during the erection that the new bishop or abbot would decide he could not possibly tolerate such an old-fashioned edifice, and would instigate a fresh campaign to modernize or extend it. Medieval Christian worship took place within permanent works-in-progress.

The congregation, then, could expect to find its church covered with wooden poles and planks and swarming with workmen, many of whom would have been none too bothered about observing the proper attitude of quiet dignity (even if they were persuaded not to speak, their hammers would keep talking). There would typically be around 200 workers employed on a site at any time, although this number fluctuated widely over the year. For one week in June of 1253, no fewer than 428 workers were on the payroll ledger at Westminster Abbey in London, and the number averaged 300 over the year. But in winter many jobs – such as the laying of stones, which was the work of the masons *sensu stricto* – could not be continued, for the conditions might be either too dangerous for the workers or potentially damaging to the work. Rainwater, for example, would penetrate between the joints of stonework and, if it then froze, would crack the stones or push them apart. So builders covered over the tops of their walls with straw or manure in the winter, and waited for spring. During November the numbers on site at Westminster fell to 100. Of these, only 5 were 'labourers' who did the most menial (and generally the most exhausting) jobs of ferrying stones, mortar and timber around the site, compared with 150–210 such workers in July: there was clearly little mobilization of materials in the winter.

This workforce was compartmentalized and specialized. Of those

who worked with stone, there were the stone-hewers who prepared basic blocks of roughly prepared ('dressed') stone from quarried blocks; skilled stonecutters who shaped more complex blocks; stone-layers who set them in place with mortar; monumental masons or carvers who worked on more decorative carving; and the prestigious sculptors or *imagiers* who created the statuary. The term 'mason' was sometimes used to imply only stone-layers, but more commonly it encompasses all of these jobs. Many of the craftsmen working on site on a cathedral project were necessarily itinerant, travelling to wherever there was work to be found, sometimes as a permanent team associated with a particular master. In addition, there were carpenters, sanders, plumbers, tilers, smiths for making metalwork that ranged from casings for windows to finely ornamented gold and silver panelling. There were roofers who worked in lead and slate, and glassmakers and tool-sharpeners. Plasterers worked up the plaster from gypsum (which was found in abundance around Paris, accounting for the term 'plaster of Paris'); painters covered it with colour. The number of tasks that had to be paid for was enormous; accounts for Saint-Lazare in 1295 detail everything down to the last nail.

Those costs began at the quarry. The quarrymen, who were usually local to the area, had one of the hardest jobs, for they worked in the open air under dangerous conditions; constant exposure to stone dust led to diseases such as silicosis. Stone was seasoned for a year or more before being used: it would be coated in a protective slurry of crude limestone plaster and stacked away under makeshift covering, sheltered from frost by straw and reeds. Given its immense weight, transportation of stone was expensive: to move it just 10 miles (16 km) could cost as much as the raw material itself. Transport by river was the cheapest option – the stones for the churches of Paris could be brought from quarries along the river Bièvre, which feeds into the Seine. In the eleventh and early twelfth centuries road haulage relied on carts drawn by oxen, animals that not only were relatively cheap to maintain but also offered valuable by-products of meat, milk and leather. By the time Chartres was built, horse-drawn transport was becoming common, for horses were faster and more enduring, as well as being easier to control in urban areas. To keep transport costs down, the stones were roughly cut to shape and dressed at the quarry itself, so that some of a project's stonecutters were employed there rather

than on the building site. William of Sens sent templates to the quarries at Caen to prepare the blocks for shipping to Canterbury.

Transporting stone was not only costly but slow, and church patrons were always eager to find local sources. When the bishop of Cambrai, Gérard I, ordered the rebuilding of the monastery of St Mary in the 1020s, he was dismayed that the nearest quarry capable of supplying stone for the columns was almost 30 miles (50 km) away:

> So he prayed Divine Mercy grant him assistance nearer at hand. One day while riding his horse, he explored the hidden depths of the earth in many surrounding places. At last, with the help of God who never fails those who put their trust in Him, he had a trench dug in the village that has always been known as Lesdain, four miles from the town, and found stone suitable for columns. And this was not the only place: on digging nearer, to be precise on the estate of Noyelles, he had the joy of finding good quality stones of another kind. Giving thanks to God for this find, he devoted all his zeal to this pious work.

This divine providence enabled Gérard to complete the building in seven years.

Suger was similarly blessed for his reconstruction of Saint-Denis by the discovery of an excellent source of marble near Pontoise, north of Paris. At first the abbot feared that he would have to fetch his marble columns all the way from Rome, 'by safe ships through the Mediterranean, thence through the English Sea and the tortuous windings of the River Seine, at great expense to our friends and even by paying passage money to our enemies, the near-by Saracens'. Suger confessed that for a long time he was at a loss for what to do, until the Lord helped him out:

> Suddenly the generous munificence of the Almighty, condescending to our labours, revealed to the astonishment of all and through the merit of the Holy Martyrs, what one would never have thought or imagined: very fine and excellent [columns]. Therefore, the greater acts of grace, contrary to hope and human expectation, divine mercy had deigned to bestow by a suitable place where it could not be more agreeable to us, the greater [acts of gratitude] we thought it worth our effort to offer in return for the remedy of so great an anguish. For near

Pontoise, a town adjacent to the confines of our territory, there [was found] a wonderful quarry [which] from ancient times had offered a deep chasm (hollowed out, not by nature but by industry) to cutters of millstones for their livelihood.

And this was not the full extent of the divine grace that Suger's project enjoyed, for he goes on to explain how, when rain drove away those who had flocked to help raise the stone out of the pit, a miracle allowed the work to continue. The ox-drivers waiting for their cargo grew impatient with the delay:

Clamouring, they grew so insistent that some weak and disabled persons together with a few boys – seventeen in number, if I am not mistaken, with a priest present – hastened to the quarry, picked up one of the ropes, fastened it to a column, and abandoned another shaft which was lying on the ground; for there was nobody who would undertake to haul this one. Thus, animated by pious zeal, the little flock prayed: 'O Saint Denis, if it pleaseth thee, help us by dealing for thyself with this abandoned shaft, for thou canst not blame us if we are unable to do it.' Then, bearing on it heavily, they dragged out what a hundred and forty or at least one hundred men had been accustomed to haul from the bottom of the chasm with difficulty – not alone by themselves, for that would have been impossible, but through the will of God and the assistance of the saints whom they invoked; and they conveyed it to the site of the church on a cart. Thus it was made known throughout the neighbourhood that this work pleased Almighty God exceedingly, since for the praise and glory of His name He had chosen to give His help to those who performed it by this and similar signs.

It is worth bearing in mind that such testimonies of God's imprimatur on Suger's bold plans for Saint-Denis made it all the harder for sceptics to criticize them.

Stone was crudely cut with axes and saws. One surviving example of a medieval stonecutter's axe has a double-bladed steel head set with serrated edges. Blocks were typically sawn up with large double-handed saws operated by two workers and lubricated with water. At the other extreme, the delicate work of the stone-carvers was done with hammer

and chisel – in the early twelfth century, masons rediscovered the use of chisels suited to making deep undercuts.

Medieval record-keepers rarely troubled themselves over the fine distinctions between different classes of mason – they typically called them all *cementarius* or *lathomus*, and the stark addition of *magister* before one of these terms is the only clue that the person so named is the master of the entire operation, the one we would now call the architect. This indifference to the gradations of skill may, as we have seen, partly speak of the snobbishness and ignorance of the ecclesiastical writers, but it also contrasts with our modern tendency to make artistic creativity distinct from stolid craftsmanship. The distinction between stone-hewer and *imagier* is just a matter of degree; and yet what degree, taking us from blank chunks of rock to the agony and majesty of Christ and the saints. It is not clear how much say the sculptors had over their choice of subject; according to a decree by the second Council of Nicaea in 787, 'Art alone [that is, the technical execution of a work] is the painter's province, the composition belongs to the Fathers.' Yet the statues in the Romanesque and Gothic cathedrals could not have been made by people ignorant of what it was they were portraying. 'By becoming a sculptor', says the historian Jean Gimpel, 'the stone-cutter graduated to the intellectual world.'

The rates of pay for building workers varied enormously, depending on the status of their work. In England a labourer who merely dug holes and shifted materials might get 1½ pennies (*d*) a day, while a stonecutter would fetch around 4*d*, and a freemason perhaps a ½*d* more (see table, overleaf). The master mason could be paid up to 2 shillings (*s*; 12*d* = 1*s*) a day, which, as we've seen, was enough to make him a relatively wealthy man over the years. An ordinary mason's wage was usually enough to support a small family, particularly if supplemented by a modest income from a plot of land or from hiring out carts for transporting materials. The man who knew how to work stone could generally find a comfortable standard of living.

Yet the working hours were demanding, even bearing in mind that there was a large number of religious feast days in the medieval calendar (all holidays were of course unpaid). In a normal week the workers would be on site for five and a half days, and would labour from sunrise to sunset. This generally meant that the working day

Wages of masons and builders

	With food included	Without food
Carpenters	3d	4d
Masons (cementarii)	1½d	3d
Tilers	1½d	3d
Freemasons	2½d	4d
Plasterers/daubers	2d	3d
Plasterers' assistants	1½d	2d
Ditchers/barrow men	1½d	2½d

These are the daily wages drawn up for workers in London in 1212.
'd' denotes a penny.

would be about twelve and a half hours long in summer, and eight and a half in winter. But you were paid only for the work you did, so wages were proportionately lower in the winter. Moreover, if you were a labourer or stone-layer then the winter months offered scant employment anyway, and you would have to earn your keep in other ways.

Winters in northern Europe were, however, relatively mild in the age of cathedral-building: this was a time now known to climatologists as the Medieval Warm Period. It is partly this fortuitous coincidence that made the cathedrals crusade viable. Had the climate in the twelfth and thirteenth centuries been as bitter as it was four hundred years later – the so-called Little Ice Age depicted so memorably by Brueghel – it is far from clear that these edifices could ever have been completed, or even contemplated.

Even while the sun shone, the mason of the Middle Ages did not labour in holy rapture, delighted to be building the house of God. He was more concerned with his daily bread. While the best sculptors were artists who must have felt some personal investment in their work, the historian Francis Andrews admits in his seminal study of medieval builders that 'there was also a contingent of labourers who were no more than mere wage-workers, who lived by their trade rather than for it and who did not work because of any higher claims, but whose primary object was to receive the present rewards'.

One has to suspect they were actually the majority. And for a project as financially precarious as the construction of a cathedral, the labourer needed to be prepared to fight, perhaps even literally, for his wage. He would take up cudgels against rival teams who threatened to undercut him, and he would go on strike if he was not paid on time.

He was a stickler for his rights. In one account of a church project in twelfth-century France, the workers downed tools when the vegetarian abbot confiscated a pig they had killed for their evening meal. And an account of the building of the Collège de Beauvais in the fourteenth century describes how, 'on the day of Lent, when the masons and labourers were in the workshop, they demanded all together that, according to the custom in workshops where work is continuous, all the workmen and labourers should be given a favour, that is the meat of one sheep which they would all eat together'. The same chronicler records that during the long hot summer days 'it was advisable to give those who were working water to drink several times to stop them from grumbling'.

But the workers were not always models of virtue themselves. Labourers on York Minster are denounced for stealing materials, arguing with one another, turning up unfit for the strenuous work, or simply not turning up at all. Botched building jobs are no modern affliction. 'For lack of proper care and of roofing there is such a quantity of water that lately a lad has almost been drowned', a report on the York construction complains. That was a minor complaint, however, compared to some of the negligence or deceit of the builders. 'There are constant references to the fall of buildings from insufficient foundations, unskilful handling, or bad workmanship', admits the historian Louis Salzman, 'for the medieval craftsman was at least as ready as the much abused modern workman to scamp his work if not carefully watched.' In 1316, for example, three English master masons were sued for building a wall around Eltham Manor, south of London, that was too thin, inadequately buttressed, and made not of good limestone but of chalk and soft stone.

Mysteries of the Lodge

Both the tradition of freemasonry and the symbolism of Chartres Cathedral have attracted many esoteric theories. So when the strange symbols engraved on some of the cathedral's stones, such as those of a column in the south transept, were first discovered, they excited much speculation. Were these secret codes of the ancient order of masons, a cipher hiding their long-forgotten mystical knowledge? As is so often the case, the minds of earlier ages were focused on far more practical matters. Stonecutters were paid according to the amount of work they completed, and so they carved their stylized signatures into the stones in order to lay claim to their handiwork. This also provided the project manager with a way of assessing the quality of the work each individual or team produced.

These marks have a runic simplicity, as befits a signature that must be executed quickly in a hard medium. Stonecutters' markers were sometimes passed down from father to son, but there was no attempt to create a registry of them until the late Middle Ages, so it is not surprising that, with such a limited lexicon of simple designs, marks were sometimes duplicated: the same mark in widely dispersed localities does not necessarily attest to a far-roving mason. Once they became 'official' emblems, however, these signs acquired something of a heraldic status.

The supposed 'secret societies' of masons began in the medieval lodges or *Bauhütte* (work huts), which were precisely that: makeshift shelters and lean-tos erected on the sides of the building from timber or stone, covered with canvas, reeds, thatch and slate. These lodges served simultaneously as headquarters, workshop, storehouse, canteen and working men's club. Here the masons kept their tools, and in poor weather it is where they ate their meals, warmed by the heated 'fire stones' that would be brought in to act as stoves. In these intimate enclaves they will have shared professional tricks and gossip, and told of other projects they had seen. Such interactions surely helped to create a body of professional lore, but these were not really the jealously guarded 'secrets' often attributed to the masons. The notion probably owes more to the regulation of lodges in the fourteenth century, which was aimed primarily at ensuring good professional conduct from their members but also included statutes that forbade

Some typical medieval masons' marks. That in the bottom right can be found on a pillar of the south crossing at Chartres.

the indiscriminate divulging of the techniques of the trade. That was no more than the standard working practice of any medieval guild. At a meeting of stonecutters in Regensburg in 1459, for example, it was stipulated that 'No workman, no master, no journeyman will tell anyone who is not of the craft and who has never been a mason how to take an elevation from a plan'. The fact that Matthew Roriczer revealed such 'secrets' in print later that century (page 156) suggests, however, that these injunctions were not particularly binding, or at any rate not very effective. There seems to have been no indication of any 'esoteric' content in freemasonry until the lodges began to admit 'non-operative' members in the seventeenth century. Gradually these non-operatives, who did not work with stone but instead had more antiquarian interests in the masonic tradition, came to dominate the organization, transforming it from a trade guild into the 'speculative' fraternity that still exists today.

Lodges in the Middle Ages were loose and temporary collectives, and not, as is sometimes suggested, formal organizations responsible for training apprentices. Young men often became master masons through a kind of dynastic succession, as with the Roriczers or the famous Parler family of Germany. Masonry was no less susceptible

to nepotism than is any other hierarchy of power and wealth.

Not all the cryptic markings found on the stones of cathedrals are masons' marks. Some were added at the quarry, intended merely as a kind of 'medieval barcode' that identified the intended destination of the blocks, their point of origin, and perhaps the quality of the stone. Other markings were used to encode assembly instructions – they showed the masons where the stones were to be placed or how they were to be married up against one another. Some of these marks have come to light only during reconstruction work, when stones are removed or buried faces are exposed. It is hardly surprising that, with no standard-sized pieces to work with, stone-layers needed guidance about where to put them. Even so, they made mistakes: some of the several thousand statues in the cathedral of Notre-Dame de Paris have been wrongly situated, for example. That kind of error could not arise when master sculptors created their statues *in situ*, carving them from stones already inserted into place in the body of the building, as they did in the twelfth century. But during the thirteenth century it became more common for these craftsmen to work with a separate block in the lodges and then to have the finished item inserted afterwards – a practice that reflects the emergence of the artist as individual, which was to shape the western vision of art during the Renaissance.

On Site

The shapes of the blocks that the masons carved were specified by the master builder. The designs for arches, windows, cornices, plinths and so forth were first drawn out at full size on a 'tracing floor': the floor of a convenient room in the building, which was covered in a thin coat of white lime plaster. The designs were drawn onto the plaster and then carved through it into the stone floor. From this drawing, templates ('templets') were cut from wood and metal that specified the outlines of each block. Even a single stone might require several different templates for its various faces, and it was down to the skill of the mason to project these two-dimensional cross-sections into a three-dimensional shape. Thus the construction of an entire cathedral might require several hundred different template designs.

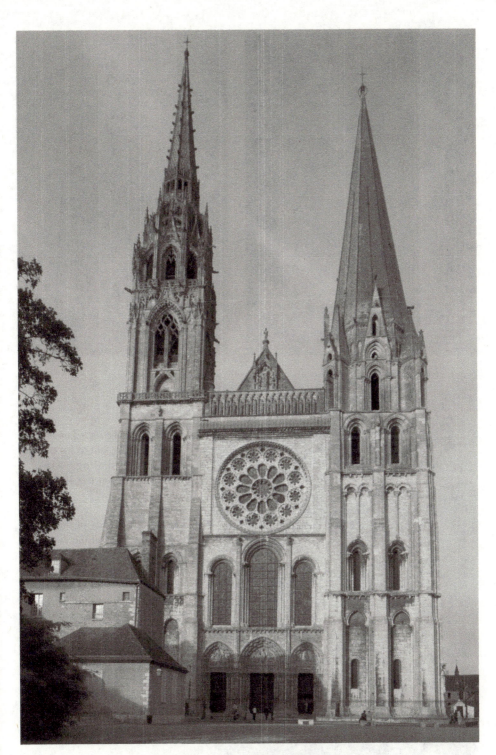

The west front of Chartres Cathedral.
(*Photo: Alex Rowbotham/AGRFoto.*)

(*Above left*) The sacred *camisa*
of Chartres, said to have
been worn by the Virgin Mary.
(*Photo: Alex Rowbotham/AGRFoto.*)

(*Above right*) Our Lady of the Crypt,
the wooden statue of the Virgin at
Chartres. This is a modern copy of
the twelfth-century original. (*Photo:
Alex Rowbotham/AGRFoto.*)

Bishop Fulbert in front of his
church, painted in the eleventh-
century by André de Mici.
(*From Obituaire de Notre-Dame de
Chartres, ms N.A. 4, folio 34 r.
Photo: Coll. Médiathèque de Chartres.*)

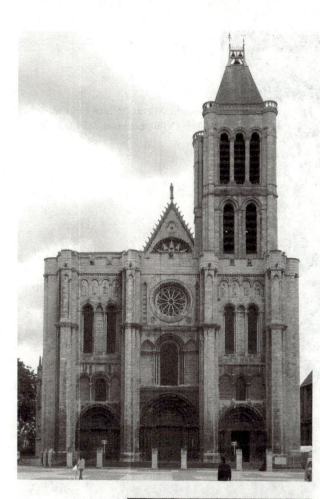

The west front of the royal
abbey church of Saint-Denis.
(*Photo: Steve Cadman.*)

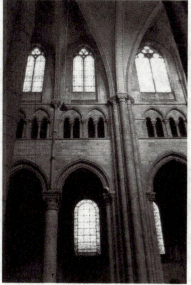

The nave elevation of Sens
Cathedral, the construction of
which began in the 1140s.
(Note that the clerestory
was remodelled in the
thirteenth century.)

God the Master Architect in the
Codex Vindobonensis 2554 (*c.*1250).

King Dagobert
visits a building site,
from a fifteenth-
century French text.
(*From Grandes
Chroniques de France, Ms.
Fr. 2600, Bibliothèque
Nationale, Paris.*)

Villard's machines:
a self-powered saw
and a perpetual-
motion device.

A mason's lodge can be seen on the right in this drawing of St Barbara by Jan van Eyck
in the fifteenth century. (*Lukas, Gent.*)

The window of the masons at Chartres provides the earliest known representation of templates in use. The templates hang above the heads of the workers on the right. (*Photo: Alex Rowbotham/AGRFoto.*)

A fourteenth-century wheel-drum still exists in Salisbury Cathedral. (*Photo: Steve Day.*)

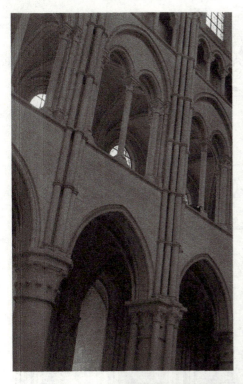

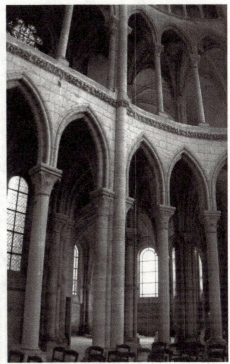

The Gothic
pointed arch at
Laon (*above left*),
and Soissons
(*above right*).
(*Photos: James
Mitchell.*)

(*Left*) The pointed
arch in the Ibn
Tulun mosque
of Cairo. (*Photo:
Jo Schmaltz.*)

The original colour scheme
of the painted walls.

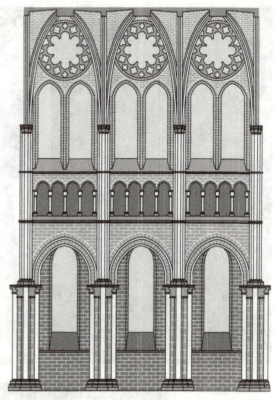

(*Below*) The presumed original plan
for Chartres included nine spires.

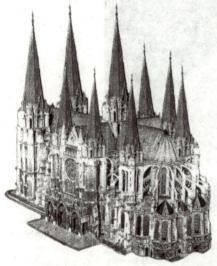

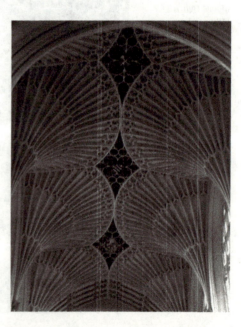

The complex traceries of ribs in late Gothic
fan vaults, culminating in the fan vaulting of
English Gothic (as at Bath Abbey, shown
here), are purely decorative, without a struc-
tural function. (*Photo: Craig Wyzik.*)

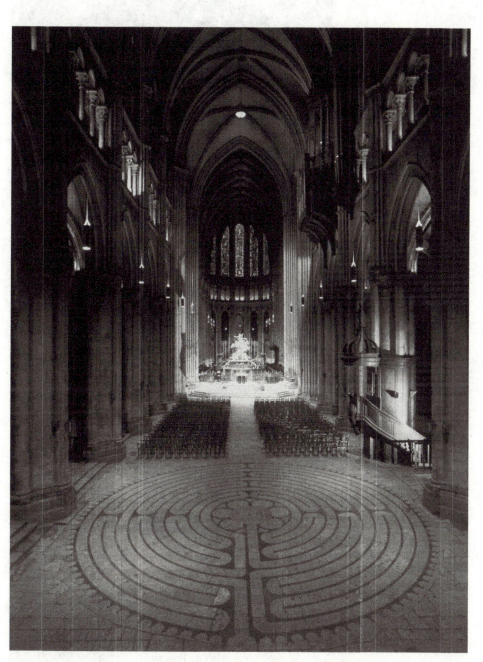

The nave of Chartres, looking east. (*Photo: Sonia Halliday.*)

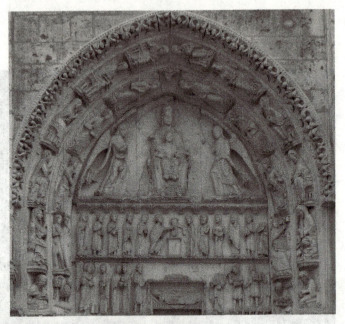

The archivolts of the southern entrance in the Royal Portal contain personifications of the liberal arts. (*Photo: Alex Rowbotham/AGRFoto.*)

The *vesica piscis* in the Royal Portal at Chartres (*above*) and its method of geometric construction (*below*).

(*Above and right*) The zodiacal calendar in the porch of the north transept shows scenes of everyday life. A woman prepares cloth by stripping flax while in February a peasant warms his feet by the fire. (*Photo: Sonia Halliday.*)

(*Above*) Pythagoras, depicted sitting at a desk, represents music, and is accompanied (*below*) by the figure of a woman playing the lure and ringing bells. (*Photos: Alex Rowbotham/AGRFoto.*)

Carpenters and wheelwrights in the Noah window. (*Photo: Alex Rowbotham/AGRFoto.*)

The 'cult of the carts' is depicted in a window at Chartres. (*Photo: Sonia Halliday.*)

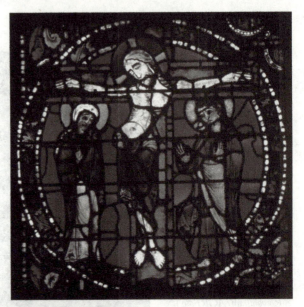

The twelfth-century Passion and Resurrection window at Chartres shows Christ not seated in majesty but suffering as a mortal being on the cross. (*Photo: Sonia Halliday.*)

The Blue Virgin window in the south ambulatory. (*Photo: Alex Rowbotham / AGRFoto.*)

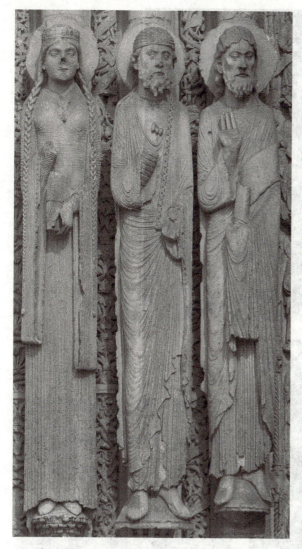

The statue of John the Baptist
in the north porch.
(*Photo: Alex
Rowbotham/AGRFoto.*)

The column statues of the Royal Portal at Chartres.
(*Photo: Alex Rowbotham/AGRFoto.*)

St Mark on the shoulders of
Daniel in a lancet of the south transept.
(*Photo: Sonia Halliday.*)

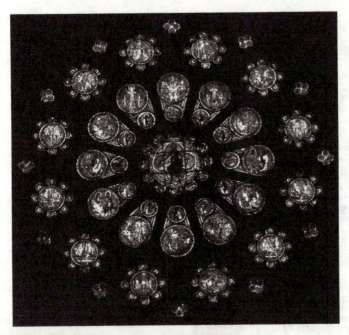

The west rose.
(*Photo: Alex Rowbotham/ AGRFoto.*)

A panel from the Noah window.
(*Photo: Alex Rowbotham/AGRFoto.*)

Grisaille tracery in thirteenth-
century glass at Chartres.
(*Photo: Dimitri B.*)

The rose window and lancets of the north transept. (*Photo: Alex Rowbotham/AGRFoto.*)

The Tree of Jesse window.
(*Photo: Alex Rowbotham/AGRFoto.*)

The baroque Assumption, by Charles–
Antoine Bridan, does little to enhance
the choir at Chartres. (*Photo: Alex
Rowbotham/AGRFoto.*)

A mason's template drawn by the Picard
craftsman Villard de Honnecourt.

Once the templates for a particular structural feature had been made,
the tracing floor was given a fresh coat of plaster in preparation for
the next inscription. The incised remnants of such tracings can still
be seen in the floors of minor chambers in York Minster and Wells
Cathedral in England. At York, one of these figures records the laying-
out of stone tracery for the aisle windows of the Lady Chapel, dating
from around 1361–5.

These tracings might sometimes be made in more prominent places:
they can be found, for example, on the walls of the triforium in the
south transept of Reims, and the outside walls of the choir of the
cathedral at Clermont-Ferrand are covered with them. At Soissons
Cathedral, the stones of the south transept are engraved with images
of two rose windows, one apparently based on the west rose of
Chartres. The builders would not have been too concerned about
defacing the stones in this way, as a coat of paint (now lost) would
have covered over the lines. It has been suggested that these images
were transferred from architects' sketches, serving as more durable
records of the intended designs. But the truth is probably quite the
reverse: the habit of marking out designs at full scale on stone may
have gradually given rise to the practice of recording them first at
small scale on parchment.

A window at Chartres donated by the stonemasons for the chapel
of the Blessed Sacrament shows the earliest known instance of
templates being used by the craftsmen. These were generally owned
by the master mason, who might take them with him if he left the
project; Gervaise of Canterbury writes how William of Sens 'deliv-
ered templates [*formas*] for shaping the stones to the sculptors'. Villard

Marks made in the tracing floor of the mason's loft at York Minster include some recognizable features of the Gothic building.

de Honnecourt sketched some template figures from Reims, suggesting that they were not merely ad hoc solutions to specific problems but were regarded as basic design elements: forms that could be taken from a palette. Some clerics were uncomfortable, however, with the thought that the designs for their church might simply be carried off by the master mason and replicated elsewhere – that is presumably what motivated the chapter of the cathedral of Saint-Etienne de Toul to demand in 1381 that the architect Pierre Perrat relinquish the templates he had used.

One of the reasons why master masons worked using geometrical construction and templates rather than by specifying dimensions is that units of measure varied from place to place. Some used the Roman foot (11⅝ inches [295 mm]), others the French Royal foot or *pied-du-roi* (12¾ inches [324 mm]) or the *pes manualis* ('foot-and-hand'; 14 inches [356 mm]). Each master would carry his own standard unit, measured out in an iron set-square. Angles, meanwhile, were measured not in degrees but in terms of right-angled triangles with sides in specific ratios – another way to circumvent lack of standardization. 'Once the unit of measure had been established on a building site', says engineering histo-

rian Jacques Heyman, 'then all individual dimensions for all parts of the building followed by simple rules of proportion. A satisfactory design could be built to any size.' For the same reason, masons and carpenters have always seemed happier with units that work on principles of subdivision – half a foot, say, or an eighth of an inch – rather than on precise numbers of some basic small measure. It's why even today they tend to prefer the imperial over the metric system.

To set stones in place, medieval builders used a mortar prepared from chalk. This rock (calcium carbonate) was crushed to powder and baked, which turns it to quicklime (calcium oxide). Quicklime was usually prepared at a quarry and then transported to the building site – as quickly as possible, since it absorbs moisture from the air. There it was 'slaked' with water, creating calcium hydroxide, and mixed with sand to make a mortar putty. Chartres stands on a chalk formation, which provided a plentiful source of lime. Both quicklime and slaked lime are highly alkaline and caustic, which is why stone-layers wore gloves when they applied mortar. It was very slow to set, remaining soft for days and in fact not fully hardening for years. (Lime mortar sets as the calcium hydroxide is converted back to calcium carbonate by reaction with carbon dioxide in the air.) This made building difficult: some structures could not carry

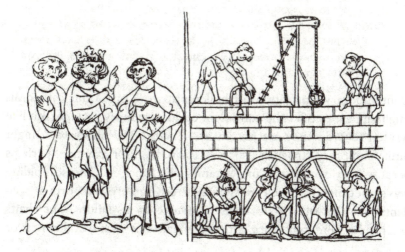

In this thirteenth-century drawing, Henry III of England discusses a building project with a master mason who holds his set-square, defining the basic unit of length, and a pair of compasses.

heavy loads until long after they were erected, and had in the meantime to be supported with wooden scaffolding.* But it also meant that the mortar could reset after cracking and that the buildings remained 'adaptive' for many years, able to accommodate small strains as the stonework settled. Masons who restore ancient monuments today lament the tendency of modern cement-based mortars, which are stronger but more rigid, to crack over the years.

The business of laying block upon block might seem the most prosaic aspect of erecting a cathedral, sharing little in the symbolic qualities that dictated the design. But Amalar of Metz, archbishop of Trier in 823, reminds us that almost everything in the early Middle Ages had a metaphysical connotation, and that the church represented so much more than a place where people might worship out of the wind and rain:

> The walls cannot be strong without mortar, mortar is made from lime, sand and water. The seething [quick]lime is the love, which combines with the sand . . . But to make lime and sand suitable for use in building a wall, they have to be mixed with water. Water is the Holy Ghost . . . For in the same way that stones in a wall cannot be linked together without mortar, nor can people be brought together in the building of the New Jerusalem without the love of the Holy Ghost.

The Woodworks

Contemporary illustrations of builders at work on Gothic cathedrals might appear to offer the equivalent of documentary footage. But like written records, they are not always reliable. The illustrators might omit temporary structures such as scaffolding, for example, perhaps because they would not understand their function. The scaffolding was sometimes unreliable in itself: there are numerous reports of accidents, like that of William of Sens, caused by its failure. The shafts and planks were joined not with metal nails but with wooden pins or

* We shouldn't imagine, however, that the mortar was essential to hold the blocks together. As we will see in the next chapter, its function was more about spreading the load evenly and preventing slippage.

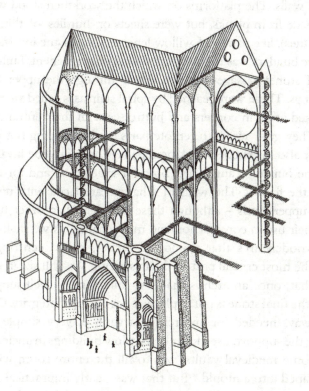

Vices and passageways in a typical Gothic church.

by lashing. Wooden wedges kept the lashings taut – a method that requires constant maintenance if the bindings are not to get loose.

Wooden scaffolds and frames were needed not only to carry the workers as they built higher, but also to prop up the stones while the mortar set. Supporting frames called falsework shored sloping structures and arches, and although the building methods relied on them, there is barely any record of how they were erected, forcing us now to rely on conjecture. For example, it is not clear how medieval builders managed to stiffen framework structures without the triangular truss employed by later engineers; one possibility was to use double, parallel beams for the main struts.

Rather than being built from the floor up, some scaffolding was attached directly to the walls via stout beams called putlogs that were inserted into holes in the masonry. Some of these holes can still be seen

in church walls. The platforms on which the workmen stood were not usually made from planks, but were sheets or 'hurdles' of thin, woven stems (withes), like panels of willow fencing. One of the innovations of the Gothic builders was to introduce a kind of permanent, built-in scaffolding of stone: passageways that thread through the upper levels of the buildings. These were reached by spiral staircases called vices, which were tucked away in corners and buttresses with their entrance doors hidden. They gave access to remote parts of the building not only for clerics but also for builders making repairs. They could be invaluable if part of the building caught fire, both for evacuation and for carrying water to the flames. The walls of Chartres are laced with nine vices onto the upper levels – although these may have had other functions beyond their use in construction and maintenance, as we shall see.

The wooden arcs that supported arches, called centring, were perhaps the most critical part of the falsework. We will see in the next chapter that, once an arch is made, it is in principle self-supporting; but until the final stone is put in place, it has no such integrity. Centring is not always needed for an arch or a vault: a very simple way of providing the support, used for relatively low buildings in ancient times and for some medieval vaults, was to fill the entire room with sand or soil shaped into a mould.* But that was clearly impractical for high Gothic vaults that stood a hundred feet or more above the ground. To support simple arches, the carpenters fashioned crescent-shaped skeletons of wood. But the frameworks that held up the curved, intersecting surfaces of the vaults must have been complex constructions – the historian John Fitchen has pointed out how complicated some of the bevelled ends of the wooden beams would have to be if they were all to fit snugly together. Even if these were standard shapes, the carpenter might have to adapt them slightly to each different vault.

The centring was itself supported on long poles – which raised the issue of how to 'decentre', to remove the falsework once the arches and vaults were in place, with the woodwork firmly wedged between arch and floor. There are various simple but ingenious methods of raising and lowering these supporting poles. One is to stand them in drums of sand, which can be emptied subsequently through small holes;

* In Chapter 8 I describe another method of making arches that does not need centring. But it is not clear that this was commonly, if ever, used in the Middle Ages.

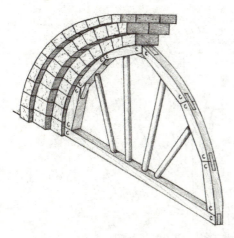

The wooden centring used to support arches during construction.

another is to use a system of sliding wedges that can be hammered to make small adjustments in height. For the highest vaults, no poles were long enough to reach all the way from the floor, so gantries must have been built to hold raised platforms while leaving the floor space clear.

To lift stones onto the walls and up into the vaults, the workers constructed huge machines of wood: levers, blocks and tackles, capstans, winches, windlasses. The largest blocks could not be heaved up on pulleys, but were lifted by cranes driven by great wheel-drums turned by the feet of men inside. Walking inside a wheel 8 feet (2.4 m) wide, a man could raise almost ten times his own body mass. Such treadwheels might measure more than 20 feet (6 m) in diameter, accommodating several men. Some of them still remain above the church vaults; for example, at Beauvais, and at Salisbury and Canterbury cathedrals in England. Walking a treadwheel required precise co-ordination – to slip and thus squander the inertia of the rotating wheel could mean not only that the block would plummet back to the ground but also that the wheel would spin out of control, at the risk of life and limb to those inside.

If the arrays of towers and engines could make a cathedral construction site resemble a city under siege, that is no coincidence: civil technology fed off military engineering, just as it does today. Not only did the business of making machines of war foster carpentry skills and experience with timber devices on an immense scale, but these war engines were sometimes designed themselves for moving stones – albeit to more destructive ends. The trebuchet used counterweights to propel stones weighing up to 150 kg (about 300 pounds) over distances

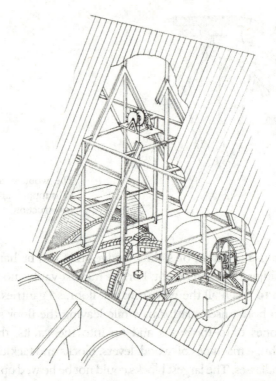

Capstans and wheel-drums for raising stones into the vaults of a church.

of a hundred metres or more. The petrary was another lever-arm machine, devised in China and brought to the West by the Arabs. The Crusaders used it in 1202 to hurl rocks against the walls of Zara on the Dalmatian coast. The ingenious and sometimes fanciful *De machinis libri decem* ('Ten books on machines') by the fifteenth-century Sienese engineer Taccola (Mariano di Iacopo) shows how closely military and civil technologies were allied by the early Renaissance: one of his cranes, for instance, is very obviously derived from a stone-throwing machine of war. It is a reminder that to talk of the 'cathedrals crusade' and of building 'campaigns' is not merely to speak metaphorically: warfare and church building in the High Gothic era were the two most demanding enterprises of Christendom, both placing unparalleled demands on the economies and technologies of the times while sustaining and indeed complementing one another in ways that seem vaguely disturbing today. They were both symptoms of a society that would stop at nothing to discharge its formidable duties to God.

8

Underneath the Arches

House of Forces

Although the wall is put together from the mass of separate stones,
it seems to disdain this fact and gives the semblance of joining in
a continuum the contiguous parts. It seems to be the result not
of art but of nature, not a thing unified but a single entity.

*The Metrical Life of St Hugh, c.*1220

A structural engineer, looking at a Gothic cathedral, will see, not
a massive array of nave piers, but the skeletal structure formed
by the centre-lines of those piers; not a thick vault, but a thin
doubly-curved sheet spanning between the mathematical centre-
lines of the ribs.

Jacques Heyman, 'On the Rubber Vaults
of the Middle Ages', 1968

The Flying Buttresses

At Chartres, the flying buttress became not just a part of the Gothic
vocabulary but arguably its defining characteristic. With this inno-
vation, it must have seemed to the Gothic builders that any heights
could now be reached without peril of collapse. The ranks of flying
buttresses surrounding the outer walls supply the framework from
which the whole edifice is suspended in apparent defiance of gravity.
One can see at once why the nineteenth-century French architect
Julien Guadet called Gothic the 'propped-up' style – although the
remark was anything but affectionate.

The spokes of the flying buttresses at Chartres, and the same feature in the west
rose. (*Photos: Alex Rowbotham/AGRFoto.*)

Whereas the earliest flying buttresses of the twelfth century tended to be designed independently from the inner church, at Chartres it is a different matter. Here they are uniquely elaborate in having radial spokes connecting the lower arch and the upper sloping beam. These spokes, consisting of cylindrical blocks stacked atop one another, would have been extremely difficult to construct, requiring complicated wooden falsework while the mortar set. They would seem to be something of a whimsical folly, if it were not for the fact that they copy the motif found in the great west rose window: an indication that the architect was now seeking unity through the entire building, inside and out. The buttress piers are also unusual in being stepped, with recesses at each step for housing statues. The nave buttresses have a third tier, abutting the clerestory at the level of the roof guttering, which was added in the four-teenth century. This upper tier rather spoils the original effect of the exterior nave wall because it juts into and obscures the pretty chalice-shaped balconies at the top.

The flying buttresses of the chevet at Chartres repeat the spoked motif but in a different form: here the spokes form pointed arches, and they are more slender – some would say, more Gothic. This stone armature splays outward from the eastern head of the church like a fan, while the deep chapels bulge out between these blades in an organic and dynamic way. It is a busy arrangement, there's no doubt; but somehow it works.

When Frankfurt, Cologne and Ulm were bombed in the Second World War, the historic cities were reduced largely to smoking rubble. Yet their Gothic spires never crumbled. The cathedrals lost bricks, glass, timber, even walls – but the basic structure of the buildings remained standing. When it was done well, Gothic architecture had a stability that seems almost eternal: the stones lock together in an impervious web of forces.

It wasn't always done well, of course. When the builders of Beauvais Cathedral tried to raise the vaults to an unprecedented height, the church collapsed twice (in the thirteenth and sixteenth centuries) and the construction was eventually abandoned without a nave at all.

Although such catastrophe was rare, mistakes were not. Troyes Cathedral, for example, begun in the early thirteenth century, experienced collapses in 1228, 1365 and 1389. Louis Salzman warns how easy it is to over-estimate the skill of medieval builders:

> One grows tired of hearing enthusiasts exclaim: 'How splendidly those old monks built!' 'Yes, they built to last!' All this amounts to is that the ancient buildings that we see are those that have survived, and that their survival is often due to a solidity obtained by a most unscientific and uneconomic prodigality of building material.

In 1210 alone, Salzman points out, the wind wrought havoc in England, bringing down many monastic buildings at Dunstable, a tower at Bury St Edmunds, two at Chichester, and one at Evesham.

Yet the great Gothic churches would scarcely have outlived their builders if they had not, by and large, been put together using sound mechanical principles. The spire of Strasbourg Cathedral, the tallest of all Gothic buildings still surviving, soars to 466 feet (142 m), equivalent to the height of a forty-six-storey skyscraper. Such lofty achievements were not equalled until the revolutions in iron and steel engineering in the nineteenth century. What has kept the cathedrals standing?

Any building is a web of forces that must be held in balance. The weight of the materials doesn't simply push downwards; arches, vaults and roofs produce sideways (lateral) thrusts too, threatening to topple pillars and walls. Openings such as windows and doorways are weak spots that must somehow be accommodated. And the shifting and settling of stone over the years can introduce new forces into the web. In the Romanesque churches the balance was achieved in an ad hoc and often 'brute force' manner that relied on sheer mass of stone: on thick, barely interrupted walls. With Gothic, on the other hand, the forces are interwoven, counterpoised and managed with a seemingly miraculous economy of materials: the masonry is skeletal, enclosing a space that is light and airy. The builders did not fully understand what they were doing in the terms that a modern structural engineer would use, but a mixture of intuition, experience and expediency enabled them to achieve feats of breathtaking boldness.

Stone Mechanics

It's easy to imagine that, in order for a structure as vast as Chartres to stay up for eight hundred years, the stone blocks have to be phenomenally strong and well glued together. Yet neither is in fact the case. The pressure at the base of the walls due to the mass of masonry above is awesome, but all the same the stones there are in no danger of being crushed by it. One could in theory build a wall 2 km (1¼ miles) high before that is liable to happen at its foot. By tapering the walls of a tower, it could be made higher still: the builders of Brueghel's Babel had the right idea. The workers would be at risk from lack of oxygen before needing to worry about the walls crumbling beneath them. The reason stone buildings fall is not because the stones break under the load, but because the structures topple – because they are pushed or displaced sideways until they lose balance.

Isn't the mortar supposed to prevent such displacement? No, it isn't – or at least, not directly. What holds Chartres together is not the mortar (which is after all spread extremely thinly) but the weight of the masonry itself, which squeezes the blocks together and locks them in place. The mortar joints are actually rather weak, which is why they are never used to secure stones against gravity in a purely vertical direction, or to prevent them from being pulled apart. In other words, mortar joints are safe in compression (squeezing) but not in tension (stretching). What the layer of mortar does is ensure that the stones are intimately bedded against one another so that the compressive stresses may be transmitted evenly from one block to the next. Rough stone faces placed dry against each other would make contact in only a few places, creating stress 'hot spots' that would be more likely to lead to cracking.

Mortar does help to prevent sliding, which can lead to structural problems – but that was also suppressed by pouring molten lead into grooves cut in the adjoining faces of the stones, which keyed the blocks together without actually 'gluing' them. Provided that slippage is prevented by means of this sort, masons had no need to assume – indeed, they had better *not* assume – that the integrity of their buildings depended on the bonding together of stones.

So what makes a wall fall over? Well, that may happen if you push it, of course – and a cathedral gets plenty of pushing from the wind, as

Stable Stable Unstable

So long as the stress line remains within the inner third of a masonry wall's width, the structure is stable even in the presence of cracking. But as the stress line approaches the outer face, instability threatens – and if the stress line moves outside this face, the masonry will hinge and tip.

Suger attested during the construction of Saint-Denis (see pages 230–1). Wind stress is mostly negligible, but during a storm it can be tremendous: high winds can make the top of the Empire State Building sway by up to 2 feet (0.6 m). Church architects could not build just for summer days, but had to ensure that their buildings would withstand the worst that nature might throw at them. The higher they built, the greater the need for architects to find ways of coping with this challenge.

But it wasn't only the hand of wild nature that threatened to tip the stones over. The building itself was shot through with stresses as the stones pushed against one another. It is easy to see how the sideways force of wind might push a wall or a tower down; but downward-acting forces can do that too. If the stress pushes down on the centre of a block, or equivalently if it is evenly distributed across the block, there is no problem. But if the stress is far off-centre, danger looms. If the line of stress falls less than a third of the block's width from its edge, the far edge of the block isn't actually compressed against the one beneath at all – it is pulled away from it. This part of the joint is, in other words, in tension. And that is a bad thing for mortar. A crack may open up, and the wall tilts.

The double-skin structure of medieval stone walls, with through-stones binding them together (*left*). Deformation of the wall, or vibrations, can cause slumping of the filler, which is irreversible (*right*). That can create structural problems. Piers also have this skin-and-filler structure.

All the same, this structure can remain standing indefinitely. In other words – and this is a crucial point to understand – cracking of masonry does not in itself necessarily indicate imminent or even eventual collapse. But suppose that the line of stress – the so-called thrust line – moves beyond the edge of the block. Then there really is a problem. The block hinges on one edge, opening up the crack so that the wall comes tumbling down.

This assumes that the blocks themselves remain rigid. In fact, stone is pretty hard but it is not rigid. Unlikely as it may seem, stone bends. For evidence of that, you need only stand at the foot of the crossing in Salisbury Cathedral, where immense stone columns hold up the 400-foot (123-m) spire. The pillars don't rise in a perfectly vertical line; they bend under the stress, as the medieval builders must have noticed to their great alarm. This deformation complicates the question of how much stress a stone structure can withstand, and what is the safest way to distribute it.

We must bear in mind also that the thick masonry walls which form the basic shell of medieval buildings are not usually mere stacks of stone blocks. These walls can be 3 feet (a metre) or more thick, but the stones themselves were never that massive. Typically, the walls consist of an inner and outer skin of blocks maybe a foot or so wide,

with the space in between filled with rubble. To prevent the two faces from drifting apart, they could be tied together with 'through-stones' which pass right through the wall at regular intervals. Even then, however, any deformation of the skins, as, for example, might be caused by the vibrations of ringing the church bells, could be made irreversible by settling of the filler material. Over time this could leave the wall surface uneven, and weaken the entire structure. One sign of such problems is the splitting-off of wedge-shaped fragments from the outer faces of the stones – a process known as spalling, which is caused by abnormally high compression at the edges of the blocks owing to their slight tilting relative to one another.

The mighty columns holding up the church vaults, especially those at the crossing, also have this skin-and-filler structure. Thus these towering pillars have hollow masonry shells – they are tubes rather than trunks. When you see the full girth of the cross-section, as you can at the visitors' centre of York Minster, you realize that it could hardly be done any other way.

The Self-reliant Crescent

In a perfectly vertical pillar or wall made from a series of identical blocks, the thrust line will always be vertical and will pass down the middle, so that the structure will be stable. But a church is not like this, because the walls and pillars generally have something on top that alters the thrust line. In particular, they may support arches.

Thrust

How an arch supports itself.

The classic Romanesque arch is a smooth semicircle made from blocks (voussoirs) stacked into a crescent. Again, it is not the mortar that is primarily responsible for holding these stones together, but their pressure against one another. When the keystone – the central voussoir – of the arch is put in place, the quadrants on either side press inwards on it and the whole structure supports itself. This seems to suggest that the keystone is somehow the uniting element, as the name implies. But in fact it is no different structurally from all the other voussoirs, in that what it does is to convert the downward pull of gravity into a lateral thrust against the faces of its neighbours. All the same, the keystone was generally the last element to be inserted into the intersecting arches of church vaults, and the structure was not stable until it was in place – which, as we saw previously, was why timber centring was needed during arch construction. The simplest kind of vault, called a barrel vault, is simply a semicircular arch extended laterally into a curved semicylindrical surface, and it works on the same principle.

John Fitchen has pointed out that the supporting thrust of the unmade portion of an arch-in-progress can be substituted by a weight hanging from a rope over the end of the incomplete arch. For a vault,

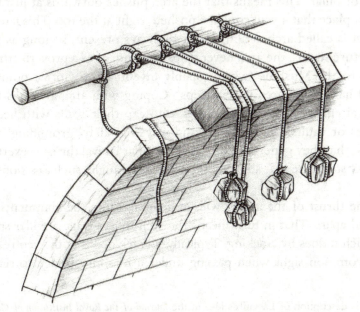

Lassaulx's proposed method for making an arch or vault without centring involves hanging weights over the edge of the arch to create compression.

ropes can be hung from the adjacent part of the edge and simply moved into place to hold each new block as it is added. Then the vault can be built 'freehand', without any centring at all. This method of vault construction was proposed in the nineteenth century by the architect to the king of Prussia, Johann Claudius Lassaulx,* but was then all but forgotten until Fitchen revived the idea. Lassaulx was convinced that the medieval masons would have used the labour-saving technique in preference to the intricate construction of centring. Fitchen agrees, suggesting that the method might account for some of the irregularities in vault contours that cannot easily be explained by subsequent settling. Yet that is speculation. There is no record of the weighted-rope method being used, and it is not hard to see that the approach would be both slower and rather more hazardous than the use of a wooden frame. 'We wonder', says Lon Shelby of Fitchen's proposal, 'if perhaps he has not leaped to a brilliant solution that possibly could have worked but that may not have been used.'

The transverse thrust of the voussoirs extends all the way to the arch springing, the point at which the arch joins the supporting wall or pillar. This means that the arch pushes outwards at just the worst place that a wall could be pushed: right at the top. This lateral thrust is called arch action, and it is always present: so long as the structure stands, the arch never stops pushing, or as a proverb attributed to the Muslims (who probably invented the Gothic pointed arch) has it, 'the arch never sleeps'. Coping with arch action is the central challenge for any builders who cap their walls with heavy arches or vaults: the aim is to find ways of safely 'grounding' the thrust that they generate. Note that a similar lateral thrust is exerted by any structure that abuts on the walls at an angle, such as a sloping roof.

The thrust of the arches will, in general, cause the abutments to spread apart. That in turn means the arch must bridge a wider span – which it does by cracking. Typically, a crack opens at the centre. 'It is a common sight when passing under a masonry bridge to see a

* In his description of Lassaulx's idea in the *Journal of the Royal Institution of Great Britain* in 1831, which made it known, William Whewell spells the name incorrectly as Lassaux, and adds a *faux* French 'de'. It is now often written in this form.

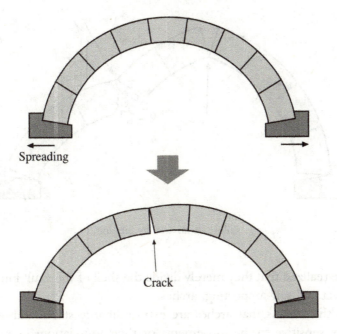

The cracking of an arch due to spreading of abutments.

crack running longitudinally along the barrel', says Jacques Heyman. But again this is not as alarming as it might look: the voussoirs on each side of the crack continue to press against one another and hold each other in place, so there is no danger of collapse.

Cracks in masonry create potential hinge points. As we've seen, these don't in themselves threaten the structure: think of two doors hinged together and laid in an inverted-V roof structure, which won't collapse so long as they are held fast at their base. Indeed, some arched bridges have hinge points added deliberately, allowing the structure to adjust slightly to expansion or shrinkage caused by temperature changes. It turns out that an arch (unlike a wall) cannot collapse by hinging movements unless it has at least *four* hinge points.

The arches of masonry vaults can be even more resilient to cracks that run parallel to the face of the arch. These may open up completely, so that one can see daylight coming through, without bringing the vaults crashing down. The architectural historian Pol Abraham called these *fissures de Sabouret* after a French engineer who identified them,

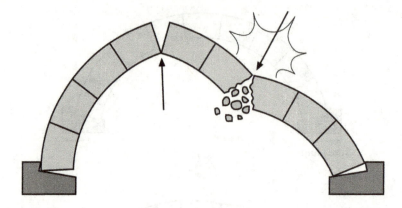

Failure of an arch by hinging.

and he realized that they merely divide the shell of the vault into separate, yet still self-supporting, arches.

'All this means that arches are extraordinarily stable and are not unduly sensitive to the movements of their foundations', says engineer James Gordon. As with vertical walls, crack-hinges become a problem only if the thrust line running through the arch passes *outside* its surface. It is only then that the hinge may open and the structure break apart.

The self-supporting stability of arches makes them attractive from an engineering as well as an aesthetic viewpoint. Which is all very well, except that the thrust on the abutments caused by arch action threatens to push apart the walls they rest on. Because of the lateral thrust of the arch, the thrust line in a wall or column does not pass vertically down the centre but follows a curving path. As the thrust line descends towards the base of the wall, it comes closer to the outer face, causing the wall to tip outwards. For stability, the thrust line should be kept within the central third of the wall at all points.

One way to do this is to thicken the wall at intervals with a series of vertical ribs, called buttresses. Both Romanesque and Gothic churches use such buttressing. Because the descending thrust line gets progressively closer to the outer face of the wall, buttresses need to be thicker at their base than at their top – this accounts for the widespread use of a tiered shape. But as Gothic vaults climbed

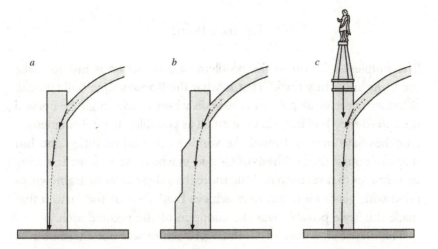

The thrust line caused by arch action can come dangerously close to the outer edge of a wall (*a*). This danger can be offset by buttressing (*b*), and/or by adding weight on top of the wall, for example with a pinnacle (*c*).

ever higher, the engineers needed to rethink their system of buttressing against the thrust. We will see shortly how they solved this problem.

Another way to pull the thrust line towards the centre of the wall is to put additional weight on top. That may be done by adding pinnacles or statues. So while such features might look purely decorative (indeed some have said frivolous) on Gothic churches, in fact they have a structural role: in a perhaps counter-intuitive way, the walls or pillars are stabilized by piling up more mass at their tops. Architectural historians have not always understood this. Paul Frankl, believing that extra weight must inevitably be destabilizing, enthusiastically repeated the sneer that Pol Abraham directed at Viollet-le-Duc's mechanical interpretation of Gothic in the nineteenth century: 'neither flying buttresses nor pinnacles were necessary. Many a French cathedral had none, and acquired them only when restored by Viollet-le-Duc.' The function of a pinnacle isn't just to recentre the thrust line, however (and in general they are not big enough to exert a strong influence of that sort). By pushing down on the stone joints, it also helps to prevent shearing of a pillar or wall at the point where the thrust of an arch threatens to displace it.

Up to a Point

The simplest solution to the problem of arch action is just to make the walls uniformly thick. That is what the Romanesque builders did. Windows were weak points in the walls where cracks might be opened up, and so they had to be kept as small as possible: many Romanesque churches have narrow tunnel-like windows that admit little light. But that is of course the antithesis of Gothic, in which the walls are towering membranes that seem to be little more than skeletal stone frameworks filled with glass. How did they achieve that? One of the factors that made this style possible was the adoption of the pointed arch.

This classic signature of Gothic architecture was not chosen for its aesthetic qualities, or not simply for that. Compared with the semi-circular Romanesque arch, the pointed arch can typically reduce the lateral thrust of an arch by 20 per cent (some claim that a reduction by as much as 50 per cent is possible).* That allowed Gothic architects to build their walls higher without fear that the arched vaults would push them apart. (There is a kind of literal truth, then, to Victor Hugo's suggestion that Romanesque churches sit squat and sombre 'as if crushed by the rounded arch'.)

This advantage of the pointed arch was surely discovered through experience; but nonetheless there remained much confusion about it throughout the Middle Ages. The confusion is apparent at the Milan expertise of 1399. The chronicle records how claims were made 'by certain ignorant people, surely through passion, that pointed vaults are stronger and exert less thrust than round'. Even the experienced French master builder Jean Mignot felt unable to pronounce definitively on this topic, and his words give a sense that he preferred to avoid the issue: 'Whether the vaults are pointed or round, they are worthless unless they have a good foundation, and nevertheless, no matter how pointed they are, they have a very great thrust and weight.'

* It remains surprisingly difficult to calculate or measure the stresses in a Gothic church, which is one reason why there are still disagreements about their mechanical principles. This also means it is hard to evaluate how sound the buildings are, and how 'well engineered'. 'Structures either stand or fall', says engineer Norman Smith, 'and if they stand then by how much is neither obvious nor measurable.' We only know when a design is poor if it collapses.

This confusion persisted during the Renaissance, when some architects felt that pointed arches produce *more* thrust than rounded arches and so could carry less weight. Certainly, the 'flaw' that the pointed apex introduced into the 'perfect' curvature of a semicircle would have been regarded as compromising geometric beauty (and along with it, structural integrity); to some later theoreticians the pointed arch was simply ugly regardless of its functional value. They saw it, moreover, as a barbaric invention, claiming that it was devised by the Teutons when, living in forests, they tied the branches of trees together for shelter. This 'forest theory' for the origins of the Gothic style was later fancifully elaborated by Schopenhauer and Spengler, whom no one could accuse of being historians.

The introduction of the pointed arch in Western churches does considerably predate Gothic, but its origin seems to lie to the east rather than the north. Such arches can be found in sixth-century Syria, and are common in Islamic architecture from the eighth century – the elegant Ibn Tulun Mosque in Cairo uses it extensively.* From Egypt the pointed arch spread to Tunisia and Sicily, and it was used in 1071 in the Benedictine abbey of Monte Cassino. It is not clear exactly when or why western builders started to use the design, but presumably they did so partly because they perceived its structural advantages. The Normans, who conquered Sicily in the 1060s and 1070s and were building cathedrals there from the late 1080s, used pointed arches in the churches of their homeland by the end of the eleventh century. It became common in Burgundy too: it was used at Cluny around 1100–20 (Abbot Hugh of Cluny saw the arches of Monte Cassino on a visit in 1083) and in the vaults of the cathedral at Autun around the end of that period. This architectural feature may have been transmitted to the West at least in part by Muslim masons in person, for some are known to have found work in Europe. The superior masonry skills of the Muslims have been detected in the stonework of Winchester Cathedral in England around 1108, while a prisoner from the Crusades known simply as Lalys was employed as an architect by Henry I of England

* This genesis led Christopher Wren to suppose that the Gothic style began among the Arabs. 'I think it should with more reason be called the Saracen style, for these people (the Goths) wanted neither arts nor learning', he wrote.

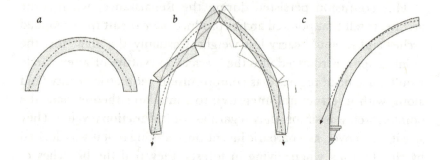

The thrust line in arches follows a catenary curve (*left*). In highly pointed arches this line can come close to the inner face at the apex, threatening to induce hinging and collapse (*centre*). The thrust line can also exit the haunches in flatter arches (*right*). Solutions include the use of heavy keystones and infilling around the haunches.

and is said to have built Neath and Margam abbeys in the early twelfth century.

By the 1130s the pointed arch could be found in Provence, the Rhône valley, Poitou and Aquitaine. By then the Parisians had awoken to its possibilities, and there are pointed arches at Saint-Denis dating from 1135–40. In England, they can be seen from before 1140 at Durham. The west towers and façade at Chartres, started in the late 1130s, also have them.

Just as the stability of a wall depends on keeping the line of thrust ideally within the middle third of its thickness, so the same applies to arches. For a perfectly semicircular arch, this line takes a curving path that comes close to the outer face at the apex, and close to the inner face at the haunches – a curve known as a catenary, equivalent to the inverted shape of a chain hanging under its own weight. That is stable enough so long as the arch is not too thin. But for pointed arches the apex tends to rise higher than the top of the catenary, especially in the exaggerated pointing of the late Gothic style. This could bring the line of thrust dangerously close to the edge of, or even outside, the voussoirs, threatening to make the arches buckle. Towards the apex of the arch the line of thrust approaches the inner face, so that the stones tend to get pushed upwards. Builders could counteract this by using particularly massive keystones, which would prevent the crown from rising. (All the same, this has happened to some Gothic vaults.) The line of thrust also comes close to the inner face in the

lower part (haunches) of the arch, which pushes them outwards. This was opposed by filling the funnelling spaces above the vaults with rubble up to a certain level, which pressed down to prevent outward buckling. In flatter arches, the thrust line can instead exit the outer face around the haunches – infilling then helps to transfer this thrust to the walls and buttresses. The Gothic builders comprehended none of this in quite these terms; but the solutions that they found suggest that they developed an empirical, and perhaps intuitive, understanding of how arches behave.

The Vaults of Heaven

As the wooden churches of early Christian Europe were replaced by stone structures, the simple tilted roofs with their skeletons of rafters were abandoned in favour of elaborate canopies of stone. It isn't clear why this happened – in fact the question is too rarely asked. It's true that stone does not burn, but the cathedral builders continued to pile wooden rafters over the stone vaults to hold immense, steeply sloping roofs: if these were struck by lightning, it's not clear that the collapse of the timbers and lead covering would have been withstood by the stones. One alternative theory, which is certainly plausible, is that

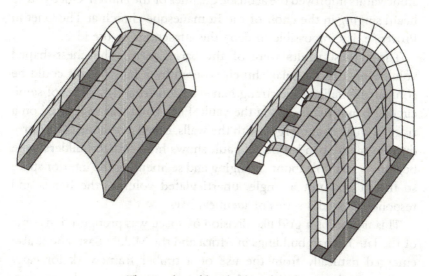

The simple and banded barrel vault.

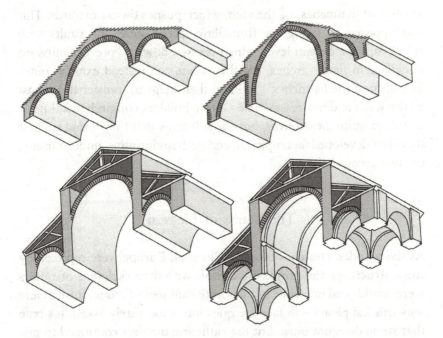

The barrel vault with barrel and half-barrel aisles (*top*). In later Romanesque churches the nave wall extends well above the level of the aisle vaults (*lower left*). The aisles are then integrated with the nave via the arcade (*lower right*).

stone vaults improved the acoustic qualities of the church. Once you've heard singing in the choir of the Romanesque church at Thoronet in Provence, it's impossible to deny the attractions of the idea.

The earliest vaults were of the barrel form. The chest-shaped volume of a rectangular church covered by a barrel vault could be compartmentalized and strengthened by constructing a series of semi-circular bands or ribs along the vault. Each band was supported on a ridge or pillar that merged with the walls, called a respond. The introduction of the banded barrel vault shows how church builders were beginning to think about arranging and segmenting the interior space so that it was not a single, unarticulated volume: the bands and responds created a series of identical bays.

This notion of a grid-like division of space was prefigured in some of the late Roman buildings in Africa and the Middle East, and it also emerged naturally from the use of a timber framework for early medieval architecture in northern Europe. But now such compart-

mentalization had a functional purpose: the ribs stiffened the barrel vault, thereby allowing it to be made from thinner masonry, and thus in turn to exert less thrust on the walls. Already it starts to become clear how the building may act as a coherent structural entity in which changes in one element facilitate or even necessitate changes in another. The Gothic style represents the ultimate expression of this coherence, in mechanical as well as visual and artistic terms.

A single barrel-vaulted nave is a relatively straightforward mechanical entity. But when church builders started to add vaulted aisles to either side, their problems multiplied. In early Romanesque churches the aisles were either barrel vaults or half-barrels. The aisle vaults return the thrust of the nave vaults where they abut one another, maintaining stability. The space above the vaults was filled with rubble, and the springing of both sets of arches was initially at much the same level, so that the thrusts were counteracted in the right places. This meant that the sloping roof of the church could extend continuously, or with only a small break, over both the nave and the aisles. In somewhat later structures, the nave walls continued well above the level of the vaults, creating a greater disjunction between the nave roof and those of the aisles.

If the aisles were to be integrated with the main church, however, the wall supporting the nave vault could not be continuous: at ground level it had to be opened up to give access to the aisles. This was done by turning it into an arcade of pillars connected by arches. This meant removing masonry at the very place it was apparently needed to sustain the vault's thrust: at the base of the nave wall. But that was not necessarily a problem, because the outer walls of the side aisles may take the strain instead, the thrust being transferred to them by the aisle vaults.

This architectural solution to the mechanics of vaulting worked just fine – except that it didn't leave much space for windows. The nave now had none: all the light had to be scavenged from windows in the walls of the aisles. How could this structure be lightened?

The answer was to carry the barrel vaulting in two orthogonal directions at once: not just east–west along the axis of the nave, but north–south, crossing the nave. This innovation, which appeared around the early twelfth century (it can be seen at Vézelay, begun around 1120), is known as the groin vault. It eliminates the continuous

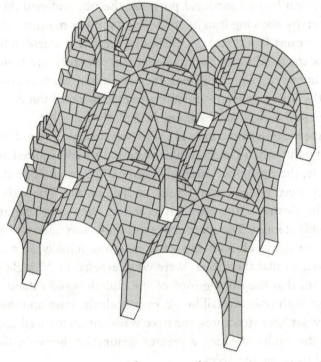

The groin vault.

thrust of the barrel vault, which runs all the way along the wall, and concentrates it at the corners of the intersecting barrels, where it is met by the thrust of the adjacent vaults. In other words, the groin vault transforms the entire web of forces. No longer is the church basically a couple of parallel walls that must be prevented from toppling over. In its place is a three-dimensional mesh of thrusts acting against each other, which weave the stones into a complex yet stable forest of stress lines. Groin vaults can be placed side by side without any adjoining wall sections at all; instead, they are supported by a lattice of pillars where the arches abut, which carry the thrusts groundward.

The cross vaults have the effect of opening up the downward-curving sides of the barrel vault, creating space for windows. The arrangement remains stable if the aisle vaults are lower than those of the nave, leaving a flat expanse of wall above aisle level. These two factors made it possible to introduce a series of high windows

above the nave – the clerestory – so that much more light could be brought into the central avenue. At the same time, the intersecting barrels create a more sophisticated, yet still repetitive and intelligible, partitioning of space. It might be argued that once the groin vault was invented, Gothic became inevitable.

Rise of the Rib

The groin vault has a drawback, however: the geometry of two intersecting cylinders is complex enough to make Euclid blanch. Building an arch simply requires wedge-shaped voussoirs;* turning an arch into a barrel means elongating them. But along the ridge of intersecting groin vaults – that is, along the so-called groin itself – the demands placed on the stonecutter are fearsome. As John Fitchen explains, each groin voussoir is a ten-sided stone, no two surfaces of which are parallel, and four of which are curving. And every stone along each ridge is different from all the others. The complexities of the problem are easy to underestimate: Viollet-le-Duc's proposal for how the voussoirs of intersecting vault arches could be cunningly interlocked along the groin was clearly never tested in practice, for he would have discovered that it becomes geometrically impossible in the upper part of the arches, where he left his drawing blank as if to imply 'et cetera'.

How did the masons cope with this geometric puzzle? One somewhat unsatisfactory solution was to patch up imperfectly matched abutments along the groin with thick mortar. But a better solution was to begin the vaults by making the boundary arches first. The Romanesque masons started to 'box in' each bay with a series of transverse arches, analogous to the ribs of banded barrel vaults, since this allowed the bays to be made independently. The ribs again created a need for responds that brought the spatial organization of the vaults down the walls and piers, visually unifying the entire structure. The natural next step, then, was to start each bay by putting in place the diagonal arches delineating the groins:

* In fact they weren't even necessarily wedge-shaped, but merely roughly squared and set at the shallow angle demanded by the arch's curve by being bedded in thick mortar.

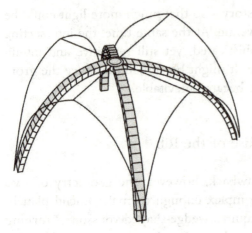

The rib skeleton of the groin vault.

an X-shaped pair of intersecting arches with a single keystone (boss) at their apex. This gave the builders a secure armature that they had then simply to fill in with the vault panels. Because the ribs hid the intersection of these panels at the groin, the voussoirs there could be married rather crudely with mortar to fill the gaps, rather than having to be carefully cut into complex shapes. And so the classic Gothic scheme of rib vaulting was born, in which the creased shell of the vault is elegantly defined by a series of arching ribs along each of its edges. Or at least, that is how the story is sometimes told. It sounds reasonable, but the fact is that we do not really know why rib vaults were introduced, and however sensible our guesses might seem, we had better not forget the injunction that engineer Norman Smith has applied to the whole business of 'cathedral studies': 'Trying to recover the thoughts in men's minds by looking at the objects they have made is a very hazardous undertaking.'

The ribbed vault can be made thinner than a barrel or groin vault, and so it can span larger spaces. This was essential for the sense of breadth that Gothic architecture introduces, which for Jean Bony is its key feature. 'This new spaciousness was really the basic revelation of Gothic architecture when it appeared on the European scene', he says. 'It was only when width had been achieved that the next generation of architects embarked on the conquest of height.' In contrast to the narrow confines of Romanesque naves, the central nave at Sens spanned 15 m (49 feet), and that at Chartres a mighty

16.5 m (54 feet) – a span imposed by the boundaries of the timber-roofed cathedral built by Fulbert, which could never have been covered with stone without the invention of rib vaulting.

For Paul Frankl, as we saw earlier, rib vaulting lies at the heart of Gothic. That is a contentious claim; but even more problematic is the issue of what structural role, if any, the ribs play. Frankl himself did not much care about such things, and perhaps that is just as well, for he did not really understand the mechanical principles involved. Vaulting with ribs may have been easier to construct, but that does not answer the question of whether or not it is more stable. There is a hint that the Gothic architects themselves did consider the ribs to have a structural function, for the French word for the rib (both then and now), *ogive*, may be derived from the Latin *augere*, 'to strengthen'. The empirical evidence, however, is conflicting. There are examples of churches where the ribs of the vaults remain while the shells have collapsed, as at the ruined abbey of Ourscamp in Picardy, implying that the ribs provide a stable skeleton. But there are also cases of the precise opposite, as at Longpont in Aisne, suggesting that the shells need no such skeleton. Theory is of little help in resolving the issue either, since the calculations of stresses in the vaults are difficult and rely on various assumptions.

Jacques Heyman has pointed out that, while the creases of the groins do 'weaken' the shells in principle in the sense of making them more 'bendable', in practice the three-dimensional shape of the groin vault is quite stable on its own because of the arched form, and the shells effectively 'supply their own ribs' along the groins. Heyman thinks that, if the ribs reinforce at all, the effect is not crucial:

> The rib, then, serves a structural purpose as a very necessary, but perhaps not finally essential, reinforcement for the groins; it enables vaulting compartments to be laid out more easily; it enables some constructional framework to be dispensed with; and it covers ill-matching joints at the groins. As a bonus, the rib has been thought to be satisfying aesthetically, and all of these functions may be thought of as the 'function' of the rib.

Crucially, he concludes, the ribbed vault is flexible and deformable, able to accommodate settling and leaning of the piers that support it. (To Frankl, unversed in mechanics, this idea, advanced in the nineteenth century, seemed absurd – everyone knew, he scoffed, that

Ribs became increasingly integrated into the fabric of the vaults. Rebating of the rib voussoirs merges them with the vault shells (*left*), while the tas-de-charge made them projections of the walls (*right*).

vaults are not made of rubber.) As for the medieval builders, it isn't clear that they had an opinion either way. They were simply concerned with making a ceiling that would stay up.

As masons become more confident in making these structures and the ribs became more slender, the master builders began to integrate them into the underlying fabric of the building. Transverse (non-diagonal) ribs would be married with the vaulting behind them by projecting the rib voussoirs into the shell and cutting rebated shelves to seat them. And the slenderness of the ribs eventually reached a stage at which their convergence at their springing points allowed the initial voussoirs of several ribs to be melded into a single stone, called a tas-de-charge. There might be five or more of these stones laid on top of one another, each simultaneously a part of the wall and a multiple vous-soir shaped with extraordinary skill. The tas-de-charge – the earliest extant example of which is at Chartres – was no mere convenience. It also acted as a through-stone that replaced the infill of the vault haunches in transmitting the thrust to the wall and buttresses.

Thus the ribbed vaults became a system of exquisitely interlocking elements. In later Gothic buildings any potential structural function of the ribs was truly lost as they proliferated in the form of tiercerons and liernes that run across the shell rather than the ridges of the vault. In the

end they became little more than delicate traceries on the vault surface, woven into intricate webs whose purpose was merely decorative.

Like the pointed arch, rib vaulting was once considered a quintessentially Gothic feature but is now seen to be much older than that. Its origins again probably lie in the East, from where it was transmitted via Islamic Spain in the second half of the tenth century. Experiments in rib vaulting start to appear in England and Italy shortly after the capture of Toledo from the Arabs in 1085, suggesting that western Europe adopted this style from the Muslims. By 1100 it was being used at Durham, and by the early 1120s it had spread into France. Systems of diagonal ribs can be found from this time in the churches of Normandy; for example, at Evreux, Lessay and Jumièges.

Searching for Unity

The simple groin vault creates square bays. But that's a problem, because the aisles of a church are narrower than the nave. The medieval builder could reconcile the discrepancy using a Platonically pleasing proportion by making the nave twice the width of the aisles: then the nave and aisle vaulting becomes commensurate by matching two bays of the aisle with one in the nave. This means, however, that only every alternate pier of the nave arcade supports a corner of the nave vault arches. Short of making the intervening piers far more massive than they need to be, the 1:2 arrangement dictated an alternation in the size of the arcade piers. Such a situation can be seen at the Cathedral of St Julien at Le Mans, for example. That this came to be perceived as an unsatisfactory solution is a sign of how church builders were starting to focus on the unity of their constructions – they felt that all the nave piers should somehow relate to the form of the nave itself.

One way to integrate the 'intermediate' piers into the structure of the nave was simply to add a new transverse rib that connected them across the nave vault. This creates two cross vaults in the nave bay, and means that the two wall arches of the vault are 'pulled down' at their apex, turning each single arch into two arches of half the width. The vaults of each bay are then divided into six cells: this is the so-called sexpartite vault. The system can be seen in many early Gothic churches; for example, at the cathedrals of Sens, Laon, Notre-Dame de Paris, and Bourges.

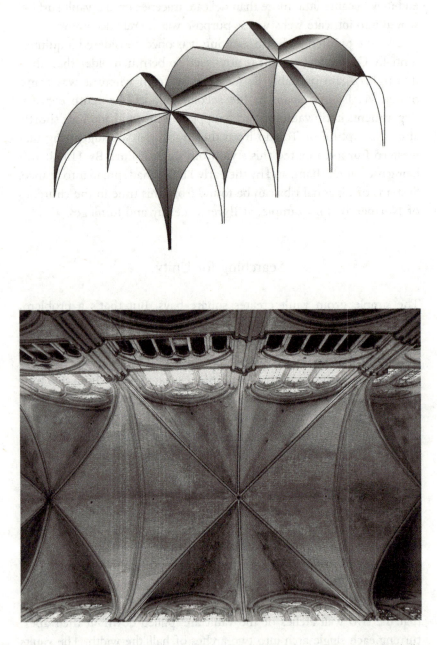

The sexpartite vault – and how it looks at Bourges Cathedral. (*Photo: James Mitchell.*)

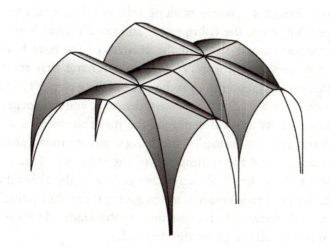

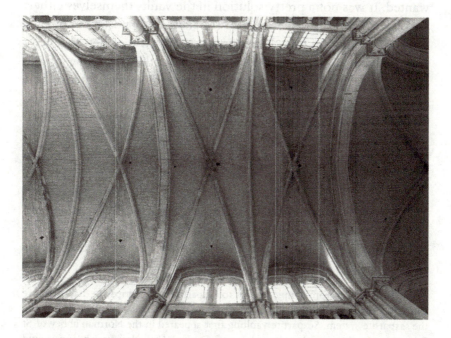

The quadripartite vault – and how it looks at Noyon Cathedral. (*Photo: James Mitchell.*)

Yet even though sexpartite vaulting relaxes the demand for alter-
nating pier diameters, the columns are still not all equivalent and do
not carry equal loads – those at the corners of the nave bays bear
the brunt of the vault thrusts. (Heyman estimates that the thrust
there is three times greater than at the intermediate piers.) The Gothic
architects were aware of this persistent disparity, and the corner piers
of sexpartite vaults are still generally the more massive, as at Sens.
This was not just a question of mechanics, but stemmed also from
the impulse to reveal the symmetries of the structure. Thus even at
Laon, where the cylindrical piers have only a slight alternation in
diameter, this pattern is emphasized by giving them alternating bases
of square and octagonal cross section. Notre-Dame de Paris is an
exception in that all the piers are identical.

So as far as the arcade was concerned, then, the sexpartite scheme
still fell short of attaining the harmony that the Gothic architects
wanted. It was not a pretty solution in the vaults themselves either:
six ribs radiate from each boss in the nave, as opposed to four for
the aisle vaults, and this clustering creates a sense of heterogeneity
and crowding. The final step, which marks the beginning of the
mature system of Gothic vaulting, came with the acceptance that
vault bays do not have to be square at all. Instead of pinching the
cross vaults of the nave together in pairs, as in the sexpartite system,
each of them can be simply run orthogonally across the nave to
create rectangular bays that are half as wide as they are long. This
is the quadripartite vault, which gives each of the nave bays the
same east–west span as those of the aisles.* This system was used
in the choir at Noyon and the transepts of Laon, both completed
by the end of the twelfth century; but it became the standard form
of Gothic vaulting at Chartres, and was subsequently used at Reims
and Amiens.

* The progression from simple square to sexpartite to quadripartite bays is more
conceptual than historical, since there are certainly rectangular vaults that precede
the sexpartite system. Sexpartite vaulting first appeared in the Norman abbey of St
Etienne in Caen in the early 1130s, while both Durham Cathedral (nave begun around
1115) and the abbey of Lessay (vaulted around 1105) have rectangular vaults. Even
when the sexpartite scheme became popular in the latter half of the twelfth century,
rectangular vaulting continued to be used alongside it. It is the decline of Gothic
sexpartite vaults in favour of quadripartite, however, that reveals this as a conscious
move towards greater coherence.

The pier cross-sections in the nave of Chartres alternate between circular and octagonal. Note that the four subsidiary columns in these compound piers have the opposite cross-section to the main columns. (*Photo: Alex Rowbotham/AGRFoto.*)

It is curious that at Chartres the master builder decided to retain an alternation in the appearance of the nave piers, which are either cylindrical or of octagonal section, even though he used quadripartite vaulting. That choice is sometimes said to have been made to avoid monotony in the nave. We do not know the real reason behind it, but the architect would surely have been familiar with, perhaps even habituated to, this rhythm in older vaulted churches, where it was imposed by the vault geometry rather than by aesthetic considerations. So one could say that it was an unnecessarily old-fashioned choice. On the other hand, the piers of Chartres are innovative in having a central core surrounded by four more slender columns. The latter are octagonal for cylindrical cores, and vice versa, and they point out the diagonals of the vaults, uniting the floor with the ceiling. They constitute the first of the composite *piliers cantonnés* that characterize the High Gothic

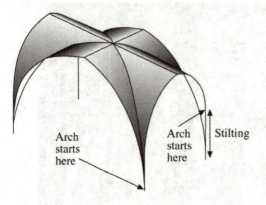

Arch starts here

Arch starts here

Stilting

Stilting allows arches of different widths to reach the same height without excessive pointing of the smaller arches.

cathedrals: a reflection of the desire to make the organization of space and stone explicit in every feature of the building.

Notice that both in sexpartite and in quadripartite vaults the greater span of the transverse arches relative to the longitudinal (wall) arches means that if they are all to reach the same height at their apex, they must be adapted in one of two ways: either the smaller arches have to curve more steeply, or they have to start higher up. The former solution is possible for pointed arches (it will not work for semicircular arches, whose curvature is fixed), but it is not very satisfactory since it makes the shape of the longitudinal arches quite different from that of the transverse arches. French Gothic architects chose the second option of raising the springing of the longitudinal arches, a feature known as stilting. This had the added bonus that it left the maximum amount of wall space free for the clerestory windows, whereas 'sharpening' the arch would squeeze this space. At Chartres the architect used somewhat anachronistic *semicircular* rather than pointed wall arches in the nave vaulting, which forces the springing to be particularly high – it begins way above the springing of the diagonal and transverse arches.*

The weight of stone vaulting is immense, but you wouldn't think so. This dimpled canopy has a tent-like form, as though it is suspended from strings. To Hans Jantzen, that was one of the central aims of the Gothic builders: to nullify gravity 'in order to create a place of

* This choice of arch might have been compelled by the use of the large round rose above the twinned lancets of the clerestory. That in itself is an innovative design, somewhat anticipated in the bishop's chapel at Noyon but here integrated into a harmonious scheme by the rounded arch that contains it.

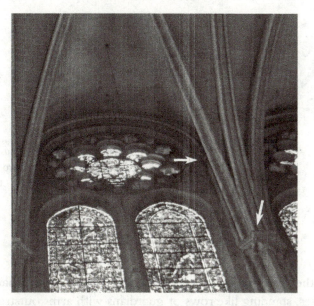

Stilting of the semicircular clerestory arches in the nave at Chartres. The springing points are indicated with white arrows. (*Photo: Alex Rowbotham/AGRFoto.*)

enchantment, a space transcending earthly experience'. Unlike the architecture of classical Greece and Rome, where horizontal lintels bridge the tops of columns in a way that is unambiguously load-bearing, the Gothic vault is all about verticality. 'The vault', says Jantzen, 'is not felt as something heavy.'

Outside Support

The Gothic builders knew very well that this weightless effect was illusory; but they sought to extend the illusion ever further, raising their vaults far into the heavens. The groin-vaulting scheme had opened up a space above the aisle vaults for the clerestory windows; but if the clerestory was carried too high, there was nothing up there to counteract the thrust of the nave vaults. One couldn't simply build buttresses up the nave wall, because the aisles were in the way.

The answer seems inevitable in retrospect. The buttresses of the aisle walls were extended as free-standing pinnacles (buttress piers), which were then connected to the nave wall by half-arches that leapt

The hidden *murs boutants*, as shown here beneath the aisle roof of Laon Cathedral, anticipate the flying buttress.

across the intervening space. These are Gothic's trademark flying buttresses, standing like rows of guardians with arms outstretched to prop up the towering church flanks.

At first, this seems to have been a makeshift solution to an evident danger. Around 1180 the master builders of Paris noticed cracks appearing in their clerestory walls level with the haunches of the arches, a little higher than the springing. And so they constructed the *arc boteret*, which abutted onto the wall at this point. The earliest known examples occur at Saint-Germain-des-Prés and at Notre-Dame – which came first has been a matter of debate, although the flying buttresses that now line the nave of Notre-Dame are nineteenth-century restorations of alterations made around 1230.* The cracking, we now know, was caused by the thrust line exiting the vault arches in the plane lying at about 30° above the horizontal of the springing level, making them buckle (see page 208).

Yet the flying buttress was anticipated by methods of support that had previously been hidden beneath the aisle roofs. The choir of the early Gothic abbey church at Saint-Germer-de-Fly, built between 1160 and 1180, has an ambulatory and tribune topped by rounded quarter-arches under the roof, while at Laon Cathedral there are wedge-shaped supporting walls at intervals beneath the

* There is a single original flying buttress at Notre-Dame nearest the transept on the north side of the choir.

roof of the aisles, called *murs boutants*, which, being pierced by a walkway, resemble primitive flying buttresses. In true flying buttresses these concealed structures are pulled out from under the roof and given piers of their own, allowing them to rise above the springing line of the nave arches. Once that was done, there seemed no limits to how high the nave vaults could be, nor any danger in making the clerestory a diaphanous veil of glass. At Chartres the nave is more than twice as high as the aisles.

Many flying buttresses have two or more tiers, with the uppermost adjoining the nave wall just below the level of the roof. Here they are too high to capture any significant thrust from the vaults, and there was considerable debate after the nineteenth-century Gothic revival about their function. One theory was that they were simply rainwater conduits. Certainly, rain did cause damage and disfigurement if it ran unchecked off the roof and down the wall; but it was hard to imagine so much effort and stone being devoted to drainage alone. Another idea was that the upper flyers were hedging structures, a precaution against the lack of precise knowledge about where the vault thrust was greatest. But if medieval engineers could not determine this precisely, nonetheless they would not have been so ignorant as to place a flyer so high that it captured none of this thrust at all. Most experts now concur with the argument that the upper tier of flyers is there to strengthen the wall against wind stress, and also against the thrust of the roof.

Chartres Cathedral showed that the flying buttress, rather than a post-hoc modification to keep the building standing, could be made an integral element of the design. For Frankl the flying buttress is 'the basic premise underlying the whole form of the cathedral at Chartres, and the entire Gothic style'. Here and at Bourges Cathedral, where work began around 1195, the architectural possibilities of the flying buttress became suddenly clear: the builders realized that these supports allowed them to build higher without having to compensate with an increased mass of masonry. Rather than being an emergency answer to the problems created by the new heights that the nave reached, the flying buttress helped to unify the inside and outside of the church, echoing the segmentation of the bays. In fact, the monumental building style of northern France in the early part of the thirteenth century has been called simply 'the architecture of the flying

buttress'. Yet they are not to everyone's taste – to some historians they look like a coarse mechanical necessity, and they have been dismissed as a form of 'artistic crudity'.

For Gothic builders they came to seem indispensable,* even though these men probably had only a minimal understanding of what was required for a flying buttress to be effective. Not all of them actually push back against the clerestory wall: some are either too thin or too steeply canted. These may, however, act as passive 'thrust conductors' that transfer the thrust of the vaults to the buttress piers, and from there to the ground. Those at Chartres are more massive than is really necessary, while at the same time those in the chevet slope at too shallow an angle to exert much thrust. As we saw earlier at Canterbury, some builders regarded the flying buttress merely as part of the Gothic vocabulary, rather than as an element with a well-defined functional role. The diversity of form, function and efficiency of flying buttresses supplies a good reminder that Gothic builders had less opportunity to learn from experience than is often acknowledged. A badly engineered cathedral may fall down, but how does one compare those that remain standing? And the classic High Gothic cathedrals were all raised over a short period relative to the time it took to construct a single one of them. Consequently, the designs that seem most impressive today were not always emulated – Bourges shows how to create a church that is massive while appearing light and elegant, but that did not avert the catastrophe of Beauvais.

Building for Eternity?

The skeletal web of masonry both inside and outside the Gothic cathedrals is, then, much more than a scheme for creating a geometrically ordered space. It is a map of the forces at play (or perhaps we should say, of the forces that the architects considered to be at play) in the building. This is one reason why the speculations of the nineteenth-century Romantics that the soaring, high-vaulted forms of these churches were inspired by forest canopies miss the mark: because they

* It's easy to overstate that case, however. Some late Gothic cathedrals, such as Aachen and Vienna, achieve impressive heights while relying only on wall buttresses.

focus on form and ignore function. The stone armature of the cathedral is a conduit for the power surging through the stones: 'there is no inert matter', says von Simson, 'only active energy'. The focusing and channelling of these forces releases the space in between into lightness, free to be pierced and glazed in brilliant colours.

Because these forces are balanced in an integrated and self-supporting web, it mattered a great deal in what order the components of a cathedral were constructed. It was dangerous to put up the flying buttresses last (although Jantzen claimed that was common), since the vaults stand at risk of collapse until the flyers are there to support them, and even then one could not load the buttresses heavily while the mortar was still setting. Similarly, the row of windows in the clerestory was little more than an arcade of slender, vulnerable columns until they were joined by arches. Wooden falsework could sometimes act as a temporary surrogate during that time: the centring for arches might relieve some of the stress, for example. But this woodwork, exposed to the elements and lashed with rope, could only be a temporary measure, while the masonry structures it supported might remain incomplete for years.

Another way to strengthen an incomplete building was to use tie-bars of wood or iron to counteract the thrusts. As we've seen, masonry is very strong against compressive stress but very weak under tension. Wood and iron, on the other hand, can resist a good deal of pulling. So the outward thrust of arches and vaults can be opposed by tie-beams stretching from wall to wall to bind them together. This was widely done, and tie-beams can still be found in many churches, such as the collegiate church at Saint-Quentin and at Canterbury and Prague cathedrals. The nineteenth-century architectural historian Auguste Choisy suggested that tie-beams alone would suffice to brace the piers and walls of the high vaults against the thrust of the vaults and roof. But Fitchen asserts that this scheme would have been highly unstable, and he posits instead the following sequence. After the laying of the foundations (if the church needed them; often, as at Chartres, the building was erected on the base of an older structure), the nave arcades and outer walls of the aisles were raised. Then the side aisles were vaulted, with tie-beams at the springing of the arches taking up the thrust of the vaults so that the arcade was not pushed inwards. The aisles would be roofed, and the buttress towers and upper nave wall (triforium and clerestory) added. The nave walls would be raised

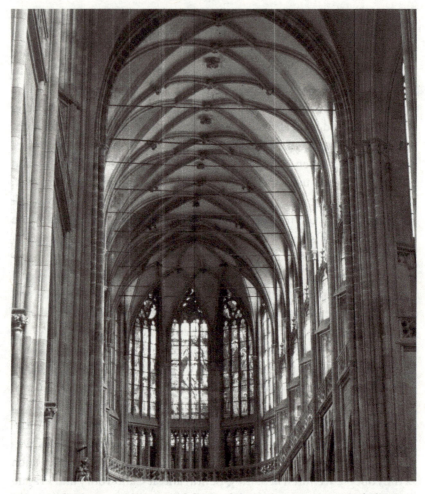

Iron tie-rods counteract the outward thrust of the vaults at Prague cathedral. (*Photo: Janusz Leszczynski.*)

to their full height and braced with the flying-buttress centring before the roof was added, anchored with timber tie-beams to reduce the thrust. Once the roof was in place, the flying buttresses themselves would be constructed (the roof then helps to stabilize the structure by pushing against their inward thrust). Finally, the high vaults were put in place under cover of the roof.

It does indeed seem clear that this last sequence, at least, was common practice. But engineers still don't agree about how stable it was: wouldn't the flying buttresses threaten to push the building inwards, without the vaults to counteract them? Maybe so – although

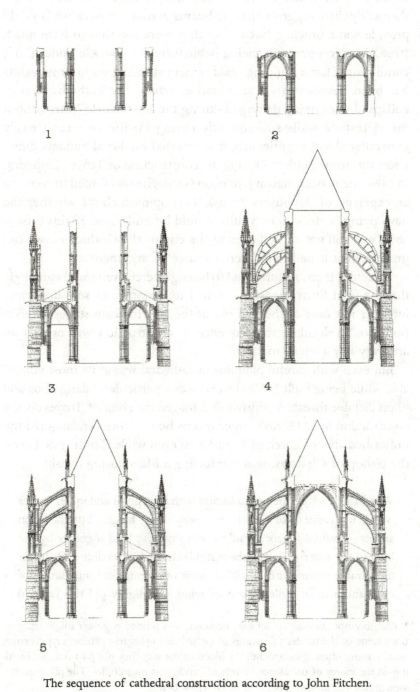

The sequence of cathedral construction according to John Fitchen.

as we've seen, some flyers are too steeply canted to exert much thrust. Fitchen suggests that tie-beams across the nave walls could provide some bracing, but in fact they were too thin to have much strength in compression, being liable instead to buckle under those conditions. That a building *could* remain standing without its vaults has been demonstrated at Soissons, where the cathedral vaults collapsed after being damaged during the First World War without the clerestory walls subsequently caving in. But one can't easily generalize. Most significantly, it seems that medieval builders didn't know the answer either. During the construction of Troyes Cathedral in 1494, the master mason Jehançon Garnache was forced to convene an expertise of 'labourers' to ask their opinion about whether the nave flying buttresses or vaults should be built first. If this crucial issue was still not settled even at the end of the Gothic era, we can imagine that it had long been a source of argument.

Evidently, then, a church had to be engineered even more cunningly than its final form suggests – it had to maintain its self-supporting integrity not only at the end but at the intermediate stages of erection too. So deciding the sequence of construction was neither an arbitrary nor a trivial matter.

But even with careful planning, a cathedral was at its most vulnerable while being built.* Wind stress was a particularly dangerous and unpredictable threat. A whirlwind damaged the choir of Troyes during construction in 1228. And Suger relates how a storm endangered the unfinished abbey church of Saint-Denis even while Geoffrey de Lèves, the bishop of Chartres, was conducting a Mass during a visit:

> When the work on the new addition with its capitals and upper arches was being carried forward to the peak of its height, but the main arches – vaulted independently – were not yet held together by the bulk of the severies [bays], there suddenly arose a terrible and almost unbearable storm with an obfuscation of clouds, and inundation of rain, and a most violent rush of wind. So mighty did this [storm]

* Probably not quite as vulnerable, however, as a trained engineer might imagine from some of the modern drawings of cathedrals-in-progress. These, says Norman Smith, 'more often than not chill the blood in the way they put part-finished buildings at the mercy of unbalanced forces of prodigious magnitude'. The pictures may look pretty, but medieval builders surely knew better.

become that it blew down, not only well-built houses but even stone towers and wooden bulwarks. At this time, on a certain day (the anniversary of the glorious King Dagobert), when the venerable Bishop of Chartres, Geoffrey, was solemnly celebrating at the main altar a conventual Mass for the former's soul, such a force of contrary gales hurled itself against the aforesaid arches, not supported by any scaffolding nor resting on any props, that they threatened baneful ruin at any moment, miserably trembling and, as it were, swaying hither and thither. The Bishop, alarmed by the strong vibration of these [arches] and the roofing, frequently extended his blessing hand in the direction of that part and urgently held out toward it, while making the sign of the cross, the arm of the aged St Simeon; so that he escaped disaster, manifestly not through his own strength of mind but by the grace of God and the merit of the Saints. Thus [the tempest], while it brought calamitous ruin in many places to buildings thought to be firm, was unable to damage these isolated and newly made arches, tottering in mid-air, because it was repulsed by the power of God.

When it was done well, however, the finished masonry structure formed a coherent mechanical unit that was all but impervious to failure. Jacques Heyman offers a compelling image: if the stones stayed in place for five minutes after the scaffolding was removed, they would stand for five hundred years. That is the time-scale on which the materials themselves begin to decay; for example, by seepage of water into cracks which then freezes and splits the stone.

In the real world, however, there is more change than that. One of the key issues was how well the building would settle as the soil on which it stood became consolidated under the weight. This subsidence was typically uneven, and could distort the fabric – crossing towers, carrying the greatest load, might sink a foot or so deeper than the rest, for example. Troyes Cathedral was plagued for centuries by its chalk foundations, which turned to a treacherous paste when it got waterlogged. Medieval builders did seem to understand the advantages of creating wide foundations to spread the awesome load of the stones above, but there was only so much they could achieve with the tools and the knowledge available. Settling of the foundations happened mostly over the period of a generation

or so after the completion of the work,* and it was during this time that the integrity of the construction was at greatest risk. Several large churches, such as those at Winchester, Gloucester and Beauvais, did collapse within twenty years of being built.

Beauvais is the most notorious of these, having undergone two catastrophic failures. The thirteenth-century vaults of the choir reached 157 feet (47.8 m), but they stood for only twelve years before crashing to the ground in 1284. It is often said that this was caused by the cathedral's excessive size and height, a reprimand to those who insisted on building to a Babel-like scale: to historian Georg Dehio, Beauvais was the 'Icarus flight of Gothic'. Yet we can't blame it all on hubris, for Beauvais was not *that* excessive: its vaults are only 2 m (6½ feet) higher than those at Cologne. The disaster may have been nothing more than bad luck: Viollet-le-Duc proposed that slow shrinkage due to settling of the mortar was to blame, while Heyman suspects that soil subsidence is the culprit. Alternatively, the collapse may have been caused simply by poor rather than by over-ambitious engineering: it has also been attributed to inadequate buttressing.

The Beauvais clerics were undeterred: the choir was repaired, and in the sixteenth century a great tower was erected over the crossing. From the top of the spire, 461 feet (140.5 m) above the ground, on a clear day one could allegedly see the houses of Paris fifty miles away. Then, on Ascension Day (30 April) in 1573 the worshippers had just left the cathedral when some sharp-eyed observer noticed with alarm that the four columns of the crossing were moving. Moments later the spire came tumbling, pushing out the air from inside the building in 'a wind so violent as to close the doors', according to a contemporary writer. The choir was rebuilt a second time in 1575, but has never been completed, and even today the building's stability relies on modern supports. Whatever the reasons for its failure, Beauvais reminds us how much trial and error and sheer good fortune was involved in balancing this weighty web of forces.

* The collapse of the crossing tower at Ely Cathedral in 1322 two centuries after it was built might have been triggered by subsidence resulting from draining of the East Anglian fens. Changes in the water table below London in the nineteenth and twentieth centuries have also affected the settling of St Paul's Cathedral, causing cracking in the south transept.

9

Holy Radiance

The Metaphysics of Light

The divine light penetrates the universe according to its dignity.

Dante, *Paradiso*, early fourteenth-century

At last we are face to face with the crowning glory of Chartres. Other churches have glass, – quantities of it, and very fine, – but we have been trying to catch a glimpse of the glory which stands behind the glass of Chartres, and gives it quality and feeling of its own . . . One becomes, sometimes, a little incoherent in talking about it; one is ashamed to be as extravagant as one wants to be; one has no business to labour painfully to explain and prove to one's self what is as clear as the sun in the sky.

Henry Adams, *Mont Saint Michel and Chartres*, 1904

The Windows

As well as being the New Jerusalem and a model of the universe, and also a meeting place and a symbol of civic prestige, Chartres Cathedral is a library. It is full of picture books, with pages of coloured glass. Everyone knew the stories, but that didn't make them dull. On the contrary, it would be hard to tire of the manner in which they are told. The ordinary man and woman, illiterate and never likely to set eyes on the parchment pages of a book, would have gazed in wonder at these stories of Christ and the Virgin, the saints and the Old Testament, glowing like miraculous visions in the dark stone.

One simply didn't see colours like this in everyday life. Ruby reds,

sapphire blues, emerald greens – real gems were surely no more glorious. These crystal panels are depicted with all the economy of the short-story writer, and executed by the finest graphic artists of the age. They evoke the Scriptures in a way that even the most eloquent priest could not rival.

The windows of Chartres, Bibles of the illiterate which replaced the murals of Romanesque churches, were very expensive – 'one is almost surprised', says Henry Adams, 'that they are not set in gold rather than in lead'. They cover about an acre (4,000 square metres), and accounted for about 10 per cent of the building's total cost. The great rose window of the west wall is one of the most marvellous innovations that Chartres Cathedral added to the vocabulary of Gothic architecture. There had been western roses before – Saint-Denis had one – but never so large or so bold. Built around 1215, it dominates the remodelled western façade. With symbolic twelvefold symmetry it shows the terrifying threats and glorious promises of the Last Judgement, an appropriate subject to be lit up by the rays of the evening sun. Christ is enthroned in the centre for his Second Coming on the Day of Judgement, surrounded by the apostles, angels, and the creatures that represent the four Evangelists. Beneath his feet, demons weigh up the souls of mankind and fling sinners into the flames of hell.

The three lancets below the rose date from the pre-Gothic church of the mid-twelfth century, mercifully preserved from the flames. It has been suggested that they were made by the same craftsman who created some of the windows of Saint-Denis. They are the most striking examples of twelfth-century stained glass now in existence; the Tree of Jesse window on the north side, which shows the genealogy of Christ from among the kings of Judah ('A shoot shall come forth out of Jesse . . . and the Spirit of the Lord shall rest upon him'), was considered by the eminent art historian Emile Mâle to be 'the most beautiful window ever made'. Henry Adams was entranced by its play of light – 'the most splendid colour decoration the world ever saw . . . even the Ravenna mosaics or Chinese porcelains are darkness beside [it]' – but he was less captivated by

the subject matter. A genealogical tree, he confessed, is not terribly interesting 'except to those who belong in its branches', and he felt the composition was put there 'not to please us, but to please the Virgin'.*

The rose window of the north transept and the lancets beneath it were donated around 1230 by Blanche of Castile, Louis VIII's queen, during the period of her regency from 1226 to 1234 when her son Louis IX was still a child. The rose has a Marian theme: she sits with the Christ Child surrounded by Old Testament kings and prophets, again reflecting Christ's ancestry in the House of David. That theme is echoed in the lancets, where Mary's mother St Anne is flanked by Melchizedek, David, Solomon and Aaron. The colours here are dominated by large areas of red, whereas the south rose and lancets are a patchwork of red, blue and gold. They were given by Pierre Mauclerc, count of Dreux and duke of Brittany, around 1224–8, and the count's chequered blue and gold heraldry recurs throughout the design. In the rose itself, Christ is enthroned in the middle of images representing the Apocalypse. Mauclerc and his family appear in person at the bases of the lancets. Mary is again venerated in the central lancet, while to either side the Evangelists sit astride the shoulders of the Old Testament prophets: Luke on Jeremiah, Matthew on Isaiah, John on Ezekiel and Mark on Daniel. The temptation to interpret this iconography as an embodiment of Bernard of Chartres's epigrammatic remark about standing on the shoulders of giants is understandably so great that few historians have bothered to resist it. But such a connection seems unlikely. As Raymond Klibansky points out, not only was the association of the four Evangelists with the four major prophets a familiar image in Carolingian art, but more to the point the artist 'can hardly have intended to call St John a dwarf in comparison to Ezechiel'.

There are too many stories in the magic lanterns of Chartres to list them all. Many of the nave windows depict the lives of the saints,

* *Did* it please her, though? The historian Elizabeth Fischer points out that here Mary is no more significant than the other figures. At this time, the churchmen may have been attempting to diminish the local Marian cult, so as to assert their own.

some of whom we now barely recall. In the largest of the south chapels, a window donated by the tanners shows the martyrdom of Thomas Becket of Canterbury, whose secretary and friend John of Salisbury ended his days as bishop of Chartres. Here Canterbury Cathedral is depicted anachronistically with its flying buttresses in place, suggesting that the artists had seen or at least heard of it as it looked in the early thirteenth century. The window of the smallest north chapel of the ambulatory shows the life of Charlemagne – at Saint-Denis a similar window was destroyed during the Revolution. And no visitor should miss the wonderful marine hues of the Noah window in the north aisle.

Not all the windows are as old as they look: the one in the south transept that shows the life of Fulbert was made in the nineteenth century by a local glassmaker and financed by the American Institute of Architects.

It is, of course, the *bleu de Chartres*, dominating these kaleido-scopic windows, that enjoys the greatest renown. This preference for blue seems to be first evident in the windows of Suger's Saint-Denis, and is expressed in many twelfth-century French churches. Cost alone does not explain the choice. Viollet-le-Duc strove to account for it in aesthetic terms, forgetting that such judgements are the products of their times: 'If you compose a window in which there shall be no blue, you will get a dirty or dull or crude surface which the eye will instantly avoid; but if you put a few touches of blue among all these tones, you will immediately get striking effects if not skilfully conceived harmony.' As we have seen, choices were rarely if ever made in medieval art for what we would now deem to be 'artistic' reasons, but relied instead on symbolism (and also, as we shall see, on what the prevailing technologies could produce). It may be that the preference for blue in the gem-like windows of the first Gothic churches owed something to the praise lavished on *saphirus* in the eleventh-century verse compo-sition *Liber lapidum* ('Book of Stones') by Marbode, bishop of Rennes, with which Suger was possibly familiar. This poetic paean to precious stones attributed marvellous powers, including healing attributes, to sapphire.* Marbode called it a sacred stone, a 'gem

of gems'. He took much of his material from Isidore of Seville's seventh-century *Etymologies*, but some also from a Latin work called *De virtutibus lapidum* ('On the Virtues of Stones') attributed to the ancient Greek writer Damigeron, who wrote that sapphire 'is vigorously honoured by God'. In his encyclopaedic ninth-century work *On the Nature of Things*, the German Benedictine cleric Hrabanus Maurus went further, suggesting that sapphire represents the hope of eternal life. What substance, then, could be more appropriately imitated in the windows of a great church?

The gloom created by this strong filtering of light was not to the taste of every age. When the choir of Chartres was modernized in 1753, some of the borders of the thirteenth-century windows were removed and replaced with plain glass. Eight of the choir windows, as well as four in the transepts, were removed entirely and – one winces to think of it – destroyed so that more light should be admitted. Yet the windows of Chartres are remarkable for their pristine state: of the 186 originals, 152 still survive. In the Second World War they were removed to safety, letting people see the church instead in 'natural' light. The result, it is said, was a harsher space, its elegant lines no longer softened by the reddish violet effulgence of Gothic illumination. And it is true that the black-and-white photographs taken during wartime have something improper about them, as though it is the Virgin herself who has been disrobed and exposed under the harsh glare of the noon sun. The space looks crude and cold, the stones pale and exhausted. Yet remember that this is also what worshippers saw in the early thirteenth century, for daylight would have flooded the interior while the builders were at work and the windows were blank voids waiting to be filled with coloured light.

* This doesn't necessarily refer to the gem we now call sapphire, which is a form of corundum tinted by impurities. The Latin *saphirus*, from the Arabic *zaffre*, could mean more or less any blue stone, and in the early Middle Ages it often referred to lapis lazuli, the mineral source of ultramarine blue. As we'll see, *zaffre* could also be cobalt ore, the prime colourant of deep blue glass.

Although the scale of Chartres' stone cliffs is unforgettable, it is not unique. One may be equally overwhelmed at Reims, Strasbourg, Cologne, at a dozen or more of the great Gothic churches. But what one will find nowhere else – what inspires people to speak of Chartres with hushed awe and reverence whether they are believers or not – is its light.

Or rather, some might say, the lack of it. It may seem curious that the Gothic architects went to such inventive lengths to strip away the masonry and open up the walls of their buildings, only to glaze the spaces with rich blues and reds that reduce the inner world to one of deep shadow and sombre gloom – to flood them, as Paul Claudel said of the blue of Chartres, with 'darkness made visible'.

Of course, we are looking at the matter from the wrong direction to make a fair comparison. Today our cathedrals of commerce seem fashioned out of limpid glass alone, with only the flimsiest of steel frames holding the panes in place. We are accustomed to dwelling in permanent daylight, even if we must make it artificially. We must remember that in the days before glass was an affordable commodity for any but the wealthiest, windows had to be as small as possible, or kept shuttered, to keep out the rain and cold; even oiled paper, the poor man's glass, admitted only a hazy glow. Everyone in the Middle Ages expected interiors to be dark. And in Romanesque churches, with their heavy walls and tunnel-like windows, they surely were: candles, not the sun, gave light to the congregation. Thus, when Suger boasts of his new choir that it shone 'with the wonderful and uninterrupted light of the most luminous windows', we need to bear in mind what he was contrasting it with.

Thomas More reminds us of this in his *Utopia*, for what was 'wonderful and uninterrupted' in the twelfth century was decidedly dim in the sixteenth. More was probably thinking as much of early Gothic as of Romanesque when his narrator Hythlodaeus says of the churches of Utopia that they

> look most impressive, not only because they're so beautifully built, but also because of their size. You see, as there are so few of them, they have to be capable of holding vast numbers of people. However, they're all rather dark, which is not, I'm told, a mistake on the part of the architects, but a matter of policy. The priests think that too much light

tends to distract one's attention, whereas a sort of twilight helps one
to collect one's thoughts, and intensifies religious feeling.

Despite Suger's claims to brightness, it appears that this preference
for attenuated light was felt until the late thirteenth century, when
churches began to be given much lighter windows of white glass. This
change in fashion, one French writer complained, 'hinders worship
and simplicity . . . evil vanity [has] made glass and windows to give
ample light, so that worship and repentance, which formerly inhab-
ited these temples, have become suspicious, and are fled because of
the great brightness'. One might be tempted to suppose that this was
a change driven by technology or economics, as methods of fabri-
cating colourless glass advanced. This surely played a part, but it was
not the whole story, for it was not impossible to make pale or colour-
less glass in the early Gothic age. It could be expensive, to be sure,
but the blue used at Saint-Denis and Chartres was even more so; those
churches could have been relatively brilliantly lit even by today's stan-
dards if the builders had so desired. Later, they clearly did desire that:
the Italian craftsman Antonio da Pisa specified around 1400 that
stained-glass windows should contain at least a third of white glass,
so that the result should be more joyous. The fourteenth- to sixteenth-
century glass of the Saint-Piat Chapel at Chartres, and also that of
the intrusive fifteenth-century Vendôme Chapel in the south aisle,
take heed of such advice, having a much lighter colour scheme than
the twelfth- and early thirteenth-century windows.

Light of God

So Suger's celebration of light must be seen as something more subtle
than a kind of Christian sun-worship. Light, to the twelfth-century
Platonists, was not about the bright glare of day. For one thing, this
effulgence took on significance only when it was contrasted with dark-
ness; an all-pervading brightness had no meaning. The biblical key to
the Platonic metaphysics of luminosity was found at the start of the
Gospel of St John: 'In him was life, and that life was the light of men.
The light shines in the darkness, but the darkness has not understood
it.' To draw men and women into contemplation of this divine light

so that it might enter and illuminate their hearts, it had to be shown radiating into gloom, like the coloured rays that speckle the ambulatory of Saint-Denis.

Moreover, for Suger at least, divine light seemed to have the quality not of blinding brilliance but of the gleam of gemstones. For it was written that the light that streamed from the New Jerusalem itself 'shone with the glory of God, and its brilliance was like that of a very precious jewel, like a jasper, clear as crystal'. It was widely believed that precious stones and jewels collected and concentrated light, which made them particularly apt as the focus of meditation on the light of divinity, for the early Christian Neo-Platonist Pseudo-Dionysius (see below) explained in his *Celestial Hierarchy* that each object and creature received and transmitted divine illumination according to its rank and worth. Reflection from such objects pointed one back towards God; and so it was appropriate, Suger felt, to dwell on things that glowed and glittered.*

Yet the early Christian Fathers took care to distinguish the true light of God, the light of creation, which they called *lux*, from that of the heavenly bodies, which is sensible light or *lumen*. The former has almost a material aspect to it, which is perhaps why Suger saw it congealed in sapphires and topazes. '*Lux* is substance itself', wrote Isidore of Seville in the early seventh century, 'and *Lumen* [is] what flows from *Lux*, that is the whiteness of *Lux*, but writers confuse these two.' John Scotus Eriugena speaks of this distinction in his commentary on the *Celestial Hierarchy*, and it would have been familiar to medieval Neo-Platonists.

This worship of light has mystical roots that reach back far beyond early Christianity. In his *Republic* Plato equated lightness with goodness, saying that sunlight is 'not only the author of visibility in all visible things but of generation and nourishment and growth'. For his Neo-Platonic followers, this reference – in truth a rather fleeting one – raised light to the status of a transcendental entity. They celebrated light and luminosity as an expression of the creativity of God and, in consequence, as a measure of the beauty of his creations. Things were the more valued the more they radiated light. When

* John Scotus Eriugena proposes in his book *Preiphyseon: On the Division of Nature* (which Suger seems to have read) that the light of the sun gets brighter as it approaches the earth – it is darker at its source. Pseudo-Dionysius himself, in John Scotus's translation, describes God as an 'invisible sun'. Was the light of God similarly a kind of 'dark light', like that in the blue glass of Saint-Denis and Chartres?

men spoke the truth, they were lucid; on perceiving it, they were illu-
minated.

This philosophy of light was expounded most influentially by a
Syrian Christian of the fifth century known now as Pseudo-Dionysius.
(The modern 'pseudo' is there to alert us to the confusion with other
important Christian figures of the same name, one of them being the
third-century St Denis, the first bishop of Paris and the so-called apostle
of France.)* Pseudo-Dionysius wrote several Neo-Platonic works that
were collected under the title *Theologia mystica*. These treatises became
an important influence on Christian thought when, in 827, they were
sent by the Byzantine emperor Michael II to his counterpart in the
West, Louis the Pious, in Paris. The Pseudo-Dionysian texts, kept in
the vaults of the royal abbey of Saint-Denis, were translated from the
original Greek into Latin by John Scotus Eriugena, who helped to
reconcile their Neo-Platonism with Christian orthodoxy.

In *De divinis nominibus* ('On the Divine Names') Pseudo-Dionysius
describes an ecstatic and mystical, indeed essentially a pagan, vision
of universal beauty as light:

> But the Superessential Beautiful is called 'Beauty' because of that quality
> which It imparts to all things severally according to their nature, and
> because It is the Cause of the harmony and splendour in all things,
> flashing forth upon them all, like light, the beautifying communications
> of Its original ray; and because It summons all things to fare unto Itself

* When St Paul visited Athens and was taken to a meeting of the council of the
Areopagus, where teachings of new religions were discussed, some of them sneered
at what he told them of the life of Jesus, but 'a few men became followers of Paul
and believed'. One of these was Dionysius, thenceforth known as the Areopagite,
who became an apostle and a saint. This Dionysius was later conflated with St Denis
of France, who was martyred on the hill in Paris that became known as Montmartre.
When Louis the Pious, king of France, commissioned Abbot Hilduin of Saint-Denis
to write a biography of his kingdom's patron saint, Hilduin mistakenly identified
him with the Syrian Pseudo-Dionysius. Although controversial at the time, this idea
came to be accepted as fact. But while at Saint-Denis in the 1120s, Peter Abelard
discovered that Hilduin's version of history – which was indeed a garbled, threefold
confusion – was undermined by the views of one of the revered Church Fathers,
Bede, who claimed that St Dionysius of France was not the Areopagite, the first
bishop of Athens, but was instead the bishop of Corinth. This discovery, as we saw
in Chapter 4, caused yet more trouble for Abelard.

(from whence It hath the name of 'Fairness') and because It draws all things together in a state of mutual interpenetration.

Even if *lux* is not *lumen* – the light that brightens our world is not the light that streams from the Creator – the two were related in that analogical sense which, in the medieval mind, goes beyond mere metaphor. By contemplating the light emanating from material objects, says Pseudo-Dionysius, we can come closer to understanding the Divine Light. 'Every creature', he says,

> visible or invisible, is a light brought into being by the Father of the lights . . . This stone or that piece of wood is a light to me . . . As I perceive such and similar things in this stone they become lights to me, that is to say, they enlighten me . . . and soon, under the guidance of reason, I am led through all things to that cause of all things which endows them with place and order, with number, species and kind, with goodness and beauty and essence.

This suggestion that the mundane and material can lead us towards the transcendental and immaterial by an affinity of their essence is an example of the concept of anagogy (literally, 'upward-leading'). It is a difficult idea for us who lack the Neo-Platonist's sense of the connectedness of the universe or the medieval notion of world as symbol. But it may have been in Suger's mind when he planned the rebuilding of Saint-Denis – in *De administratione* he speaks of how one may be 'transported from this inferior to that higher world in an anagogical manner'. 'Bright is the noble work', he said of his church, 'but, being nobly bright, the work should brighten the minds, so that they may travel, through the true lights, to the True Light where Christ is the true door.'

Thus Suger suggests that precious, light-charged materials such as gems act as a kind of aid to spiritual meditation – stepping stones, you might say, to knowledge of God. When he describes the cross of St Eloy, the patron saint of goldsmiths, which stood encrusted with jewels atop the altar and took the finest craftsmen of Lotharingia two years to fashion, he mentions that it is made from eight of the nine precious stones that Adam wore in Eden: 'the sardius [ruby], the topaz, and the jasper, the chrysolite, and the onyx, and the beryl, the sapphire,

and the carbuncle, and the emerald.' And he goes on to explain their purpose:

> To those who know the properties of precious stones it becomes evident, to their utter astonishment, that none is absent [on the altar] from the number of these (with the only exception of the carbuncle), but that they abound most copiously. Thus, when – out of my delight in the beauty of the house of God – the loveliness of the many-coloured gems has called me away from external cares, and worthy meditation has induced me to reflect, transferring that which is material to that which is immaterial, on the diversity of the sacred virtues: then it seems to me that I see myself dwelling, as it were, in some strange region of the universe which neither exists entirely in the slime of the earth nor entirely in the purity of Heaven; and that, by the grace of God, I can be transported from this inferior to that higher world in an anagogical manner.

The idea that materials have spiritual values may sound strange today, but it is central to an understanding not only of the stone universe of Chartres but of all medieval art. These gleaming materials that spread their light through reflection and refraction have intrinsic religious power. Suger may have drawn inspiration here from John Scotus Eriugena, who said 'It is impossible for our mind to rise to the imitation and contemplation of the celestial hierarchies unless it relies upon that material guidance which is commensurate to it.' In the glow of coloured windows and the glistening of gold ornaments, the faithful may find their way to the true light of Christ.

The near-worship of light in the twelfth and thirteenth centuries found expression in the natural philosophy of that age. At the University of Oxford, Robert Grosseteste (c.1168–1253) and his student Roger Bacon (c.1214–92) made some of the early major discoveries in optics – an achievement that historians of science have tended to present in an anachronistically positivist manner. Grosseteste, although in many ways an Aristotelian, was as Neo-Platonic in his reverence for light as any of his contemporary theologians: 'Physical light', he said, 'is the best, the most delectable, the most beautiful of all the bodies that exist. Light is what constitutes the perfection and the beauty of bodily forms.' He attributed to light a kind of intrinsic and perfect

proportion that made it 'equal to itself'. With the re-emergence of
Aristotelianism, such metaphysical speculations could now be used to
inform natural philosophy. In *De iride* (1235) Grosseteste was the first
to give a clear account of how refraction of the sun's rays by rain-
drops produces the arc of a rainbow. For Roger Bacon, optics was a
kind of universal science that could be used to address any problem.

All that Glitters

Suger's exaltation of light in his description of the rebuilding of Saint-
Denis, and his evident (or at least, public) belief that his patron saint,
the first bishop of Paris, was the same as the fifth-century Syrian
mystic and the biblical Areopagite, has led to an almost unspoken
assumption that Suger was a Neo-Platonist who had immersed himself
in Pseudo-Dionysius's works, and that this is what led him to turn the
choir of the church into a blazing crown of light. Erwin Panofsky was
the principal architect of the idea that Suger found theological justi-
fication for the radiant stained-glass windows of his new choir in
Pseudo-Dionysius's mystical celebration of light. This idea supported
his assertion of a correspondence between the abstract theological
and scholastic disciplines of the twelfth century and the design of the
Gothic cathedrals. He calls some of Suger's writings an 'orgy of neo-
Platonic light metaphysics' and suggests that 'one can imagine the
blissful enthusiasm with which Suger must have absorbed these neo-
Platonic doctrines'. The link seems so natural that it might appear
perverse, almost churlish, to question it. Many have not: Georges
Duby remarks that the abbey church is 'a monument of applied theol-
ogy', while Otto von Simson goes so far (indeed, too far) as to say
that without the 'forged credentials' of Pseudo-Dionysius, 'Gothic
architecture might not have come into existence'.

But this all may be another aspect of the Suger myth. Suger was
hardly an academic or philosopher and displayed little interest in schol-
arly theology. He is rare among prominent religious leaders in having
written not a single theological treatise himself, his forte being poli-
tics and administration. So it is unlikely that his appreciation of Pseudo-
Dionysius's philosophy went very deep.

This is not to imply that Suger was unaware of Pseudo-Dionysius's

enthusiasm for light – the most cursory reading of his works would have revealed that. And it would have been remarkable if Suger had not studied the *Celestial Hierarchy*, which was kept at Saint-Denis alongside John Scotus Eriugena's translation. But Suger may have been content to possess no more than a superficial understanding of these ideas, before getting on with the practical business of giving them concrete form. Peter Kidson calls him aptly a 'diluted Platonist'. So even if the Dionysian Neo-Platonic metaphysics of light played some part in the generous windows of Saint-Denis, one need not suppose an especially profound intellectual link between the two. It may have been that Suger merely found in Pseudo-Dionysius a convenient justification for his almost childlike fascination with baubles and bright things. After all, despite Panofsky's claims Suger makes not a single direct reference to Pseudo-Dionysius in the three works he compiled on the rebuilding of his abbey church. If, as Panofsky suggests, Suger was keen to enlist the textual support of 'Saint Denis' to head off anticipated criticisms of the lavish new building from Bernard of Clairvaux, he chose a remarkably indirect way of doing so.

Some historians dismiss entirely the suggestion that the Gothic style was a manifestation of Neo-Platonic light metaphysics, raising the valid objection that there are many ways architects could have brought more light into their churches, of which Gothic architecture is but one. And it's true that the choir of Saint-Denis makes sense only when seen as a bold innovation derived from, and not orthogonal to, the earlier styles of church building: the new windows of the Gothic choirs and clerestories are a consequence of the general expansion of the Romanesque wall, not a puncturing of previously blank spaces. Moreover, church windows served a very practical purpose as storytelling devices for moral instruction. They cannot be regarded as having a single meaning or function. Yet we could scarcely understand the wider predilection for experiments with coloured glass in Gothic churches if it had not coincided with an intellectual climate in which Platonic philosophy, scientific speculation and Christian theology seemed to unite in giving primacy to light.

The Glass Palette

But we should not let such abstractions blind us to the practicalities of glass. Art historians have too often assumed that all it takes to make great art is grand ideas. Artists know otherwise; for whether or not the windows of Saint-Denis and Chartres are expressions of a metaphysical principle, only craftsmen knew how to make them. How might the capabilities and limitations of that craft have affected the design of the glazing?

Suger certainly did not instigate the habit of using coloured glass to illuminate a church; monasteries in northern England had stained glass in the seventh century, and painted glass windows are known in Germany in the late ninth century. The practice of giving churches permanent stained-glass windows had already become common in France during the late eleventh and early twelfth centuries.

The discovery of how to make glass from sand and alkaline ash was made in the Middle East, probably around 2500 BC. The alkali lowers the temperature at which sand melts, so as to make this feasible in ancient furnaces. Glass was coloured by adding other minerals. A touch of copper from a mineral such as malachite will produce a red, green or blue tint, depending on the conditions in the kiln. The richest blues came from cobalt minerals, which are rather rare. But ancient glass tended to come out coloured even without any additives, owing to impurities such as iron in the sand or the ash – the common suggestion that *all* coloration was due to the purposeful addition of tinting agents is misleading. Sometimes this spontaneous colour was considered desirable, and glassmakers learned to control it to an extent. Yet it was difficult to avoid tinting altogether during glass manufacture, so 'white glass' was rare and costly: Pliny says that 'the most highly valued glass is colourless and transparent, as closely as possible resembling rock crystal'. It could be made by choosing sand that was relatively free from impurities; alternatively, the Romans found that additives such as antimony or manganese (found in some minerals) could 'scrub' colour out.*

* This may sound odd in view of the discussion below of manganese as a colouring agent. But it appears that here the purple-pink colour of manganese was used to cancel out the greenish colour imparted by iron impurities, producing the slightly opaque greyish glass used in the Middle Ages for the white, geometrically decorated windows known as grisaille (see below, p. 253).

Yet for the medieval glassmakers of northern Europe, producing colour-less glass remained a major challenge until at least the late thirteenth century, and in consequence it was expensive. This, then, demolishes the idea advanced by some historians that the ordinance of the Cistercians in 1134 banning coloured glass from their churches was due to their rejection of the extravagant cost. It must have stemmed instead from an aversion to the 'decadence' of colour (a long-standing western prejudice), which they forsook even at a great price.

In his craftsman's manual written around 1122, a Benedictine monk named Theophilus opens a window on the arts of the early twelfth century. He is generally identified as the German metalworker Roger of Helmarshausen, and his book *De diversis artibus* ('On Divers Arts') provides detailed instruction on medieval crafts ranging from brass-making to church organ construction and how to mix up ink. Theophilus's advice speaks of first-hand experience, and reminds us that the artisan of the Middle Ages had no off-the-shelf resources but had to do virtually everything for himself.* The section on glassworking begins with a description of how to make a furnace the size of a small shed, in which the ingredients of raw glass are melted. Two smaller furnaces are needed, Theophilus explains, for annealing the product and for flattening it out into sheets.

If Theophilus's account makes glassmaking sound like hard work, the fact is that even he skates over some parts of the process that would have been extremely labour-intensive. To make the alkaline ashes, for example, he states briskly that one should 'take beechwood logs completely dried out in the smoke'. But it is no easy matter to collect large quantities of beech logs from a forest: a modern study suggests that it might take ten hours for a few people to collect enough wood to produce about 2 kg (4½ pounds) of glass. To make ashes suitable for glassmaking, the wood was burnt and the raw ash sieved

* Theophilus's motivation for writing the book may have been more than pedagog-ical. He compiled it at much the same time that Bernard of Clairvaux penned his attack on the excesses of the arts, and the manual contains hints of a riposte to the Cistercian's charges. In a proclamation that would have delighted Suger, Theophilus asserts that King David 'avidly desired the embellishment of the material house of God . . . [for] he knew from devout reflection that God delights in embellishment of this kind'. To this end 'he entrusted to his son Solomon almost all the materials – gold, silver, brass, and iron – for the Lord's house'. Solomon's skills as a metalsmith were legendary.

to remove large chunks of carbonized wood. The quality of the alkali obtained this way, and thus of the glass that could be made from it, may have varied considerably, depending on factors such as the chemistry of the soil where the beech grew, the local climate, the wood's age and the part of the tree from which it was taken. The sand, meanwhile, typically came from rivers – Theophilus states that it is 'collected out of water, and carefully cleaned of earth and stones'. In view of all this, it is hard to imagine that any glassmaker worked alone; he would probably have needed a team of assistants to gather and prepare the materials, adding to the cost of the glass.

Preparing the molten glass was a complex and drawn-out procedure, involving a preliminary stage called fritting in which the sand and ash were heated at a relatively low temperature that consolidated them without fully melting them. During fritting, Theophilus states, the mixture should be stirred with an iron ladle 'for a night and a day'. To make smooth sheets from a bowl of molten glass, the viscous liquid was gathered on the end of an iron blowpipe and blown into a sphere that was allowed to sag to form a cylinder. This was then split down one side with a hot iron and softened in a furnace so that it could be opened out and flattened with a pair of tongs.

Theophilus's manual seems to imply that he relied on impurities to give colour to his glass, making it a rather hit-and-miss affair. He says that to control this colour one must vary the length of time that the liquid glass is heated:

> If you see a pot [of glass] changing to a saffron yellow colour, heat it until the third hour and you will get a light saffron yellow . . . And if you wish, let it heat until the sixth hour and you will get a reddish saffron yellow . . . But if you see any pot happening to turn a tawny colour, like flesh, use this glass for flesh-colour, and taking out as much as you wish, heat the remainder for two hours, namely, from the first to the third hour and you will get a light purple. Heat it again from the third to the sixth hour and it will be a reddish purple and exquisite.

These colour changes were due to metals, primarily iron and manganese, in the raw ingredients, which can produce a wide range of yellow-red hues depending on their chemical state. Reactions

involving oxygen in the furnace would convert them from one coloured form to another: manganese compounds are purple in oxygen-rich conditions, for example, while a paucity of oxygen makes them pale yellow. Theophilus's tawny flesh colour comes from a mixture of the purple and yellow states, while the richer 'reddish saffron' was probably due to a blend of manganese and iron. Such golden-yellow glass, the chance result of a happy balance of metals, was highly prized and used in windows to depict objects such as haloes. Glassmakers knew by experience that they could adjust these colours by altering the burning conditions in the kiln: there is less oxygen when the flame is smoky. They might have achieved this control by partially blocking one of the access vents ('glory holes') to the kiln, or by using greener wood in the fire. A twelfth- or thirteenth-century addition to a book on the colour-making arts of the Romans (*De coloribus et artibus Romanorum*) by the tenth-century Italian monk Heraclius suggests that the colour could also be influenced by selecting the source of the alkaline ashes used to fuse the sand. The wood of the beech tree, the manuscript says, gives rise to purple and flesh-coloured glass. This is because beechwood is naturally rich in metals such as manganese – but of course Heraclius and his later editors had no inkling of that.

Despite the impression given by his booklet, however, Theophilus was not really so ignorant of the use of additives to colour glass; it is just that the relevant chapters have been lost. The titles alone remain, and these – 'The pigments that are made from copper, lead, and salt', 'Green glass', 'Blue glass' and 'The glass called *gallien*' (a deep-red glass coloured with copper) – make it clear that he knew how to achieve a wider palette than that offered by chance in the composition of raw materials. The medieval abridger of Heraclius possessed that knowledge too, and his instructions give us an idea of the likely content of Theophilus's lost chapters. He advises that copper filings, burnt 'until they are reduced to a powder', should be thrown into the pot to make red (*gallien*) or green glass. (He says that copper will make yellow glass too, 'if I am not mistaken' – but his uncertainty, which is warranted, suggests that this was distinctly second-hand knowledge.) Copper-tinted red, green and blue glass is widespread in the medieval churches; and since its manufacture was a more reliable process than those which depended simply on the impurities and heating conditions encountered during glassmaking, it is perhaps not surprising that twelfth- and

early-thirteenth-century windows feature reds, greens and blues more than yellows and whites.

Stained glass is not always coloured throughout. In a technique called flashing, a thin layer of coloured glass was placed on top of clear glass and the laminate was then refired to weld the two together. By this means, glass that was very deeply coloured or rather opaque, such as reds tinted with copper, would be 'diluted' so that it did not exclude too much light. It was also a way to make this relatively expensive variety of coloured glass go further.

Bleu de Chartres

Theophilus admits that some glassmakers were reliant on recycling the products of the ancient world, which they no longer knew how to make for themselves. 'Different kinds of glass, namely, white, black, green, yellow, blue, red, and purple, are found in mosaic work in ancient pagan buildings', he says. 'These are not transparent, but are opaque like marble, like little square stones.' And he goes on to reveal that the precious deep blue glass of that time – including the famed blues of Saint-Denis and Chartres – may have been scavenged from the relics of another age or culture:

> There are also found various small vessels in the same colours, which are collected by the French, who are most skilled in this work. They even melt the blue in their furnaces, adding a little of the clear white to it, and they make from it blue glass sheets which are costly and very useful in windows. They also make sheets out of their purple and green glass in the same way.

This blue glass was coloured with cobalt, a technique that had been practised in southern Europe since antiquity. A ninth-century manuscript from southern Italy called the *Mappae clavicula* ('The Little Key to Painting') explains that blue glass may be made from *zaffre*, which here refers to a blue cobalt mineral. The process does not seem to have been known in medieval northern Europe, and so the French, German and English had to rely on imports.

Archaeological evidence supports the idea that this was indeed the

origin of the *bleu de Chartres*. Both there and at Saint-Denis, and also at York Minster, the deep blue glass contains cobalt. The glass matrix itself has a different chemical composition from that in the rest of the windows: it is 'soda glass', characteristic of the Mediterranean region, where the ash of coastal or desert plants contains much sodium. In contrast, northern European medieval glass, made using beechwood ash, is potash glass, rich in potassium. It seems that there was trade in the southern, cobalt-tinted blue glass from at least the eleventh century: a Byzantine or Islamic merchant ship from this period has been discovered submerged in the Aegean Sea off Turkey, with a cargo of several tons of blue, green and amber soda-glass shards. That would account for its expense, which was so great that workers at Chartres scavenged fragments of blue glass from the wreck of the cathedral after the 1194 fire and reused them in the new building.

This would also explain what Suger meant when he claimed to have had 'sapphires' pulverized and melted into his glass to give it its blue colour. Since true sapphires would have made essentially no difference to the colour (and since they are extremely hard to crush), it seems unlikely that, as some have suggested, the abbot was taking to literal extremes his metaphorical desire to embed gems in his own New Jerusalem. Rather, these 'sapphires' were probably pieces of Roman or Byzantine blue glass. If so, Suger's desire to embody the vision of the classical world – to rebuild a new culture from the fragments of the old – would have found material expression in his windows.

The use of this foreign blue soda glass at Chartres has ramifications for art-historical interpretations of the imagery. The blue is rightly famed and adored, but until the 1970s it was even more prominent than the medieval craftsmen intended. Potash glass tends to acquire an opaque surface encrustation over time, while soda glass does not. And so when historians began to study the windows of Chartres in the nineteenth century, their perceptions were misled by the relative clarity of the deep blue glass compared with the rest. Happily, the balance has now been largely restored in the west windows due to a cleaning and restoration programme in 1973–6. This is why we must remember that, when Henry Adams and others enter into raptures about the *bleu de Chartres*, they were not necessarily seeing it as we do today, nor as it was intended.

The recipe books of Theophilus and Heraclius challenge the common assumption that medieval stained-glass artists had a full range

of colours available to them and could make their colour selections according to symbolic or aesthetic criteria. It appears that, on the contrary, copper was the only metal purposely added into the kiln mixture to generate colour, giving pale blue, red or green. Deep blue glass was an expensive foreign import, and while it was possible to make purples, yellows, flesh tones and white, this was done in a rather haphazard manner that was difficult to guarantee. It is entirely possible, then, that the preference for reds and blues in Romanesque and early Gothic glass was dictated not so much by any stylistic or symbolic considerations but by the limitations of the glassmaker's art.

Painting with Crystal

To make a stained-glass window from coloured panes, the artist drew his design (once it was approved by the patron) with a lead or tin point onto a wooden board covered with wet chalk dust. He then emphasized the outlines with red or black paint. 'Then arrange the different kinds of robes', Theophilus instructs, 'and designate the colour of each with a mark in its proper place; and indicate the colour of anything else you want to paint with a letter.' The next step was to transfer the shapes of the pieces onto the glass itself, which was done by laying a slab of coloured glass over the respective part of the drawing and tracing the outline of the panel in a slurry of powdered chalk, using a brush made 'out of hair from the tail of a marten, badger, squirrel, or cat or from the mane of a donkey'. 'Delineate all the kinds of glass in the same way', says Theophilus, 'whether for the face, the robes, the hands, the feet, the border, or any other place where you want to put colours.'

The glass was cut to shape using an iron cutting tool, a rod thick-ened at its tip. Place this in the fire, says Theophilus, and

> when the thicker part is red-hot, apply it to the glass that you want to cut, and soon there will appear the beginning of a crack. If the glass is [too] hard, wet it with saliva on your finger in the place where you had applied the tool. It will immediately split and, as soon as it has, draw the tool along the line you want to cut and the split will follow.

In the twelfth and thirteenth centuries, the hue of each panel in a window could not be altered, but the glassworker could at least modify its tone. He might lay on a rather opaque, blackish pigment that changed the depth of colour depending on how thickly it was applied, allowing him to pick out decorative patterns, facial features, cross-hatching and fabric folds, and so forth. This pigment was made from a mixture of oxidized copper powder and ground blue and green glass, mixed with wine or urine to form a paint and fixed to the glass by fusing it under mild heat in a furnace.

To pick out details, either the dark paint was applied in lines with a paintbrush in the normal way, or the entire piece of glass would be covered with it and then areas rendered transparent by scraping the paint away. Theophilus recommends this latter method for picking out bright lettering on a dark background. He says that it is possible to create a delicate gradation of tone and a range of highlights and shadows by smearing the pigment with the brush. 'You ought also to do the same under the eyebrows and around the eyes, nostrils, and chin, around the faces of young men, and around bare feet and hands and the other limbs of the nude body, and it should look like a painting composed of a variety of pigments' (albeit of all the same hue!), he says. It is remarkable how much subtle shading the window-painters could introduce in this way. This method of painting relief using a single black or dark brown pigment was called grisaille, meaning 'shadow' (after the French gris, 'grey'), and it was commonly used in the late thirteenth century to pick out delicate patterns and tracery on a bright background of plain white glass. From around that time, manuscript illuminators used the same style for shading their translucent colour washes – there was always considerable exchange of both style and technique between the various arts.

In the 1270s, French glassworkers discovered a method called 'silver stain' – long known to Islamic artists – which offered some colour variation on a single sheet of glass. They laid on an alloy of crushed silver and antimony mixed with yellow ochre in water, which gives a yellow tint when fired. On white glass this could produce hues ranging from pale yellow to deep orange. The introduction of silver stain led to increased use of yellow in the windows of later Gothic buildings, since it was more reliable than making the colour by manipulating natural impurities as described by Theophilus.

Theophilus provided tips for constructing effective colour schemes in stained glass. It was good, he suggested, to create contrasts of brightness, placing deep and vivid colours against white glass. On a background of clearest white, the figures 'should be decked out with purple, green, blue and red'. But on grounds of blue, green and red, 'make the robes out of the purest white, for no robes are more resplendent than this'. The finest yellow glass, he says, is best reserved for haloes and for depicting gold objects. His advice seems to be heeded in, for example, the figure of King David in the north rose of Chartres – but the truth was that, with so limited a palette, window artists had a challenging enough task simply to ensure that each pictorial field was coloured differently than those adjacent to it.* At Chartres, the grounds and decorative areas are predominantly red and blue, so that white, yellow, green and purple are confined largely to the figures.

Once the individual pieces of coloured glass were cut, painted and fired to fix the pigment, they were joined into the jigsaw of the window. The joins were made from strips of lead called cames, with an H-shaped cross-section into which the edges of the glass were slotted. Needless to say, even these items could not simply be bought from a hardware store by the medieval glassworker, but had to be made from scratch: Theophilus describes how to make a mould from iron or wood for casting cames from lead. The same moulds were used to cast the sticks of solder – five parts tin to one part lead – used to weld the cames together. When the glass had been laid between the ribs of the came, the lead casings were soldered using another red-hot, blunt-ended iron rod as a soldering iron, and the window assembled piece by piece. The completed window was fitted into a strong iron armature which defined the basic geometric scheme of the design. Some of these frames were simple square grids – for example, in the Prodigal Son and Life of Mary windows at Chartres. But the Chartrain glaziers began to experiment with other, delightfully inventive forms, such as those of the Mary Magdalene and Charlemagne windows.

* The problem is akin to a famous conundrum in mathematics called the four-colour theorem, which claims that any map in a plane can be coloured with just four colours such that no two adjacent regions have the same colour. This was proved to be so in 1977.

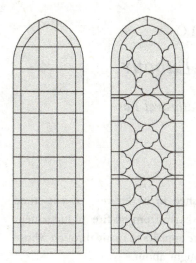

Some armatures of the windows at Chartres are simple grids, such as that of the Prodigal Son window (*left*); others are more ornate, such as the Assumption window (*right*).

In this way, Theophilus says, a building may be embellished with a variety of colours 'without repelling the daylight and the rays of the sun'. For this humble craftsman-monk, at least, there is no sign that the beauty of coloured glass was considered to represent anything more than a devotional offering. The skilful artisanship is not an expression of any metaphysical idea, but simply aims to awaken the piety of the worshipper with a dazzling play of colour. Whether we are devout or not, we must concede that the results are incomparable; and when, as at Saint-Denis, the ravages of time and fate have necessitated modern replacements to fill the window frames, the results can only lead us to suspect that some fundamental quality of this art has been lost.

IO

Hard Labour

How the Cathedral Rose

Springing up anew, now finished in its entirety of cut stone beneath elegant vaults, it fears harm from no fire 'til Judgement Day; and salvation from that fire appears to many through whose aid the renewed work was brought about.

William the Breton, *Phillippids*, 1214–15

The Roof

If it had been built according to the original plans, it seems that Chartres Cathedral would have had as many as nine spires: as well as the two at the west end, there would have been two on each transept, two astride the choir, and one over the crossing. The crossing tower was abandoned in 1222, but the chapter did not fully relinquish their plans for the others until 1260, when, on 24 October, the church was finally consecrated. The cathedral remains, like so many others of its time, a frozen compromise between visionary dream and sober economics.

Even the roofs of the Gothic cathedrals were grander and bolder than anything that had gone before. Those of Romanesque churches have a gentle incline, but in Gothic buildings the pitch increased to as much as 65°, raising the central ridge of the edifice to imposing heights. At Chartres, the original wooden, lead-covered roof was lost in a fire in 1836, which destroyed the reputedly marvellous timber-work beneath. The present construction of copper sheeting on an iron frame, giving the building its verdigris carapace, was put in place as a temporary measure, but was never replaced.

Why have a pitched roof at all? All that timber created a fire hazard, while the steep faces invited serious wind stress. Yet the Gothic architects not only persisted with these roofs but made them even higher and steeper. It isn't clear why. A roof provided cover while the vaults were being built, however, and the higher they were, the more headroom they offered. A greater height also increased the weight, which might sound troublesome but in fact helped to channel the vault's thrust downwards, just as we saw pinnacles doing earlier (so long as the roof's thrust was itself neutral- ized with timber tie-beams). The weight also keeps the roof in place: rather disconcertingly, most Gothic roofs are not fixed to the clerestory masonry but simply rest on it, held in place by friction alone.

Perhaps the motivation for these immense leaden slopes was also bound up with the 'vertical aspirations' of the Gothic builders, making their churches all the more imposing from a distance and at the same time stretching their outlines further up towards heaven.

Joyous that the Virgin herself had ensured the safety of her most holy relic while the cathedral blazed, in 1194 the townsfolk of Chartres set their shoulders to the raising of a new church, even grander than Fulbert's. At least, that is what the stories say. How comforting it is to picture the medieval town as a harmonious community of devout burghers and clerics, selflessly contributing their time, sweat and money to this truly Herculean enterprise in the name of God. But was that how things really were?

It has been claimed since the twelfth century that the Chartrains put aside their daily toil and offered themselves as draught-animals, to pull with their own hands the carts that brought the great stones of the cathedral from the quarry at Berchères. That, according to Robert of Torigni, abbot of Mont-Saint-Michel, was what happened after the earlier fire of 1134, when the two towers were being built at the west end of the cathedral. In 1144 Robert wrote:

In this same year men first began to harness themselves and drag to Chartres carts loaded with stones and timbers, corn and other things, to help towards the building of the church, whose towers were then being constructed. The person who did not see all this, will now never see anything like it. Not only in this place, but also over pretty well the whole of France and Normandy and many other places, there was universal abasement and suffering, universal acts of penance and remission of wrongs, universal grief and contrition. You could have seen men and women moving on their knees through thick mud, and being beaten with scourges, many miracles happening all over the place, chants and hymns of joy being offered to God. On this hitherto unheard-of event there is a letter of Hugh, archbishop of Rouen, to Theodore, bishop of Amiens, who was trying to find out about the event. You would have said that the prophecy was being fulfilled: The spirit of life was in the wheels.

This 'cult of the carts' has become a part of the legend of the great medieval cathedrals. Not only ordinary men and women but also nobles and even kings worked in a rapture of hysterical piety to put the stones in place. 'They were built in a great wave of mystic fervour', says the historian Thomas Goldstein, 'by young people or grown women and men, who were passing the bricks from hand to hand and chanting hymns to the rhythm of their labor, or intoning the holy songs around their campfires at night.' Such images seem to be supported by other contemporary accounts, like that of Abbot Haimon of Saint-Pierre-sur-Dives in Normandy in the mid-twelfth century:

Who ever saw, who ever heard, in all the generations past, that kings, princes, mighty men of this world, puffed up with honours and riches, men and women of noble birth, should bind bridles upon their proud and swollen necks and submit them to wagons which, after the fashion of brute beasts, they dragged with their loads of wine, corn, oil, lime, stones, beams, and other things necessary to sustain life or build churches, even to Christ's abode? Moreover, as they draw the wagons we may see this miracle that, although sometimes a thousand men and women or even more, are bound in the traces (so vast indeed is the mass, so great the engine, and so heavy the load laid upon it), yet they go forward in such silence that no voice, no murmur is heard; and, unless we saw it with our own eyes, no man would dream that so great

a multitude is there. When, again, they pause on the way, then no other voice is heard but confession of guilt, with supplication and pure prayer to God that He may vouchsafe pardon for their sins, and while the priests there preach peace, hatred is soothed, discord driven away, debts are forgiven, and unity is restored betwixt man and man.

Suger himself said that, as the west front of his church at Saint-Denis was being built, columns from the quarry at Pontoise were transported 'by our own people and the pious neighbours, both common folk and nobles ... acting as draft animals'. And if you should be so presumptuous as to suspect these words of a little embroidery, you can see the scene for yourself in the second of the aisle windows to the west of the south transept at Chartres.

But the idea that the cathedrals were constructed from crypt to spire by the ecstatic efforts of untrained zealots from the local community is absurd. Episodes like these do indeed seem to have taken place – there are a dozen such instances recorded for churches built between 1066 and 1308 – but they would have been sporadic at best, and they were not the spontaneous outbursts of 'mystic fervour' that the churchmen portrayed. Rather, it appears that they were orchestrated and supervised by the clerics, based on a common model and designed as acts of penance and piety. Peter the Deacon, librarian of the abbey of Monte Cassino in the early twelfth century, records how, half a century earlier, the faithful monks unloaded and carried a column of marble brought from Rome for the new building 'on the strength of their necks and arms'. Suger, who visited Monte Cassino in 1123, seems to have embellished this image for his account of the reconstruction of Saint-Denis. It was a useful notion to encourage: when some of the congregation of Hugo of Amiens, archbishop of Rouen, returned after travelling to help at Chartres in 1145, he put them to work on his own church.

Once these mass efforts were under way, social pressure and fear of condemnation from the clergy would have made it very difficult for anyone to exempt themselves. Panofsky suggests that for every person singing psalms there would surely have been several others grumbling under their heavy loads. It is likely that many of their efforts were tokenistic. 'It was common enough to put one's shoulder to a cart, to extricate it from the mud, and thus to give concrete

expression to one's enthusiasm,' says historian Alain Erlande-Brandenburg, 'but very little more than this was done.'

In any case, untrained labourers would have been useless for anything much more than pulling carts. Everything to do with the preparation, loading and unloading, and positioning and setting of stones and timber would undoubtedly have required the expertise of masons, carpenters and other paid craftsmen. And it is unlikely that these professionals would have welcomed assistance from ecstatic locals, for no one who is being paid to do a job likes to see it being offered for free by volunteers. Surviving accounts for cathedral construction record payments to labourers for even the most unskilled manual work, showing that there was no ready, reliable supply of free muscle power.

Complicating the cult of the carts is one thing, and no historian today would suggest the medieval cathedral is anything other than the work of a skilled labour force. But it has nevertheless long remained the view that all of society pulled together to keep the project on track until the walls were raised and the vaults closed. The citizens might need prodding towards their purses now and again when the money ran out, but they all shared the same goal. Isn't that precisely the message displayed with such touching frankness and humility in the windows of Chartres, where we can see the labours of the guilds who dug into their coffers to sponsor the glazing?

Well, not exactly. As far as we can tell – and we must always recognize that this is not as far as we might like to imagine – the church of Notre-Dame de Chartres took shape in a social atmosphere that was often sour and acrimonious, when tensions occasionally spilled over into open violence. The town was a community divided in several ways, and it is no surprise that most of the money for the construction probably arrived from beyond the municipal walls.

Who Pays?

Chartres was conceived from the outset as a vastly expensive project, and the cost could not be met by the three years of contributions to which the bishop, Regnaud, and chapter committed themselves in 1194. How, in any case, could you budget for a building that would take a generation or more to erect, and which would be made on a

scale and in a style that was without precedent? It has often been implied that an economic boom in the Île-de-France generally, and in Chartres in particular, made the financing possible. Trade and agriculture were certainly healthier than they had been when Fulbert was bishop, and it is true that the period over which Chartres Cathedral was constructed coincided with the economic apogee of the region – although French historian André Chédeville says that the subsequent slowing of growth around the middle of the thirteenth century can be attributed at least in part to the toll taken by the building costs. But Chartres, for all its renown as a pilgrim's destination, was never an especially rich city. The historian Henry Kraus has estimated that to sustain a typical church-building project (Chartres was probably rather more than that) required something like 1,500–2,500 livres per year, which is a considerable sum. According to Chédeville, the building work at Chartres was undoubtedly disproportionate to the financial capacity of the region. That seems like a polite way of saying that this was a project that today would be dismissed as ridiculously ambitious.

All the same, the viability of a church-building scheme didn't necessarily hinge on the wealth of its town. That's what you might expect if it was deemed the responsibility of the entire community – but it wasn't. In general, and certainly at Chartres, the clerics and the townsfolk inhabited separate worlds, and that within the cathedral complex was far wealthier than the one outside. What little we know about the financial support provided by citizens for their cathedrals suggests that the sums involved were often meagre. In 1393, for example, the citizens of Meaux gave just 260 livres, and 200 more the following year, for the reconstruction of the cathedral's west façade – a tiny fraction of what the work will have cost. At Lyon, where rebuilding began around 1167, donations often provided barely a few hundred livres, and the work progressed at a pitiful rate for the best part of a century.

And why should the laity have done otherwise? They could see that the canons had much more money than they did. It was hardly in their interests to have an oversized church looming over them and reminding them of the hierarchy of power and wealth. Granted, a grand cathedral might bring in a little extra trade from pilgrims on festival days, but was that sufficient recompense for living and working amidst the clamour and disruption of a building site that would still

be there long after they had gone to the grave? They had good reason to doubt that the clerics were acting out of civic pride: in the end all this expense and travail was serving the glory of God (and perhaps of the bishopric too). 'In the thirteenth century,' Chédeville notes wryly, 'the cathedral surely brought back less to the town of Chartres than it does today.'

The financing was the responsibility of the chapter and the bishop – but they did not always share a common view. A bishop might decide that 'his' church (the legal ownership was contentious, as we have seen) needed modernizing, only to be faced with a chapter that baulked at the expense. Contemporary records make it clear that pride and envy were indeed sometimes the motivating factors. During the flowering of the Gothic era, the bishop of Auxerre is said to have been dismayed that his cathedral 'was an old building and very small, suffering from decay and age, while others in every direction round about were raising their heads in a wonderfully beautiful style. So he determined on a new building and that it should be designed by those skilled in the art of masonry, lest it might be in any way unequal to others.' Some bishops surely pushed their luck, insisting that if the church was to be updated then the episcopal palace (where the bishop lived) could not be expected to remain archaic in comparison. Suger negotiated his way around the chapter's doubts about the rebuilding of Saint-Denis (although it

Bread features in many images at Chartres, both in the windows (*facing page*) and in the statuary (*right*: trumeau of the south porch).

stalled after he died), but others were far less successful. Bishop Arnoul of Lisieux was suspended by the pope after the chapter accused him of squandering church money by rebuilding the cathedral nave in 1181.

It seems canons sometimes raised objections simply because they did not fancy having to pay for the work even if it was sorely needed. Equally, however, they could be major contributors to a project. Chapter statutes often stated that a regular proportion, typically a quarter, of the church's regular income was to be used for building and maintenance. That rule wasn't applied consistently; in fact, Kraus says it was so rare for these obligations to be met that we tend to see those who did as virtuous. From the start of the thirteenth century, however, it appears that canons became increasingly involved in building work on their cathedral – not just the financing but also the management of the site. The canons of Chartres, at any rate, agreed to join the bishop in heeding the papal legate Melior of Pisa's exhortation by pledging a significant proportion of their income to the project for three years. We don't know how big this figure was; contemporary records merely indicate that the sum was 'by no means modest'. Some say that all the revenue (presumably beyond a subsistence level) was given over to the rebuilding, but this seems unlikely.

The diocese of Chartres was relatively wealthy in the twelfth

century: its bishop had an annual income equivalent, in a calculation dating from 1956, to $1,500,000. Contrary to what is often said, it was not primarily wool or trade fairs that brought money to the region, but bread: the grain of the Beauce. Much of the church's money came from the arable land owned by the chapter – 35 square km (13½ square miles) of it by the year 1300 – which accrued not only income from the sale of wheat but tithes and other dues from the peasants who worked the fields. This brought in a sum probably in excess of 6,000 livres per year: a vast amount, given that the entire rebuilding of the eastern end of Saint-Denis is estimated to have cost around 2,100 livres, while one could usually put up a tower for less than 2,000.

So in the end it was bread, not pious donations, that swelled the accounts of the clerics: 'the cultivation of grains . . . provided the material basis for building the cathedral', says the historian Jane Welch Williams. That fact is acknowledged throughout the building: piles of bread are depicted no fewer than five times in the windows, while the trumeau (the column between the two doors) of the south porch includes a nobleman (often said to be Pierre Mauclerc, although it is more probably Louis, count of Chartres and Blois) offering bread at the feet of Christ. Around 1175, the Chartrain scholar Pierre de Celle even wrote for the bishop, John of Salisbury, a 'Book of Bread' (*Liber de panibus*), praising its allegorical Christian virtues.

Yet Chartres Cathedral could not have been erected so quickly without an immense expenditure, and even the church's income was not enough by itself to fund the work. Donations from outside the cloister were essential, and these seldom arrived without persuasion. 'The financial needs of a cathedral under construction were so great that coercive methods had repeatedly to be used to keep the flow of contributions focused on this goal', says Henry Kraus. Some money came from nobles such as the Mauclerc family – quite possibly for secular as well as religious motives, for they saw the church as a buttress that stabilized and preserved the social order. Yet their contributions were infrequent and often rather self-serving. Nobles were willing to spend considerable sums on specific features such as the windows, because they could then advertise their generosity and piety in the glass itself by depicting their heraldry or even family members. The houses of Beaumont, Courtenay and Montfort are all represented in the glass of Chartres, their portraits facing east towards the land

of the Crusades. They would build chapels too, but only for their private use. There is scarcely any evidence of lords giving money for the laying of stones in the main body of a church.

As for the king of France, he didn't seem to feel under the slightest obligation to help pay for the great churches in his realm. It is true that the north porch of Chartres was initially funded by Philippe Augustus, Louis VII's successor, and that his son Louis VIII continued this financing subsequently. And Louis's widow Blanche of Castile, regent for their son Louis IX, paid for the windows. But their contributions were modest: Philippe gave a mere 200 livres to Chartres in 1210, while Louis VII gave no more than that to the cathedral of Notre-Dame in the heart of his capital.

Fair Trade?

It has become part of the Chartres legend that the local trade guilds and brotherhoods of craftsmen and merchants in the town pooled their resources to outfit the church with the most glorious glazing. There are no fewer than forty-two 'windows of the trades', containing 125 images of at least twenty-five different trades, and it has been claimed that they were all donated by the guilds at a cost of at least 30 livres each. Many historians have assumed that the tradespeople concluded that the advertising justified the outlay: the trades windows are placed low down in the side aisles, potentially the best advertising spots where they would be clearly visible to the milling crowds. In the window over the north aisle that tells the story of Noah, insets show carpenters and wheelwrights wielding their axes. Apothecaries weigh out their wares in the window of the Miracles of St Nicholas, while elsewhere customers are seen purchasing items from fishmongers (the St Anthony and St Paul the Anchorite window, south ambulatory), shoemakers (Assumption window) and butchers (Miracles of Mary window), complete with slabs of red meat and a hanging pig's carcass that served as the shop sign. Never mind Christ's condemnation of the money-lenders in the temple; in the church's variegated glass we find money-changers with their coins and scales, plying their trade at their benches or *bancs*.

The popular notion, then, is that these windows show scenes from

everyday life in the early thirteenth century, making them the closest thing we have to a cinematic newsreel of the age of High Gothic. This is an idea that Jane Welch Williams has painstakingly picked apart. For one thing, she says, these images of men at work are highly stylized, drawing on a rather limited repertoire of tropes that can be found in almost identical form at other churches, such as Beauvais, Amiens and Le Mans. Labourers such as smiths and cobblers are shown bent over their work, often with one elbow thrust upwards in the standardized pose of the manual worker. Merchants are depicted facing a customer and gesticulating, or perhaps being handed a coin. Almost identical poses can be seen in Roman art, and it is likely that such images taken from late classical antiquity – the last time before the eleventh century when there was any attempt to depict the artisan and merchant classes – served as the models for stock imagery that would have been placed in the 'copybooks' used by artists and glass-workers. The supposedly quotidian scenes in the windows of Chartres probably come straight from the designs that were used in early Christian art for illustrating incidents in biblical stories and the lives of the saints.

The problem with the idea that the windows were donated by the guilds, meanwhile, is that there is no good evidence that trade guilds even existed in the late twelfth century. Although wool was probably the town's most important trade after wheat production, it was not until 1268 that we find the first official mention of a *confraire* of wool workers, when they were given a trade statute. At Chartres the trades seem to have been organized and administered by a master (provost) appointed by, and accountable to, the count of Blois and Chartres. The tradesmen were obliged to pay taxes to the count – and this, it seems, was one of the major causes of unrest, and perhaps the real key to the meaning of the trades windows.

The dues owed to the count and to the clergy were a constant source of discord in Chartres. The clerics declared that any work conducted within the cathedral's cloister was exempt from taxation – so that, by employing labourers to produce goods, they could obtain them at lower prices than in the rest of town. The cloister workers were called *avoués*, and they were a thorn in the side of the count and his provost, who would occasionally seize, imprison and even kill them. It was a dispute over the *avoués* that had brought the

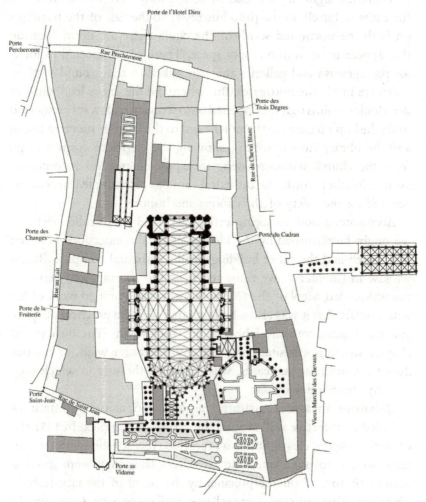

The cathedral cloister of Chartres as it appeared in 1750.

papal adjudicator Melior of Pisa to Chartres at the time of the fire in 1194.

To the townspeople, the *avoués* personified the arrogance and selfishness of the chapter, whose prime consideration seemed to be their own wealth and comfort and whose horizons barely extended beyond the cloister. No doubt the count's provost did nothing to dispel that impression. Far from affording the clerics their humble respect, the ordinary people of Chartres appear to have resented and despised them.

There are signs of how bad these tensions were in the stones of the cathedral itself. In the third buttresses to the east of the transepts on both the north and south of the choir, there are doors high up that appear to open into empty space. These are connected to interior passageways and galleries that are linked to the ground level by stairways inside the buttresses. But where did the doors lead? Jan van der Meulen claims that they opened onto wooden walkways connected to the bishop's palace (to the north) and to the chapter meeting house and the library (to the south), allowing the clerics to come and go from the church without having to expose themselves to potential assault. In other words, the cathedral contains defensive features incorporated for the safety of the canons and bishop.

Accustomed now to seeing cathedrals stand in splendid isolation, we might be disturbed by the idea of physical connections between the church and the other buildings in the cathedral complex. But as we saw in Chapter 2, we must reconcile the alluring, and certainly not unfounded, view of the Gothic cathedral as a unified work of art with the fact that it was also a building that served a practical purpose and was knitted into the fabric of the 'holy town'. The bishop and chapter would not hesitate to build onto the outer walls, or cut out doorways and raise staircases, when it suited the way in which they used the church day by day.

Defensive measures against the local population sometimes included a protective wall around the cathedral complex. In 1251 the Chartres chapter, clearly still in a precarious relationship with the citizens, sought to build one, and five years later they were granted permission to wall off the precinct by the count of the city, Jean de Châtillon. They erected a crenellated wall of the kind one would expect to see around a fortress, and the count stipulated only that the chapter should not go so far as to include obviously defensive features such as towers. The wall was not completed until the fourteenth century, but from the outset it would have symbolically reinforced the isolation of the clerics from the town. Chartres was not alone in this regard: the bishop of Coutances raised a wall around the cathedral, palace and canon's precinct in 1294, and the chapters of Châlons and Langres also decided to protect their properties this way in the thirteenth and fourteenth centuries. Sometimes these defences were truly needed – that at Lyon was breached twice by

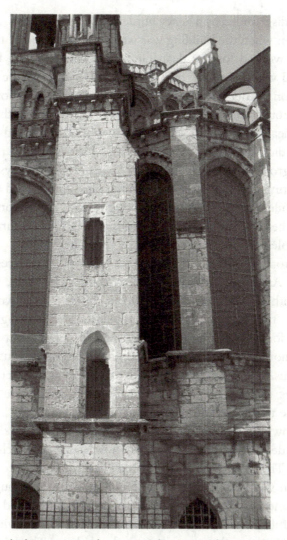

Doorways in the buttresses at Chartres may have opened onto walkways leading to the chapter houses.

resentful citizens, who looted the cathedral precinct in 1269 and 1310. So much for the supposed cohesion and harmony of the medieval community.

Chartres did not suffer quite as badly as Lyon, but the tension ignited on at least one occasion, in 1210. The *avoués* were at the centre of that outburst, although the fact that the money-raising by the canons seems to have peaked around this time suggests that the townspeople may

have been disgruntled by a heavy burden of tithes and taxes. In October of that year, when the building was well underway, one of the cloister serfs who worked for the dean Guillaume took it upon himself to 'berate and verbally abuse' one of the 'town rustics of the countess'. In retaliation, a crier was sent out by the countess throughout the city, 'who cried out in the streets and by-ways to the mob that they all rush upon the dean's home with their arms to demolish it'. And that is just what they did. The dean, 'as soon as he saw the increased rage of the mad mob grow, fled to the church' (over one of the walkways, perhaps). In the fighting that followed, there were many injuries and even some deaths, while 'looting continued at night with light from burning candles'. The canons responded by pronouncing the excommunication of the whole town with the ringing of the church bells.

The uproar subsided in the days that followed, but unrest was still in the air. As the priests attempted to conduct services, they were greeted with a 'mocking clamour' from the crowd of worshippers. Eventually the dean and canons appealed to the king, Philippe Augustus, for help. He came to the town in person, but stayed for barely an hour and clearly failed to find any lasting resolution to the antagonisms. Five years later violence broke out again over much the same issues, and the chapter and the count's provost were still wrangling in the mid-thirteenth century.

If the town labourers were so unhappy with the clerics, why then do the trades windows of Chartres show scenes of such apparent harmony? This, Welch Williams thinks, is actually a piece of propaganda. The windows depict life not as it was but as it ought to be, with workmen going about their business in a dutiful and respectful way, mindful of their proper place in society. *This*, the windows say, is how the working classes are supposed to behave. The windows are, according to Welch Williams, 'art in the service of clerical ideology'. John of Salisbury reiterated that ideology in his book *Policraticus*, where he introduced an image (which later political philosophers developed) of society as a body – with the workers as the feet.

And who paid for the 'windows of the trades'? It is quite possible that the *avoués* did indeed make a contribution from their profits – but whether this was voluntary or compulsory, we do not know.

Money-making Miracles

Among the most lucrative assets of a church were its holy relics, which drew donations from pilgrims. The shrine of St Thomas Becket at Canterbury brought in a quarter of the cathedral's total yearly revenue. Relics were regarded as investments, and could be used to secure loans. Chartres was therefore understandably delighted in 1204 to receive from the count of Blois a precious relic acquired when Constantinople was sacked: the head of St Anne, mother of the Virgin Mary. The cartulary (collection of deeds and charters) records that 'The head of the mother was received with great joy in the church of the daughter'. To celebrate this gift (and perhaps to remind people of it), St Anne was made the subject of the central portal of the north transept, a statue of her being placed on the trumeau. She is depicted also in the middle lancet window below the north rose.

Relics might be sent far afield on fund-raising tours. That was done at Chartres when the money ran short and construction faltered around 1197. The Chartrain clerics were even permitted to seek contributions in England, notwithstanding the fact that Philippe Augustus and Richard the Lionheart were at war. Similarly, in 1113–14 the relics of Laon were taken to Canterbury, Winchester, Salisbury and Exeter.

The church had the authority to confer spiritual rewards such as indulgences on those who gave money or payments in kind (Melior of Pisa suggested to the Chartres chapter that it might raise funds this way). A sermon delivered at Amiens in 1260 promised potential donors that 'you can be twenty-seven days nearer to Paradise than you were yesterday . . . and so can you advance the souls of your fathers, your mothers and all those whom you wish to include'.

And if the generosity of donors flagged, a miracle could reinvigorate it. When there was no money left to pay the workmen at Chartres, a series of miracles attributed to the Mother of Christ brought it flooding in. It is likely that the document called *Miracles of the Blessed Virgin* was commissioned in the thirteenth century as propaganda to attract such contributions. This document related inspirational tales designed to remind the populace that the Virgin was active in daily life (generally in life beyond the town itself, since that is where the message was aimed). In one story, a young Englishman hears an

appeal for funds in a wayside church and is so moved that he donates a gold necklace intended as a gift to his sweetheart. That night the Virgin herself, holding the necklace, appears to the man as he sleeps in a barn. She gives her thanks, demanding meanwhile that the young man thenceforth lead a chaste life. (Giving away a gift meant for your lover is surely a good way to start.) In another tale, a mother leaves her baby in the care of her eldest daughter, who later tracks the woman down in the street and begs her to return home, for the Devil has appeared in the baby's room. Praying to Mary for assistance, the woman returns to find the cradle scorched with fire but the baby unharmed. Other stories told of the Virgin intervening in the building process itself. When a load of quicklime being carried from Bonneval in open carts was caught in the rain, it was nevertheless delivered to the site untouched by the water. The *Miracles* encouraged the notion that a 'cult of the carts' had recurred after the 1194 fire.

In the thirteenth century, the financing of cathedrals became less haphazard and more systematic with the creation of a church office, the vestry, for managing the cash flow. The vestry was administered by the chapter, and the canons and bishop became obliged to give it a fixed proportion of the church income. The office was responsible for setting a budget for building and ensuring that the work was constantly funded. A vestry is first recorded explicitly at Strasbourg in 1246, and that at Chartres is not mentioned until the fourteenth century – but it is clear that this office was by that stage well established and running smoothly, and thus had already been in existence for some time. Vestries were given a dedicated building, initially made of wood but later built in stone and often called the fabric fund hut. (At Strasbourg this still exists and has been turned into a museum.) The office housed not only the accounts but also the building plans. Alain Erlande-Brandenburg suggests that Villard de Honnecourt's architectural sketchings were made not directly from the buildings he portrayed but from drawings he copied in the respective fabric fund huts.

No doubt the income to the vestry continued to fluctuate and was not always sufficient to cover the costs of the work in progress. But the very existence of this office belies the common notion that the building of all the great cathedrals lacked any coherent system of funding and management.

The Order of Construction

Building practice today, in which land is first cleared and the new construction erected in systematic fashion from foundations to roof before being put into use, bears little relation to the way a medieval church was raised. Even when a cathedral was being totally rebuilt, the earlier church was demolished only as it was being replaced – or sometimes afterwards. This was because it had to remain active as a place of worship throughout the long process – the spiritual life of the community could not simply be suspended. Cathedrals-in-progress were given temporary wooden roofs, and makeshift services were conducted in these half-built structures. Rites could be transposed from their usual location if necessary – the altar might be placed in the nave while the apse was constructed – but they had to take place somewhere within the church. These services were separated from the building work by temporary screens, some of them rather robust structures that were never subsequently removed. The congregation often had to accept on faith that these great monuments, begun before their birth, would one day stand in glory long after the worshippers were reduced to bones and dust.

Much ink has been spilt over the question of the sequence in which Chartres Cathedral was assembled. The matter is still not fully settled. It is more than an academic historical detail, for the way in which the construction proceeded speaks directly of the intentions of the architect who planned it.

All but the west end of the church, with its two proto-Gothic towers, needed to be built more or less from scratch – but constrained by the ground plan of the eleventh-century crypt, which defined the approximate outline of both the nave and the choir. The key question, over which Louis Grodecki and Paul Frankl, the two doyens of Gothic architectural history in the 1950s and 1960s, crossed swords, was whether the architect began with the choir and worked from east to west, or whether he went in the opposite direction. In other words, did the nave come first, or the choir?

Grodecki argued for the former, which in many ways seems the most logical: to start from the part of the building already standing. An inspection of the architectural style seems to make a compelling case, for the nave has a more massive and seemingly 'older' appearance. Its aisle

windows are simple lancets, while those of the choir aisles are more sophisticated: two lancets topped by a rounded opening called an oculus. The same is true of the flying buttresses: those of the choir are more 'mature', more slender and elegant, than those of the nave. And while the radial spokes of the nave flying buttresses carry heavy, rounded arches, those of the choir support slender, pointed ones, plausibly later in style.

But Grodecki's case has a very serious flaw, as Frankl pointed out: the marriage of the new nave to the old west towers is a very clumsy one. The westernmost bays of the nave are markedly narrower than the others: the nave doesn't so much join up with the west end as crash into it. The mismatch is in fact so bad that the westernmost window of the south aisle is accommodated only by cutting back the buttress of the old tower. This is precisely what one would expect to find if the construction had proceeded from east to west and the architect discovered only at the end that his calculations didn't quite fit. But it is hard to imagine any reason why the building work would have *started* with this botched union of west towers and nave, only to straighten itself out later. And in any case, it was normal (if not universal) practice to build a new cathedral from east to west.

Isn't it unlikely, though, that a master builder capable of creating an edifice as coherent as Chartres would have miscalculated the length of the nave to such a degree? Perhaps, but it is possible he did not think at first that he would have to squeeze his nave into the space delimited by the west towers. They were, after all, built

The windows of the nave aisles at Chartres (*left*) seem to be in an older style than those of the choir aisles (*right*). But are they?

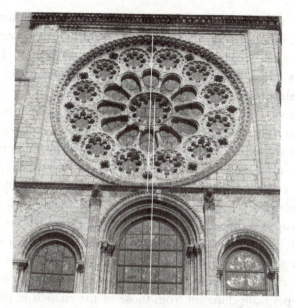

The west rose window at Chartres is slightly misplaced with respect to the lancets below (centre lines are indicated in white).

fifty years earlier in a style that was, by the 1190s, looking decidedly dated. The west end, admired though it is today, would have cramped the style of a man who was above all else searching for unity and clarity, and it seems quite likely that he hoped to demolish it and begin anew. For the chapter, however, the very fact that the west towers survived the fire must have suggested that the Virgin had intended to preserve them, which made demolition unthinkable. Could it be that the architect had to accept only late in the day that the west end was there to stay?

The great west rose window is really too big for the present façade, and may have been squeezed in when a new west front was ruled out. Moreover, the wall housing this window, which was built at the same time as the rest of the Gothic building, had to stretch between two towers of very different shapes, and close inspection reveals the join to be rather messy. And the centre line of the nave, whose position was already dictated by the old foundations and crypt, does not pass exactly through the midpoint of the west façade, but slightly to the north of it. Yet the rose window had to sit aligned with the

transverse arches of the nave vaulting. As a result, the lowest point of the rose is not directly above the apex of the central lancet window below it, as it should be, but slightly to the north of it. The architect clearly had to make the best of what was, to a stickler for precision and elegance, a bad job.

Regardless of what it might have meant for the sequence of building, Grodecki is right to say that the base of the chevet needed to be modified before the choir could be started. The chevet of Fulbert's church had three rather long radiating chapels, which were partially engulfed when the twelfth-century architect extended the choir by adding a second ambulatory and placing new, shallow chapels between the old ones. To support this additional mass, the old foundations had to be reinforced. The base of the new, small apsidal chapels is somewhat irregular and poorly positioned, and this disparity could be corrected above the crypt level only at the expense of making the arcs of the upper chapel walls different from those of the chapels in the crypt. It also means that the window openings are out of alignment above and below, creating the structurally poor situation of buttresses that end above the lower window openings. Why is this arrangement such a botch? Given the precision evident in the main choir and chevet, it seems possible that the building was begun by a lesser architect and that his successor had to work around his mistakes. That he was prepared to sacrifice continuity, and perhaps even stability, for the sake of unifying the structure of the radiating chapels illustrates how strongly this urge for order was felt.

In any event, both the west-to-east theory of Grodecki and the east-to-west theory of Frankl seemed plagued with problems. In 1967 Jan van der Meulen proposed what now seems to be the obvious way out: neither theory is correct, for the cathedral was built not vertically, bay by bay, but horizontally, with the nave and choir being erected more or less simultaneously. The same idea has been proposed by other historians for Cluny III, Reims and Amiens.

Van der Meulen made the rather startling proposition that the work actually began in the *middle* of the church – the first elements to be put in place, he said, were the western piers of the crossing. These differ from the east piers in that the central shaft continues beyond the capitals, suggesting that there was a change of plan by the time the east side was constructed – most probably, the aban-

donment of a scheme to put a lantern tower over the crossing. Drawing on archaeological evidence, van der Meulen proposed the following sequence:

1 With the western piers of the crossing in place, two bays of the western aisles of the north and south transepts are constructed, with the initial intention of extending the transepts only this far. Then work begins to extend the nave westwards, with the intention of demolishing the old west end. Sculptures are made for a new west façade.

2 The decision is taken to retain the west towers, forcing the awkward fit of the nave.

3 The pillars and side aisles of the choir, ambulatory and chapels are built, along with most of the remaining pillars and aisles of the transepts. These are extended by an extra bay, and it is decided that, rather than having a single portal as originally planned, they will have more elaborate porches to house the sculpture previously intended for the new west front.

4 The triforium, clerestory and high vaults of the nave are put in place.

5 A lantern tower planned for the crossing is abandoned. The crossing is vaulted, and the upper parts of the choir and first two transept bays are constructed.

6 The outer bays of the transepts are completed.

Was all this the work of a single architect? We do not know – all we really have to go on are judgements based on style. Grodecki was insistent that the flying buttresses of the choir, among other features, are too different from the style of the rest of the building to be the work of the same man. But a more slender kind of flyer is demanded by the form of the choir: it does not have to signify a choice made by a later architect purely on the grounds of changing fashion. In any case, there is a 'transitional' style of flying buttress on the east of the transepts that seems to mark an attempt to merge the different styles of the nave and choir, as though this was part of the plan all along. And the spoke arches of the choir flyers mirror the shapes of the choir aisle windows, just as those of the nave mirror the west rose: one can find coherence and intention even across the changing styles.

John James, who has spent years studying the fabric of Chartres

brick by brick, has a more radical theory. While agreeing with van der Meulen that the cathedral was built horizontally, he suggests that there was no real architect as such at all, but merely a succession of 'contractors' who came and went in a series of building campaigns, each lasting no more than a year, to execute a design whose continuity was imposed by the clergy. James claims to have discerned the handiwork of nine different contractors and their teams, each of them adding to the work of the previous campaign to raise the cathedral like a layer cake. He says that the squeezing of the westernmost bays of the nave was not an accident at all, but was somehow required by the demands of the 'sacred geometry' according to which Chartres was built.

One can't doubt the exhaustive (and exhausting) nature of James's study of the stones of Chartres, but how he reaches conclusions about particular contractors and sequences of events isn't clear. His ideas about the chronology and organization of the construction of the cathedral are therefore seen by many historians as an act of faith, if not downright eccentric.

The order of construction could of course be clarified if we knew anything about the dates by which the various components of the cathedral were standing. But evidence, both documentary and archaeological, is rare. A wood-dating technique called dendrochronology has been applied to the stumps of wooden tie-bars inserted into the springing of the vaults, which confirms van der Meulen's assertion that the nave slightly predates the choir. It suggests that the arcades of the nave were made around 1200, while those of the choir were standing by around 1210. According to this picture, the builders began with the nave while establishing the foundations for the transepts and sanctuary.

All of this accords with the dating most generally accepted now for the installation of the windows: those of the nave aisles and clerestory are thought to have been inserted between 1200 and 1210, while the glazing of the ambulatory is considered to have begun around 1210. The clerestory of the choir is believed to have been glazed between 1210 and 1220, which is consistent with a record in the cartulary stating that the choir stalls were put in place just before the new year of 1221. Grodecki thinks that the transepts were probably begun in the early 1200s – Philippe Augustus is said to have mounted a flight of stone steps on the side of the cathedral when he visited Chartres to quell the riot of 1210. Grodecki argues that the transept façades were added

between 1210 and 1220, the north before the south. The side portals in the north transept were an afterthought once construction had begun, while the entranceway of the south transept was apparently planned as a whole (although some have claimed that the south transept might originally have been intended to have no portals at all). The transept porches came last: that of the south wing was probably added after 1224, when records show that a wooden lean-to was removed, presumably to make room for the construction of the stone porch.

The addition of such large transepts would quite possibly have created conflict about the ownership of the land they were to occupy. Within the cathedral complex land space was at a premium, and we shouldn't imagine that it was all considered to be simply God's property. Some of it was owned by canons, some by the bishop, and both parties were keen to hold on to what was theirs. If the bishop wanted to build on land owned by the chapter, he would have to buy it from them. The building of Lausanne Cathedral in the thirteenth century was constrained by the refusal of one canon to relinquish the land on which his house stood.

Finishing the Job

The inspiring sight of a cathedral rising from the ground is sensitively conveyed by the anonymous author of a thirteenth-century text celebrating the life of St Hugh, bishop of Lincoln, written around 1220:

> The old mass of masonry was completely demolished and a new one rose. Its state as it rose fitly expressed the form of a cross. By arduous labour its three parts are integrated into one. The very solid mass of the foundation goes up from the middle, the wall carries the roof high into the air. The foundation is thus buried in the bowels of the earth, but wall and roof lie open, as with proud boldness the wall soars up towards the clouds, and the roof towards the stars. The costliness of the material is well matched by the zeal of the craftsmanship. The vault seems to converse with the winged birds; it spreads broad wings of its own, and like a flying creature jostles the clouds, while yet resting upon its solid pillars. The gripping mortar glues the white stones together, all of which the mason's hand has hewn true to the mark . . . the shafts themselves stand soaring and lofty, their finish is clear and resplendent, their order graceful and

geometrical, their beauty fit and serviceable, their function gratifying and excellent, their rigid strength undecayingly sharp to the touch . . . The foundation is the body, the wall is the man, the roof is the spirit.'

As the spires of the new church rose during the early thirteenth century, visitors approaching across the wheatfields of Beauce could see them from a distance of 15 miles (25 km). Around 1214-16* the chronicler and royal poet William the Breton wrote of the cathedral at Chartres that 'None can be found in the whole world that would equal its structure, its size and décor . . . None is shining so brightly than this nowadays rising anew and complete, with dressed stone, already finished up to the level of the roof.' He was right, for at Chartres every element of the architecture had become bigger than before: the arches were like great bridges, the piers were taller than trees, the windows were fields of coloured light. 'Power is the key word at Chartres', says Jean Bony: 'power in constructional engineering, power in the carving of space, power too in the whole vocabulary of forms.'

There is a common perception that the great Gothic cathedrals were each raised over a century or more, and at Amiens and Reims that is true. But Chartres was essentially completed by about 1220, only twenty-six years after it was begun. This very rapid construction must have called for a workforce considerably larger than usual, and it seems the builders had to cut corners to meet the time-demands imposed by the chapter. The master builder succeeded in making a virtue of necessity, for the simplifications of the design at Chartres, relative to the early Gothic churches, help to give it a unity and clarity that made it the template for thirteenth-century church architecture. Its forms and principles are copied in all the great cathedrals that came after: Reims, Orbais, Troyes, Amiens, Beauvais. 'No building', says Bony, 'had a more general or a more lasting influence.'

* This date is given in most texts as 1222 – only recently was William's work re-interpreted as having been written some seven or eight years earlier. The precise date is still a matter of debate.

11

A New Beginning

The First Renaissance

The generation that lived during the first and second crusades tried a number of original experiments, besides capturing Jerusalem. Among other things, it produced the western portal of Chartres, with its statuary, its glass, and its *flèche* [spire], as a by-play; as it produced Abélard, Saint Bernard, and Christian of Troyes . . . but what we do not comprehend, and never shall, is the appetite behind all this; the greed for novelty: the fun of life.

Henry Adams, *Mont Saint Michel and Chartres*, 1904

I sometimes feel that a lot of our theology has lost that extraordinarily vivid or exhilarating sense of the world penetrated by divine energy in classical theological terms.

Rowan Williams, archbishop of Canterbury, 2005

The Choir and High Altar

Jehan de Beauce remains a celebrated local in Chartres, but he did his city's cathedral few favours. The sixteenth-century north spire is his; and while in fairness we must remember that architects of Jehan's time felt little obligation to harmonize their additions with the efforts of their predecessors, nonetheless this ornate, flamboyant belfry can hardly be called a model of sensitivity to its surroundings. We can enjoy the fantastical invention of the Renaissance masons at close quarters, but there is not much of the true spirit of Gothic left in them.

At least the north spire might be regarded as giving Chartres's west end a kind of lopsided charm. Jehan de Beauce has more to answer for inside the church. His choir screen, begun around 1514, is much admired for its elaborate sculpture, and would perhaps justify that admiration if it had been placed where it did not so obstruct the unity of the choir. It is impressive enough if you like this kind of thing; but in comparison with the honesty and directness of High Gothic it does not appear to have a great deal to say for itself. The sculptures occupying the forty niches that Jehan created around the screen, showing scenes from the lives of Christ and Mary, display a mixture of styles, for many were not added until much later. The earliest of them, on the south side, were made between 1520 and 1525 by the Parisian sculptor Jean Soulas; the last were not put in place until the eighteenth century, apparently due to lack of funds.

The arrogance of eighteenth-century artistic chauvinism is breathtaking. The interior of Chartres was completely whitewashed, as were Saint-Denis and Notre-Dame de Paris. It was at this time too – in 1773 – that the choir was surrounded with incongruous wrought-iron railings, and worst of all, that Charles-Antoine Bridan's marble high altar depicting the Assumption was dumped in its midst. The doyens of Enlightenment taste apparently remained blind to the way that the towering Gothic vaults made this Virgin seem all the more mired and earthbound, struggling to get aloft like a bedraggled bird. It is with good cause that Bony raged against the 'scandal' of guidebooks that denounce the French Revolutionaries for their ecclesiastic vandalism without breathing a word against the philistine horrors perpetrated in the pre-Revolutionary decades in the name of 'improvement'. Victor Hugo agreed with that:

> Fashions have done more harm than revolutions. They have cut into the quick, they have attacked the wooden bone-structures of the art, they have hewn and hacked and disorganized, and have killed the building, in its form as well as its symbolism, its logic as well as its beauty. They have also remade it: which neither time nor revolutions

had presumed to do. Shamelessly, and in the name of 'good taste', they have stuck their wretched, ephemeral baubles over the wounds in the Gothic architecture.

How lucky we are, then, that at Chartres those baubles and wounds are so few.

In the eleventh and twelfth centuries, a coherent vision of the world was dreamed in the West for the first time since the fall of Rome. That vision was expounded in different but related ways by Bernard, Thierry and the other schoolmen of Chartres, by Peter Abelard, and by the men who built the first Gothic cathedrals. Scholars started to believe that they were not merely raking through the dying embers of antiquity, but were minting fresh thoughts. They were creating a kind of modernity. 'For the first time,' says the historian Gordon Leff, 'there was something like a universal aware-ness of logic and a growing recognition that it has an importance in all thinking, including matters of faith.' This was the pivotal point for European civilization: the Age of Reason began here, and we should see the intervening period – the rather dismal and disorien-tated fourteenth century and the slow recovery of the Renaissance – as the aberration, rather than imagining that the novelty and vitality of the thinking that informed the High Gothic era were somehow isolated and distinct from modern times.

For anyone who values science and humanism, and who thinks it desirable that we should ask questions about our surroundings, our origins and our own being, the intellectual achievements of the twelfth century are surely worth celebrating. But they came at a price. For Bernard and Thierry of Chartres, William of Conches, Gilbert de la Porrée and John of Salisbury, reason was a compass on the ocean of faith: it guided one towards reverence for God and his works. But in retrospect, the project that these men set in train exposed the fundamental dilemma of the medieval (and not just the medieval) world: can reason really be reconciled with faith? We can go still further than that: by starting a programme of inquiry that

would lead to the evolution of modern science, the Chartres schoolmen and other like-minded thinkers began a process that ultimately deposed God from the hearts and minds of countless people in the West. Without intending to do so, these men made God a natural phenomenon, and thus an explicatory contingency for which there seemed to be ever less need.

How did that happen? It can be simply described. Reasonably, devoutly, humbly, these rational men implied that the Bible could be approached as a source not of myth and moral instruction but of fact. They were not alone in that, of course – all medieval thinkers considered the Scriptures to be factually true, and many people still do. But problems arise once you start to examine the consequences of that idea, instead of leaving it obscured by the mists of faith. Christianity was the universal conceptual framework of the Middle Ages, so there could be no 'medieval science' that excluded it. And so it was that Thierry wanted to understand the Creation in terms of physics, and William of Conches felt that there must be divine laws that govern the universe, making it more than just a mental juggling trick performed without cease by God. But once logic and natural philosophy were legitimized in this way, they were transformed by degrees into a field of secular learning which inevitably came to provide an explanatory system so powerful that it rivalled, rather than rationalized, theology itself.

One could argue that the undermining of faith by reason was inevitable once people were granted the freedom, leisure and dignity to think about their lives instead of just submitting to authority, or merely struggling to survive. Certainly, medieval society demanded too much of Christianity: people wanted it not just to frame their spiritual life but to underpin the social fabric, to provide the scaffold of natural philosophy, to make sense of history, to be a guide to morals and politics, and to justify wars of conquest and glory. 'There is not an object or an action,' according to Johan Huizinga, 'however trivial, that is not constantly correlated with Christ or salvation.' If religion had been less pervasive, it might ultimately have proven to be stronger.

These conflicts arose in the twelfth century, but they had not yet evolved into a parting of ways when Chartres Cathedral was built. The building represents a confluence not just of heaven and earth but

of mind and matter, and, most crucially, of faith and reason. That is a part of what makes the church so wonderful, and is no doubt why it speaks now both to those who practise the Christian religion and those who do not. Sit here late in the day, when the tourists have left (it is still possible to find such a time), and you can believe that the place embodies the last moment when some kind of reconciliation of faith and reason seemed feasible.

By the end of the thirteenth century the cathedrals crusade had exhausted itself. Architects had seemingly run out of inspiration: late Gothic is mostly mere ornamentation superimposed on a technical framework that was more or less fixed by 1300. This loss of momentum was in some ways no more than a reflection of what was happening in society as a whole: no new towns were being built, the population had stopped growing. The Middle Ages had passed its zenith even before the ruptures caused by the outbreak of the Hundred Years War in 1337 and the appearance of the Black Death in the 1340s. Gothic building continued, but Gothic thinking was lost.

The Rise of the Particular

The Neo-Platonic physics of Chartres was not the Aristotelianism of the thirteenth-century proto-scientists, in which universal forms became replaced by worldly particulars. That shift was in a sense a triumph of Abelard's nominalism, and was a necessary precursor to the genuine early science of Roger Bacon and Albertus Magnus, in which the properties of individual entities became worthy of study in their own right, rather than being seen as debased reflections of transcendental archetypes.

The historian of technology Lynn White dates this transition as early as 1140 – the time when Saint-Denis and the west front of Chartres were constructed. Before then, he says, 'the world had been created by God for the spiritual edification of men, and served no other purpose'. People saw the universe as 'a cryptogram to be decoded'. That was the context against which the Platonic geometry of Romanesque architecture must be viewed, and it made the art of that time contemplative and introspective, stylized and symbolic. Gothic draws on that tradition, but it offers something new, too: a particularized humanity, shining

out of the faces of the stone saints. In the Royal Portal of Chartres, as in many Romanesque images, we see Christ in majesty; but in the church's windows of the late twelfth and early thirteenth centuries we find him humanized as we follow him step by step from Bethlehem to the Crucifixion. And in that final stage we see at last his agony. The Romanesque Virgin and Child gaze out at the viewer as eternal, holy beings; their Gothic counterparts turn by degrees to face each other, transformed into a real mother cradling her baby.

In the Gothic world, the rationalistic framework of the Platonists becomes a structure on which to hang specifics, to look at details, and to cultivate an interest and even delight in the physical world. 'The transition from Romanesque to Gothic charts the passage from an age indifferent to the investigation of nature to one deeply concerned with it', says White. Adelard of Bath expresses this dissatisfaction with symbols alone with his customary charm and directness: 'I am not the sort of fellow who can be fed with the picture of a beefsteak!'

This increasing focus on the tangible and specific can be seen to take root and grow, as it were, in the incidental sculpture of the cathedrals: the floral decorations that embellish the great stone columns. Romanesque capitals bear leaves so stylized that they are barely recognizable as such, seeming rather to be abstract, curling designs. By the mid-twelfth century the leaves of early Gothic are more alive – at Laon, Noyons and Provins they evoke natural forms, although there is still no real attempt to mimic them. In Gothic churches of the century's last quarter one can find lobed, lifelike flora; for example, in the capitals of the nave at Notre-Dame de Paris. But in the north and south portals of Chartres, nature has finally and unambiguously imposed its distinctions: here we can identify the leaves of many different species, including ivy, hawthorn, eglantine and fig. And at Reims this wild nature has taken over, as the capitals sport profuse thickets laden with grapes. This exuberance took increasingly dynamic form as the sculptors imitated the writhing of plant stems and vines, ultimately leading away from realism and into the flamboyant, mannerist whorls and crockets of late Gothic.

A belief that nature was worth studying for its own sake is apparent in the works of Francis of Assisi (c.1181–1226), and it was the

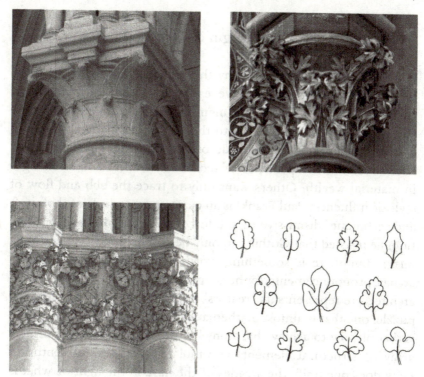

The transition from symbolic to particular values can be seen in the floral decorations of church capitals. In Romanesque and early Gothic (as at Laon, *top left*) they are highly stylized. Gradually they acquire more life and naturalism (La Sainte Chapelle, *top right*). In the High Gothic of Reims, nature has run riot (*bottom left*). At Chartres, meanwhile, there are all manner of realistic leaves, the identifiable species of which include fig, hawthorn, holly and ivy (*bottom right*). (Photos: James Mitchell, Frédéric de Villamil. Drawings after Jalabert.)

Franciscans Grosseteste and Bacon, along with John Duns Scotus and William of Ockham, who made contingent nature the focus of their philosophies, thereby paving the way to true science. 'Modern science, as it first appeared in the later Middle Ages,' says White, 'was one result of a deep-seated mutation in the general attitude towards nature, of the change from a symbolic-subjective to a naturalistic-objective view of the physical environment.' Logic had taught men how to order their thoughts and observations, how to pose tractable questions and to distinguish between alternative answers. It gave them a vision of, and trust in, an ordered universe.

The Origin of Order

It would be as mistaken to deny the influence that some of these intellectual currents must have exerted on the construction of Chartres as it is to forget that men had to measure and cut stone and haul it up the walls and into the vaults. Yet many accounts of Gothic building neglect one side of the affair or the other. Some have stressed the importance of technical advances and of changes in material wealth. Others want only to trace the ebb and flow of stylistic influence. Paul Frankl is an extreme case: disdainful of craft and technique, dismissive of the forces of economics and production, he insisted that Gothic can only be comprehended in aesthetic terms. But there is something worth taking away from Frankl's archaic pronouncements, for he is right to suggest that Gothic church architecture represents its creators' responses to a kind of technical puzzle, one that is almost mathematical in its definition. The puzzle is that of how to achieve harmony by the combination of a diverse array of structural elements accumulated over several centuries. How does one unify the arcades of the nave in the light of what is happening structurally and geometrically in the vaults? How match the rhythm of the buttresses with those of the windows and arches? How divide up space while maintaining its intelligibility? And how is 'true proportion' to be factored into all of this, as Vitruvius and Boethius insist it must? It is misguided to think that there must be some unique, perfect solution to this challenge, just as some scientific 'authorities' have been wrong to imply that the colour combinations of a great painting can be assessed objectively and graded for their proximity to the 'right' answer. But nonetheless one can acknowledge that some solutions work better than others. The builders of the twelfth and thirteenth centuries explored many of them, and each of us can judge for ourselves how well they succeeded. But there is a wide consensus that the genius responsible for Chartres found one of the best arrangements, and the first that truly created a sense of unity among the stones.

Even this is, of course, to oversimplify the task of erecting a monument like Chartres. It was a question of how to make a stable building, on a colossal scale, with a vocabulary of stone and glass

that was defined by a bewildering set of constraints: of engineering, theology, economics, tradition, geometrical symbolism, climate and the practical demands of the patrons. There's no denying Frankl's assertion that 'no amount of knowledge of metaphysics can help one to build a rib-vault'. In this respect, attempts at a grand, abstract synthesis of 'Gothic form' like those of Panofsky and von Simson can be seen to be quixotic, or at the very least incomplete.

Where does this leave the idea that the first Gothic buildings are a synthesis of the vision of orderly nature developed at the Chartres school, the Neo-Platonist fascination with light evinced by theologians, and the systematizing habits of the twelfth-century schoolmen? It seems to be part of human (or at least, of academic) nature to discard an idea the moment flaws have been identified in it, but there is no reason to be so extreme. Rather, it seems more productive to regard these parallel developments as reflecting a particular mind-set that crystallized in the twelfth century, and which entailed a profound change in the way that humankind interacted with the world.

For one thing, we must remember that innovation and self-expression were seldom encouraged in the Middle Ages: much art was of a prescriptive nature, and many church patrons demanded no more than that the works they commissioned look like others they had been impressed by elsewhere. It was this very conservatism that forces us to look very closely at the motives behind changes of artistic style, and that permits us to read into them some more fundamental shift in the way the world was conceptualized. Even if we concede that the master builders did not really think like the scholastics, and that their geometry was of a rough and ready variety that does not bear too close a comparison with that of the Platonists of the Chartres school, we shouldn't assume that there was no common thread in these intellectual disciplines. In the hundred years or so that began with the founding of the abbey of Cîteaux and ended with the closing of the choir vaults of Chartres, western culture awoke to its own vitality. It left behind a sense of inferiority before the long shadows of Greece and Rome, and began to find confidence and new ideas. It would not be going too far to say that, during this time, the West learnt how to solve problems, not by searching feverishly

for the answer in the half-glimpsed scrawl of old palimpsests, but by thinking.

This was as true for philosophers such as Peter Abelard, William of Conches and Thierry of Chartres as it was for William of Sens and the architects of Saint-Denis, Laon and Chartres. Both groups acquired analytical ways of approaching a problem, and both were searching for the same basic thing: a scheme that exhibited unity, consistency and harmony. 'At Chartres,' says Jean Bony, 'what had been renewed and reaffirmed was the concept of Gothic as a method, as a systematic and analytical mode of thought, breaking down problems into their simplest terms in order to solve them.' The overall vision that emerged, he says, was of 'an intelligible and perfectly ordered universe'.

How does one account for these simultaneous changes in two seemingly disparate disciplines – in architecture and philosophy? Since we cannot be sure that there was much genuine intercourse between the two activities, we should not simply wave our hands as though to suggest that 'something was in the air'. No, we can do rather better than that. First and foremost, Christian theology was the bedrock on which all of cultural life was constructed, and it is eminently clear that builders were mindful of that just as were logicians, grammarians and proto-scientists. Church schools and abbeys were the repositories of the technical as well as the metaphysical literature of the ancient world, and those books often recognized no boundaries between the two spheres of thought. Moreover, these conceptual links were particularly explicit in the Platonic tradition, which apotheosized geometry and geometrized theology. And Platonism was a remarkably versatile glue, binding together the ideas of men as theologically distinct as Suger, Bernard of Clairvaux and William of Conches. We will probably never know whether architects had much understanding of Plato's ideas on order, but it seems unlikely that they were wholly ignorant of them in some form, however debased, and we have seen some of the channels along which these ideas might have spread.

Perhaps we must simply accept that we can go no further – that we cannot know quite to what extent the ordered universe envisaged at the school of Chartres is embodied in the stones of its cathedral, or the holy luminance of Pseudo-Dionysius is represented in the pris-

matic sunlight that floods into the ambulatory each morning. But I believe we can live with the uncertainties about the degree or the precise modes of transmission of this knowledge. For it cannot be doubted that in twelfth-century France a vision of order was dreamed, and that men wrought such a vision out of the hard, shell-studded limestone of Berchères and made from it a monument that towers above the wheatfields of Beauce, signifying a new kind of faith and a fresh relationship with the universe.

Architectural Glossary

aisle: a passageway to the side of the nave, separated by an arcade of columns.

ambulatory: a passageway circulating around the choir and the apse. Can more generally mean any covered passageway for walking within a church structure, such as an aisle or cloister.

apse: the easternmost section of a church, generally of semi-circular plan.

arcade: a row of columns connected by arches.

archivolt: the roughly semicircular arches above a portal or opening. In many principal church portals, the archivolts form a system of nested arches.

barrel vault: a rounded stone vault with a semi-cylindrical shape.

bay: a subdivision of a nave, choir, transept or apse, comprising the basic repeating module created by the vaulting system.

blind triforium: a triforium in which the arches are sealed by masonry rather than opening onto a gallery behind.

boss: an ornamental projection or covering, typically round, over the central crossing point of arches in a vault.

buttress: a projecting columnar support for a church wall.

capital: the broad section at the top of a column or pier, generally distinguished by carving from the rest of the column.

centring: the wooden frameworks used to support stone arches during construction.

chancel: the eastern part of the church near the altar, reserved for the clergy and choir.

chapel: a recessed enclosure in a church, often with its own altar and dedicated to a particular saint or personage.

chevet: an apse with recessed, semi-circular chapels.

choir: the part of a church between the high altar and the nave or crossing.

choir screen: an ornamental screen, often intricately carved from wood or stone, separating the choir from the ambulatory.

clerestory: the uppermost glazed section of a church wall.

compound pier: a pillar consisting of a central section surrounded by a cluster of smaller, partly or wholly detached shafts.

crossing: the section of a church where the nave intersects with the transepts.

cross vault: the vault arches running north–south across a nave or choir.

crypt: the vault or chamber beneath the main body of a church, often used for burial.

elevation: the vertical elements of a church wall.

falsework: wooden scaffolding used to support masonry structures such as arches and sloping sections that were unstable during construction.

flying buttress: a half-arch on the outside of a church connecting an external buttress pier to the main wall of the building, which counteracts the outward thrust of the vaults.

groin: the 'crease' where two vaults, running in different (generally perpendicular) directions, intersect.

groin vault: a vault formed from the intersection of barrel vaults

high altar: the main altar of a church, generally in the chancel to the east of the choir.

jamb: a post to the side of a doorway, or in the centre of a double doorway.

jubé: see *rood screen*

keystone: the central voussoir of an arch.

lancet: a tall window arched at the top.

lantern: a glazed tower above the crossing.

lintel: a horizontal beam across the top of a doorway.

lodge: originally a temporary work hut erected by masons, often on the side of the outside wall of a church in construction. Later, a term for a collective organization of masons.

narthex: an interior porch or antechamber at the western entrance to a church, at the end of the nave.

nave: the rectangular section of a church between the west end and the transepts or choir, where most of the congregation would be accommodated.

pier: a pillar supporting an arch.

portal: an entrance to a church.

quadripartite vaulting: a system of vaulting in which each bay consists of a central east–west vault crossed by a smaller one running north–south, creating four vault cells per bay.

radiating chapel: a semicircular chapel in the chevet.

rib: a 'skeletal' masonry arch projecting from a vault, typically at the groins.

rood screen: a screen, often of elaborately decorated masonry or of wrought iron, separating the nave from the choir.

rose window: a round window. Normally this term refers to a large, intricately structured window at the west end of the nave or at the ends of the transepts.

sanctuary: the innermost and holiest part of the chancel of a church, containing the high altar.

sexpartite vaulting: a vaulting system in which two angled cross vaults intersect with the central east–west vault in each bay, creating six cells per bay.

spandrel: the blank, roughly triangular space between an arch and an adjoining wall, or between two arches.

springing: the point at which an arch launches out from the vertical support.

stilting: the raising up of the springing of an arch in a cross vault, to avoid the need for distorting the arch's shape in order for all the topmost points to be at the same height.

string course: a thin projecting shelf of stone or brickwork that runs horizontally along a wall.

tas-de-charge: voussoirs containing the carved segments of vault ribs, which may form the lowest segments of the ribs nearest the springing.

template, templet: wooden or metal plates cut into the cross-sectional shape of stone blocks used for pillars, arches and other masonry structures.

tie-beam: a bar, usually of wood or iron, used to 'tie' the two sides of an arch together and oppose its outward thrust.

transept: the arms of a church running north–south at the east end of the nave.

tribune: a gallery of open arches above the nave arcade, providing openings to admit light from the upper windows of the aisle walls.

triforium: a narrow gallery of arches below the clerestory, generally with a passageway behind.

tympanum: the roughly semicircular space between the lintel and arch of a portal, often highly decorated with carving.

vault: a church ceiling with an arched form.

vestry: a church building originally used as an office, particularly for managing church funds.

vice: a spiral staircase to the passageways that lace through the upper church, providing walkways for clerics and access for construction and repairs of the building fabric.

voussoir: a block of masonry, generally wedge-shaped, used to build an arch or vault.

Notes

Biblical quotations in the text are taken from the New International Bible (London: Hodder & Stoughton, 1987).

Introduction

'The greatest works of architecture are not so much individual as social creations': quoted in Erlande-Brandenburg (1994), p.7.

'the book of architecture no longer belonged to the priesthood': ibid.

'A symbol of French unity': ibid. p.11.

Chapter 1

Epigraph quoted in V. Sablon, *Histoire de l'Auguste et Vénérable Église de Chartres*, Chapter XII (1671). Reprinted in Branner (1969), pp.111–12.

'an honest widow who had always served her': ibid., in Branner (1969), p.110.

'rebel[s] against the king as if by hereditary right': quoted in Grant (1998), p.53.

'devastated all his lands, both in Brie and in Chartres': Suger, *The Life of Louis the Fat*, Ch. XIX: taken from an online medieval sourcebook: http://www.fordham.edu/halsall/basis/suger-louisthefat.html

'The church was not simply burned, but actually totally destroyed': quoted in Branner (1969), p.91.

'Since I do not have the wherewithal to restore it in a fitting manner': quoted in Ward (1986), p.8.

'By the grace of God along with your aid': ibid.

'considered as the totality of their misfortune': ibid., p.15.

'seized with incredible anguish and grief': ibid.

'so preserved from mortal danger under the protection of the Blessed Mary': ibid.

'the Virgin and Mother of God': quoted in von Simson (1964), p.163.

Chapter 2

'We resolved to hasten, with all our soul and the affection': Suger, *De consecratione*, in Panofsky (1946), p.89.

'Chartres was often treated as though it had no antecedents': Kidson (1996), p.493.

'At first I was completely dazzled': quoted in Dunlop (1982), p.87.

'Both Bourges and Chartres were thought through completely': Bony (1983), p.132.

'transparent logic of French cathedral Gothic': Jantzen (1984), p.36.

'those who practised architecture produced buildings': Vasari (1965), p.39.

'Nowadays it is no longer used by men of ability': Giorgio Vasari, *On Technique* (original introduction to *Lives of the Artists*, 1550), trans. L. S. Maclehose (New York, Dover, 1960), pp.83–4.

'Cursed be the man who introduced "modern" architecture': quoted in Frankl (2000), p.263.

'a fantastical and licentious manner of building': quoted in Dunlop (1982), p.208.

'the measureless height of the houses of prayer': quoted in Bentmann and Lickes (1979), pp. 50, 52

'the wrong side of the stuff': quoted in Dunlop (1982), p.68.

'completely worldly and depraved': quoted in Grant (1998), p.184.

'It was at your errors, not at those of your monks': quoted in Panofsky (1946), p.10.

'capable of governing the universe': quoted in Dunlop (1982), p.1.

'beggar, whom the strong hand of the Lord has lifted up from the dunghill': quoted in Panofsky (1946), pp.30–1.

'allotted a short and spare body': ibid., p.32.

'small of body and family, constrained by twofold smallness': ibid., p.33.

'He excelled at being human': ibid., p.37.

'neither very exquisite nor very coarse': ibid., p.12.

'destined by moral and natural law to be subjected to the French': ibid., p.32.

'On a certain night, when I had returned from celebrating Matins': ibid., pp.95–6.

'I, who was Suger, being the leader': ibid., p.51.

'Often on feast days, completely filled': ibid., p.87.

'the narrowness of the place forced the women to run': ibid., p.43.

'For three years we pressed the completion of the work': ibid., p.105.

'betrays the complacency of the great patron': Kidson (1987), p.11.

'a powerful mind at work, thinking imaginatively': ibid.

'whether he knew it or not': ibid.

'Of the diverse counts and nobles from many regions': quoted in Panofsky (1946), p.113.

'the King himself and his officials': ibid., p.115, with transposition for clarity.

'We who have turned aside from society': Bernard, *Apologia ad Guillelmum*, Ch. 12, quoted in Eco (1986), p.7.

'moves the soul rather to delight': Thomas Aquinas, *Summa theologiae*, quoted in Eco (1986), p.9.

'since the devotion of the carnal populace cannot be incited': quoted in Dunlop (1982), pp.13–14.

'what is the good, among poor people like yourselves': quoted in Duby (1981), p.122–3.

'incessant war against weight': Jantzen (1984), p.71.

'In the Gothic nave wall there is no hint of load bearing': ibid., p.72.

'reject the characteristic of continuous mass': ibid., p.75.

'The entire expanse of wall is set against a background of space': ibid., pp.75–6.

'proposed a general sense of direction': Frankl (2000), p.268.

'a chain of creations': ibid.

'Reims was a correction of Chartres': ibid., p.116.

'who understands the language of stone': ibid.

'in the regions where the Gothic style was born': ibid., p.263.

Chapter 3

'To understand the meaning of a Gothic church': Frankl (2000), p.243.

'Architecture always had something significant to say': Jantzen (1984), p.170.

'Contemporary man places an exaggerated value on art': E. R. Curtius, *European Literature and the Latin Middle Ages*, trans. W. R. Trask (London, 1953), p.224, n.20.

'The nations will walk by its light': Revelation 21:24–6.

'never forgot that all things would be absurd': Huizinga (1972), p.194.

'God's discourse to man': Eco (1986), p.54.

'actualized a synthetic vision of man': ibid., p.61.

'The eleventh-century Christians': Duby (1981), pp.9, 76.

'By reason the Supreme Author of things': quoted in Benson and Constable (1982), p.61.

'If you are to get the full enjoyment out of Chartres': Adams (1986), p.96.

'The Blessed Virgin is nine': quoted in James (1982), p.84.

'even the least canon of our church': quoted in Welch Williams (1993), p.20.

'whoever should be elected to the deanship': Chartres Cathedral Charter of

26 May 1224, from L. Merlet and E. de Lépinois, *Cartulaire de Notre-Dame de Chartres*, Vol. 2, (Chartres, 1861–5), p.103. Quoted in Branner (1969), p.99.

'New wine, just freshly broached': from *Medieval French Plays*, trans. R. Axton and J. Stevens (Oxford, 1971), p.135.

Chapter 4

'Western religious art is an accurate reflection': Jantzen (1984), p.170.

'One of the most singular phenomena of the literary history': quoted in Adams (1986), p.134.

'innumerable multitudes of the faithful': Erlande-Brandenburg (1994), p.120.

'I have never seen anything as beautiful': E. Viollet-le-Duc, letters to his wife dated 16 May and 22 May 1835. Quoted in Midant (2002), p.7.

'The twelfth century schools': Southern (1979), p.9.

'He keeps in his palace a great number of books': Duby (1981), p.18.

'There shalt thou find the volumes that contain': Alcuin, *Versus de sanctis Eboracensis ecclesiae* in A. West, *Alcuin and the Rise of the Christian Schools* (New York, Scribner, 1892), p.35.

'no scholarly ambition more ancient than this': Southern (1979), p.12.

'continuously stimulating scientific thought': Klibansky (1939), p.37.

'I desire to have knowledge of God and the soul': Augustine, *Soliloquies* I, 2, n.7. Quoted in Luscombe (1997), p.10.

'In points obscure and remote from our sight': quoted in Crombie (1959), p.75.

'what did it profit me?': Augustine, *Confessions* IV, xvi. Quoted in Russell (1946), p.347.

'many holy people have not studied them at all': Augustine, *Retractions* I, 3.2. Quoted in Chadwick (1986), p.35.

'a passion for wrangling and a kind of childish parade': Augustine, *De doctrina Christiana*, 2.31.48. Quoted in Paffenroth and Hughes (2000), p.99.

'can give us swollen heads and stiff necks': *De doctrina Christiana* 2.13.20. Quoted in ibid.

'knowledge puffs up; love builds up': 1 Corinthians 8:1.

'The proud cannot find you': *Confessions* 5.3.3, trans. Warner, p.92. Quoted in Eamon (1994), p.62.

'For with much wisdom comes much sorrow': Ecclesiastes 1:18.

'I grieve to think of that subtle intelligence': St Bernard, *Epistolae, Patrologia Latina*, vol. 182, ed. J. P. Migne (Paris, 1844–64), 238–9. Quoted in Lawrence (1984), p.154.

'translate into Latin every book of Aristotle': Boethius, Commentary on *Peri hermenias*. Quoted in Pieper (1960), p.30.

'as far as you are able': quoted in Pieper (1960), p.37.

'deprived the medieval world of an opportunity': Klibansky (1939), p.22.

'God the Creator of the massive structure': Boethius, De arithmetica I.1. Quoted in Hiscock (2000), p.82.

'what is easiest and most useful in arithmetic': Crombie (1959), p.66.

'If we turned our backs on the amazing rational beauty': quoted in Goldstein (1988), p.88.

'Our generation has this deep-rooted defect': quoted in Le Goff (1993), p.55.

'violent, emaciated man': Duby (1981), p.119.

'Be fearful when grace smiles on you': quoted in G. R. Evans, Bernard of Clairvaux (2000), p.91.

'Born of sin, of sinners, we give birth to sinners': quoted in Le Goff (1993), p.46.

'What purpose is there in these ridiculous monsters': St Bernard, Apologia to William of St Thierry, in G. Coulton, Art and the Reformation (London, 1928). Quoted in Swaan (1969), p.52.

'All my works frighten me': St Bernard, Epistola 306. Quoted in Pieper (1960), p.89.

'blind to the visible world': Panofsky (1946), p.25.

'to spend the whole day in admiring these things': quoted in ibid., p.25.

'his analysis of what he rejects is extraordinarily fine': Eco (1986), p.7.

'Don't allow yourself to be ignorant of beauty': quoted in von Simson (1964), p.235.

'forbidden knowledge by forbidden means': Eamon (1994), p.62.

'is worth more than any man': quoted in Robertson (1972), p.9.

'You will find much more in forests': quoted in Le Goff (1993), p.21.

'I . . . turned my face towards Paris': The Letters of John of Salisbury, Vol. II, The Later Letters (1163–1180), ed. W. J. Millor and C. N. L. Brooke (Oxford, Clarendon Press, 1979), letter 136, p.7.

'I became most burdensome': quoted in Robertson (1972), p.18.

'In the Paris of the twelfth century': quoted in Dunlop (1982), p.2.

'possessed with an inordinate impulsion': Taylor (1919), p.373.

'He had a miraculous command of words': Robertson (1972), p.32.

'My masters are not Plato and Aristotle': quoted in Luscombe (2002), p.16.

'Sin has no reality': quoted in Abailard's Ethics, trans. J. R. McCallum (Merrick, New York, Richwood Publishing, 1976), pp.19, 68.

'The crime lies in the intending': quoted in Duby (1981), p.117.

'is trying to make void the merit': quoted in Taylor (1919), p.416.

'he goes farther than is meet for him': Pieper (1960), p.83.

'We seek through doubt': quoted in Duby (1981), p.115.

Chapter 5

'We are amazed at certain things': quoted in Binding (1999), p.41.

'A considered arrangement of symmetries': H. Focillon, *The Art of the West*, trans. D. King (London, 1963), Vol. I, p.8.

'Venerable Socrates of the Chartres Academy': quoted in Miller (1996), p.10.

'Without himself writing anything great': Southern (1987), p.191.

'the most perfect Platonist of his time': quoted in Jeauneau (2000), p.36.

'Such is the method that Bernard of Chartres followed': ibid., p.37.

'We are dwarfs on the shoulders of giants': quoted in Crombie (1959), p.46.

'Let us begin with what we now call water': Plato, *Timaeus* (1971), pp.67–8.

'surrounded by fire and cut up by the sharpness': ibid., p.80.

'God placed water and air between fire and earth': ibid., p.44.

'the ignorant mob and the mish-mash of the schools': quoted in Dronke (1988), p.362.

'without learning, without distinction': William of Conches, *Dragmaticon* I, i, 33–41, ed. I. Ronca (Turnhout: Brepols, 1997), p.5.

'Most of these prelates seek in the whole world': ibid.

'By making Plato into a Christian': quoted in Toman (1998), p.11.

'If anyone considers not only Plato's words': Southern (1979), p.25.

'the composition of the globe': quoted in Chenu (1968), p.10.

'One will say that it conflicts with divine power': quoted in Jeauneau (2000), p.50.

'Certainly God can do everything': quoted in Le Goff (1993), p.51.

'not without a natural reason too': quoted in Crombie (1959), p.45.

'I do not detract from God': ibid.

'Ignorant themselves of the forces of nature': quoted in Chenu (1968), p.11.

'[From] the stock of serpents has emerged a viper': quoted in Jeauneau (2000), p.50.

'not through God, but by nature': quoted in Le Goff (1993), p.48.

'this great factory, this great workshop': ibid., p.57.

'All work is the work of the Creator': ibid.

'where the pilgrims learn the working of metals': ibid.

'have been dazzled by the great name of Chartres': Southern (1979), p.28.

'It remains clear that there are important and widely influential': W. Wetherbee, in Dronke (1988), p.21.

'reduce all things to numbers': Aristotle, *Metaphysica*, 1036b, 1080b. In D. Fowler, *The Mathematics of Plato's Academy: A New Reconstruction* (Oxford, 1987), p.302.

'He began the division as follows': Plato (1971), *Timaeus*, p.48.

'Reason is nothing else than number': Augustine, *De ordine* II.18.48. Quoted
 in Hiscock (2000), p.103.
'setting aside the judgement of the ears': Boethius, *De institutione musica*, ed.
 G. Friedlein (Leipzig, 1876), I, 33.
'In the body a certain symmetrical shape': Cicero, *Tusculan Disputations*, trans.
 J. E. King (London and Cambridge, 1950), IV.13.
'the beautiful comes about': quoted in E. Panofsky, *Meaning in the Visual Arts*
 (Harmondsworth: Penguin, 1970), p.96.
'I would not describe as beauty of form': quoted in Binding (1999), p.42.
'During the "concentrated" phase of this astonishingly synchronous devel-
 opment': Panovsky (1957), pp.20–1.
'it is not very probable that the builders of Gothic structures': ibid., p.23.
'the architect himself had come to be looked upon': ibid., p.26.
'the unity of truth. . . palpably explicit': ibid., pp.28, 30, 34.
'Pre-Scholasticism had insulated faith from reason': ibid., p.43.
'multiplication of useless questions, articles, and arguments': ibid., p.35.
'Gothic art would not have come into existence': von Simson (1964), p.106.
'The Gothic builders . . . are unanimous in paying tribute': ibid., p.13.
'The first Gothic, in the aesthetic, technical and symbolic aspects': ibid.,
 p.39.
'the lapidary translation of scholastic philosophy': quoted in van der Meulen
 (1989), p.809.
'wonderful consummation in the parallel phenomena': ibid.
'Gothic at last took its place as a major manifestation': Kidson (1987), p.1.
'the temptation to rewrite history rather more emphatically': ibid.
'facile little tract': van der Meulen (1989), p.809.
'the theological origins of every individual form': ibid., pp.809–10.
'The gentle reader may feel about all of this': Panofsky (1957), p.86.
'Thou hast ordered all things in measure': Apocrypha, Wisdom of Solomon
 II.20 (Authorized Version).
'The temple that King Solomon built for the Lord': I Kings 6:2–17.
'Let no one be so foolish or so absurd': St Augustine, *De trinitate* IV.4.10.
 Quoted in Hiscock (2000), pp.104–5.
'constructed in the most regular proportions': Clement of Alexandria,
 Stromateis VI.11. Quoted in Hiscock (2000), p.158.
'As the living stones are bonded in a fabric of peace': quoted in ibid., p.148.
'Ramwold . . . commanded the erection of a crypt at St Emmeram': quoted
 in ibid., p.151.
'demonstrate and explain the proportions of completed works': Vitruvius
 (1999), p.21.
'educate him as a page or an architect': ibid., p.14.

'The composition of a temple is based on symmetry': ibid., p.47.

'the appropriate harmony arising out of the details': *Vitruvius on Architecture*, trans. F. Granger, I.2.4 (London, Macmillan, 1931–4).

'an attractive appearance and a coherent aspect': Vitruvius (1999), p.25.

'Proportion consists in taking a fixed nodule': *Vitruvius on Architecture*, III.1.1. Quoted in Eco (1986), p.29.

'Everything is of a piece': Hugo (1978), p.124.

'Vitruvius was not widely read': White (1978), p.91.

'the universe ceased to be a code that the imagination strove to decipher': Duby (1981), p.117.

'The presence of proportions in a building': Kidson, 'Architectural proportion' (1996), p.344.

'So much of what has been written on the subject is nonsense': Fernie and Crossley (1990), p.229.

'There was not one decision that was not made through geometry': James (1982), p.148.

'doodle . . . yourself [and] you will effortlessly come up with geometric forms': James (1981), p.33. Quoted in van der Meulen (1984), p.84.

'shows there are alternative geometric proportions': Hiscock (2000), p.277.

Chapter 6

'The early master had the tradition of generations': Salzman (1979), p.25.

'An honourable work glorifies': A. Seeliger-Zeiss, *Lorenz Lechler von Heidelberg und sein Umkreis* (Heidelberg, 1967). Quoted in Coldstream (2002), p.55.

'He who was master of this work': quoted in Andrews (1992), p.23.

'Master Jean de Chelles commenced this work': quoted in Gimpel (1992), p.118.

'It would be difficult to name a monument of similar importance': von Simson (1964), p.225.

'Gothic architects were not engineers, but artists': Jantzen (1984), p.81.

'But one, William of Sens, was present with the other workmen': quoted in Andrews (1992), p.19.

'constructed ingenious machines for loading and unloading ships': quoted in Erlande-Brandenburg (1995), p.148.

'No one other than himself was in the least injured': ibid., p.150.

'the master though still in bed gave directions': quoted in Andrews (1992), p.20.

'in workmanship of many kinds acute and honest': quoted in Erlande-Brandenburg (1995), p.151.

'all the good and pleasant services': ibid., p.67.

'And if it be that the said William Horwood makes not end': ibid., p.163.

'work with words only . . . rarely or never putting his hand to the task':
 quoted in Gimpel (1992), p.119.

'everything is always': Jantzen (1984), p.20.

'the decisions to employ a particular set of constructional features': Radding
 and Clark (1992), p.3.

'It ought to be obvious to art historians, if to no one else': Kidson (1987), p.1.

'On one side, there will be an arch adjoining the chapel': quoted in Erlande-
 Brandenburg (1995), p.142.

'For the foundations, the said Jehan must go at his own expense': ibid.

'Although it may be difficult': Branner (1957), p.374.

'Marvel you not that I said that all science': quoted in Shelby (1972), p.396.

'And they took their sons to Euclid to govern them at his own will': ibid.,
 p.396. From Knoop and Jones (1967), p.97.

'Does not geometry teach how': Robert Kilwardby, *De Ortu Scientiarum*
 (*c.* 1250). Quoted in E. Whitney (1990): 'Paradise restored: the mechan-
 ical arts from antiquity through the thirteenth century,' *Transactions of
 the American Philosophical Society* 80: 120.

'Each skilled person in the mechanical arts': quoted in Binding (1999), p.43–4.

'The entire discipline of geometry is either theoretical': quoted in Shelby
 (1972), p.401.

'So long as masons managed to keep themselves secluded': Kidson,
 'Architectural proportion' (1996), p.347.

'appears to have been overwhelmingly more popular': Fernie and Crossley
 (1990), p.230.

'standard Gothic rectangle': Hiscock (2000), p.7.

'art without science is nothing': quoted in von Simson (1964), p.19.

'Rigid distinctions that continue to be made': Hiscock (2000), pp.17–21.

'lime and pagan brick and linseed oil': quoted in Andrews (1992), p.69, n.2.

'Here begins the method of drawing as taught by the art of geometry':
 quoted in Gimpel (1992), p.139.

'natural appearance . . . subordinated . . . to the laws of geometry': Jantzen
 (1984), p.90.

Chapter 7

'With wonderful art he built the work': quoted in Erlande-Brandenburg
 (1995), p.132.

'Of all the experiments, all the innovations': Duby (1981), p.83.

'frivolity and vanity, but also intelligence': quoted by U. Geese in *The Art of
 Gothic*, ed. Toman (1998), p.300.

'changed its nature and become architecture': ibid., p.302.

'So he prayed Divine Mercy grant him assistance': quoted in Erlande-Brandenburg (1995), pp.146–7.

'by safe ships through the Mediterranean': Suger, ed. Panofsky (1946), p.91.

'Suddenly the generous munificence of the Almighty': ibid.

'Clamouring, they grew so insistent that some weak': ibid., pp.92–3.

'Art alone is the painter's province': Gimpel (1983), p.71.

'By becoming a sculptor': ibid.

'there was also a contingent of labourers who were no more than mere wage-workers': Andrews (1992), p.5.

'on the day of Lent, when the masons and labourers were in the workshop': Erlande-Brandenburg (1995), p.139.

'For lack of proper care and of roofing': quoted in Gimpel (1992), p.107.

'There are constant references to the fall of buildings': Salzman (1979), p.25.

'No workman, no master, no journeyman will tell anyone': Gimpel (1983), p.85.

'delivered templates for shaping the stones': quoted in Dunlop (1982), p.22.

'Once the unit of measure had been established': Heyman (1997), p.26.

'The walls cannot be strong without mortar': quoted in Binding (1999), p.48.

Chapter 8

'Although the wall is put together from the mass': quoted in Erlande-Brandenburg (1995), p.132.

'A structural engineer, looking at a Gothic cathedral': Heyman (1968), p.182.

'One grows tired of hearing enthusiasts exclaim': Salzman (1979), p.25.

'We wonder if perhaps he has not leaped': Shelby (1961), p.401.

'It is a common sight when passing under a masonry bridge': Heyman (1997), p.17.

'All this means that arches are extraordinarily stable': Gordon (1978), p.190.

'neither flying buttresses nor pinnacles were necessary': P. Abraham, *Viollet-le-Duc et le rationalisme mediéval* (Paris, 1934), p.88n. Quoted in P. Frankl, *The Gothic* (Princeton, NJ, 1960), p.807.

'Structures either stand or fall': Smith (2001–2), p.102.

'as if crushed by the rounded arch': Hugo (1978), p.127.

'by certain ignorant people, surely through passion': Erlande-Brandenburg (1995), p.156.

'Whether the vaults are pointed or round': ibid.

'I think it should with more reason be called the Saracen style': C. Wren, *Parentalia, or, Memoirs of the family of the Wrens*, viz. of Matthew Bishop, printed for T. Osborn, London, 1750.

'Trying to recover the thoughts in men's minds by looking at the

objects they have made is a very hazardous undertaking': Smith (2001–2),
 p.106.
'This new spaciousness was really the basic revelation': Bony (1983), pp.73,
 76.
'The rib, then, serves a structural purpose as a very necessary': Heyman
 (1997), p.54.
'in order to create a place of enchantment': Jantzen (1984), p.71.
'the basic premise underlying the whole form': Frankl (2000), p.86.
'there is no inert matter': von Simson (1964), p.7.
'more often than not chill the blood': Smith (2001–2), p.127.
'When the work on the new addition with its capitals': quoted in Panofsky
 (1946), p.109.
'a wind so violent as to close the doors': quoted in Ward (1986), p.65.

Chapter 9

'The divine light penetrates the universe': quoted in von Simson (1964), p.52.
'At last we are face to face with the crowning glory': quoted in Adams (1986),
 p.123.
'one is almost surprised that they are not set in gold': ibid., p.130.
'the most beautiful window ever made': quoted in Dunlop (1982), p.34.
'the most splendid colour decoration the world ever saw': Adams (1986),
 p.124.
'can hardly have intended to call St John a dwarf': Klibansky (1936), p.148.
'If you compose a window in which there shall be no blue': quoted in Adams
 (1986), p.125.
'is vigorously honoured by God': quoted in Gage (1993), p.73.
'darkness made visible': quoted in Dunlop (1982), p.7.
'with the wonderful and uninterrupted light': quoted in Panofsky (1946), p.101.
'look most impressive, not only because they're so beautifully built': T. More,
 Utopia, trans. P. Turner (Harmondsworth: Penguin, 1965), p.125.
'hinders worship and simplicity' quoted in Gage (1993), p.69.
'In him was life, and that life': John 1:4–5.
'shone with the glory of God': Revelation 21:11.
'Lux is substance itself': quoted in Gage (1993), p.70.
'not only the author of visibility in all visible things': Plato, Republic, Book
 VI, trans. B. Jowett (Charles Scribner & Co., New York, 1871).
'But the Superessential Beautiful is called "Beauty"': Dionysius the Areopagite,
 The Divine Names, trans. C. E. Holt (London, 1920), pp.95–6.
'Every creature, visible or invisible': quoted in Panofsky (1946), p.20.
'transported from this inferior to that higher world': ibid., p.65.

'Bright is the noble work': ibid., pp.47–9.

'the sardius, the topaz, and the jasper, the chrysolite': quoted in ibid. (1946), p.63. The list of stones is given in Ezekiel 28:13.

'To those who know the properties of precious stones': ibid., pp.63–5.

'It is impossible for our mind to rise to the imitation': ibid., p.24.

'Physical light is the best, the most delectable': quoted in Duby (1981), p.148.

'equal to itself': quoted in Eco (1986), p.49.

'orgy of neo-Platonic light metaphysics': Panofsky (1946), p.21.

'one can imagine the blissful enthusiasm with which Suger': ibid., p.24.

'a monument of applied theology': Duby (1981), p.63.

'forged credentials': von Simson (1964), p.106.

'the most highly valued glass is colourless and transparent': Pliny, *Natural History* XXXVI. 200. Quoted in Jackson (2005), p.763.

'avidly desired the embellishment of the material house of God': Theophilus (1979), pp.77–8.

'take beechwood logs completely dried out': ibid., p.52.

'collected out of water, and carefully cleaned': ibid., pp.52–3.

'for a night and a day': ibid., p.53.

'If you see a pot changing to a saffron yellow colour': ibid., pp.55–7.

'until they are reduced to a powder': *Original Treatises on the Arts of Painting*, trans. M. P. Merrifield (New York, Dover, 1967), Vol. 1, p.214.

'Different kinds of glass, namely, white, black, green': Theophilus (1979), p.59.

'There are also found various small vessels': ibid.

'Then arrange the different kinds of robes': ibid., p.62.

'when the thicker part is red-hot, apply it to the glass': ibid., p.63.

'You ought also to do the same under the eyebrows': ibid., p.64.

'should be decked out with purple, green, blue and red': ibid.

'without repelling the daylight': ibid., p.48.

Chapter 10

'Springing up anew, now finished in its entirety': quoted in Branner (1969), p.97.

'In this same year men first began to harness themselves': quoted in Ward (1986), p.13.

'They were built in a great wave of mystic fervour': Goldstein (1988), p.160.

'Who ever saw, who ever heard, in all the generations past': quoted in Ward (1986), p.14.

'by our own people and the pious neighbours': quoted in Panofsky (1946), p.93.

'It was common enough to put one's shoulder to a cart': Erlande-Brandenburg (1994), p.230.

'In the thirteenth century, the cathedral surely brought back': Chédeville (1983), p.95.

'was an old building and very small': *Gesta pontificum Autissiodorensium*, in Labbe, *Nova bibliotheca manuscripta* (Paris, 1657), I, ff. 487. Quoted in Harvey (1972), p.230.

'the cultivation of grains ... provided the material basis': Welch Williams (1993), p.35.

'The financial needs of a cathedral under construction': Kraus (1979), p.xv.

'who cried out in the streets and by-ways to the mob': Welch Williams (1993), p.25.

'art in the service of clerical ideology': ibid., p.139.

'The head of the mother was received with great joy': quoted in Dunlop (1982), p.91.

'you can be twenty-seven days nearer to Paradise': quoted in Gimpel (1983), p.48.

'The old mass of masonry was completely demolished': quoted in Erlande-Brandenburg (1995), pp.132–4.

'None can be found in the whole world': quoted in Miller (1996), p.13.

'Power is the key word at Chartres': Bony (1983), p.233.

'No building had a more general': ibid., p.243.

Chapter 11

'The generation that lived during the first and second crusades': Adams (1986), p.133.

'I sometimes feel that a lot of our theology': quoted in R. Shortt, *God's Advocates* (Grand Rapids, Mi., W. B. Eerdmans, 2005).

'Fashions have done more harm than revolutions': Hugo (1978), p.126.

'For the first time, there was something like a universal awareness': Leff (1958), pp.91–2.

'There is not an object nor an action': Huizinga (1972), p.147.

'the world had been created by God': White (1978), p.27.

'The transition from Romanesque to Gothic': ibid., pp.26–7.

'I am not the sort of fellow who can be fed': quoted in L. Thorndike, *History of Magic and Experimental Science* (New York, Columbia University Press, 1929), Vol. II, p.29.

'Modern science, as it first appeared in the later Middle Ages': White (1978), p.41.

'no amount of knowledge of metaphysics can help one:' Frankl (2000), p.265.

'At Chartres, what had been renewed and reaffirmed': Bony (1983), p.245.

Bibliography

Adams, H. (1986) *Mont Saint Michel and Chartres*. Harmondsworth, Mx: Penguin.

Alexander, K. D., Mark, R. and Abel, J. F. (1977) 'The structural behaviour of medieval ribbed vaulting', *Journal of the Society of Architectural Historians* 36: 241–51.

Anderson, W. (1985) *The Rise of the Gothic*. London: Hutchinson.

Andrews, F. B. (1992) *The Mediaeval Builder*. New York: Dorset Press.

Barnes, C. (1982) *Villard de Honnecourt: The Artist and His Drawings: A Critical Biography*. Boston: G. K. Hall & Co.

Barnes, C. F., Jr (1989) 'Le Problème de Villard de Honnecourt', in *Les Bâtisseurs des cathédrales Gothiques: Catalogue de l'Exposition de Strasbourg*. Strasbourg: Les Musées de la ville de Strasbourg, pp.209–23.

Barnes, C. F., Jr (1996) 'Cult of carts', in *The Grove Dictionary of Art*, vol. 8, pp.257–9. London: Macmillan.

Barnes, C. F., Jr (1996) 'Villard de Honnecourt', in *The Grove Dictionary of Art*, vol. 32, pp.569–71. London: Macmillan.

Benson, R. L. and Constable, G., eds (1982) *Renaissance and Renewal in the Twelfth Century*. Oxford: Clarendon.

Bentmann, V. R. and Lickes, H. (1979) *Medieval Churches*, trans. A. Lloyd. London: Cassell.

Binding, G. (1999) *High Gothic: The Age of the Great Cathedrals*. Cologne: Taschen.

Bony, J. (1983) *French Gothic Architecture of the 12th and 13th Centuries*. Berkeley: University of California Press.

Borg, A. and Mark, R. (1972) 'Chartres Cathedral: a reinterpretation of its structure', *Art Bulletin* 55: 367–72.

Branner, R. (1957) 'A note on Gothic architects and scholars', *Burlington Magazine* 99: 372–5.

Branner, R. (1960) 'Villard de Honnecourt, Archimedes, and Chartres', *Journal of the Society of Architectural Historians* 19: 91–6.

Branner, R., ed. (1969) *Chartres Cathedral*. Norton Critical Studies in Art History. New York: W. W. Norton.

Brooke, C. (1969) *The Twelfth-Century Renaissance*. London: Thames & Hudson.

Bucher, F. (1968) 'Design in Gothic architecture', *Journal of the Society of Architectural Historians* 27: 49–71.

Cantor, N. F. and Werthman, M. S., eds (1972) *Medieval Society: 400–1450*. New York: Thomas Y. Cowell.

Chadwick, H. (1986) *Augustine*. Oxford: Oxford University Press.

Chédeville, A., ed. (1983) *Histoire de Chartres et du Pays Chartrain*. Toulouse: Privat.

Chédeville, A. (1991) *Chartres et ses Campagnes (fl¾e-fl¾¾¾e)*. Paris: Editions Jean-Michel Garnier.

Chenu, M. D. (1968) *Nature, Man, and Society in the Twelfth Century: Essays on New Theological Perspectives in the Latin West* ed. J. Taylor and L. K. Little. Chicago: Chicago University Press.

Clemen, P. (1938) *Gothic Cathedrals: Paris, Chartres, Amiens, Reims*, trans. M. Cunynghame. Oxford: Blackwell.

Coldstream, N. (2002) *Medieval Architecture*. Oxford: Oxford University Press.

Constable, G. (2000) *Cluny from the Tenth to the Twelfth Centuries*. Aldershot, Hants: Ashgate.

Courtenay, L. T., ed. (1997) *The Engineering of Medieval Cathedrals*. Aldershot, Hants: Ashgate.

Crombie, A. C. (1959) *Augustine to Galileo 1: Science in the Middle Ages 5th–13th Century*. Harmondsworth, Mx: Penguin.

Crosby, S. M., Hayward, J., Little, C. T. and Wixom, W. D. (1981) *The Royal Abbey of Saint-Denis in the Time of Abbot Sugar (1122–1151)*. New York: Metropolitan Museum of Art.

Delaporte, Y. (1961) 'Remarques sur la chronologie de la cathédrale de Chartres', *Bulletin Société Archéologique d'Eure et Loire* 21: 299–320.

Derry, T. K. and Williams, T. I. (1960) *A Short History of Technology*. Oxford: Clarendon Press.

Dronke, P. (1969) 'New approaches to the school of Chartres', *Anuario de Estudios Medievales* VI: 117–40.

Dronke, P., ed. (1988) *A History of Twelfth-Century Western Philosophy*. Cambridge: Cambridge University Press.

Duby, G. (1981) *The Age of Cathedrals*. Chicago, IL: University of Chicago Press.

Dunlop, I. (1982) *The Cathedrals Crusade*. London: Hamish Hamilton.

Eamon, W. (1994) *Science and the Secrets of Nature*. Princeton, NJ: Princeton University Press.

Eco, U. (1986) *Art and Beauty in the Middle Ages*. New Haven, CT: Yale University Press.

Erlande-Brandenburg, A. (1994) *The Cathedral: The Social and Architectural Dynamics of Construction*, transl. M. Thom. Cambridge: Cambridge University Press.

Erlande-Brandenburg, A. (1995) *The Cathedral Builders in the Middle Ages*, transl. R. Stonehewer. London: Thames & Hudson.

Evans, G. R. (2000) *Bernard of Clairvaux*. Oxford: Oxford University Press.

Favier, J. (1990) *The World of Chartres*. London: Thames & Hudson.

Fernie, E. and Crossley, P., eds (1990) *Medieval Architecture and its Intellectual Context*. London: Hambledon Press.

Fischer, E. L. (2005) 'The Virgin of Chartres: Ritual and the Cult of the Virgin Mary at the Thirteenth-Century Cathedral of Chartres'. Thesis, Williams College, Williamstown, MA.

Fitchen, J. F. (1955), 'A comment on the function of the upper flying buttress in French Gothic architecture', *Gazette des Beaux-Arts*, 6th ser., 45: 69–90.

Fitchen, J. F. (1961) *The Construction of Gothic Cathedrals*. Chicago, IL: University of Chicago Press.

Frankl, P. (1963) 'The chronology of the stained glass in Chartres Cathedral', *Art Bulletin* 45: 301–22.

Frankl, P. (2000) *Gothic Architecture*. New Haven CT: Yale University Press.

Freestone, I. (1993) 'Theophilus and the composition of medieval glass', in *Materials Issues in Art and Archeology* ¾¾¾, MRS Proceedings, vol. 267, ed. P. B. Vandiver, J. R. Druzik, G. S. Wheeler and I. C. Freestone. Pittsburgh, PA: Materials Research Society.

Gage, J. (1993) *Colour and Culture*. London: Thames & Hudson.

Gimpel, J. (1983) *The Cathedral Builders*, transl. T. Waugh. Wilton, Wilts: Michael Russell.

Gimpel, J. (1992) *The Medieval Machine*. London: Pimlico.

Goldstein, T. (1988) *Dawn of Modern Science*. Boston, MA: Houghton Mifflin.

Gordon, J. E. (1978) *Structures, or Why Things Don't Fall Down*. Harmondsworth, Mx: Penguin.

Grant, E. (1981) *Studies in Medieval Science and Natural Philosophy*. London: Variorum.

Grant, E. (1996) *The Foundations of Modern Science in the Middle Ages*. Cambridge: Cambridge University Press.

Grant, L. (1998) *Abbot Suger of Saint-Denis*. London: Longman.

Grodecki, L. (1951) 'The transept portals of Chartres Cathedral: the date of their construction according to archaeological data', *Art Bulletin* 33: 156–64.

Harvey, J. (1972) *The Mediaeval Architect*. London: Wayland.

Haskins, C. H. (1927) *The Renaissance of the Twelfth Century*. Cambridge, MA: Harvard University Press.

Henderson, G. (1968) *Chartres*. Harmondsworth, Mx: Penguin.

Heyman, J. (1968) 'On the rubber vaults of the Middle Ages and other matters', *Gazette des Beaux-Arts* 71: 177–88.

Heyman, J. (1977) 'The Gothic structure', *Interdisciplinary Science Reviews* 2: 151–64.

Heyman, J. (1997) *The Stone Skeleton: Structural Engineering of Masonry Architecture*. Cambridge: Cambridge University Press.

Hiscock, N. (2000) *The Wise Master Builder: Platonic Geometry in Plans of Medieval Abbeys and Cathedrals*. Aldershot, Hants: Ashgate.

Huffman, C. (2003) 'Archytas', in *The Stanford Encyclopedia of Philosophy*, Fall 2003 edn, ed. Edward N. Zalta, see http://plato.stanford.edu/archives/fall2003/entries/archytas/

Hugo, V. (1978) *Notre-Dame de Paris*, transl. J. Sturrock. Harmondsworth, Mx: Penguin.

Huizinga, J. (1972) *The Waning of the Middle Ages*. Harmondsworth, Mx: Penguin.

Huyghe, R., ed. (1963) *Larousse Encyclopedia of Byzantine and Medieval Art*. London: Hamlyn.

Jackson, C. M. (2005) 'Making colourless glass in the Roman Period', *Archaeometry* 47: 763–80.

Jackson, C. M., Booth, C. A. and Smedley, J. W. (2005) 'Glass by design? Raw materials, recipes and compositional data', *Archaeometry* 47: 781–95.

Jalabert, D. (1932) 'La flore Gothique. Ses origines, son évolution du XIIe au XVe siècle', *Bulletin Monumental* 91: 181–246.

James, J. (1981) *The Contractors of Chartres*. Wyong, Australia: Mandorla Publications.

James, J. (1982) *Chartres: The Masons Who Built a Legend*. London: Routledge & Kegan Paul, 1982.

Jantzen, H. (1984) *High Gothic*. Princeton, NJ: Princeton University Press.

Jeauneau, É. (2000) *L'Age d'Or des Ecoles de Chartres*. Chartres: Editions Houvet.

Kidson, P. (1987) 'Panofsky, Suger and St Denis', *Journal of the Warburg and Courtauld Institutes* 50: 1–17.

Kidson, P. (1996) 'Architectural proportion', in *Grove Dictionary of Art*, vol. 2, pp.343–52. London: Macmillan.

Kidson, P. (1996) 'Chartres', in *Grove Dictionary of Art*, vol. 6, pp.492–7. London: Macmillan.

Kimpel, D. and Suckale, R. (1985) *Die gothische Architektur in Frankreich 1130–1270*. Munich: Hirmer.

Klibansky, R. (1936) 'Answer to query no. 53 – Standing on the shoulders of giants', *Isis* 26, 147–9.

Klibansky, R. (1939) *The Continuity of the Platonic Tradition during the Middle Ages*. London: Warburg Institute.

Knoop, D. and Jones, G. P. (1967) *The Medieval Mason*. Manchester: Manchester University Press.

Kraus, H. (1979) *Gold Was the Mortar*. London: Routledge & Kegan Paul.

Lawrence, C. H. (1984) *Medieval Monasticism*. Harlow, Essex: Longman.

Leff, G. (1958) *Medieval Thought*. Harmondsworth, Mx: Penguin.

Le Goff, J. (1993) *Intellectuals in the Middle Ages*, transl. T. L. Fagan. Oxford: Blackwell.

Luscombe, D. (1997) *Medieval Thought*. Oxford: Oxford University Press.

Luscombe, D. (2002) *Peter Abelard*. Oxford: Davenant Press.

Mark, R. (1972) 'The structural analysis of Gothic cathedrals', *Scientific American*, 227: 90–9.

Mark, R. (1979) 'The contractors of Chartres' (review), *Journal of the Society of Architectural Historians* 38: 278–9.

Melve, L. (2006) '"The revolt of the medievalists." Directions in recent research on the twelfth-century renaissance', *Journal of Medieval History* 32: 231–52.

Mews, C. J. (2001) *Abelard and His Legacy*. Aldershot, Hants: Ashgate.

Michler, J. (1989) 'La cathédrale Notre-Dame de Chartres: reconstitution de la polychromie originale de l'intérieur', *Bulletin Monumental* 147: 117–31.

Midant, J.-P. (2002) *Viollet-le-Duc: The French Gothic Revival*, trans. W. Wheeler. Paris: L'Aventurine.

Miller, M. (1996) *Chartres Cathedral*, 2nd edn. Andover, Hants: Jarrold.

Mumford, L. (1938) *The Culture of Cities*. London: Secker & Warburg.

Murray, S. (1976) 'The collapse of 1284 at Beauvais cathedral', *The Thirteenth Century Acta* 3: 17–44.

Murray, S. (1979) 'The contractors of Chartres' (book review), *Journal of the Society of Architectural Historians* 38: 279–81.

Murray, S. (1981) 'The contractors of Chartres' (book review), *Art Bulletin* 63: 149–52.

Murray, S. (1987) *Building Troyes Cathedral*. Bloomington: Indiana University Press, 1987.

Paffenroth, K. and Hughes, K. L., eds (2000) *Augustine and Liberal Education*. Aldershot, Hants: Ashgate.

Panofsky, E. (1946) *Abbot Suger on the Abbey Church of Saint-Denis and Its Art Treasures*. Princeton, NJ: Princeton University Press.

Panofsky, E. (1957) *Gothic Architecture and Scholasticism*. New York: New American Library.

Pestell, R. (1981) 'The design sources for the cathedrals of Chartres and Soissons', *Art History* 4: 1–13.

Pevsner, N. (1942) 'The term "architect" in the Middle Ages', *Speculum* 17: 549–62.

Pieper, J. (1960) *Scholasticism*. London: Faber & Faber.

Plato (1971) *Timaeus and Critias*, transl. D. Lee. Harmondsworth, Mx: Penguin.

Prache, A. (1990) 'Observations sur la construction de la cathédrale de Chartres au XIIIe siècle', *Bulletin de la Société Nationale des Antiquaires de France* 327–34.

Radding, C. M. and Clark, W. W. (1992) *Medieval Architecture, Medieval Learning: Builders and Masters in the Age of Romanesque and Gothic*. New Haven, CT: Yale University Press.

Robertson, D. W., Jr (1972) *Abelard & Heloise*. London: Millington.

Royce-Roll, D. (1994) 'The colors of Romanesque stained glass', *Journal of Glass Studies* 36: 71–80.

Royce-Roll, D. (1997–8). 'Twelfth-century stained glass technology according to Theophilus and Eraclius', *Avista Forum* 10(2)/11(1): 13–23.

Russell, B. (1946) *A History of Western Philosophy*. London: Allen & Unwin.

Salvadori, M. (1980) *Why Buildings Stand Up*. New York: W. W. Norton.

Salzman, L. (1979) *Building in England Down to 1540*. Oxford: Clarendon Press.

Scott, R. A. (2003) *The Gothic Enterprise*. Berkeley, CA: University of California Press.

Shelby, L. R. (1961) 'The construction of Gothic cathedrals' (book review), *Technology and Culture* 2: 400–2.

Shelby, L. R. (1970) 'The education of the medieval English master mason', *Medieval Studies* 32: 1–26.

Shelby, L. R. (1971) 'Medieval masons' templates', *Journal of the Society of Architectural Historians* 30: 140–54.

Shelby, L. R. (1972) 'The geometrical knowledge of mediaeval master masons', *Speculum* 47: 395–420.

Silvestri, A., Molin, G. and Salviulo, G. (2006) 'Sand for Roman glass production: an experimental and philological study on source of supply', *Archaeometry* 48: 415–32.

Smedley, J. W., Jackson, C. M. and Booth, C. A. (1998) 'Back to the roots: the raw materials, glass recipes and glassmaking practices of Theophilus', in *Ceramics and Civilisation*, vol. 8, ed. P. McCray and W. D. Kingery. Columbus, OH: American Ceramic Society.

Smith, N. A. F. (2001–2) 'Cathedral studies: engineering or history?', *Transactions of the Newcomen Society* 73: 95–137.

Smith, N. A. F. (2005) 'Cathedral studies: insight or hindsight?', *Interdisciplinary Science Reviews* 30: 47–58.

Southern, R. W. (1979) *Platonism, Scholastic Method, and the School of Chartres.* University of Reading.

Southern, R. W. (1987) *The Making of the Middle Ages.* London: Cresset.

Swaan, W. (1969) *The Gothic Cathedral.* London: Elek.

Taylor, H. O. (1919) *The Mediaeval Mind.* New York: Macmillan.

Theophilus (1979) *On Divers Arts,* trans. J. G. Hawthorne and C. S. Smith. New York: Dover.

Tobin, S. (1995) *The Cistercians: Monks and Monasteries of Europe.* London: Herbert Press.

Toman, R., ed. (1998) *The Art of Gothic.* Cologne: Könemann Verlagsgesellschaft.

van der Meulen, J. (1967) 'Recent literature on the chronology of Chartres Cathedral', *Art Bulletin* 49: 152–72.

van der Meulen, J. (1984) 'The contractors of Chartres' (book review), *Catholic Historical Review* 70: 83–9.

van der Meulen, J. (1989) *Chartres: Sources and Literary Interpretation.* Boston, MA: G. K. Hall.

Vasari, G. (1965) *The Lives of the Artists,* transl. G. Bull. Harmondsworth, Mx: Penguin.

Villette, J. [no date] *Chartres and its Cathedral,* transl. M.-Th. Olano and I. Robertson. London: Michael J. Wolfson.

Vitruvius Pollio (1999) *Ten Books on Architecture,* transl. I. D. Rowland. Cambridge: Cambridge University Press.

Von Simson, O. (1964) *The Gothic Cathedral.* New York: Harper & Row.

Ward, C. (1986) *Chartres: The Making of a Miracle.* London: Folio Society.

Welch Williams, J. (1993) *Bread, Wine and Money: The Windows of the Trades at Chartres Cathedral.* Chicago, IL: University of Chicago Press.

Westra, H. J. (1992) *From Athens to Chartres: Neo-Platonism and Medieval Thought.* Leiden: Brill.

White, L. (1962) *Medieval Technology and Social Change.* Oxford: Oxford University Press.

White, L., Jr (1978) *Medieval Religion and Technology.* Berkeley, CA: University of California Press.

Wilks, M., ed. (1984) *The World of John of Salisbury.* Oxford: Blackwell.

Willis, R., ed. (1730) *Sketch-Book of Wilars de Honecourt.* Oxford: Parker.

Wilson, C. (1990) *The Gothic Cathedral.* London: Thames & Hudson.

Zenner, M.-T., ed. (2004) *Villard's Legacy: Studies in Medieval Technology, Science and Art in Memory of Jean Gimpel.* Aldershot, Hants: Ashgate.

Index